Reading Poetry, Writing Genre

Bloomsbury Studies in Classical Reception

Bloomsbury Studies in Classical Reception presents scholarly monographs offering new and innovative research and debate to students and scholars in the reception of Classical Studies. Each volume will explore the appropriation, reconceptualization and recontextualization of various aspects of the Graeco-Roman world and its culture, looking at the impact of the ancient world on modernity. Research will also cover reception within antiquity, the theory and practice of translation, and reception theory.

Also available in the series:

Reading Poetry, Writing Genre

English Poetry and Literary Criticism in Dialogue with Classical Scholarship

Edited by
Silvio Bär and Emily Hauser

BLOOMSBURY ACADEMIC
LONDON • NEW YORK • OXFORD • NEW DELHI • SYDNEY

BLOOMSBURY ACADEMIC
Bloomsbury Publishing Plc
50 Bedford Square, London, WC1B 3DP, UK
1385 Broadway, New York, NY 10018, USA

BLOOMSBURY, BLOOMSBURY ACADEMIC and the Diana
logo are trademarks of Bloomsbury Publishing Plc

First published in Great Britain 2019
Paperback edition first published 2020

Cover design: Terry Woodley
Cover image: Lyric Music, 1912 (bronze), Paul Howard Manship, (1885–1966)/
Cincinnati Art Museum, Ohio, USA/Wilson Fund/Bridgeman Images and courtesy
of Manship Artists Residency + Studios (www.ManshipArtists.org)

A catalogue record for this book is available from the British Library.

Library of Congress Cataloging-in-Publication Data

Names: Bèar, Silvio, editor. | Hauser, Emily (Fiction writer), editor.
Title: Reading poetry, writing genre: English poetry and literary criticism
in dialogue with classical scholarship / edited by Silvio Bèar and Emily Hauser.
Description: London, UK: Bloomsbury Academic, an imprint of Bloomsbury
Publishing Plc, 2018. | Series: Bloomsbury studies in classical reception |
Includes bibliographical references and indexes.
Identifiers: LCCN 2018022508 (print) | LCCN 2018058635 (ebook) |
ISBN 9781350039339 (epdf) | ISBN 9781350039346 (epub) |
ISBN 9781350039322 (hb:alk.paper)
Subjects: LCSH: English poetry—History and criticism. | English
poetry—Classical influences.
Classification: LCC PR508.C68 (ebook) | LCC PR508.C68 Z86 2018 (print) |
DDC 821.009—dc23

LC record available at https://lccn.loc.gov/2018022508

ISBN: HB: 978-1-3500-3932-2
PB: 978-1-3501-7130-5
ePDF: 978-1-3500-3933-9
eBook: 978-1-3500-3934-6

Series: Bloomsbury Studies in Classical Reception

Typeset by RefineCatch Limited, Bungay, Suffolk

To find out more about our authors and books visit
www.bloomsbury.com and sign up for our newsletters.

For our teachers

Contents

Acknowledgements

The publication of this volume would not have been possible without the help and support of many colleagues, friends, and – above all – our contributors. We would like to single out, in particular, Emily Greenwood and Fritz Gutbrodt, who were of great assistance to us during the process of bringing this volume to life. Special thanks are due to several anonymous reviewers who helped improve the quality of the chapters significantly, and to Sofia Heim for having compiled the indices so swiftly and professionally. Finally, we are grateful to Bloomsbury for having accepted our volume in the *Studies in Classical Reception* series, and to Emma Payne, Alice Wright, Clara Herberg, Lucy Carroll, Ken Bruce and Merv Honeywood for their untiring support and efficiency.

Silvio Bär and Emily Hauser
Oslo and Boston, July 2018

List of Illustrations

List of Contributors

Silvio Bär is Professor of Ancient Greek at the University of Oslo. His research interests encompass Greek epic and lyric poetry, Attic tragedy, the Second Sophistic, mythography, rhetoric, intertextuality, narratology and the reception of ancient themes in English literature and popular culture. He is the co-editor of *Quintus Smyrnaeus: Transforming Homer in Second Sophistic Epic* (2007) and *Brill's Companion to Greek and Latin Epyllion and Its Reception* (2012).

Emma Buckley is Senior Lecturer in Latin and Classical Studies at St Andrews University. She has published widely in early imperial literature, especially Senecan drama and Flavian epic; in early modern reception of Seneca, Ovid and Vergil; and in early modern neo-Latin and vernacular theatre. She is editor (with Martin Dinter) of the *Companion to the Neronian Age* (Blackwell-Wiley, 2013).

Lilah Grace Canevaro is Lecturer in Greek at the University of Edinburgh. She is the author of *Hesiod's* Works and Days: *How to Teach Self-Sufficiency* (OUP, 2015) and co-editor of *Conflict and Consensus in Early Greek Hexameter Poetry* (CUP, 2017). Her forthcoming book *Women of Substance in Homeric Epic: Objects, Gender, Agency* (OUP, 2018) shines new light on the *Iliad* and *Odyssey* by bringing together gender theory and the burgeoning field of New Materialisms to decentre the male subject and put centre stage not only the woman *as* object but also the agency of women *and* objects.

Fiona Cox is Associate Professor in French and Comparative Literature at the University of Exeter. She is the author of *Aeneas Takes the Metro – Virgil's Presence in Twentieth Century French Literature* (1999) and of *Sibylline Sisters – Virgil's Presence in Contemporary Women's Writing* (2011). Her most recent monograph entitled *Ovid's Presence in Contemporary Women's Writing – Strange Monsters* will be published in 2018 and she is also preparing with Elena Theodorakopoulos an edited volume on modern and contemporary women's receptions of Homer.

Amanda J. Gerber is Lecturer in English at the University of California, Los Angeles and the author of classical reception studies such as *Medieval Ovid: Frame Narrative and Political Allegory* (2015). She is currently at work on a study of how medieval scholars used classical literature to develop previously unclassified scientific fields.

Emily Hauser is Lecturer in Classics and Ancient History at the University of Exeter. Her research interests include ancient women writers, gender and authorship in the classical world, and the reception of classical women by contemporary female authors. She has published on women writers in ancient Greece and Rome, as well as the reception of the *Odyssey* in Margaret Atwood's *The Penelopiad*. Her current project explores terminology for authorship and its intersection with gender in antiquity, as a new way into reading the relationship between poetics and identity in classical literature.

Isobel Hurst is Lecturer in English at Goldsmiths, University of London. She is the author of *Victorian Women Writers and the Classics: The Feminine of Homer* (OUP, 2006) and has recently contributed essays on Victorian poetry and classical reception to *The Oxford Handbook of Victorian Poetry*, ed. Matthew Bevis (OUP, 2013) and *The Oxford History of Classical Reception in English Literature*, vol. 4, ed. Jennifer Wallace and Norman Vance (OUP, 2015).

Juan Christian Pellicer is Professor of English at the University of Oslo. He has written extensively on georgic, pastoral, and the reception of Vergil's works, especially in the eighteenth century, and has edited works by John Philips and John Dyer. He is currently preparing a book chapter on the nineteenth-century reception of Theocritus.

Ariane Schwartz works in education and management consulting. She taught for several years at Dartmouth, UCLA, and Harvard, and is Assistant Editor for the I Tatti Renaissance Library. She has co-founded the Society for Early Modern Classical Reception (a Society for Classical Studies affiliate group) and has been involved in several digital humanities initiatives, including Quantitative Criticism Lab and the Online Public Classics Archive. She received her PhD in Classical Philology from Harvard University

Caroline Stark received a PhD in Classics and Renaissance Studies from Yale University and is Assistant Professor of Classics at Howard University. Her research interests include ancient cosmology, anthropology, ethnography, and the reception of classical antiquity in Medieval and Renaissance Europe and in Africa and the African Diaspora. She is co-editing *A Companion to Latin Epic 14–96 CE* for Wiley-Blackwell and has published numerous articles on the reception of classical antiquity in the literature and art of Medieval and Renaissance Europe and in African American literature and film.

Introduction

Silvio Bär and Emily Hauser

In the preface to her introductory survey to classical reception studies from 2003, Lorna Hardwick observes that 'reception studies in Classics is a rapidly changing field' (Hardwick 2003: iii). Fifteen years later, this statement is not only still valid, but the field of reception studies has also continued to proliferate, both in the quantity of research produced and published and in its diversification (and theorization) into numerous subfields.[1] However, despite this development and the immense diversification of the field, the major part of reception studies still tends to be concerned with the influence of classical 'models'[2] upon specific authors, texts, and genres of a given post-classical period and/or a defined linguistic and/or geographical area – or, in more nuanced ways, with the reciprocity between two reference texts.[3] In essence, these types of studies can be regarded as synchronic because they focus on classical influences at, and upon, a specific point in time (and often also a specific geographical area). In contrast, diachronic reception studies, which trace classical reception through more than one period and thus are more process-orientated than product-orientated, seem to be less common. A relatively recent example of a decidedly diachronic reception study is Stuart Gillespie's monograph *English Translation and Classical Reception: Towards a New Literary History*, published in 2011. In this study, Gillespie successfully attempts to write and map English literary history as a story of the translation of ancient classical literature, arguing, in his conclusion, that the 'disciplines of Classics and English can come together in translation because it presents us with a transformative moment involving more than one culture' (Gillespie 2011: 181).

This volume aims to map the history and development of English poetry and the literary history and criticism connected to it as a story of genre discourse in dialogue with classical scholarship. The significance of classical influences in English literature, and especially poetry, in all periods can be regarded as

an undisputed (and well-investigated) fact.[4] In a similar vein, it is almost a commonplace to state that literary genres are, as a rule, not given or fixed entities, but that they develop and change (or die) through their articulation in relation to other – ancient or post-classical – genres; that perceptions of genre are subjective and unstable (as well as historically situated); and that the reception of genre by both writers and scholars feeds back into the way genre is articulated in specific literary works.[5] In light of this, it is, however, surprising to note that the significance of scholarship and literary criticism (and their history, development and productivity) is comparatively rarely taken into account in connection with reception studies and its relation to the study of genres and genre history. It is, for example, telling that Hardwick and Stray's comprehensive and authoritative *Companion to Classical Receptions* (2008) contains, *inter alia*, a chapter on translation, but not on (the history of) scholarship and/or literary criticism.

The principal goal of this collection is therefore to address the ways in which classical scholarship and English literary history and literary criticism interact, and how this interaction affects, changes, sharpens, blurs, or perhaps even obstructs views on genre in English poetry. These themes – *classical scholarship*, *literary criticism*, and *genre* – form a triangle of key concepts for our endeavour, approached in different ways and with different productive results by our contributors from across the fields of reception studies, English literature, and Classics. In this introduction, we attempt both to give a critical background to the study of genre, as well as to focus, reflect and further theorize the observations of the individual chapters, so much so that we can begin to move towards a reception history of genre discourse in the history and criticism of English poetry, as perceived through the lens of classical scholarship.

Key Concepts: Between Genre, Classical Scholarship, and Literary Criticism

It is important to note that the key concepts of this volume are not seen as fixed and static entities in and of themselves. Rather, it is through the investigations of the collected chapters, and the texts that they bring to the discussion, that these concepts are examined, called into question, reworked across disciplinary boundaries, formed and reformed in a continual process of dialogue and change.[6] In what follows, we provide a brief overview of the critical history of genre, with the aim of giving a frame of reference for the scope (both historical and

interpretative) of the work subsequently done by the chapters in this volume. We then offer an overview of the volume's contents, with discussions of individual chapters as well as their interrelationships, tensions and interactions to give the reader a sense of the plan and aims of the book.

'Genre', as has often been noted, has classical roots: both in the etymology of the word (from Latin *genus*, 'type, kind, sort', cognate with Greek γένος), and in the history of genre criticism in relation to English literature, which begins (as so often with poetic criticism) with Aristotle.[7] Genre, and its study, originated with the classification of texts and their assignment to different 'types'. Aristotle introduced a combination of thematic and formal criteria (in particular meter) as the measure of different genres. We might, by way of example, turn to his description of the original separation of different genres as he discusses them in his treatise *The Poetics* (Ar. *Poet.* 1448b):

> Because mimesis comes naturally to us, as do melody and rhythm (that metres are categories of rhythms is obvious), in the earliest times those with special natural talents for these things gradually progressed and brought poetry into being from improvisations. Poetry branched into two, according to its creators' characters: the more serious produced mimesis of noble actions and the actions of noble people, while the more vulgar depicted the actions of the base, in the first place by composing invectives (just as others produced hymns and encomia).[8]

As Farrell (2003: 385) points out, although Aristotle shows an interest in some of the limiting cases of the correlation between meter, theme and genre (for example, Homer as tragic in spite of the hexameter), he nevertheless 'obviously does regard genre as having some sort of immanent character' (that is, he considers genre as a pre-existing framework into which works may be classified by virtue of their subject and meter). Following Aristotle's lead, the conception of genre as a formal and intrinsic characteristic of poetry became the standard approach among ancient critics and theorists and held sway among literary critics until relatively recently. Genre was seen as a unitary 'type' to be attributed to a poem rather than the site of negotiation, mediation or response, and ancient critics and later commentators alike would engage in genre only insofar as to label it within the classificatory category of 'epic', 'lyric', 'georgic' and so on.[9] Importantly, Depew and Obbink (2000: 3), in the introduction to their edited volume *Matrices of Genre*, point out that this view of genre as a classificatory system was largely confined to theorists and critics, rather than the practice of poets, in antiquity: 'theorizing about genre arose quite apart from

conceptualizations of genre that were production- and performance-based'. It was, however, the Aristotelian theoretical model, and not the practice-based realities of ancient poetry, which informed subsequent conversations around genre. It was precisely this theoretical and critical movement which could lead the Roman poet (and critic) Horace in his treatise *Ars Poetica* ('The Art of Poetry') – 300 years after Aristotle – to define genre as prescriptively delimiting style (*pedem proferre pudor vetet aut operis lex*, 'either a sense of shame or the law of the work may forbid you to turn back', line 135). Similarly, in 1561, the Italian humanist and poetic theorist Julius Caesar Scaliger (1484–1558) published his *Poetices libri septem* ('The Seven Books of Poetics'), an influential work of literary criticism and a direct response to Aristotle, 'our commander' (*imperator noster*, bk 7 [2] ch 1). In his introduction to the 'kinds' of poetry ('kind' being the common term to designate 'genre' in the Renaissance), he wrote – looking back to both Aristotle and Horace – that 'the poetical art is a science, that is, it is a habit of production in accordance with those laws which underlie that symmetrical fashioning known as poetry' (bk 7 [1] ch 2).[10] Essentially, Scaliger conceives poetry as working on the basis of natural laws and, thus (it is implied), genres as fixed and given entities. The latter observation is in line with the hierarchy of literary taxonomies that is central to Renaissance poetry and poetics and the role that prescriptive poetics (viz., theory) played in shaping the production of poetry at that time. Significantly for our project, then, the origins of genre in the western literary tradition lie in the intersection (and tension) between poetry and criticism.

This 'classical' conception of genre has been significantly challenged in both literary criticism and classical scholarship over the last 30 years. The major issue at stake has been whether genre is a classificatory type based on formal rules intrinsic to poetry – and if not, how (and by whom) it is constructed. Bawarshi and Reiff (2010: 4) point out that this tension is evident in the Latin root for 'genre' – with *genus* ('type') as itself a cognate of the verb *generare* ('to generate, give birth'). Genre as *genus* thus suggests the 'classical' (that is, the Aristotelian approach) to genre, defined by forms and types. Genre from *generare*, however, intimates a conception of genre that is generative and processual in the creation of meaning – which, as we will see, is a perspective that has become increasingly prevalent in recent scholarship. In the split etymology of the English word and the tension between Latin *genus* and *generare* we therefore have a neat contrast between different approaches to genre criticism, and an example of the ways in which the classical world and the world of English poetry interrelate in questions of genre.

Bawarshi and Reiff (2010) outline five predominant models in the history of criticism of literary genres, which bear summarizing here to contextualize our perspective. Following classical models of genre, they identify (1) *neoclassical* approaches to literary genre: trans-historical categories which build on those identified in classical literature to suggest certain overarching forms that cross chronological periods. These are, for example, the traditional triad of lyric, epic, and the dramatic, which are perceived as existing separate from cultural and historical context – allowing for transhistorical comparisons between archetypes of, for example, lyric from Horace to Wordsworth to Yeats, without reference to the cultural and historical conditions in which they emerged.[11] (2) They identify an opposite tendency, namely, the *structuralist* approach, which emphasizes the social and historical roots of genre, seeing genres as institutions which organize and shape texts according to specific rules (following Horace's description of the 'law of the work' in his *Art of Poetry*). (3) *Romantic and post-romantic* approaches either discard genre as a constraint on creativity, or – as with Jacques Derrida's influential 1980 article, 'The Law of Genre' – accept it, but only as an aspect of a text's participation and performance, not an external prescription. Derrida (1980: 59) summarizes this position as follows:

> I would speak of a sort of participation without belonging – a taking part in without being part of, without having membership in a set. With the inevitable dividing of the trait that marks membership, the boundary of the set comes to form [...] and the outcome of this division and of this abounding remains as singular as it is limitless.

This contrasts with *reader response theory* (4), where genre is seen as a construct imposed upon the text by the reader – in particular the literary critic. In this model, genre is a literary-critical tool which we as recipients bring to a text. This can shape how we read a particular work.[12] Rather than an intrinsic quality of texts across time or a shaping institution, genre is perceived as an external tool to be applied to aid interpretation, separate from the text itself. (5) Finally, *cultural studies* approaches to genre question the binary and mono-directional aspect of many of the above theories, suggesting instead an ongoing dialogue between genres, texts and literary, cultural and social contexts. As Bawarshi and Reiff (2010: 23) summarize it, 'Cultural Studies genre approaches seek to examine the dynamic relationship between genres, literary texts, and socio-culture – In particular, the way genres organize, generate, normalize, and help reproduce literary as well as non-literary social actions in dynamic, ongoing, culturally defined and defining ways.'

This volume falls into the latter approach in its conception of genre, with a particular focus on the discourses of literary criticism and classical scholarship as they interact with, help to shape, structure and define notions of genre in English poetry. There have been other productive approaches to genre in English literature and its relationship to the classical world in the wake of the renewed interest in genre studies: volume two of the *Oxford History of Classical Reception in English Literature* (*OHCREL*), covering the years from 1558 to 1660, contains an entire section on genre. As the editors make clear in their introduction, their focus is on 'emphasizing how English authors rework classical forms', with genre as 'a major framework for the recovery of classicism by English authors' (Cheney and Hardie 2015b: 2). The general approach of the *OHCREL* volumes towards genre is typified by their chapter headings, for example 'Pastoral and Georgic' in vols. 2 and 3, 'Lyric and Elegy' in vol. 3 and so on – suggesting that classical generic forms existed fixed and unmediated, and could be 'recovered' as a claim to classicism, with little reference to contemporary movements in classical scholarship and literary critical debates.[13] In addition to this, this way of looking at genre reception as genre recovery also (implicitly) harks back to the ancient idea of a hierarchy between genres – with the danger of transferring the same concept with the same sort of hierarchization from ancient genre theory to post-antique genre perception.[14] As beneficial as this kind of approach may at times be, it fundamentally ignores the fact that – as Zymner (2003: 198) puts it – 'there is in no case *the*, but always only *a* history of a genre'.[15] Thus it obfuscates the critical, engaged, situated aspect to genre formation which we want to add here.

In this volume, we want to emphasize how genre is constantly negotiated, reworked and contested in dialogue with contemporary debates in literary criticism and classical scholarship. This is radically different from the approach to genre espoused by Rosmarin (1985: 48–9) in *The Power of Genre* (which falls under Bawarshi and Reiff's reader response category), where genre is seen as a literary-critical tool adduced by critics as a means to explain texts: 'genre is most usefully defined as a tool of critical explanation, as our most powerful and reasoned way of justifying the value we place or would place on a literary text.' For us, it is the permeability of genre in response to its literary and cultural context, its openness to re-shaping and its dialogism with (rather than simply formation by) critical movements, which crucially not only determines the ways in which poetry is constructed, but also allows poets (and poetry) to be agents in the process of that construction. In stressing the cultural context and situatedness of genre, we focus on one particular aspect of that construction and conversation: the interactions between literary-critical movements and classical scholarship.

In this sense we are close to Devitt's (2000: 715) call for 'a genre theory that sees genres as involving readers, writers, text, and contexts; that sees all writers and readers as both unique and as necessarily casting themselves into common, social roles; that sees genres as requiring both conformity with and variation from expectations; and that sees genres as always unstable, always multiple, always emerging'. Each of the chapters in the collection, therefore, approaches genre not as an aspect of a text which is fixed and non-negotiable or in some way abstracted from literature/culture, but as part of the process of the poet's and/or the text's situated self-positioning in relationship to other texts, literary traditions, historical contexts, and critical commentaries.

Overview of the Volume

The chapters gathered in this volume offer a chronological survey of the development of genre in English poetry in dialogue with classical scholarship and contemporary literary criticism. To facilitate a diachronic approach as outlined above, a wide range of different periods in the history of English poetry are treated, extending from medieval England to contemporary poets working in English, as well as a broad range of genres, from tragedy to epic to georgic. Rather than attempting to present a complete coverage of English poetic production, however – which would in any case be impossible – it instead develops a series of case studies centred around particular authors, texts or periods, in an attempt to trace a few salient (but fragmentary) examples among the multiple threads in the story of genre-formation in relationship to classical scholarship in English poetry. Chapters cover the triangle between genre, classical scholarship and literary criticism in English poetry from multiple different directions and in multiple genres and signal the richness of reading English poetry at the intersection of literary criticism, classical scholarship and genre studies. We do not attempt to cover all aspects of these inter-relationships or to present a unitary account of genre-formation in English poetry: rather, the present volume is intended as a signpost to the many potential and fertile routes of inquiry available when we work at and across the boundaries of traditional disciplines, and when we allow literary analysis to co-exist with intellectual history and the history of scholarship and criticism. The collection is intended not only for classicists and scholars of English literature, but also for students of related areas such as comparative literature, reception studies, and intellectual and cultural history, who are interested in theorizing genre as a dialogic and

relational activity or who are engaged with the history and reception of the classical tradition in relation to English literature.

Amanda J. Gerber begins the volume with a programmatic piece offering an account of the fragmentation (and re-assembly) of 'classical' approaches to genre in medieval England (Chapter 1, 'Classical Pieces: Fragmenting Genres in Medieval England'). Gerber's study establishes the foundational work for the other chapters of the volume, grounding the early development of English poetry in relationship to classical forms, and isolating the mechanisms and contexts of their transmission. She retraces the educational practices that taught writers to craft works in imitation of the classical forms they studied, focusing on the academic introductions that inculcated in medieval writers the importance of crafting pagan narratives according to pagan terms. Above all else, these introductions classified classical works as history or fable, with the former often used to classify epics and the latter to identify texts with animals. Despite their distinct definitions, history and fable began to bleed together in the late Middle Ages as writers considered classical genres neither continuous nor antithetical to each other. As a result, Gerber argues that medieval students learned from commentaries to experiment with mixed forms of fragments, thus facilitating the inundation of classical genres in English literature.

Chapter 2 moves from the Middle Ages to the Elizabethan period ('"Poetry is a Speaking Picture": Framing a Poetics of Virtue in Late Elizabethan England'). Emma Buckley investigates the intersections between classical scholarship, literary criticism and poetry in 1580s and 1590s Elizabethan England, by arguing that writing and literary criticism in Latin within English universities not only ran a parallel course to work in the vernacular but may also have interacted with the sophisticated implication of classical texts, scholarship, and creative literature in English. The chapter starts with a reading of Alberico Gentili's *Defence of Poetry and Acting* as responsively 'corrective' to Sir Philip Sidney's *Apology* in its insistence on poetry as an active instrument of civic philosophy. Buckley subsequently offers William Gager's (1592) *Ulysses Redux* as a case-study for the responsiveness of neo-Latin tragedy and tragicomedy to the ethical and legal framing of vernacular tragedy and tragicomedy. Her chapter thus suggests that the neo-Latin drama of the universities ought to be considered part of – rather than distinct from – contemporary genre discourse in discussions of English literary history.

In Chapter 3 ('A Revolutionary Vergil: James Harrington, Poetry, and Political Performance') Ariane Schwartz moves to post-revolutionary England with the Vergilian translations of the republican political theorist James Harrington

(1658–9), opening up the discussion around the translation of classical texts and its relationship to analogous movements in literary criticism which will be picked up throughout the volume. Schwartz argues that reading Harrington's translations of the *Aeneid* and *Eclogues* through the lens of his political engagement reveals his classical scholarship as mediated through political criticism. Through his reception of Vergil, Harrington offers an important perspective on the heroic couplet and shifts of form and genre in translation, as well as on epic and bucolic as political vehicles, which will become central themes for subsequent English poets and translators. The regularity and flexibility of Vergil's hexameters and the political content of his poetry, Schwartz suggests, led Harrington to choose to translate into heroic couplets, as well as to revise Vergil's poems into a post-revolutionary meditation on the importance of freedom of property and language. As Vergil reshaped the past through his poetic expression, so Harrington reformed the Roman past in a novel form that allowed him to concentrate on the importance of freedom for the English future.

Caroline Stark traces a different response to Vergil and the potential forms of epic in English poetry, in her analysis of John Milton's *Paradise Lost* (Chapter 4, 'The Devouring Maw: Complexities of Classical Genre in Milton's *Paradise Lost*'). The generic complexity of *Paradise Lost* was recognized almost immediately by his earliest critics and commentators. At a time when neoclassical aesthetics were not yet fully established and genres ('kinds') had not only cultural but also potentially political resonances, Milton appropriated many types of genres to achieve a universal Christian epic in unrhymed English verse. In the elaborate interweaving of his predecessors, Stark suggests, Milton emulated the poets whom he set as models and challenged his readers to shake off the yoke of their cultural and political preconceptions and engage fully with his use of the past. By exploring Milton's own perceptions of genre in his early writings, the reclamation of genre from his contemporaries, and the intricate interweaving of genre in his engagement with the past in *Paradise Lost*, Stark's chapter argues that Milton's generic voices reveal through his creative lens a discourse of genre that stretches back to antiquity.

Juan Christian Pellicer also turns to the reception of Vergil, focusing this time on the *Georgics*. His contribution (Chapter 5, 'Georgic as Genre: The Scholarly Reception of Vergil in Mid-Eighteenth-Century Britain') argues that, while eighteenth-century British scholarship on Vergil's *Georgics* reflected a contemporary tendency to assess the poem's precepts as scientific facts, the standard approach of eighteenth-century scholars to Vergil's didactic poetry was not as naïvely positivistic as it has been held to have been. Instead, editors and

commentators such as John Martyn and Edward Holdsworth, as well as translators like William Benson and Joseph Warton, emphasized that Vergil's scientific accuracy mattered in purely literary terms, as a requirement of didactic poetry. Such praise for Vergil's combination of stylistic sublimity with scientific accuracy seems to have raised the bar for contemporary imitators of Vergil in English and led to a new understanding of the georgic as a genre characterized by generic flexibility and capaciousness.

Lilah Grace Canevaro asks how poetic form, and specifically rhyme, interact with Homeric scholarship and contemporary literary criticism in Dryden, Pope and Morris' translations of Homer (Chapter 6, 'Rhyme and Reason: The Homeric Translations of Dryden, Pope, and Morris'). She begins by investigating how Pope and Dryden's heroic couplets (as touched on in Schwartz's investigation of Harrington's translations of Vergil) can provide a closer understanding and translation of Homeric aesthetics. Pope's *Essay on Criticism* is subsequently used to reflect on the relationship between translation, poetry, genre, and literary criticism, as well as the function of versification in poetic classification. Finally, Canevaro asks why Morris revisited the rhyming couplet 'post-Wolf' and how he innovated on it. Her conclusion suggests that, while Dryden and Pope used the rhyming couplet to recover a Homeric 'unitarian' aesthetic and to shore up their own literary critical moves, Morris' translation practice is related to his understanding of contemporary analytical classical scholarship – and his response to epic tradition.

Continuing the focus on Homer, Isobel Hurst's chapter (Chapter 7, 'From Epic to Monologue: Tennyson and Homer') examines the reception of Homer in the poems of Alfred Tennyson and the implications of his use of the dramatic monologue form for his reworkings of Homeric characters such as Ulysses (Odysseus) and Oenone. Hurst suggests that, instead of contributing to the epic tradition by writing a conventional epic of his own – an endeavour which Victorian poets felt to be prestigious but outdated – Tennyson staked his claim as a poet by writing his brief Homeric poems in the 1830s in the contemporary and yet familiarly classical form of the dramatic monologue. His interpretations of the Homeric poems are mediated by Ovid's *Heroides*, the *Posthomerica* of Quintus of Smyrna and Dante's *Inferno*, and subvert readers' expectations of heroic poetry. Hurst argues that Tennyson's use of the dramatic monologue to give a voice to those who had previously been unheard in literature or history laid the groundwork for subsequent uses of the form, creating a particular association with later re-voicings of the classical tradition by women writers.

Silvio Bär's chapter moves from large-scale epic to epyllion, and from the nineteenth to the twentieth century (Chapter 8, 'The Elizabethan Epyllion: From Constructed Classical Genre to Twentieth-Century Genre Propre'). The so-called 'Elizabethan epyllion' is a genre of mythological (and mostly erotic) narrative poems that were exceedingly popular in English Renaissance literature for several decades, with its climax in the 1590s (famous examples include William Shakespeare's *Venus and Adonis*, *The Rape of Lucrece*, and Christopher Marlowe's *Hero and Leander*). After a sketch of the history of the invention of the ancient 'epyllion' by classicists around 1800, Bär traces the development of the use of the term 'epyllion' in relation to these mythological narrative poems from the Elizabethan era. It is demonstrated that the designation of the Elizabethan epyllion as 'epyllion' occurred as late as 1931 when an influential publication extended the concept of the ancient 'epyllion' to Ovid's *Metamorphoses*. The idea of the *Metamorphoses* as a series of 'epyllia', Bär suggests, made the same term attractive for English literary critics because of the Ovidian nature of the Elizabethan epyllion. He finishes his chapter by pointing out some specific deficiencies in contemporary scholarship both in the realms of Classics and of English philology, and argues that these 'blind spots', in combination, shape the way scholars speak and think about the Elizabethan epyllion to this day.

In Chapter 9 ('"Homer Undone": Homeric Scholarship and the Invention of Female Epic'), Emily Hauser returns to, and picks up on, Hurst's anticipation of women writers' responses to Homer in her analysis of female-authored epic and its engagement with movements in Homeric scholarship. Looking at two major texts in the formation of female epic – Elizabeth Barrett Browning's *Aurora Leigh* (1856) and H.D.'s *Helen in Egypt* (1961) – Hauser suggests that the often-noted generic flexibility of female epic derives from its interaction with contemporary Homeric scholarship. Barrett Browning and H.D. are seen as interacting with, and defining themselves in counterpoint to, landmark points in the history of Homeric scholarship, that is, Friedrich August Wolf's *Prolegomena ad Homerum* and Milman Parry's oral-formulaic theory. Female epic, Hauser argues, has always been in conversation with Homeric scholarship and contemporary literary criticism, given its crossing between female-gendered authorship and the expectations (after Homer) of traditionally masculine epic. She further suggests that the anxiety experienced by female epic poets is not merely anxiety of influence, authorship, or genre, but rather, a combined awareness of the constraints of female-gendered authorship, the male-gendering of epic, and the weight of the influence and critical reception of Homer.

Finally, Fiona Cox closes the volume with her exploration of the work of the contemporary poet Josephine Balmer (Chapter 10, 'Generic "Transgressions" and the Personal Voice'). Cox surveys the response to 'the personal voice' in classical scholarship, suggesting that the radical shift towards endorsing a critic's autobiographical experience to classical texts has shaped Balmer's critical view of her own poetry, as well as her writing. In her recent monograph *Piecing Together the Fragments: Translating Classical Verse, Creating Contemporary Poetry* (2013), Balmer describes how she regards her poetic creations as 'transgressions': works in which the original classical texts remain discernible, even though these texts (including lines from Catullus, Vergil, and Ovid) have been transformed through Balmer's voicing of her own individual circumstances. Cox's chapter explores the poetry that results from this meeting of personal voice, classical scholarship and translation by analysing the poems in Balmer's latest anthology *Letting Go* (2017). In examining Balmer's responses to the ancient world in these poems of grief, Cox argues that this contemporary poetry re-contextualizes Vergil's epic *Aeneid* and poeticizes Livy's prose *History of Rome*; thus, she inserts Balmer into a tradition of female authors who have transgressed both gendered and generic boundaries in their reworkings of history and epic.

Classical Pieces

Fragmenting Genres in Medieval England

Amanda J. Gerber

University of California, Los Angeles

Supposedly rife with wilful ignorance and rudimentary artlessness, medieval poetry has long been accused of violating the principles of classical literature, principles subsequently recovered by Renaissance humanism's high rhetorical culture.[1] Many medievalists have attempted to salvage the reputations of medieval writers and scholars with interpretive manoeuvres that repeatedly push the date of the humanist Renaissance earlier into the traditional Middle Ages.[2] Rather than further attempting to mitigate the notion that medieval poetry disfigured its classical predecessors, this chapter proposes to embrace the belief that medieval pedagogical practices disassembled classical literature – but disassembled it as part of a praxis-orientated verbal arts curriculum that subsequently catalysed its recreation. The dismantling of classical literature, of course, occurred long before medieval writers encountered it, with Aristotle's *Poetics* in particular offering a taxonomic guide to poesy, a guide largely unknown to medieval writers until the end of the Middle Ages, but whose principles, I propose, survived in the reduced forms that best served their didactic roles in medieval curricula. This chapter suggests that the resulting disassembly and reduction of classical norms derived from medieval exegetes' and pedagogues' microscopic attention to them in both the scholastic lemmata, or notes keyed to specific words, that manuscripts had accumulated since antiquity and in the pedagogic instructions that prompted students to focus on passages, instead of complete texts, exemplifying compositional skills. The goal was not to recreate classical works in entirety, but rather to piece together some components of a literary corpus that eluded them and to establish compositional practices with historical traditions. In the end, it was these very acts of literary, especially

grammatical and rhetorical, dissection in Latin curricula that facilitated the eventual revivification of classical forms in Renaissance vernaculars by retaining classical compositional practices as the foundation for literacy training.

To examine these dissections, the following pages focus on the paratexts that conducted these literary experiments – that is, the manuscript annotations that bear evidence of early readers' and scholars' approaches to classical curricular authors. The evidence itself seems scant, but by compiling these traces, this chapter proposes to rebuild a paradigm that rendered the components of classical genres applicable for both their medieval and Renaissance beneficiaries. Thus, the following pages begin with an overview of the educational program that introduced classical literature to all medieval students before turning to the rhetorical features routinely identified, analysed, and imitated by these scholastic programs. Finally, the components of these scholastic programs lead to a re-evaluation of the current state of classical reception criticism, which has variously attempted to reconstruct medieval notions of classical genres. As a result, this chapter uncovers both a preserved and a developing awareness of classical genres during the Middle Ages, genres explored throughout this volume.

Classics in the Medieval Schoolroom

To begin with, the word 'classical', like the literary genres with which it became associated, did not appear during the Middle Ages. The term derives from Latin *classicus*, which first surfaced in a 1546 reference to ancient authors, but which more commonly appeared as Middle French *classique*, a term in 1548 that denoted esteemed medieval vernacular authors. *Classical*'s modern association with revered Latin authors only gained consistent circulation in 1680.[3] Instead, medieval scholars and writers called these works 'ancient' (*antiquus*), identifying an historical separation from the material circumstances that produced such texts while also regarding their own place in literary history as a continuation of the past.[4] For the sake of continuity and specificity, this chapter employs the anachronistic term 'classical' even though it explores the medieval understanding of the generic traits to which the term currently applies. The disparate connotations nonetheless importantly demonstrate that medieval writers differentiated literary production according to historical rather than stylistic distance, in part because the literate class continued to disseminate its lore in the same Latin language and perpetuated many of antiquity's own approaches to its classical corpus. To reconstruct how medieval audiences perceived their

relationship to the ancient past, it helps to begin with the schooling, often in grammar schools, that first introduced students to the classical corpus, providing educated audiences ranging from theologians to courtiers like Chaucer with their first foray into composition in general. Admittedly, it is often difficult to determine the exact use of a classical manuscript because few owners supply colophons of their own, yet the paratexts that accumulated in the margins, between the lines, or as separate texts called *catena* commentaries were both written and disseminated for didactic purposes. In these formats, classical literature became the purview of grammar training, developing from a medieval understanding of grammar as a discipline pertaining to letters, with literature', (or in Latin *litterae*) being a collection of them.[5] Although the discipline exhibited little impact on vernacular writers during the early Middle Ages, Latin education became increasingly available as diverse social classes began to seek the benefits of literacy by the fourteenth century.[6] Such educational expansion resulted in a smattering of vernacular writers who, like Chaucer, received training in the classical style and distributed their learning even further than the original claustral bounds of medieval education.

Beginning with grammar schooling, students were trained to use this study of letters to imitate classical literature, forging classically derived notions of composition for topics as varied as orthography, sentence construction, meter, tropes, figurative speech, rhetoric and compositional structure. The resulting notions of classical literature include both the familiar (such as invocations) and the currently less customary (such as sententious exempla). When starting grammar school, students needed to have a basic understanding of reading Latin. The early days of their classroom training then turned to grammatical textbooks, some of which originated from late antiquity (such as Donatus's *Ars minor* and *Ars maior*) and some of which were classically inspired (such as Geoffrey of Vinsauf's *Poetria nova*).[7] These textbooks exemplified the grammar lessons they presented. Geoffrey of Vinsauf, perhaps the most adept practitioner of this method, demonstrated grammatical features ranging from the order and length of sentences to advanced ornamentation. For instance, he provides examples of abbreviation as well as expansion, explaining the purposes that suit the use of each. To introduce his section about amplification, he describes repetition:

> If you choose an amplified form, proceed first of all by this step: although the meaning is one, let it not come content with one set of apparel. Let it vary its robes and assume different raiment. Let it take up again in other words what has

already been said; let it reiterate, in a number of clauses, a single thought. Let one and the same thing be concealed under multiple forms – be varied and yet the same.[8]

Identifying repetition as a form of amplification, the passage belabours its own lesson on reiteration. He states his point according to apparel, language, and then forms to illustrate different ways for 'dressing up' recapitulations. For the *Poetria nova*, repetition presents more than a restatement of the same words; it recasts information in various manners to underscore its contents. As such, repetition constitutes one of the grammatical text's four attributes of amplification (repetition, periphrasis, comparison and apostrophe) before providing model exercises in which students explore applications for the concepts prescribed and described in the section. The combined passages create a curriculum based on exemplars and praxis, curricular objectives served by dissecting the components deemed worthy of copying.

The resulting array of information showed how many options students had for their own compositional agendas rather than circumscribing a specific collection of rhetorical attributes. Textbooks frequently connected these options directly to classical authors by including quotations as exemplars to prompt students to appropriate these methodologies for their own writing. For example, Isidore of Seville's *Etymologies*, a popular seventh-century encyclopedia used for didactic purposes throughout the Middle Ages, inserts classical examples for all the tropes mentioned. After defining and classifying all the categories that modernity associates with grammar, such as parts of speech, Isidore turns to more stylistic features, which he still groups with grammar because of its aforementioned medieval definition. Isidore explains these tropes, or *modi locutionum* ('ways of speaking'), within the verbal arts sections of the *Etymologies*' first book, rather than the rhetorical and dialogic sections of the second book (I.XXXVII.1). Isidore indicates that there are too many such tropes to name them all, so he limits his discussion to 24, including 13 borrowed from Donatus: metaphor, catachresis, metalempsis, antonomasia, epitheton, synecdoche, onomatopoeia, periphrasis, hyperbaton, hysteron proteron, parenthesis, tmesis, synthesis, hyperbole, allegory, irony, antiphrasis, enigma, charientismos, paroemia, sarcasm, astysmus, homoeosis (*similitudo* in Latin) and simile (I.XXXVII.1–35). To explain hysteron proteron, Isidore turns to the master of this mode himself (I.XXXVII.17):

Hysteron proteron sententia ordine mutate ut (Verg. Aen. 3.662): *Postquam altos tetigit fluctus, et ad aequora venit. Antea enim ad aequora venit, et sic tetigit fluctus.*

Hysteron proteron is a sentence with the order changed, as Vergil, *Aen.* 3.662: "Then he touched the deep waves and came to the water." For he came to the water first, and thus touched the waves.[9]

Isidore hereby defines *hysteron proteron* as inverted syntax and logical sequencing, which he demonstrates with a Vergilian quotation. Such an approach influenced most classical commentaries, the scholarship that had been accumulating in manuscripts since antiquity to guide teachers, students, and general readers through the interpretation of classical literature. These commentaries as well as their simpler lemma relatives similarly applied the phrase *hysteron proteron* into the margins of Vergil's corpus, prompting audiences both to decipher the complicated syntax of classical poesy and to acquire an example for the reader's own composition endeavours. Isidore's encyclopaedia epitomizes both these scholastic objectives as he identifies passages that encapsulate the concepts he defines and employs them in a new composition, a practice not restricted to his books about verbal arts, but one which relates most concretely to their grammar-school use. Just as the *Poetria nova*, the *Etymologies* thus exemplifies applicable tropes that, although abbreviated as Isidore himself acknowledges, demonstrated the compositional array that classical literature supplied.

Pupils would follow such abbreviated compositional directions as they culminated their verbal arts schooling with the classical works upon which these textbooks' precepts were based.[10] As works compiled for the same audiences and from the same academic traditions, classical commentaries and paratexts relied on the organizing principles dictated by grammatical textbooks, especially including the topical designations in their margins that Geoffrey of Vinsauf and his cohort explained. In 1934, Eva M. Sanford noticed these categories consistently marked in the margins of Lucan's *Pharsalia*, categories that often correlate with those found in grammatical textbooks. Sanford explains the different types of marginal comments, beginning with simple rhetorical notes, which especially value similes and metaphors – usually denoted as *comparationes* or, on occasion, *similitudines*. She also notices the frequency of poetic terms *narrat, describit, oratio, arenga, invocatio, apostrophe,* and *poeta,* words that signal the active composition of poetry for praxis-orientated grammar-school curricula (Sanford 1934: 291). Their pedagogical applications primarily pertained to students studying how to create their own compositions in the same style by pointing out the different modes of expression at a writer's disposal.

Students would then demonstrate what they had learned by creating either written or oral compositions in imitation.[11] Although some Church fathers quibbled

over the suitability of teaching grammar-school children by practicing *imitatio* of pagan authors, it was rare for anyone to advocate for completely removing it from the curriculum.[12] Jan Ziolkowski points out that medieval scholarship generally promoted imitation of canonical authors by recollecting and citing passages: the preference for original creativity only emerged after post-Romanticism instilled the notion that imitation increased a work's distance from ideal forms.[13] Regardless of their imitative predilections, medieval compositions were not hackneyed; they instead relied on creative evaluation and adaptation, which reconstructed both the lines of classical poetry and the characters described therein.[14] Pupils would craft such works of original, but classically inspired, content either on wax tablets or aloud, with the latter becoming increasingly common during the late Middle Ages as the educational system expanded to include students who could not afford their own expensive manuscript copies of classroom materials.[15] These oral compositions contribute to what Marjorie Curry Woods deems a primary hindrance to reconstructing the uses of these medieval commentaries, uses that contradict modern scholarship's habitual textual approaches.[16] For example, the repetition often attributed to medieval commentaries served a practical, not an aesthetic, function that allowed medieval students to transcribe or memorize the material when books were too expensive for most students to purchase (Woods 2013: 334–5).

Despite these historical changes to classroom circumstances, the resulting grammatical traditions lacked national disparities in Europe.[17] First of all, the clerics who created medieval curricula and their texts regularly crossed regional and temporal boundaries. Second, many distinctions between medieval and Renaissance commentaries have been delineated arbitrarily and anachronistically. Renaissance commentators often perpetuated what they learned from their medieval forebears just as medieval commentators perpetuated theirs, with the most important differences largely originating from the different material circumstances of their production: namely, the increased paper availability in the Renaissance and the creation of the printing press.[18] Thus, the subsequent examples include details from manuscripts throughout Europe during the Middle Ages and the early Renaissance, but are applied particularly to England in conjunction with this volume's emphasis.

Poetic Modes: A Close-up View of Poetic Composition

Medieval England's contributions to studies of classical genres have proven difficult to define, considering that most of the words now used to identify them

did not exist in Middle English. Words like 'epic', 'elegy', and even 'genre' (essential monikers for generic studies) did not appear in English until the sixteenth or, in the case of genre, the late-eighteenth century.[19] Medieval writers tended to prefer classifications of history, fable, and allegory, regarding the separation between fact and fiction as more important than the overall classical aesthetics that often conveyed them.[20] As a result, the origins of the classical genres to which such words pertain have long-fascinated yet eluded scholars. Henry Ansgar Kelly's 1993 essay, 'Interpretation of Genres and by Genres in the Middle Ages' criticizes 'historical accounts of genres' for mostly suffering from 'methodological confusion and a lack of attention to primary evidence' (Kelly 1993: 109) – a lack of attention that, despite Kelly's elucidation, still persists in terms of the medieval reception of classical genres. As Kelly (1993: 112–13) observes, the word 'tragedy' rarely appeared, as did 'generic thinking of all kinds'. Nevertheless, 'tragedy' proves particularly important in understanding the development of the medieval English vernacular understanding of classical genres because it is the first classification to appear in vernacular English and it did so in Chaucer's 'Monk's Tale' as will be discussed below. The earliest appearances of the Latin term occur in isolated references, including early-twelfth-century Honorius Augustodunensis's remarks on four types of poetry: tragedies, comedies, satiric pieces, and lyrics.[21] Matthew of Vendôme's *Ars versificatoria*, written in the middle of the twelfth century, also mentions these four genres, but replaces lyrics with elegies and typifies them as four personified attendants upon Lady Philosophy in a dream vision.[22] Due to these infrequent and inconsistent characterizations of classical genres, modern studies other than Kelly's tend to elide their multiple medieval connotations. Nevertheless, the lack of consistent labels for classical genres should not be confused with a lack of awareness of their constituent pieces, pieces that provided applicable tools for students of composition.

Just because the English language overlooked such words does not mean that the concepts they characterized lacked relevance for medieval England's perceptions of classical literature. In fact, terminology used to typify the components of classical literature became a part of literary language long before the phrases that designated their holistic design. For instance, 'ekphrasis' predated the Renaissance, appearing in Latin as *ecphrasis* in the fifteenth century.[23] Some key words became significant earlier than *ekphrasis*, especially words that accumulated in manuscript margins of classical literature. The most commonly applied classical labels from grammatical textbooks included hysteron proteron, *similitudo* (a Latin variant for homoeosis), hypallage, synecdoche and

metonomy.[24] These rhetorical designations surfaced throughout the classical corpus, appearing at least by the ninth century and continuing long past the fifteenth. Rhetorical notes became increasingly important during the fifteenth century, expanding beyond the figures of speech (such as synecdoche) and *ordines* (such as hysteron proteron) to include all-encompassing forms of textual evaluation (such as *prosodia*).[25]

As much as any other rhetorical feature, paratexts focused on the invocations of Muses and of ancient authorities, that is, poets' pursuit of literary guidance from both supposedly figurative poetic inspirations and literal authors with established reputations. Alastair Minnis pointed out this medieval investment in the authority of classical authors by reintroducing medieval emphases on *auctores* and their *auctoritas*.[26] But such authorial interests proved to be more than a means for establishing authority; they also provided a structural system affiliated with the traditional opening invocation of the Muses. For example, Oxford, Bodleian Library, MS Rawlinson B 214 provides a diagram of the Muses and the writers they inspired in order to introduce its collection of primarily classical and historical materials, including a commentary on Ovid's *Metamorphoses* and the only extant copy of Thomas Walsingham's *Dites ditatus*.[27] The diagram's central circle presents the Muses in relation to Hippocrene, the fount of inspiration on Mount Helicon, and Pegasus, the horse often associated with the spring and the Muses. The next ring includes the names of the nine Muses, who are in turn engirded by the names of ancient authors, including Homer at the top, Ovid next to him, Lucan at the bottom, and Statius in the bottom left quadrant. The creator of this diagram presents the route of classical transmission according to genealogical and geographical figures, reconstructing classical influences as emanating from the Muses' fount of inspiration and classical authors as relating to their invocations of the Muses. This diagram, although a rare extant example of its kind, reflects a perception of classical authors as being the product of their rhetorical means for establishing authority, an authority based on their mastery of classical rhetorical modes, not necessarily of character qualities or generic structures.

The emphasis on rhetorical modes pertained especially to the medieval academic tradition's emphasis on utility, an emphasis made explicit in *accessus* or academic introductions. Similar to modern critical editions, many medieval copies of classical texts included prefatory historical overviews as well as some points of scholastic consensus for novice readers.[28] The appearances of these *accessus* varied: some manuscripts placed them before the copied poem, some placed them after, some omitted them entirely, and others collected

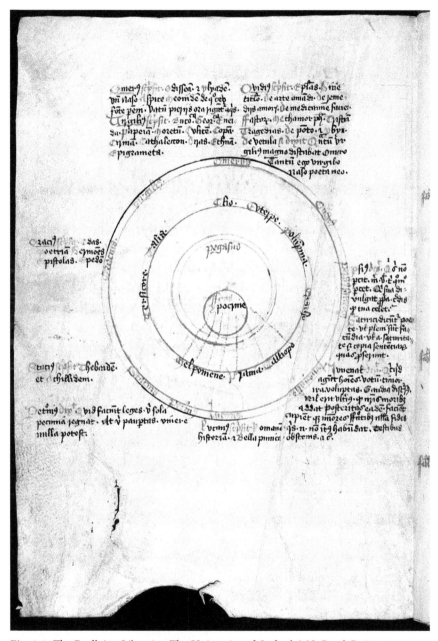

Fig. 1.1 The Bodleian Libraries, The University of Oxford, MS. Rawl. B. 214, fol. 202v.

only *accessus* without the poems themselves.[29] Despite their irregular manifestations, their contents proved formulaic. Even introductions for different authors resembled each other. Many early *accessus* drew from grammarian Servius's commentaries on Vergil, one of the few surviving commentaries from late antiquity.[30] Many later *accessus* adhered to the prototype offered by Arnulf of Orléans, whose introductions still related to Servius and other classical grammarians, introductions that emphasize the following categories: *vita poetae, titulus operis, materia, utilitas, intentio, cui parti philosophiae subponatur* ('life of the poet, title of the work, subject matter, usefulness, intention and the philosophical category to which the work is to be assigned').[31] As these categories reveal, scholars directed students' attention to historical context (poet's life and intentions for writing), narrative content (subject matter), and rhetorical applications (usefulness). Although structural classifications might seem to relate to the title and philosophical categories, the former merely pertains to a work's name, usually supplied by the author, and the latter typically provides a formulaic phrase *ethicae subponitur* – that is, 'it comes under ethics'. This ethical designation results from a notion popularized during the thirteenth century that all poetry relates to ethics because it examines human behaviours.[32]

For all their formulaic tendencies, *accessus* still tailored their remarks to the contents they introduced. These introductions might remark on authors' political circumstances, or, more importantly for this chapter, they might define the work's poetic classification.[33] The latter category occasionally gestures towards genres known today, using many of the same words that continue to be circulated; however, medieval scholars' systematic dissections of these terms created classifications that might seem unfamiliar to the modern reader. Tragedy in particular, which has attracted more attention from medievalists than other classical genres, is seen to pertain to a sudden fall from fortune.[34] The popularity of this term results from the fact that Chaucer himself mentions it when classifying the narratives he includes in the 'Monk's Tale' (VII.1970–7). Boccaccio's *De casibus virorum illustrium* served as Chaucer's immediate source for his Monk's miniature story collection, yet both found precedents in classical commentaries. The few commentaries that mention tragedy often add a decidedly more etymological approach to the structural propositions of Chaucer and his inspiration Boccaccio, despite discussing the same narrative content, such as the fall of Emperor Nero. For example, the *accessus* for Lucan's *Pharsalia* found in Munich, Bayerische Staatsbibliothek, MS Clm 19475, MS Clm 4593, and Cologne, Erzbischöfliche Diözesan- und Dombibliothek, MS 199 states:

Hic dum scribentium laudem et utilitatem perpenderet, scribendi desiderium inuadit;
fuit enim tragedus optimus, stilo florens grandiloquo. 53. Tragas Grece, Latine dicitur
yrcus, inde tragedia, quia illam scribenti yrcus dabatur in precium. 54. Hec regales
personas habens materiam leto principio, tristi fine contexebatur. 55. Differtur ergo
tragedia a comedia, quia comos est uicus [fol. 9rb30 / fol. 9va1] *ode carmen, inde*
comedia que mediorcres personas et flebile principium cum leto fine habet.

When Seneca was considering the fame and utility of writers, a desire for writing
took possession of him; in fact, he was an excellent tragedian, colorful in his
grand style. 53. *Tragas* (*tragos*=goat) is said in Greek, *hircus* in Latin and hence
'tragedy' because a goat was given as a prize to the one who writes it. 54. Having
royal characters for subject matter, it was constructed with a happy beginning
and a sad ending. 55. Tragedy therefore differs from comedy because *comos* is
"village," *ode* "song": hence, comedy, which has ordinary characters and a tearful
beginning with a happy ending.[35]

This section from an introduction to the *Pharsalia* characterizes the poem
according to an authority on the genre, namely, Seneca, to establish an historical
collection of materials that exemplify a literary tradition, rather than a discrete
example of the mode. The description also includes a brief identification of the
genre's structure, a structure that focuses on the activities of royal characters and
transpires according to a downward trajectory. Certain aspects of this *accessus*
might seem customary, albeit convoluted, to those familiar with the same
narrative structures that Aristotle proposes in the *Poetics* (XV.15–30). The
accessus, nevertheless, simplifies Aristotle's emphasis on moral quality and good
character to royal characters. Part of the convolution originates from the text's
indirect access to the ancient Greek source. Dissemination of Aristoleian works
increased by the end of the twelfth century after William Moerbeke directly
translated Aristotle's corpus from Greek to Latin, yet this *accessus* appeared
earlier in the twelfth century.[36] The tragedy trajectory introducing the *Pharsalia*
lacked a direct line of transmission from Aristotle; it instead became part of a
classical pastiche that reduced forms to facilitate their application in the texts
they explicated. In this instance, the commentator compiles his indirect
Aristotelianism alongside a partially Isidorean etymology that attributes the
correlation between tragedy and goats to Horace (VIII.vii.5), relating the genre
to the items used to reward its composers. Such explicit classifications of genres
are rare both within classical commentaries and grammar textbooks because
both tend to prefer the minutiae of compositional practices. Even when
addressing the topic of tragedy, the academic introduction underscores its
grammatical, compositional roots. Bearing a likeness to Isidore's *Etymologies*,

this Lucanian *accessus* connects the poem to the meanings invoked by the word used to identify it as much as it does the structure of the content within it. As a result, the introduction treats Lucan's *Pharsalia* as one of a series of interrelated ancient traditions connected by linguistic labels more than structures, condensing classical genres to minute, sometimes even mundane in the case of the goat, distinguishing markers.

Other *accessus* seem to treat tragedy more comprehensively, but still by devoting more attention to the words for genres than to their contents. For example, one introduction to Ovid's *Sine titulo*, also called the *Amores*, depicts tragedy through personified goddesses, Tragedy and Elegy, who present themselves to the author; the former urges the poet to write and the latter opposes Tragedy to suggest that Ovid write a third book in her style. The commentator then differentiates between the two personified genres with brief definitions at the end of the introduction, stating:

> *Et sciendum est quod Tragedia dea est facti carminis de gestis nobilium et regum. 14. Elegia autem dicitur dea miserie – contingunt etiam in amore miserie et aduersitates – et scribitur impari metro et exametro.*

> And one should know that Tragedy is the goddess of poetry that is composed about the deeds of noble men and kings. 14. Elegy, moreover, is spoken as a goddess of woe – woes and hardships occur also in love – and is written with an unequal meter [i.e. pentameter] and a hexameter.[37]

The definitions prove to be somewhat standard despite lacking frequency, demonstrating a general perception of tragedy as being defined according to its subjects, whereas elegy acquires an association with both its woeful content and its meter. Such designations became more common, though never universal, along with the rise of the *accessus* tradition during the late Middle Ages. Before academic introductions consistently circulated in classical manuscripts, commentaries and paratexts rarely addressed the overall nature of a poem's classification.

Even after they acquired holisitic classifications, commentaries and paratexts maintained many of their piecemeal interests. The aforementioned *accessus* for Lucan's *Pharsalia*, for instance, further dissects the tragic form by identifying traits such as its meter and its mode:

> *Metrum istud est heroycum, quia constat ex humanis diuinisque personis continens uera cum fictis et ex dactilis constat, ad primam dico inuentionem, set propter difficultatem concambium fecit et spondeum ubique nisi in penultimo recepit, trocheum etiam in ultimis. [. . .] Mixtum modum recitandi habet; sunt enim tres*

stili: dragmaticon ubi introducte persone locuntur, ut in Ouidio epistolarum;
exagematicon, ubi auctor tantum loquitur, ut in primis libris Georgicorum;
misticon, ut in Eneide. 70. Latinis etiam nominibus uocatur hii stili; proprius,
alienus, mixtus. 71. Liber iste habet stilum grandiloquum et mixtum modum. 72.
Est etiam historicus et tamen satyricus.

This meter is heroic, because it consists of human and divine characters,
containing truths together with falsehoods, and because it consists of dactyls – I
mean at the time of its first invention – but it made a change on account of its
difficulty and accepted a spondee everywhere except in the fifth foot and a
trochee in the final foot. [. . .] It has a mixed mode of reciting, for there are three
styles: dramatic, where introduced characters speak, as in Ovid's Epistles
(*Heroides*); narrative, where the author only speaks, as in the first books of the
Georgics; and mixed, as in the *Aeneid. 70.* These styles are also called by Latin
names: one's own, belonging to another, and mixed. 71. This book has a grand
style of writing and a mixed mode of reciting. 72. It is also historical and yet
satirical.[38]

Although this *accessus* predates the transmission of Aristotle's works in Latin,
vestiges of his and Plato's notions of meters and their genres remain. Both Plato
and Aristotle present classifications of narrative styles, such as the *Poetics'*
distinction between tragedy and epic partly relying on the latter's use of an
unmixed verse style and a singular narrative (VIII.10–15). The *accessus*, like
other paratexts for classical literature, condensed such classical classifications to
the equivalent of sound bites, preserving many of the ancient words Aristotle
designated for their study, but with partial descriptions and often corrupted
forms – such as the use of *dragmaticon* for *dramaticum*. The reduced results
overwhelmingly focus on rhetorical, grammatical and, in this example, metrical
traits, including number of feet, likely because such traits proved more
immediately applicable for the writers guided by them. The passage above, for
instance, directs audiences to focus on the metrics that best convey their points,
relating meters to the topics described; that is, the commentator explains that
'heroic meter' pertains as much to the meter as it does to the human/divine and
historical/fictional subjects that meter encompasses. Due to these blended focal
points for defining the poem's style, the introduction presents a mixed notion of
genre. Rather than ascribing the *Pharsalia* to one tradition, the poet sees the text
as a conflation of generic interests, just as the passage itself conflates its classical
inheritances from Greek antiquity in reduced Latinate forms.

Such conflations became one of the salient features of commentary
classifications as schoolmasters often avoided associating texts exclusively with

individual genres. This overlap is perhaps seen most clearly in commentary discussions of histories and fables, categories that proved to be much less discrete than their modern designations. In his analysis of classical *accessus*, Mikhail Shumilin discusses the tendency for medieval commentators to 'rehabilitate poets by finding fiction in apparently "historical" content' (Shumilin 2014: 8). For example, 'master Anselm', presumably Anselm of Laon, teacher of Peter Abelard, describes the *topographiae* ('landscape descriptions') of Lucan's *Pharsalia* as the characteristic that renders Lucan a fictional poet. Anselm points out that Lucan's topographies often fabricate details when describing otherwise historical places.[39] Shumilin (2014: 8) finds a similar statement in Monacensis Clm. 4593, another copy of Lucan's *Pharsalia* which also dates to the twelfth century:

> *Notandum quoque quod iste non proprie dicitur poeta, cum posis* (sic) *dicatur ficcio; sed tantum quia in topographiis fingit, inde vocatur poeta. nam in scribendo mutat portus ipsos.*

> It should also be mentioned that he is not called a poet in the proper sense of the word, because it is fiction that is called poetry; but only since he makes things up in his topographies, that is why he is called a poet. Since when he writes he even changes harbours.

Although making a similar point about Lucan's position between fictional poet and factual historian, this passage associates him more with history, deeming his fabricated topographies a minor interruption to his otherwise historical concerns. Shumilin (2014: 5–6) schematizes these distinctions according to three categories of narrative content: *fabula*, *historia*, and *argumentum*. *Fabula*, which correlates with Greek *mythos*, relies on fantastic information that does not resemble truth. *Historia* constitutes truthful events, and *argumentum* presents something that could have, but did not actually, occur. Shumilin (ibid.) considers tragedy and epic the purview of *fabula*, whereas history is the only genre commensurate with *historia*.

These definitions undeniably reflect ancient usage of these terms, yet Shumilin also recognizes that medieval usage became more nebulous as fact and fiction frequently intersected in medieval lore. Servius's commentary on Vergil's corpus, for example, remarks on the infusion of historical information in the poetic *Aeneid*.[40] Shumilin and Monika Otter, like some medieval writers themselves, consider rhetorical ornamentation a disruption to the historical content of a text because features such as hysteron proteron interfere with the chronological organization of information; other medievalists have noted the similarities between medieval versions of epics and chronicles, similarities resulting from a

pronounced interest in historical exegesis.[41] Chronicles by definition refer to events in chronological order, but manuscripts of Vergil's *Aeneid*, for example, consistently identify hysteron proteron and hypallage, both of which manipulate the order of narratives. Medieval writers were acutely aware of the distinctions between the genres of history and epic, but they also considered aspects of classical epics as chronological and aspects of history as epic.

Early mythographers like Fabius Planciades Fulgentius supported such distinctions between historical and fictional genres by separating rhetorical ornamentation from classical literature's supposedly historical contents. Fulgentius's resulting *Mythologiae* offered material for many Christian writers by classifying pagan mythology as either true or false historical records, excising objectionable details for a Christian audience.[29] However, the distinction between history and rhetorical ornamentation proved more difficult to practise than to expound. The grammar-school practice of analysing portions of classical poems for their components created fragmented and continuous compositions, demonstrating that cohesive medieval narratives could be built from amalgamated portions of their ancient inheritance. In general, medieval notions of genre were less formally contrived than in the Renaissance because, at the core of it, they fused classical literature with their contemporary interests in reduced, fragmented, and cohesive forms.

Conclusion

The thirteenth-century rediscovery of Aristotle has long been considered the impetus for medieval writers' increasing attention to form and classification.[42] Yet vestiges of Aristotelian classifications can be seen in classical commentaries and paratexts long before his translated texts reintroduced systematic divisions of contents. The early strategy, promoted in part by medieval grammars, of analysing classical literature in pieces enabled these pieces to be regarded for the various elements of their composition, not just their overall generic classification. Although initial attention to compositional elements focused on narrative components and their ethical value, the late Middle Ages increased efforts to reconstitute these divided works, rebuilding classical traditions from their dismantled elements. These reconstituted texts attended to aspects of genre, but because they were reassembled according to reduced, divided, and applicable productions, they had a more flexible perception of genre than the humanistic literature of the Renaissance. In other words, medieval reception, with all its

attention to the elements of classical narratives, did not consider classical genres antithetical to each other, but allowed for their coexistence within the same texts because medieval audiences attended more to the aspects of literature on which they were trained to focus than on the aggregate genres they formed. The distinction between aspects of genres and the genres themselves seemingly emerged from a praxis-orientated approach to literacy training, training that dissected classical traits to prompt budding writers to develop compositional skills in imitation of classical literature. Nevertheless, by promoting discrete classical skills, rather than complete recreations, medieval scholarship facilitated the production of works that included aspects from different genres with scholars showing more regard for contemporaneous use than holistic duplication, use by those ranging from theological exegetes to courtiers and eventually the mercantile class.

The result was a general medieval writing system founded on the traits of classical literature. Although most would argue that complete epics were not written in English between *Beowulf* and Milton's *Paradise Lost*, classical commentaries and paratexts reveal that knowledge of classical genres' basic components was never lost. Medieval writers merely attended more to their components than to their overall genres, allowing writers to mix and match to develop their own continuous texts. The very emphasis on the elements of classical works also allowed for their eventual reconstitution in the Renaissance, retaining the tradition of literary imitation and of genre classification systems. Part of the taste for reading classical rhetoric as disparate pieces derives from the medieval taste for reading classical works in general – that is, in excerpted form. As annotation records and grammatical textbooks indicate, readers approached classical literature practically, seeking applicable modes to adopt for their own compositions. Medieval audiences benefitted from the lemmatized scholarship that parsed classical literature for replicable tools, hence the use of textual markers to underscore specific sections of poems. The Renaissance inherited this piecemeal approach to classical literature, further developing commonplace books in which student readers would record selections from works that they appreciated or wanted to emulate. The same approach continues today in anthologies of excerpted texts, which provide samples of 'high art' for those who want to cover as many texts as possible and to understand the primary merits of such works. But the Renaissance turning point, as many have noted, was the greater distribution of works such as Aristotle's *Poetics*, which articulated how the dissected pieces of classical works should be combined into cohesive genres. Furthermore, with the increased availability of translations and of Greek epics,

the Renaissance reader had the benefit of self-instructed comparisons. These translations facilitated autodidactic study and cover-to-cover reading of classical works, as opposed to medieval emphases on cultivating skills and on excerpting literature. Nevertheless, these changes were built upon the classical foundations that medieval scholars disseminated and developed. In the end, medieval and Renaissance writers alike forged their notions of literacy from the classical pieces they inherited, pieces with interpretive structures that disseminated aspects of Aristotle's *Poetics* before complete translations of it. Thus, medieval scholars successfully retained classical pieces and practices long before they were 'reborn.'

2

'Poetry is a Speaking Picture'

Framing a Poetics of Virtue in Late Elizabethan England

Emma Buckley
University of St Andrews

Poesis est loquens pictura

Gentili, *Commentatio* (1593) ed. Binns p. 231

Introduction

In the final decades of Elizabeth I's reign, English writers were beginning to respond to the extensive theorizing about poetics on the continent with some famous treatises of their own: George Puttenham's *Arte of English Poesie* (London, 1589), William Webbe's *Discourse of English Poetrie* (London, 1586), and most famously, of course, Sir Philip Sidney's acute but ambivalent defence of the didactic potential of poetry and creative literature more generally, *An Apologie for Poetrie* (probably begun 1579, published London, 1595). Yet, as William Ringler noted as far back as 1940, such theorizing did not just react to works produced on the continent. It was also influenced by and developed out of the home-grown university backgrounds of these English poet-critics, via a 'social humanist' educational experience that put the study of classical texts to work in framing a training in rhetoric, logic and philosophy – which would in turn inculcate the kind of 'virtue' that would qualify its students for leading roles in service to God and country.[1]

Still, little account has been taken of Elizabethan neo-Latin literary criticism and poetry in larger discussions of English literary history. No doubt a continuing reluctance to explore the possible impact of neo-Latin theorizing has much to do with the efforts of early modern vernacular literary critics to press a

strong suit for an English-language poetry encoding the cultural sovereignty of the nation, even as university authorities jealously defended the intellectual hegemony of Latin and shunned comparison with more popular vernacular verse and drama, at least in their public pronouncements on the matter.[2] Furthermore, the teleological arc of early modern contact with the Classics – from reproduction, through translation, to creative reconfiguration; from dependency to independence; and from Latin to English – offers a satisfying trajectory of progression that fits with the broader story of a Renaissance culture reaching its acme in a creative vernacular, by definition 'leaving behind' Latin.

Even so, it may be worth taking more seriously the possible interaction of neo-Latin theory and creative work with its vernacular counterparts, for of course a lively and innovative Latin literary culture continued to flourish even as vernacular literature came into its own. Stuart Gillespie (2011) has recently shown that translation of the Classics plays a crucial role in English literary history, recovering a new past for the English literary tradition and serving as a decisive factor in making 'home-grown' literary culture possible. In this chapter I wish to return to the question of the intersections between classical scholarship, literary criticism and poetry in the Elizabethan period, investigating the extent to which neo-Latin literary theory, verse and drama – and in particular theory and practice concerning tragi-comedy – may also have interacted with the vernacular in 1580s and 1590s Elizabethan England. While some very limited traces of 'academic' influence on the drama of the public stage have been gleaned via investigations of allusive influence, my aim is not to suggest that neo-Latin drama and theory is decisively influential on the direction of vernacular criticism and creative composition. Rather, I want to situate my discussion in the broader ethical questions about the utility and benefits of poetry that are at the heart of early modern literary theory and trace their exploration in one particular neo-Latin drama. First offering a reading of Alberico Gentili's 1593 *Commentatio* against and as 'corrective' to Sidney's *Apology*, I then show how a highly prescriptive attitude to the didactic potential of poetry is set in tension with the playfully innovative tragicomedy *Ulysses Redux* (1591). I will argue that this neo-Latin but still quintessentially English drama is influenced by and responds to the innovations of vernacular tragedy; more broadly shares importantly connected ethical 'horizons of expectation' with vernacular drama/criticism; and constitutes an important generic experimentation in tragicomedy that ought to be considered alongside the other centripetal efforts to provide an 'English' tragicomedy in this period.

Interactive Literary Criticism? Gentili and Sidney

The final quarter of the sixteenth century saw several efforts to grapple with poetics and critical theory within the universities and in Latin, in works such as Henry Dethick's *Oratio in laudem poësos* (London, *c.* 1575) and Richard Wills' *De Re Poetica* (1573).[3] These works, products of life spent within the university system, often began life as academic orations, and Richard Wills' *De re poetica*, framed as a classical forensic oration, was specifically addressed to the pupils of Winchester College.[4] But in J.W. Binns' assessment, 'the best and most penetrating' example of such theorizing, also born out of a specific academic occasional context (a university speech delivered at a graduation ceremony, given at some point between 1583 and February 1591/2), was Alberico Gentili's *Commentatio ad L[egem] III C[odicis] de prof[essoribus] et med[icis]*.[5] Printed by John Barnes, the Oxford printer, in 1593, this defence of poetry is at first glance a rather dry document: it is in form a legal commentary on the subsection of the Justinian Code which granted immunity from taxation to grammarians, rhetoricians and logicians, but not poets. Gentili – who was a lawyer and had been appointed Regius Professor of Civil Law at Oxford in 1587 – makes the case that the Code is wrong to treat poets so. But the legal issue serves, in fact, as a springboard for a much more wide-ranging conceptualization of the role of the poet and poetry in society, incorporating (and at times challenging) a wide range of literary–critical theory, both ancient and modern. Grounding his theory in discussions of poetry as an art of mimesis, emphasizing the exemplary function of poetry via its genealogical ancestry with logic, and arguing for its didactic utility and improving moral effect, Gentili interweaves arguments familiar from contemporary vernacular poetic theory with repeated reference back to his main thesis: that poets deserve the same privileges as philosophers and grammarians, deploying a conspicuously learned range of examples and allusions to classical, legal and biblical scholarship as he does so.[6]

While Gentili is not concerned with a definition of poetry *per se*, his work – an eclectic and challenging defence of poetry that is framed via a typically Renaissance humanist fusion of Aristotelian and Horatian theory, and is aimed particularly at poetry's ethical and instructive potential – certainly addresses the central issues of other vernacular Elizabethan literary criticism.[7] All such works tend to operate within a similar network of ideas, valorizing the role of the poet, considering poetry with regard to the universal and particular, reading it against or as part of history and philosophy, and arguing for poetry as an active force with the capacity to inspire good conduct. Nor is it easy to discern a

traditional, 'allusive' relationship given the way in which all such works tend to form their ideas out of a tissue of quotations and commonplaces: in a sense it is precisely the tendency of these authors to collapse and entangle what in antiquity had been distinct strands of thought and approach that makes this work distinctly that of the High Renaissance.[8] Nevertheless, I think that a good case can be made that Gentili's arguments in the *Commentatio* are working in particularly pointed responsion with the most famous and complex statement of contemporary vernacular literary criticism, Sidney's *Apologie for Poetrie*.[9] For Sidney, of course, it is the situation of contemporary English poetry and its potential that is at the heart of the treatise, and the two texts are structured very differently (Sidney's *Apology* framed as classical forensic oration, Gentili's *Commentatio* addressing the legal issue from various angles, with arguments buttressed by proofs and precedents). Still, in their privileging of 'big ideas' over formal features of poetry; their combative and challenging attention to their ancient and contemporary sources; and in a distinctive vision of the purpose of poetry that implicates the language of vision and performance, imitation and civic virtue, Gentili and Sidney share a vision of the power of poetry that seems to this reader quite distinct from the accounts and approach of Puttenham and Webbe.[10]

There are good reasons, moreover, to look for a special connection between Gentili's work and Sidney's take on poetry, for Gentili – an Italian Protestant, who had arrived in England in 1580 after fleeing the Inquisition – had been introduced to Sidney soon after his arrival in England and would go on to find security and patronage from Sidney's uncle, the Earl of Leicester. In the dedicatory epistle to a previous work, *De Legationibus* (published 1585), Gentili indeed recalled an active relationship with Sidney, asserting that his work had been spurred by and arose out of conversations the two had had concerning diplomacy and ambassadorship. According to Christopher Warren, this 'intellectual closeness' between the two in the early 1580s could also be read the other way, as the legal issues that were at the heart of Gentili's scholarly work were reflected and refracted in the revisions Sidney made to his *Arcadia*.[11] While there is no explicit articulation of a connection to Sidney's *Apology* in the *Commentatio*, then (Sidney himself died in 1586; and his *Apology* would not be published until 1595) it seems perfectly plausible that Gentili would both have been part of the circle that had access to Sidney's *Apology* in manuscript form and would have wanted to continue to engage with Sidney's ideas in his own *Commentatio*. This work at any rate certainly begins with reprise of the central proposition of Sidney's *Apology*,

Poesy is an art of imitation, for so Aristotle termeth it in his word *mimesis*, that is to say, a representing, counterfeiting, or figuring forth – to speak metaphorically, a speaking picture – with this end, to teach and delight.

Apology 86/17–20

Sidney's allusive fusion of Aristotle and Horace, built upon Simonides' famous definition of poetry as 'speaking picture', serves as the imaginative nexus and launchpoint for Gentili's own consideration of poetry, which is fleshed out, with further reference to Plato and extra scholarly 'footnoting' at the beginning of his commentary[12]:

> *Et huc igitur mihi animum adverte: atque recogita, quam facit pene eundem poetam, pictoremque Plato, et vero sic est et vulgatum illud Simonidis Melii, "Pictura est muta poesis. Poesis est loquens pictura".*

> And consider how closely Plato identifies the poet and the painter; and indeed the common saying of Simonides of Melos is also the same, that "Painting is silent poetry, poetry is a speaking picture".[13]

Binns 1972: 230, 252

Gentili continues by defining three types of poetry (epic, tragedy, and comedy) against this standard, before going beyond the Aristotelian assertion that poetry describes what *might* be,[14] to argue that with epic and tragedy poets must depict what *should* be: while the deeds of princes surely have some foundation in fact, Gentili admits, poetry can offer the best possible explanation for what was, in the image of the best and most industrious prince (*in imagine optimi, et laboriosissimi principis*, Binns 1972: 231). And so, Gentili concludes, *Sic et poesis, et pictura fingunt sub imagine veri. Ut ita capitur Horatius ilic, "Pictoribus, atque poetis"* ('Thus both poetry and painting feign under the image of truth. And so Horace's line is understood, "Painters and poets"').[15]

In stretching Aristotle's consideration of the 'verisimilitude of imitation', Gentili is engaging with a famous strand of Renaissance literary criticism,[16] but his strongly moralizing interpretative twist is obviously reminiscent of Sidney's own articulation of the utility of 'the speaking picture of poesy',[17] for Sidney makes a more explicitly self-aware pivot away from Aristotle in engaging with Gentili's distinction between 'what was' and 'what should be'.[18] After considering in particular the role of the poet Vergil at some length, Gentili returns to Sidney's point:

> *Hic videlicet verae poeticae finis est. Ut quae delectat tantum, ea adulatoriae non immerito conferatur: et iudicetur pestifera, quae foedis exemplis mores corrumpit. "Et prodesse volunt, et delectare poetae". Ut inquit Horatius.*

This, it is clear, is the end of true poetry. That which merely delights may not unworthily be compared to flattery; and that which corrupts morals by foul examples may be judged pernicious: "Poets wish both to profit and delight". As Horace says.

<div align="right">Binns 1972: 238, 259</div>

Gentili and Sidney are alike, then, not just in framing poetry as a powerfully moral force, precisely because of its ability to go beyond 'what was' to 'what should be', but also in repeatedly linking this to the visual register.[19] But gaps begin to open up in their exploration of the exemplary potential of poetry when that feigned vision is realized. Sidney chooses to activate two famous examples in exploring this ethical framework for poetry, Xenophon's 'feigned' Cyrus and Vergil's 'feigned' Aeneas, explicitly articulating this not just as the compositional choice of the poet, but also the interpretative choice for the reader:

> For, indeed, if the question were whether it were better to have a particular act truly or falsely set down, there is no doubt which is to be chosen. [...] But if the question be for your own use and learning, whether it be better to have it set down as it should be, or as it was, then certainly is more doctrinable the feigned Cyrus of Xenopohon than the true Cyrus in Justin, and the feigned Aeneas in Vergil than the right Aeneas in Dares Phrygius [...].

<div align="right">*Apology* 92/8–30</div>

As Sidney signals with his mention of Dares Phrygius, the 'historical' Aeneas on record – the Aeneas 'that was' – was by no means an example to stimulate virtuous action. Sidney's artful and complex awareness of the malleability of truth is echoed by Gentili, who again uses the painting example as spur to consider poetry's 'truth' and 'falsity'.[20] Yet though he is clearly also aware of the historical 'perfidious Aeneas' tradition, Gentili suggests merely that the poet has an opportunity lacking to the historian to fill in the unknowns of history:

> *Et in epopoeia, ac tragoedia fundamentum videris ab historia, vel fama. Sic silicet gesta principum sunt, personarum horum poematum, ut in obscuro iacere nequeant. [...] Et in his superest poetae locus ad suum illud verisimile imitationis, quod conficit in imagine optimi, et laboriosissimi principis.*

> Both in epic and in tragedy you can see that there is a foundation in history, or legend. To be sure, the deeds of princes, the characters of these poems, are such that they cannot remain in obscurity. [...] And in this there survives an opportunity for the poet for his own verisimilitude of imitation, which he accomplishes in his conception of the best and most industrious prince.

<div align="right">Binns 1972: 231, 252</div>

Indeed, Gentili goes further. Drawing from Scaliger, he offers the *Aeneid* as the *exemplum* to be defended above all others, not just because it has created the consummate *vir virtutis*, but also because of its active ethical efficacy:

> *An passim quae observat Scaliger de Virgilii virtutibus recito? Artes pacis omnes, et belli uno in Aenea cognitas, exponit in Idaea. et haec in summa, "Nullis profecto philosophorum praeceptis aut melior, aut civilior evadere potes, quam ex Virgilii lectione".*

> Shall I mention those things which Scaliger observes everywhere about the virtues of Vergil? In his *Idea* he declared that all the arts of peace and war are comprehended in Aeneas alone. And in sum, 'You can be neither a better nor a more polished person from any of the philosophers, than from a reading of Vergil.'

<div align="right">Binns 1972: 234, 256</div>

This approach chimes with Sidney's own famous argument in the *Apology* that poetry must be put above history or philosophy, since philosophy offers a merely 'abstract and general' wisdom. For Sidney too, poetry offered an 'image of that whereof the philosopher bestoweth but a wordish description, which doth neither strike, pierce, nor possess the sight of the soul': for all its value, philosophy's teachings of virtue 'lie dark before the imaginative and judging power, if they be not illuminated or figured forth by the speaking picture of poesy' (*Apology* 190/22–4).

There is of course, however, a famously destabilizing twist to the powerful speaking picture of virtue in poetry advocated by Sidney and endorsed by Gentili. For Sidney's argument was itself framed in artful and complex fashion, with the declaration that he had been 'provoked' to defend poetry and his 'unelected vocation', as the result of some unknown 'mischance' that had provided him with 'idlest times' (81/25–7). With such programmatic self-positioning Sidney not only showed his own awareness of his implication in the potentially morally dubious world of poetry; he also advertised the extent to which he had been cut off from the world of 'virtuous action' his poetic manifesto preached, for he must now write poetry as an alternative to the active life of diplomat and courtier.[21] It is here that Gentili makes a distinct turn way from the *Apology*, shunning the self-ironizing defeat of the 'prodigal' Sidney and countering with a reframing of poetry as precisely the kind of 'active' civic undertaking that positions poetry as instrument of civil philosophy:

> *Est poetica, quemadmodum rhetorica, instrumentum activae philosophiae civilis: nam per poetas, et poemata mores civium bonos facit. Et sicut verbis per oratores hoc praestat rhetorica: ita poetica per poetas factis fictis et fictis actionibus. Ut ista*

Scaliger, et luculentius explicavit doctissimus Zabarella. Hic videlicet verae poeticae finis est.

Poetry, like rhetoric, is an instrument of active civil philosophy. For through poets and poems, it makes the morals of the citizens good. And just as rhetoric fulfils this function with words through orators, so does poetry through poets with invented deeds and fictitious actions. As Scaliger, and more clearly the most learned Zabarella, explained. This, it is clear, is the end of true poetry.

Binns 1972: 238, 253

Gentili expresses his commitment to the conclusions of Scaliger and his contemporary Jacopo Zabarella, the Aristotelian philosopher who claimed to have been the first to argue that poetry was a branch of logic, an argument: and later, in a response to an attack on poets that Sidney had also rebutted with similar examples,[22] Gentili doubles down on this defence, this time taking aim at the Stoic Zeno: 'To Zeno we thus reply, that poetry is not an instrument of contemplative, but of active, philosophy' (*Zenoni sic respondemus, non esse poeticam instrumentum philosophiae contemplativae, sed activae*, Binns 1972: 261, 239).[23] Such emphasis on the traditional categories of the 'active' and 'contemplative' life derive from Augustine and Aquinas and are still dominant modes of categorization in sixteenth-century humanist thought.[24] But in a turn away from the kind of distinction Sidney himself made in the *Apology* between the active life of the diplomat/courtier and the writer (a distinction itself grounded in a Renaissance mindset that separated the active life of the Prince from the contemplative scholar), Gentili arrogates to poetry the power of philosophy, reframing it as active interventionist and inculcator of virtue.[25]

Gentili's *Commentatio* serves not so much as a contradiction to Sidney's self-ironizing depiction of the virtuous potential of poetry, then, than as a corrective that flattens the ambivalence of the 'prodigal' writer of the *Apology*. This broader corrective may, indeed, be linked more specifically with Sidney: for, as Joanna Craigwood has recently shown, Gentili had already addressed precisely these issues in his *De Legationibus* (published 1585), a treatise on diplomacy both inspired by, and dedicated to, Philip Sidney himself.[26] In a pre-articulation of the implication of active and contemplative virtue addressed via poetry and performance in the *Commentatio*, Gentili had reflected upon the 'mimetic art' of diplomacy, making the diplomat assume a performing role (*persona*) that was, in Craigwood's words, 'also a true and moral art,'[27] and framing Sidney himself as the perfect 'speaking picture' of virtue, an embodied image (*imago*) of the perfect diplomat and man. Indeed, in his dedicatory epistle to Sidney, Gentili

conspicuously styled himself a copyist-painter, whose imitation in words fails to do justice to the original.[28] In the climax to his three-book discourse on diplomacy, he had returned to the theme, summarizing his work as an attempt to offer the pattern (*forma*) of the perfect ambassador, but disavowing the need for any special pictorial skill:

> *At neque priùs te dimitto, quàm, quod Socrates iucundius adhuc existimabat, tibi etiam imaginem istam, speciemque vivam perfecti legati exhibeam. ad quam scilicet rem nec mihi Zeusis artificio, nec alterius cuiusquam, qui quid simile sunt executi, censeo opus esse: in vno enim viro excellentem hanc formam inueniri, & ostendi posse confido: nam is omnia sic habet, quæ ad summum hunc nostrum oratorem constituendum requiruntur, vt cumulatioria etiam habeat, & ampliora. Is est PHILLIPVS SYDNEIVS.*

<div align="right">Gentili 1585: 146</div>

> But I shall not dismiss you without showing you what Socrates considered to be a still greater source of pleasure: a living image and example of the perfect ambassador. Nor do I think that I shall have need of the skill of Zeuxis or any artist of that kind. For I am sure that this excellent pattern can be found and demonstrated in one man only – a man who has all the qualities which are needed to make this consummate ambassador of ours, and has them indeed in greater abundance and on a more generous scale than is required. That man is Philip Sidney.

<div align="right">Laird 1924: 201</div>

While Sidney was alive, Gentili could play at 'copying' Sidney: the *Commentatio*, written after Sidney's death and in the wake of Sidney's forestalled diplomatic career, had to offer a broader corrective to the tensions programmed within the *Apology* and a re-assertion of the power of poetry as active, civic philosophy with the ethical power to inculcate virtue. In the *Commentatio*, Gentili corrects the self-ironizing picture of virtue Sidney's own written self had left behind, reasserting an unambiguous opportunity for, and a broader reification of, the self-implicating nexus of performance, poetry, and virtue that underpinned both Sidney's and Gentili's defences.

From Poetics to Genre: William Gager's *Ulysses Redux*

Gentili's reflections on the potential virtues and utility of poetry and performance in the 1593 *Commentatio* did not just reframe his previous work, articulating arguments (in dialogue with Sidney's *Apology*) on the utility of performed poetry

as ethically valuable. His symbiosis of literature and life in the creation of the perfect *imago* of excellence could be studied in particular performances of poetry and virtue undertaken by elite youth in the regular cycle of university dramas in which both undergraduates and fellows participated. Indeed, in an extended digression in defence of acting within the *Commentatio* (Binns 1972: 244–8, 264–70) Gentili also anticipated the objections from Puritan scholars in particular that this form of poetic performance was positively injurious to virtue.[29] The issue of performance and virtue was brought to the fore by Gentili's close friend William Gager, in the 1580s and 1590s Oxford's pre-eminent academic playwright, in the wake of plays staged for Queen Elizabeth's visit to Oxford in 1592.[30] Gager's decision to introduce in the epilogue to the final play, *Hippolytus*, a carping critic named 'Momus', who railed against the 'bad judgement and corrupt morals' of both actors and audience of the drama, sparked a backlash from Puritan scholar John Rainolds;[31] in response, Gager had to offer not only a defence of the role of academic drama, but also the 'new tragedy' he had debuted, entitled *Ulysses Redux*:

> Neyther doe I see what evill affections could be stirred up by owre playes, but rather good [...] Whoe was not moved to compassion to see *Vlysses* a great Lorde dryvne so hardly as that he was fayne too be a begger in his owne house? Whoe did not wisshe hym well, and all ill to the wooers, and thinke them wortheley slayne, for their bluddye purpose agaynst *Telemachus* and other dissolute behaviour, not so muche expressed on the Stage as imagined to be done within? [...] Lastly whoe was not glad to see *Vlysses* restored to his wife and his goods, and his mortall enemyes overthrowne and punished?[32]

Gager's presentation of the *Ulysses* as clear-cut morality tale fits with the educative and ethical model of poetics proposed by Gentili in his 1593 *Commentatio*,[33] and some recent readers of *Ulysses* have indeed seen the protagonist of this play as a self-controlled patriot, even 'a scourge of God punishing evil', within a plot that offers a distinctly Elizabethan combination of harsh retributive justice with a broader 'providential' perspective.[34] But such interpretations occlude the tensions and 'explorative' openness of Gager's *Ulysses*, which is a remarkable synthesis of classical scholarship and self-aware generic intervention. Gager undertakes a sustained and close reworking of Homer's *Odyssey* at a time when no English translation of the poem existed (Chapman's *Odyssey* would be published first in 1616); he offers fast plotting, spectacular action scenes, and a keen appreciation of the tragic-comic tension to be drawn in this 'tragedy with a happy ending'; in creating Ulysses as both a brooding

tragic revenger and the bringer of vengeance responsible for the 'happy ending' to the tragedy,[35] he not only makes a distinct and self-aware contribution to the genre of tragicomedy, but also, in his *tragaedia nova*, forces a complex consideration of competing models of virtue within the play that positively challenge the simple appeal to the virtues of the text Gager himself made in his later defence of its propriety.[36]

Of course, attempts to define precisely what Sidney called 'mongrel tragicomedy' are doomed to failure, for this fluid genre, defined by the concept of 'mixture', is particularly resistant to generic taxonomy of the kind so favoured in the Renaissance. It is standard to start discussions of early modern tragicomedy in English with Fletcher's definition in his prologue to *The Faithful Shepherdess* (1608/9), but many different instances of tragicomedy preceded this, and Gager takes obvious pleasure in responding to the central issues and tropes of early modern tragicomedy.[37] While Gager clearly departs from Guarini's prescription that tragicomedy should be played within the framework of 'il pericolo, non la morte', in Ulysses' interactions with his family and the suitors we see not just moments of knock-about comedy (in particular the fisticuffs with Irus), but also more profound exploration of the issues of role-playing, disguise and revelation, as the plot's final *anagnorisis* scenes and Ulysses' happy *peripeteia* respond to the providential vision of the genre.[38] Moreover, in his extended attention to the female characters – not just a classically 'Homeric' Penelope in his chaste but quick-thinking wife of Ulysses, but also his creation of a significant role for the licentious handmaid Melantho, who delights in her relationship with Antinous, only to lament her mistakes in a classic 'gallows-speech' at the end of the play – Gager's treatment of the issue of female sexuality and its threat to the social order echoes the concerns of much early modern tragicomedy.[39]

Gager's double prologue to *Ulysses Redux* highlights Gager's own playful awareness that he is transgressing generic decorum in his 'new' kind of tragedy. In the prologue 'Ad Criticum' he notes that the play provokes laughter via the comic character of Iris, works within a lowly comic register linguistically, and – the major problem for a tragedy – offers a happy ending.[40] He also pointedly avoids categorizing his own work, airily dismissing it as 'tragedy, fiction, or historical narrative – or whatever it's right and lawful to call it' (*sive tragediam, sive fabulam, sive narrationem historicam, sive quicquid eam dici ius fasque est*).[41] As Stephanie Allen argues, Gager puts the hybrid form of his play-text firmly at the feet of Homer himself, in implicit recognition of contemporary theorizing from the continent, above all Cinthio's use of Homer's *Odyssey* to sanction 'mixed tragedy' (and possibly even also of Guarini's *Il Pastor Fido*, which was not

published until 1590, but was composed between 1580 and 1585, together with his anonymous 1588 defence of the tragicomedy in his reply to his critics, *Il Verrato*). Gager raises the spectre of Guarini's ultimately harmonious, bloodless and providential universe, Allen well concludes, in productive tension with the harsh morality of a Ulysses who achieves his harmonious world by an excessively harsh vengeance.

Gager's attention to the genre discourse of tragicomedy and his clear response to the central issues of vernacular tragicomedy combine to offer a fascinating but difficult example of the intersection between classical scholarship and contemporary English poetry. For Gager's depiction of a dark, 'tragic', and even potentially tyrannical Ulysses, wreaking vengeance on dissolute suitors, not just played by the young men of the university but also consistently compared with the wooers of Ithaca within the play itself, provides an alternative but similarly self-ironizing take on the ethical efficacy of drama so straightforwardly asserted by Gentili's *Commentatio* and later defended by Gager himself.[42] While the medieval Dares and Dictys tradition had played up the demonic cunning and treacherous nature of Ulysses, an allegorizing tradition from the Early Church fathers on had stressed both Ulysses' wisdom and his exemplary suffering, and this was the dominant reception of the character of Ulysses in sixteenth-century England.[43] Gentili's *Commentatio* makes much of Homer, quoting Justinian on Homer as the father of all virtue (*omnis virtutis parentem*), adducing Plato among others on Homer as the fountain of all wisdom, and concluding with the same quote from Horace's *Epistles* used by Sidney on Homer's value, that Homer 'teaches what is beautiful, what foul, what is useful and what is not, in a fuller and better way than Chrysippus and Crantor' (*Qui, quid sit pulchrum, quid turpe, quid utile, quid non, / Plenius, ac melius Chrysippo, et Crantore docet*).[44] Indeed, Gentili himself again collapses the boundaries within his treatise between literary criticism, legal comment, and active ethics as he reworks an example from his *De Iure Belli* (1588–9) to illustrate the connection between Homer and virtue – via the negative *exemplum* of Hannibal, whose unjust behaviour in war is directly linked in Gentili's mind to his contempt for Homer.[45]

It is immediately evident from Gager's *Ulysses Redux*, however, which takes its start from *Odyssey* 13 with Ulysses washed up on the shore of Ithaca, that the protagonist of the neo-Latin drama activates not just the Homeric Odysseus' wisdom in suffering but also the affinity for deceit, trickiness and deception heralded by the poet at the start of the *Odyssey* (ἄνδρα μοι ἔννεπε, Μοῦσα, πολύτροπον, ὃς μάλα πολλὰ / πλάγχθη, 'Sing to me, Muse, of the wily man who

suffered much,' *Od.* 1.1–2). Responding to Ulysses' attempt to pull the wool over
Minerva's eyes at the beginning of the play, Minerva compliments him as 'artist
at trickery and fraud' (*doli ac fraudum artifex*, I.118):

> MIN. *Sane esse Creta patria tibi tellus potest,*
> *Ita metiendi fraude Cretensem refers,*
> *Astutiarum semper ingenuus faber.*
> *O versipellis! O doli ac fraudum artifex!*
> *Nimis esse oportet callidum, te qui artibus*
> *Praetereat istis, sit licet is aliquis deum.*
>
> UR. I.115–20

> Surely Crete can be your homeland, since you show yourself to be a Cretan in the
> guile of telling lies, you who are always a clever manufacturer of stratagems. Oh,
> you cunning man! Oh, you artist at trickery and fraud! He would have to be
> exceedingly wily to outdo you at those skills, even if he were a god.[46]

Such an introduction follows Homer closely, but it also brings to mind the more
pejorative backdrop of Odysseus' incarnation in the Latin tradition: in particular,
the Ulixes of Seneca's *Troades*, who achieves the slaughter of the innocent child
Astyanax by tricking his mother Andromache into revealing his hiding place
and who is condemned by Andromache as 'false inventor of deceit and heinous
cruelty!' in Heywood's popular 1559 translation (*o machinator fraudis et scelerum
artifex! Tr.* 750). Gager's Minerva thus activates a literary tradition which reminds
us that Ulysses is an amoral liar. Gager's Ulysses is not just the Homeric Odysseus
polumētis, then: he is also, potentially, a more sinister figure, as his opening
soliloquy makes clear. Summoning his resources in a way precisely reminiscent
of his villainous turn in *Troades*, he recalls the self-reflexive words of Seneca's
anti-hero in that play (*nunc advoca astus, anime, nunc fraudes, dolos, / nunc
totum Vlixen;* 'Now call upon your cunning, mind of mine, call upon your guile
and plots; now call upon "the whole Ulixes"', *Tro.* 613–14) in a similarly self-
reflexive exhortation to self to instigate the action of the play:

> *Nunc ecce, si sis ille Laerte satus,*
> *Ithacae dominus, advoca ingenium vetus,*
> *Et totum Ulyssem. Callidos qui tot dolos*
> *Saepe eruisti, fraudis hunc nodum expedi.*
>
> UR I. 65–8

> Now look: if you are really Laertes' son and lord of Ithaca, summon your old
> cunning, the whole Ulysses. You who so often devised so many clever schemes,
> loose the knot of this deception.

Above all, though, it is Gager's combination of scenes of extreme revenge (the killing of the suitors; the execution of the handmaids; the particularly ghastly fate befalling the treacherous Melanthius) interspersed with moments of cruel wit and much broader episodes of blunt humour, that make this a ground-breaking play which anticipates later tragicomedy. Gager, in fact, signals his attentiveness to this in Minerva's other designation of Ulysses at the outset of the play, 'Oh, you cunning man!' – or even more self-consciously – 'You shape-shifter!' (*O versipellis!* UR. I.118),[47] while Ulysses himself will evoke his comedy-based reputation for using cunning to solve problems and resolve plots when he exhorts himself to 'unravel the knot of deception' (*fraudis hunc nodum expedi*, UR. I.68).[48] While this drama will showcase the importance of fidelity and the folly of disloyalty and decadence, its protagonist is no simple Christian hero but a complex and frightening character who harnesses his classical reputation for cruel cunning and amoral plotting to accomplish a so-called 'justice' of which any Elizabethan revenger could be proud.[49]

Gager's prologic prediction that his Ulysses is a character who 'treads the stage not in tragic buskin [...] but in comic slipper' (*UR. Prol.* 28–34) is placed under further stress in the protagonist's obsessive contemplation of revenge. In the opening to Act IV, Ulysses delivers a tragic prologue not just Senecan but also strongly reminiscent of contemporary revenge tragedy[50]:

Quo raperis, anime? Siste ne propera dolor.
Iam tempus aderit ira quo, rupto obice
Torrentis instar, gurgite ruet spumeo,
Stragemque dabit horrenda, quo meritas proci
Paenas rependent, quoque semesam domum
Sanguine reponent.
[...]
Hostem iuvat ridere. Quanto plus iuvat
Mactare? Non est suavius spectaculum
Hoste interempto. Tu meas vires alis,
Vindicta dulcis, nulla te melior dea est.
Te propter unam, sufficio tantis malis.

<div align="right">UR. IV.1179–84, 1189–93</div>

Where are you whirling off to, mind of mine? Halt, *dolor*: do not hurry forward. The time is very near at hand in which my wrath – the equal of a torrent when the dam has broken – that terrible wrath will pour forth in a foaming flood and make a massacre, through which the suitors will pay the price they deserve and replenish my half-consumed home with their blood. [...] It's a pleasure to laugh

at your enemy. How much more pleasant to slaughter him? There is no sweeter sight than a slain enemy. You feed my strength, Sweet Revenge: there's no better goddess than you. Because of you alone, I am the match of all this suffering.

Ulysses' obvious affinities with the tragic revengers of the vernacular stage makes it difficult to read the final acts of *Ulysses Redux* as straightforward 'morality tale', instead inviting rather similar challenges to the ethics of justice and revenge being considered within contemporary tragedy and tragicomedy.

Such destabilization of virtue is pressed further in the execution of Ulysses' revenge, as Gager makes significant changes to the staging and plotting of the death of the suitors. In Homer's *Odyssey*, Odysseus is outnumbered and must fight furiously to kill the suitors, who have been armed by the traitor-servant Melanthius (*Od.* 21.107–59), in a truly perilous confrontation that lacks overt divine assistance (*Od.* 21.236–8). Gager's Ulysses stages his revenge very differently. A more calculating character, he plots an intricate revenge plan which, following the 'symmetry of revenge' demanded in contemporary revenge tragedy, returns on the malefactors a punishment artfully crafted to fit the crime: he will trap them in the hall where they have feasted away his wealth, and destroy them as they are barricaded within, unarmed and helpless. Indeed, he makes a point of 'correcting' the mistake of Telemachus in the *Odyssey* which leads to the suitors gaining their arms and staging their battle: revelling in the helplessness of his quarry, he recalls the exultant language of Seneca's *Thyestes*, and an Atreus gloating that his victims – in that case the innocent sons of Thyestes – are now trapped like beasts:

> Telemachus, and you two, equally faithful in my affairs, stop talking, since the work demands hands. Now there is a labor for your hands and your intelligence. They are many, I know, but at my command Telemachus has removed all the weapons, and scarcely a dagger remains for the Suitors. They are pent up: walls of solid rock block their escape. Bars lock the doors, and all the exits have been shut, so that man can escape alive if I'm unwilling. My booty is held fast in the nets I have spread which no beast, however bold, could break through.[51] Eumaeus: you take your position now at that blocked door that leads to the garden. And you, Philaetius, guard the back door. We will watch the entrance to the dining hall itself, the busiest route. First, we shall shoot the suitors with arrows sent down from above. Let a drum beat outside, so that the noise will not reach the palace or rouse the city. When the bugle signals you, open wide the doors and rush in together. We shall kill them as they are hemmed in, unarmed and wounded.[52]

> UR.V.1606–27; contrast *Od.* 21.107–59

Gager positively forces his audience to reflect on the morality of Ulysses' actions here, as his killing of the wrong-doers is not just re-modelled as a Senecan-inspired and ruthlessly efficient series of executions (as opposed to a Homeric battle-scene), but also accompanied by extended conversations with several of the doomed suitors that frame the question with contemporary flavour. The suitor Eurymachus in the *Odyssey* pleads for mercy, offers reparation and claims that Antinous' death should suffice for revenge (*Od.* 22.42–60) and ends by calling on the suitors to draw their swords. The Eurymachus of *Ulysses Redux* cannot fight back, but he also offers a fresh argument for mercy, making an appeal to moderation based on the rightful behaviour of a king (*UR*. V.1656–61). Eurymachus' appeal to mercy makes a claim to good government in terms that sound rather contemporary, but Ulysses' response suggests that he has no interest in playing the just prince:

> *Hostine tu constituis irato modum?*
> *Ecquem ira teneat nostra violati tori*
> *Regnique rabies? Iam furere par est magis.*
> *Si posset una caede saturari dolor,*
> *Nullam petisset.*

<div align="right">UR. V.1669–73</div>

Do you set a limit for your angered enemy? Should my madness over my violated marriage-bed and kingdom keep anyone from its fury? Now it is reasonable for me to rage all the more. If one man's killing could sate my outrage, it would have sought none at all.

Such a perspective even forces Ulysses to the execution of Amphinomus, a suitor he admits is innocent. Amphinomus has not sinned in deed, Ulysses will accept, but he has sinned in intention[53]:

> UL. *Utcunque multi, Amphinome, te sceleris putem*
> *Esse innocentem, non mihi probabis tamen*
> *Optasse reditum te meum, ut votis putem*
> *Nec ambiisse coniugem toties meam.*
> *Tu carpere uvas vite voluisti mea,*
> *Tu liberos uxore voluisti mea*
> *Tibi procreare, socia tibi placuit mea.*
> *Proinde morere, Amphinome, nec enim te decet*
> *In morte socios deserere. morere, improbe.*

<div align="right">UR.V.1710–18</div>

UL. However innocent of wrongdoing I consider you to be, Amphinomus, you will not convince me that you hoped for my return, in order that I should believe that in your prayers you did not covet my wife. You wanted to pluck the grapes from my vine, you wanted to father children with my wife, my woman was pleasing to you. So die, Amphinomus: it's not seemly for you to desert your friends in death. Die, wicked one.

Ulysses' execution of justice is now framed as the working-out of a characteristically tyrannical paranoia: declaring that his murder of the suitors will confirm his marriage (*nox una thalamos ista firmabit meos, UR.* V.1684), he exults in a revenge that is implicitly bound up with the reaffirmation of his marriage, in much the way that Atreus confirms the 'true' paternity of his own children by murdering Thyestes's, or Medea's infanticide somehow reclaims her virginity[54]:

> *Sic ille ducat, quisquis alienam viro*
> *Vivente sociam tentat. O spectaculum!*
> *O nuptialis thalamus! O sponsi inclyti!*
> *Iuvat videre sanguine aspersas dapes*
> *Sanie fluentes aspicere mensas iuvat.*

<div align="right">UR.V.1747–51</div>

So let him die, whoever makes an attempt on another man's wife while that man lives. Oh, what a sight! Oh, the bridal chamber! Oh, famed wedding-contract! It's a pleasure to look on a blood-spattered banquet, to behold tables running with gore.

If this is justice, then, it is a justice that Gager is not afraid to characterize very much like criminal revenge, casting a Ulysses who rejects moderation, executes the innocent, and takes real pleasure in the accomplishment of reprisal. This potentially problematic depiction of Ulysses' actions is confronted explicitly in Ulysses' conversation with Agelaus, the fiery suitor already marked in the *Odyssey* for his martial vigour.[55] In the *Odyssey* he has no explicit confrontation with Odysseus before death, but Gager gives him the opportunity to criticise the way Ulysses takes his revenge:

> AGE. *Dux magne Danaum, quae tibi laus haec erit*
> *Iuvenes inermes flebili letho dare?*
> *En instar ovium, caula quas tenet, a lupis*
> *Laniamur. At nos tela capiamus simul.*
> *Pugnando liceat cadere, mors saltem viris*
> *Honesta veniat. More iam pecudum, inclyta*

Morimur iuventus. Nil ego pro me loquor,
Pectore sagitta fixus, et morti imminens.
Quin perage facinus, perage, crudelis, tuum,
Quod nulla taceat, nulla posteritas probet,
Quod esse credat cuncta posteritas tuum,
Nocturne semper miles, et fraudum artifex.

UR. V.1684–95

AGE. Great lord of the Greeks, what kind of glory will there be for you in giving unarmed youths a pitiful death? We are like sheep in a fold, savaged by wolves. Instead let us take up weapons likewise: if one can die fighting, at least an honourable death comes to a man. As it is we distinguished youths are dying like beasts. I do not speak for my own benefit at all, since I've been hit in the chest with an arrow and am approaching death. No? Well then, commit your crime, cruel man, commit a crime which no later age will keep silent about, which no later age will approve, which every later age will believe to be typical of you: ever the nocturnal soldier and artist at deceit.

Agelaus's argument, like Eurymachus's, also clearly comes from an aristocratic code of honour which appeals as much to the sixteenth century as Homer: he stresses the high-born status of his companions, appeals to the elite ethos of the 'noble death', and attempts to classify Ulysses' actions as a criminal act. Indeed, they do more. These words once again evoke the work of Gentili, whose ground-breaking treatise on international law *De Iure Belli Libri Tres* (1588–9) – a work to which he looks back in his *Commentatio* – devotes considerable space to the treatment of prisoners, advocates a 'proportionate' response to actions committed by the enemy, urges the humane treatment of prisoners and dedicates an entire chapter (2.16 *De Captiuis et non necandis*) to the condemnation of their killing.[56]

Evoking contemporary discussion about the ethics of the legitimate treatment of prisoners, then, Agelaus attempts to characterize Ulysses' conduct as criminality. He then compounds this critique condemning Ulysses as 'ever the nocturnal soldier and artist at deceit' (*nocturne semper miles, et fraudum artifex*) the words that Seneca's Andromache used to complain about Ulixes' execution of an innocent child in *Troades*:

O machinator fraudis et scelerum artifex,
virtute cuius bellica nemo occidit,
dolis et astu maleficae mentis iacent
etiam Pelasgi, vatem et insontes deos
praetendis? hoc est pectoris facinus tui.

nocturne miles, fortis in pueri necem
iam solus audes aliquid et claro die.

<div align="right">Sen. <i>Tro.</i> 753–9</div>

Machinator of deceit and artist at crimes – by whose martial virtue none has
ever fallen, and by whose tricks and the cunning of a wicked mind even Greeks
lie dead – do you offer as a justification [sc. for the death of Astyanax] a prophet
and innocent gods? This is the crime of your own heart. Night-fighter, courageous
when it comes to the death of a child, now you dare something alone and in the
light of day.

Conclusion

Agelaus' accusations force the audience to deliberate upon the true nature of this
vengeance, then, in ways that appeal to, but re-frame, the nexus of virtue, law and
poetics within which this chapter began. This academic tragedy, written out of
Gentili's advocacy of an 'ethical poetics', but destabilized by Gager's own acute
framing of virtue within the generic frame of tragicomedy, succeeds in forcing
an exploration of Ulysses' virtue, in ways that clearly make the intersection of
classical scholarship and genre discourse in *Ulysses Redux* part of a larger
contemporary trend in English poetry rather than outlier to it. Before we leave
Ulysses, however, it is worth considering Ulysses' own defence of his behaviour.
For in Ulysses' eyes, the suitors have made a crucial mistake in thinking that they
deserve the honour accruing from death in battle:

> UL. *Agelae, quae laus alta sperari a malis,*
> *Quam quae expetendis profluere paenis solet?*
> *Omnis necandi iusta latronem via est,*
> *Nec honesta vitae convenit mors improbae.*

<div align="right">UR. V.1696–9</div>

> UL. Agelaus, what glory is to be hoped for from wrongdoing, other than that
> which is accustomed to result from the exacting of punishment? Every way of
> killing a thief is just, nor would an honourable death befit your dishonourable life.

Using the legal diction of punishment (*poenam expetere*), Ulysses neatly turns
Agelaus' appeal to justice on its head, by re-categorizing him not as a prisoner of
war, but as common criminal: and therefore, by the robust standards of Elizabethan
attitudes to justice, liable to the death of a criminal rather than a gentleman-
soldier. Indeed, Gentili's *De Iure Belli* can be applied in defence of Ulysses' actions:

not only does his treatise on the treatment of prisoners of war allow for execution where those prisoners have committed crimes, he also distinguishes between those who may wage war and *latrones*, thieves, whose violence is merely criminal. Gentili's entire grounding for the theory of war in fact begins from the notion of just punishment: he argues that war is legitimate when it is waged to avenge wrongs, punish wrongdoers, and to defend one's rights.[57]

Agelaus' protests, then, on careful consideration from the audience, may be seen for what they are: a specious appeal that might superficially attract an aristocratic audience but, on further reflection, ought to be rejected. Amphinomus' fate may also begin to look less extreme within the moralizing purpose of academic drama, as a particularly potent *exemplum* for its audience of youthful elites: indeed Ulysses himself had both sympathised with and predicted the young suitor's downfall earlier in the play:

> UL. *Miserande iuvenis, triste nec fatum deus*
> *Vitare nec te proprius patitur furor.*
> *Sodalitas ut prava praeclaram indolem*
> *Corrupit, involvetque funesto exitu!.*

<div align="right">UR.II.721–4</div>

Wretched youth, neither the god nor your own madness allows you to avoid your gloomy destiny. How bad company has corrupted a noble character and will embroil it in a fatal outcome!

Ulysses Redux shows the consequences that befall not just the criminal but also those merely led astray by the wrong sort of company. Even the apparently incorrigible Melantho, who at first revels in her illicit relationship with Eurymachus and is one of Ulysses' chief tormentors finds herself remorsefully regretting her behaviour in an extended gallows speech (*UR.*V.1806–37) which lays her problems squarely at the door of the 'blind youth, shameless Venus, and cruel Cupid' (*Et o iuventus caeca! Proh Venus impudens, / Et tu, Cupido saeve! UR.* V. 1822–3).

Gager's *Ulysses Redux* is not just an attempt to write neo-Latin drama that has incorporated vernacular taste, but is also a response to the sophisticated challenge to virtue embodied in Sidney's *Apology* and the legal framing of literature and virtue to be found in Gentili's *Commentatio*. *Ulysses Redux* asks its audience to consider not just the dangers of licentious behaviour but also larger questions about the nature of justice, the limits of righteous vengeance, the rights and behaviour of the victorious in war as well as the treatment of the defeated and guilty. Fittingly, the shadow of disaster remains in this play even after Ulysses has achieved his final, happy reunion with Penelope. For, while the *Odyssey* provides

a satisfying resolution to the tale of Odysseus' home-coming, with the potential for future and continuing disaster averted by the intervention of the gods, the final lines of *Ulysses Redux* look not to a 'happy ever after' but to a looming and unresolved future of cycle of violence:

> *Et nos procorum gravior a patribus manet*
> *Procella, non dum navis ad portum appulit.*
> *Remedia nos, Telemache, meditemur malo.*

<div align="right">UR. V.1976–8</div>

> A weightier tempest awaits us from the Suitors' fathers: our ship has not yet put into port. Telemachus, let us plot a remedy for this ill.

Happy ending or no, it is fitting that in the final words of the play William Gager's Ulysses is already preparing a plot for a new phase of tragic violence. This Elizabethan Odysseus is only too aware of the contingency of tragicomedy's providential 'resolution' and the capacity for vengeful action to inspire a further cycle of violence.

In this chapter I have concentrated on the ethical horizons of expectation to be found in the performance of poetry, via a neo-Latin work of literary criticism and an important early experiment in the genre of tragicomedy, *Ulysses Redux*. Reading against the trend of university authors themselves, who claim that their work should be set apart from vernacular English literary history, I suggest that neo-Latin criticism and drama is genuinely 'English' in its preoccupations, both in literary critical attempts to defend poetry and acting and in its creative ability to self-critically destabilize those attempts, in ways that not only map onto the literary theory but also the ethics of contemporary English tragedy and tragicomedy. *Ulysses Redux* offers something new to English drama: a genuinely distinctive tragicomic 'Odysseus.' In its conspicuous de-stabilizing of the potential of poetry in performance to inculcate virtue in dangerous ways, its synthesis of law and mimesis – responding not only to the legal literary theory of Alberico Gentili's 1589 *Commentatio* and the self-ironizing poetics of virtue offered in Sidney's *Apology*, but also to the broader ethical and legal horizons of vernacular drama – it serves as a genuinely 'English' play that should be considered alongside other explorations of tragicomedy in the vernacular. Sidney might have dismissed the genre of 'mongrel tragicomedy' out of hand, but he would, perhaps, have enjoyed the 'speaking picture of poetry' offered by Gager – not simply because of its adherence to the idea that poetry teaches and delights, but precisely because that didaxis came packaged with the self-aware and ironizing pressure so provocatively programmed into the *Apology* itself.

A Revolutionary Vergil

James Harrington, Poetry, and Political Performance

Ariane Schwartz

I Tatti Renaissance Library/Independent Scholar

In me alone a rime or reason
Must either be a crime or treason.

Harrington 1658, f.A3V

The republican political theorist James Harrington (1611–1677) famous for his utopian pseudo-allegorical romance-spectacle *The Commonwealth of Oceana* (1656), was not a typical Vergilian translator and critic. Active during the English Civil War and a friend of Charles I, Harrington also advocated for constitutional reform and was imprisoned on charges of conspiracy issued by Oliver Cromwell, who had tried to suppress *Oceana* despite Harrington's decision to dedicate the work to him. Like his contemporaries John Milton and Andrew Marvell, Harrington was concerned with both poetry and politics. Writing poetry placed him as a transgressor and critic of the boundaries of conventional politics, and his translations responded to the political turmoil of the 1640s and 1650s. His editions of the *Aeneid* and *Eclogues* (1658–9), which contain translations of Vergil's poems as well as Harrington's own original poetic compositions, reveal the extent to which he exercised freedom of thought and language in his classical scholarship through political criticism.[1] Through the lens of the early modern monarchist Vergilian tradition, he concentrates on the political statements in Vergil that resonate with republican thought in his editions and thereby creates a new hybrid political translation that departs from his predecessors' work.[2]

In considering Harrington's translations of Vergil's poems into heroic couplets, it will be helpful to think of them in the context, not only of political, but also of

generic change. As Christina Schäffner points out, it is necessary to understand genre to contextualize a translation.[3] Once a text is assigned to a specific genre, how do the conventions associated with that genre guide the reader and translator? How could we best define the genre of a translation? What impact do changes in poetic form and rhyme have on the genre of a translation? How does the reader recognize that change, and how does that recognition further shape the understanding of the poem? These are some of the questions that will be explored in the following chapter.

Over the past two decades, David Norbrook and Joy Connolly have offered illuminating and productive discussions of Harrington's Vergilian side from the perspectives of early modern English literature, historiography, politics, and classical reception. While Norbrook and Connolly both examine Harrington's translations and accompanying material in context, neither pays sufficient attention to the questions of genre and the act of translation alongside literary history in Harrington's work.[4] Through his poems, translations, and prefatory work, I suggest, Harrington offers an important perspective on epic and bucolic as political vehicles, beginning a dialogue about generic concerns in the reception of Vergil by creating his own narrative for his time and making use of poetic and political licence to rework and adapt Vergil to suit his concerns. The translations of *Eclogues* 1 and 9, for example, precede his *Aeneid* translation for a political purpose: they discuss the redistribution of land. The dire circumstances of Vergil's singers in the aftermath of the Civil Wars help support Harrington's belief that republicanism can only exist under the conditions of just distribution of property;[5] so Harrington created his own narrative, distinct from Vergil's bucolic and epic.[6] As Vergil reshaped the Homeric and early Roman past through his poetic expression,[7] so did Harrington reform the Roman poetic past in a translation that allowed him to concentrate on the importance of freedom for the English future through his classical learning.

Harrington's Politics

Harrington was a product of the classical republican tradition in England in the middle of the seventeenth century.[8] Thanks to Machiavelli, Harrington was able to depict England as a classical republic in *Oceana*, and this republicanism was a language, a means of sharing ideas, rather than any sort of official political programme.[9] This new political order in which Harrington was able to participate has been viewed as potentially resulting from Harrington's presence on the

scaffold at the death of Charles I, and he was joining Milton in thinking about the humanist tradition in the context of the new republic.[10] But he was somewhat of a transitional and controversial figure, both in his politics and in his translations of Vergil; Proudfoot argues that he anticipates Dryden's translation with its 'promiscuity of both diction and metre'.[11] Throughout the 1640s and 1650s, Harrington seemed to have an unclear allegiance to royalists, and did not actively participate in the civil wars during that period.[12] While he was very close to Charles I and was connected with the royalist political philosopher Thomas Hobbes, he also argued for constitutional reform and in particular for a commonwealth as the superior form of government in *Oceana*. For England, he believed in a republican form of government in the middle of the seventeenth century as well as blurred boundaries between monarchies and republics.[13]

Harrington and his engagement with classical texts

Both Greenleaf and Pocock observe that Harrington blends continuity with innovation in his political thought.[14] Continuity, in this case, represents the traditions of western political theory and civic and republican humanism, while innovation is seen in his desire to replace that continuity with modifications for the present state of disruption in property and politics. One major way in which Harrington lays claim to continuity is through his engagement with classical texts; it is these quotations of and participations in classical learning which, I want to suggest, lay the foundation for his political–poetic engagement.

Harrington is best known for his *Commonwealth of Oceana*, published two years before his translations of Vergil. *Oceana*, indebted to Machiavelli and falling under the genre of the ideal commonwealth treatise along with Thomas More's earlier *Utopia* and Francis Bacon's *New Atlantis*, pushed Harrington into the spotlight with its commentary on the present state of politics in England.[15] Significantly, the epigraph on the title page is drawn from a classical text, and features three lines from Horace's *Satires* (1.68–70):[16]

> *Tantalus a labris sitiens fugientia captat*
> *flumina: quid rides? mutato nomine, de te*
> *fabula narratur.*

> Thirsty Tantalus grasps at streams escaping from his lips.
> What are you laughing at? With the name changed,
> the story is told about you.[17]

This Horatian opening to *Oceana* signals Harrington's emphasis on what he considers to be a just distribution of wealth and property through an engagement with classical texts. Horace's satire, dedicated to Maecenas, concentrates on greed, wealth, and the setting of boundaries. The man who values the act of possessing and hoarding wealth is figured as being similar to the position of the mythical Tantalus: as he tries to drink water from the pool in Hades in which he eternally finds himself, the water constantly recedes.

Harrington's concern for establishing these boundaries through reference to works of classical literature is a key feature of his political programme. Questioning the tradition of royalist agendas and the authority of antiquity in his translations of Vergil, he makes a bold announcement of the changes he will make (in a lettered list):

Yet things and persons well distinguish'd, we,
What's possible, and what is not, may see.
Thou never shalt perswade me to inform
Our Age, (a) Aeneas in thy greatest storm
Could raise both palmes, though to the Gods; one hand
At least had hold, or there he could not stand.
(b) Nor is it in a Picture to devise
How Hector round his Troy should be dragg'd twice;
Thou shalt not make me say, (c) A Fleet could glide
Without a Wind or Oare, a Stream or Tide.
Nor than an (d) Archer in the Empty Ayr
His Art and sounding Bow, or to compare
Or boast with any other e'er was seen.
I will not yield that the (e) enamour'd Queen
Should spare a tear that she to stay had no
Little Aeneas, when the great would go.
(f) Like Pentheus, mad Orestes, never shall
I shew her overt passion. Leige [sic] Lord,
In these I may not give thee word for word;
Nor if my freedom be obtained in these,
Shall I be nice to use it as I please.[18]

In this note from translator to author at the beginning of his second volume of Vergil, Harrington therefore acknowledges that tradition in both text and politics cannot be taken for granted – they must be modernized for their time, even if that means expanding on some points and excising others. Harrington rewrites Vergil for his time, and his rewriting of the Dido episode will be explored further later in this chapter.

Translations of Vergil up to Harrington

English readers encountered the political side of Vergil through the late antique Vergilian grammarian Servius' commentary.[19] Servius' political reading of the *Aeneid* has been described as 'clear and univocal—to praise Augustus through his ancestors' and natural given the political circumstances under which Servius himself was writing.[20] From Chaucer onward, English translators of Vergil tended to look to his authority or imperial politics.[21] Edmund Spenser's nationalistic praise of Tudor history in *The Faerie Queene* represents a glorification of English history in the English reception of Vergilian allegory, as Caldwell points out, 'through heroes who set virtuous examples for the poet's contemporary and future countrymen'.[22]

Vergilian translators were also eager to adapt Vergil's language to their own, reinventing his ancient words and metre for their own space and time. As Burrow points out, Richard Stanyhurst's translation of the first four books of the *Aeneid* represents a 'linguistic conquest' in English quantitative meter, where he naturalized Vergil's hexameters into English in 1583 as part of a nationalist movement.[23]

Around 50 imitations (whether religious or historical or literary) and translations of Vergil were published during the second half of the seventeenth century, both during and after the English Civil War.[24] It is not surprising that this period generated so much activity, since writers looked to Vergil writing during his own period of civil war for guidance and inspiration. Richard Fanshawe's 1648 translation of *Il Pastor Fido* stitches together translations of *Aeneid* 4 and 6 and a recollection of *Eclogue* 1 – perhaps a precedent for Harrington's own assemblage of Vergilian texts in his translations[25] – emphasizing recovery from the suffering of civil war and finding hope for future reconciliation.[26] Harrington's position, writing in the late 1650s before the restoration of Charles II in 1660, allowed him to use Vergil's poetry as a basis for his own innovation.

That spirit of innovation through Vergil is present in genre discourse at the time. The varieties of translations and adaptations of Vergil began to assert themselves as legitimate entities by merging these new forms with political content. As Caldwell notes,

> Even during those decades of the seventeenth century when attempts to resurrect the divinity of English monarchy called upon the vision of the English Renaissance Vergil, attention to contemporary imperatives ensured a steady movement away from time-honored literary forms and values. Yet the activity outlined here took place in genres generally deemed trivial—indeed undeserving

of the status of a genre—and therefore unworthy of critical attention: translation, adaptation, and parody ... These genres [were important] not just as homes for the Classics but as active participants in the evolution of English literature.[27]

The fragmentary translations of Vergil's Interregnum and Restoration reception therefore tried to make Vergil resonate in a time of intense political unrest where it was deemed dangerous for any Royalist sympathizer to turn to Vergil.[28] Harrington's translations of Vergil resonate with contemporary movements in Vergilian receptions, both in their political content and in their form. It is the formal elements of his translations – in particular, their rhyme scheme and its relationship to genre – to which I will turn now.

Generic concerns in the middle of the seventeenth century

In the mid-sixteenth century, Henry Howard, Earl of Surrey (1517–47), published an innovative translation of several books of the *Aeneid* in blank verse, where he introduced a meter to English poetry that 'plausibly captures the resonance of Virgil's dactylic hexameters' (Simpson 2016: 601). As Simpson goes on to affirm, 'the formal decision to adopt blank verse, in Surrey's case at least, contributes to the diminution, if not total effacement, of the poet's presence' (2016: 614). By translating Vergil into heroic couplets, Harrington directs the reader's attention away from Vergil and toward his own translation. How, then, can we consider a translation into heroic couplets and not into blank verse when both would be formally understood as epic poetry? What happens when those heroic couplets represent a translator's literary criticism and classical learning combined with versification?[29] Does the addition of rhyming elements change the genre of what is still verse?[30]

Harrington's decision to translate both the *Aeneid* and the *Eclogues* into rhyming heroic couplets signifies, I suggest, his desire to fashion his English Vergil as a serious undertaking. While Vergil's Latin hexameters were known for their flexibility, the poetic tradition in which Harrington was working emphasized 'classical restraint' through the imposition of rhyme.[31] By rendering his political Vergil in heroic couplets, Harrington made a deliberate decision to alter Vergil's Latin hexameters into a rhyming form, as did his predecessors (Chaucer) and, notably, his successors (Dryden, Pope—on which see further Canevaro's chapter in this volume).[32] That decision also reflects a desire to place his work in the tradition of English Vergilian translations and set the stage for what was to come.[33] Harrington's work is a preview of Dryden and Pope's more

well-known association of heroic couplets with hexameter classical poetry.[34] As in Harrington's purely political work, he strove to blend continuity with innovation in choosing this rhyme scheme for his Vergil.

Harrington's concern with his choice of rhyme scheme is laid out clearly in the prefatory letter to the reader of his first volume of Vergil:

> I Have reason'd to as much purpose as if I had rimed, and now I think shall rime to as much purpose as if I had reason'd.
>
> f. A2R

As Connolly points out, this sentence, as well as the entire preface, indicates Harrington's choice to fuse his creative energy with political reasoning: he pushes reason and poetic genre into one entity.[35] Later in the preface, he elaborates on this theme by contemplating the link between 'phansie' and reason:

> ... the soul of man is as well indued with phansie as with reason when memory: the harvest of reason when she is predominate, is natural Theology or Phylosophy, that of memory; story, and prudence: Phansie of her self (that is where the other two do not check but obey her) produceth but a flower, which is Poetry. ... it is clear enough that Poetry is not *the wine of Divels*, but a sprightly liquor infused into the soul by God himself.
>
> f. A2V

Here, Harrington makes the argument that he derives his poetic inspiration and authority from God, who has infused its essence into his soul; it is 'phansie' that has produced the bud of poetry. In this prefatory note to his audience, he sets the stage to justify his decision to translate Vergil into English verse – it is because of divine essence that he is able to do so, and the poetic form is not 'the wine of Divels'. It is in this form that he is able to blur the lines between politics and poetry and establish his own voice by focusing the attention on his authorial act of translation in heroic couplets.

Harrington's Vergils: An overview

In his biography of Harrington, John Aubrey (1626–97) was quick to dismiss his foray into Vergilian translation as misguided:

> He made severall Essayes in Poetry, viz. love-verses, &c., and translated ... a booke of Vergill's Æn.; but his muse was rough, and Mr. Henry Nevill, an ingeniose and well-bred gentleman, a member of the House of Commons, and

an excellent (but concealed) poet, was his great familiar and confident friend, and disswaded him from tampering in poetrie which he did *invitā Minervā,* and to improve his proper talent, viz. Political Reflections.[36]

While these love verses are no longer extant, Harrington translated more than a single book of Vergil's *Aeneid*: he, in fact, translated half of the epic. The first two books were published in 1658 along with translations of *Eclogues* 1 and 9, and books three to six were published one year later. In that second volume, Harrington grew more confident and explained his own theory of translation:

> *Vergil's* poetry is the best in Latine; and he who can bring it to be the best in English, be his liberty for the rest what it will, shall be his truest translator: which granted, the English Reader may sufficiently judge of like translations, without referring himself unto the Originals.[37]

While Harrington acknowledges the potency of Vergil's language and genre in its original Latin, he emphasizes that the act of translation indicates poetic freedom and thus political freedom. He closely connects the two ideas at the beginning of his second volume of Vergil, thereby announcing his intention to create a new political form through Vergil's verses. He even goes so far as to call the Roman poet his 'Soveraign in Poetry' in a poem addressed to Vergil in the prefatory material to this volume; it is only through Vergil's voice that Harrington is able to use his own political voice after civil war. His translations exercise political liberty as did his *Oceana*, but with Vergil he reshapes the Roman past for an English future by employing an English poetic form (the heroic couplet) to structure his free translation.

Case studies: *Eclogue* 1, *Aeneid* 4, *Aeneid* 2

In his first Vergilian volume, Harrington's translations of *Eclogues* 1 and 9 are products of his desire to create an innovative blend of rhyme, genre and politics through the Vergilian tradition. As discussed above, Harrington directs his reader away from Vergil's Latin and toward his own translation, thus signifying a shift towards a tradition rooted in English poetry. At the beginning of the translation, Harrington firmly situates both *Eclogues* in their historical context with a prose 'Argument':

> The occasion of writing this Eclogue and the next was this, When after the death of *Julius Caesar* ... *Augustus* his son, by a war against them that slew him ... had

obtained the victory of them all, he divided the lands of the inhabitants of
Cremona among his souldiers, meerly because they had quarterd his enemies . . .
he also divided those of *Mantua* after the same manner, for no other reason then
that *Mantua* was neerest *Cremona*. *Vergil* being an inhabitant of *Mantua*, and
coming by this means to lose his patrimony, repaired unto *Rome*.

<div align="right">f. A4R</div>

While Vergil's property was eventually seized by a centurion named Arrius
during the course of which Vergil was nearly killed,[38] Harrington's mention of
the situation in which Vergil found himself writing *Eclogues* 1 and 9 indicates
that he is taking part in the mainstream early modern reception of the *Eclogues*.
The Meliboeus of *Eclogue* 1 also had his land taken from him, but Harrington
presents his readers with Vergil as Tityrus and the inhabitants of Mantua
collectively represented by Melibeus:

> In this Eclogue the Poet represents himself by *Tityrus*, by *Melibeus* the miserable
> condition of those of *Mantua*: Which City he coucheth under the name of
> *Galatea*.

<div align="right">f.A4R</div>

Harrington's chief concern from the beginning of his presentation of his
translation of these *Eclogues* is to make his reader keenly aware of his own focus
on liberty and property rights in his reading of Vergil/Tityrus; that focus will also
cause his translation not only to depart from Vergil's Latin at numerous points,
but also to push those words into balanced, predictable pairs with emphatic end-
rhyme, which a reader would be able to easily recognize and remember.

Vergil's compact statements about loss in his Latin hexameters are transformed
into a more emotional outpouring about the loss and lands in Harrington's
couplets; the act of translation here represents a passionate shift in perspective
from the voice of the speaker. That emotion is heightened with Harrington's
selection of this rhyme scheme for his translation (the Latin original and
translation is given first, followed by Harrington's translation):

Meliboeus:
> . . . *undique totis*
> *usque adeo turbatur agris. en ipse capellas*
> *protenus aeger ago*

<div align="right">*Ecl.* 1.11–13</div>

> . . . such unrest is there on all sides in the land. See, heartsick, I myself am
> driving my goats along . . .[39]

Melibeus/Mantua:
They take away our lands! Ah do but see
How sick I drive my goats along with me.

<div align="right">f. A4V</div>

Harrington takes Vergil's *turbatur* and turns it into an active verb, thereby emphasizing the act of stealing land, loss, and the image of the sad goatherd minding his business while his property is taken away from him against his will. As Servius pointed out here, Vergil's use of the impersonal *turbatur* signifies how the verb applies to everyone generally – the expulsion from their lands was a collective act, and Harrington uses this Servian tradition to his advantage.[40] Harrington makes a similar point later in the *Eclogue*:

Tityrus:
Libertas, quae sera tamen respexit inertem,
candidior postquam tondenti barba cadebat,
respexit tamen et longo post tempore venit

<div align="right">*Ecl.* 1.27–29</div>

Freedom, who, though late, yet cast her eyes upon me in my sloth, when my beard began to whiten as it fell beneath the scissors. Yet she did cast her eyes on me, and came after a long time . . .

Tityrus/Vergil:
Why truly when I saw the souldiers come,
And here misuse us so; though late it were,
And that it snow'd if I but clipt my hair,
I thought upon it and began to see
What kind of thing it was call'd Liberty.

<div align="right">f. A5R</div>

While Liberty actively gazed at Tityrus in Vergil (*respexit*), in Harrington's rendering Tityrus is described gradually viewing Liberty in an inverse relationship ('I thought upon it and began to see / What kind of thing it was call'd Liberty'). Liberty is within reach but requires engagement from Tityrus to be obtained, and Harrington almost goes so far as to replace Tityrus' pro-Augustan words with sarcasm. As Connolly points out:

> Harrington's inflated representation of Vergil/Tityrus' economic reliance on Augustus rests on a problem Vergil himself articulates in the text, by linking the themes of *libertas* with land ownership and poetic composition. What emerges in his Englishing is a systematic sounding of the political limits, historically speaking, of Vergil's poetic expression.[41]

Harrington therefore sees it as his responsibility to stretch Vergil's limited poetic expression one step further by testing the limits of his poetic voice and producing a new text for his own time on freedom and property and, as we can see toward the end of the poem, civil strife:

Meliboeus:

impius haec tam culta novalia miles habebit,
barbarus has segetes? en quo discordia civis
produxit miseros: his nos consevimus agros.
insere nunc, Meliboee, piros, pone ordine vitis.
ite meae, felix quondam pecus, ite capellae.
non ego vos posthac viridi proiectus in antro
dumosa pendere procul de rupe videbo

Ecl. 1.70–6

Meliboeus:

Is a godless soldier to hold these well-tilled fallows? A barbarian these crops? See where strife has brought our unhappy citizens! For these have we sown our fields! Now, Meliboeus, graft your pears, plant your vines in rows! Away, my goats! Away, once happy flock! No more, stretched in some mossy grot, shall I watch you in the distance hanging from a bushy crag

Melibeus/Mantua:

But this the impious souldier must possess,
This corn the barbarous! Ah blessed peace!
See Citizens what discord sows, and who
Must reap! Be sure you graft your apples now
And dress your vineyards. Hence: no more shall I
By the green arms of trees protected lie
And see you far away, once happy flocks,
Brouzing the shrubs and hanging on the rocks:

f.A5V

Harrington emphasizes Vergil's language on war and peace here, combines them through rhyming couplets, and inserts 'Ah blessed peace!'

* * *

As Harrington boldly announced at the beginning of his second volume of Vergil, he rewrote parts of Vergil's original text, including the Dido episode in Book 4. He wanted to remove the emphasis on the details of her romantic relationship with Aeneas:

I will not yield that (e) the enamour'd Queen
Should spare a tear that she to stay had no
Little Aeneas, when the great would go.[42]

The original passage to which Harrington refers comes from Dido's speech to Aeneas, in *Aeneid* book 4:

saltem si qua mihi de te suscepta fuisset
ante fugam suboles, si quis mihi paruulus aula
luderet Aeneas, qui te tamen ore referret,
non equidem omnino capta ac deserta uiderer.

<div align="right">Aen. 4.327–330</div>

In Stanley Lombardo's translation:

If you had at least left me with a child
Before deserting me, if only a baby Aeneas
Were playing in my hall to help me remember you,
I wouldn't feel so completely used and abandoned.[43]

These lines are not included in Harrington's translation and, as Connolly points out, he takes his excisions one step further by deleting any emotion from the passage and instead concentrating Dido's civic responsibility and self-control.[44] He, in fact, turns this famous lament of Dido into a speech for Aeneas, and one with a political focus at that. The Bacchic madness of Dido that introduces the speech is removed from the scene, while Aeneas is transformed into a more passionate figure than he was in Vergil.[45] By contrast, a contemporary Royalist translation of book 4 includes the original Vergilian passage as a Caroline expression of love and authority:

I never could have thought my self undone,
Had but kind Heaven indulg'd me with a Son
Resembling thee, in whose (though Childish) face
I might retrive thy Look and princely grace.[46]

The result of Dido and Aeneas' passionate union remains in this contemporary translation, as does the allusion to Dido's mental state ('my self undone'). Harrington therefore made a deliberate decision in his translation to create a Dido who becomes almost a male figure of civic responsibility with her emotion diluted, as is seen in the lines below (again, Vergil is given first followed by a modern translation and then Harrington's version):

saevit inops animi totamque incensa per urbem
bacchatur, qualis commotis excita sacris

Thyias, ubi audito stimulant trieterica Baccho
orgia nocturnusque vocat clamore Cithaeron.
tandem his Aenean compellat vocibus ultro:.

<div align="right">*Aen.* 4.300–304</div>

In Stanley Lombardo's translation (original emphasis):

> . . . She went out of her mind,
> raging through the city
> *as wild and furious*
> *As a maenad when the holy mysteries have begun,*
> *Her blood shaking when she hears the cry 'Bacchus!'*
> *In the nocturnal frenzy on Mount Cithaeron,*
> *And the mountain echoes the sacred call.*

Contrast Harrington:

> The Queen, no longer able to controul
> The cruel Orgy's of her restless soul,
> Thus to the Trojane vents her grief.

<div align="right">Harrington 1659, f. C1</div>

Harrington balances the end-rhyme of 'controul' and 'soul' in his couplet, creating a kind of tension between the two in his translation. He calls her soul 'restless', condensing the Bacchic elements of Vergil's Latin, in stark contrast to a contemporary translation of *Aeneid* book 4 by Edmund Waller and Sidney Godolphin, whose Dido is 'more inrag'd with grief' (rhyming at the end of their line with the description of Aeneas as 'the Trojan Chief'.[47] Harrington's Dido, therefore, is not only restrained but also appears balanced due to the end-rhyme of his heroic couplets; 'controul' and 'soul' are the key words that the reader takes away from the lines.

Harrington appeared particularly captivated by Vergil's account of Priam's death in *Aeneid* 2, which Henry Power understands as symbolizing what Harrington may have experienced while watching the beheading of Charles I in 1649.[48] While Priam's decapitation occurs after his death in Vergil (noting the shift in verbal tense), Harrington adjusts that detail, placing the decapitation as the actual death in his translation:

> *hoc dicens altaria ad ipsa trementem*
> *traxit et in multo lapsantem sanguine nati,*
> *implicuitque comam laeua, dextraque coruscum*
> *extulit ac lateri capulo tenus abdidit ensem.*

haec finis Priami fatorum . . .

 . . .iacet ingens litore truncus,
auulsumque umeris caput et sine nomine corpus

 Aen. 2.550–9

So saying,
He dragged Priam, trembling and slipping
In his son's blood, up to the altar. Winding
His left hand in the old man's hair, with his right
He lifted his flashing sword and buried it
Up to its hilt in his side. So ended Priam,
Such was his fated doom . . .

 . . . he lies now
A huge trunk upon the shore, head severed
From his neck, a corpse without a name.

 Lombardo

At which with all his strength he dealt a stroke,
That *Pyrrhus* with his brazen target broke,
And took him sliding in the blood yet warm
Of his cold son, then would about his arm
The snowy tresses of the feeble sire,
And drag'd him to the Altar. Go, enquire
Among the shades (says he) whose son I am,
Or tell my father how I Soil his name.
Which words by unrelenting *Pyrrhus* said,
The other hand strikes off old *Priam*'s head . . .
. . . His mighty trunk upon the shore is thrown
A common carkass, and a corse unknown.

 Harrington 1658, f. D3V

The final two lines in this translation, where the result of Priam's decapitation is described by highlighting the bleak finality of death, become especially memorable because of the end-rhyme in the couplets; they are nearly mnemonic hooks that allow the reader to pair the ease with which Priam's completely lifeless, decapitated body can be tossed with its new, generic state of existence. For Harrington, this act of death *by* decapitation (as he translated it) may have felt eerily familiar, both because of Charles I's beheading and because of the intense familiarity of death in wartime England. His translation creates a new space for the English reader to connect Vergil's poetry with politics in an accessible and familiar way.

Concluding thoughts

At the beginning of his 1659 Vergil, Harrington suggests 'the English reader may sufficiently judge of like translations, without referring himself unto the Originals'.[49] For Harrington, this act of translation signified a departure from tradition – from Vergil's Latin, from his epic and bucolic, and from property rights according to the old ruling class, as well as from the meter and rhyme scheme of both the original Latin and subsequent translations. As we have seen in this chapter, Harrington begins a dialogue about concerns of rhyme, metre, and traditionality in his translation of Vergil by fashioning a text that comments on what Vergil means for England in the late 1650s. Through his translation of classical texts, he blends continuity with innovation in his political thought and thereby creates a foundation for poetic–political engagement – as well as, potentially, for genre change from epic to political narrative, in the numerous omissions and alterations in his translations of the *Aeneid*.[50] Harrington's translations of Vergil's hexameter poems thus combine classical reception, the English poetic tradition and political criticism with their emphasis on freedom in both content and form – to create a new kind of Vergil for a new revolutionary world.[51]

The Devouring Maw

Complexities of Classical Genre in Milton's *Paradise Lost*

Caroline Stark

Howard University, Washington

The generic complexity of John Milton's *Paradise Lost* was recognized almost immediately by his earliest critics and commentators and has preoccupied Milton scholarship ever since.[1] Perhaps Samuel Taylor Coleridge most eloquently captures Milton's capaciousness and originality in his description of the two 'glory-smitten summits of the poetic mountain', Shakespeare and Milton, whom he views not as rivals but as complementary compeers (Coleridge 1817: 22):

> While the former darts himself forth, and passes into all the forms of human character and passion, the one Proteus of the fire and the flood; the other attracts all forms and things to himself, into the unity of his own IDEAL. All things and modes of action shape themselves anew in the being of MILTON; while SHAKSPEARE becomes all things, yet for ever remaining himself.

At a time when neoclassical aesthetics were not yet fully established and genre ('kinds')[2] potentially had not only cultural but also political resonances, Milton appropriated all 'kinds' to achieve a universal Christian epic in unrhymed English verse. In the elaborate interweaving of his predecessors, Milton emulated the poets whom he set as models and challenged his readers to shake off the yoke of their cultural and political preconceptions and engage fully with his use of the past. Far from a learned 'cento', Milton's *Paradise Lost* uses genre and its attendant modes to express the various consequences of God's gift of freedom. By exploring Milton's own perceptions of genre in his early writings, the intricate interweaving of genre in his engagement with the past in *Paradise Lost* and the reclamation of genre from his contemporaries as illuminated in the early reception of *Paradise Lost*, in his later works, and in his literary debate with John Dryden, this chapter argues that Milton's generic voices reveal through his creative lens a discourse of

genre that stretches back to antiquity and ensures his prominent place in English literary history.

Milton sets out his epic ambitions in the preface to the second book of *The Reason of Church-government urg'd against Prelaty* (1642).[3] While hinting at an epic that would draw from ancient and contemporary models, Milton expresses his intention to celebrate England's 'noble achievements': 'That what the greatest and choycest wits of Athens, Rome, or modern Italy, and those Hebrews of old did for their country, I in my proportion with this over and above of being a Christian, might doe for mine' (38).[4] His initial ideas indicate a historical subject with a Christian hero (be it a king or knight) along the lines of Torquato Tasso's *Gerusalemme Liberata*. Instead of Godfrey in the first crusade, the battle of Belisarius against the Goths, or Charlemagne against the Lombards, Milton entertains the possibility of recounting similar stories from England's ancient past (38). From this early exposition, Milton seems to have had in mind a national epic of an important moment in English history, written in the vernacular and with an ethical didactic purpose (39). While his intentions are clear and long-standing, even at that time, 'which have liv'd within me ever since I could conceiv my self any thing worth to my Countrie' (40; cf. *Paradise Lost* bk 9, lines 25–6), Milton did not turn to what would eventually become *Paradise Lost* until almost two decades later. By the time this early conception came to fruition with the publication of *Paradise Lost* in 1667, much had seemingly changed.

In its first printing in quarto, *Paradise Lost* was presented simply as 'a poem in ten books' without any specification as to its genre. This ambiguity, its lack of rhyme, and the complexity of the work itself subsequently fueled speculations of the work's genre by critics and scholars. Subsequent printings attempted to address this criticism by likening the poet and his poem to his ancient predecessors, Homer and Vergil, and their epic poems. At the beginning of the 1668 edition in a note to the reader, the printer discloses that he had received requests for arguments to each of the books and for an explanation for the poem's lack of rhyme, both of which he has procured for the reader and which preface the edition. Among other things, the arguments signal the work's adherence to ancient 'conventions' of epic,[5] such as its opening phrase 'Of Man's First Disobedience'[6] and the beginning of its action *in medias res* (Horace, *Ars Poetica* 128–52). In response to the criticism for its lack of rhyme, which was typical of seventeenth-century epics,[7] Milton explains his choice of blank verse as 'that of Homer in Greek, and of Vergil in Latin' and an example of 'ancient liberty recover'd to Heroic Poem from the troublesom and modern bondage of

Rimeing' (*The Verse* 1668). For the octavo edition of 1674, the poem was reordered into 12 books, which thereby aligned it more closely to the Vergilian model, and the arguments were placed at the beginning of each book rather than all at the beginning. Instead, after a changed title page that signaled the new book division, attestations of the poem's 'majesty' and 'sublime verse' precede the work: a tribute in Latin by S.B. (likely Samuel Barrow) and a poem in rhymed verse by Andrew Marvell.

In *In Paradisum Amissam*, Barrow praises, in Vergilian terms, the expansiveness of Milton's epic, temporally, geographically, and metaphysically, from the beginning of creation to its ultimate end, from the heights of heaven to the depths of hell and its *fata* (lines 1–12): *Res cunctas [...] continet iste liber* ('this book encompasses all things', lines 3–4). Although he praises the heavenly battles and the towering figures of Michael and Lucifer, Barrow stresses the importance of the limitless (*sine fine*) 'reconciling love towards men garnered in Christ', *In Christo erga homines conciliatus amor* (line 14). Rather than the claims of one earthly nation, that is, Jupiter's *imperium sine fine* ('empire without end', Verg. *Aen.* 1.279), Milton celebrates the universal triumph of God's limitless love to humankind through his Son (*sine fine [...] amor*). In comparison to the grandness of Milton's epic, he claims, the epics of Homer and Vergil will seem like the parodic epyllia of frogs and gnats (the *Batrachomyomachia* and the *Culex*) attributed to them, respectively (lines 39–42).[8] Milton's *fama* outshines them all: *Cedite Romani Scriptores, cedite Graii / Et quos fama recens vel celebravit anus* ('Yield, Roman poets, yield, Greeks, and those whom ancient or modern fame has honored', lines 39–40). Like Barrow, Marvell connects Milton 'the Poet blind' to the ancient poet Homer and prophet Tiresias and links their respective blindness to their poetic and prophetic wisdom, which has combined in Milton for the divine subject of his poem.[9] Rather than end with laudatory praises, Marvell thinly veils his attack on Milton's critics, those who object to his lack of rhyme (lines 45–54) and have presumed to adapt Milton's poem as a drama, that is, John Dryden et al. (lines 18–30). Whether Marvell's derogation of Dryden stemmed from poetic rivalry or perhaps from a fear of an operatic success eclipsing his friend's 'by ill imitating would excell' (line 20),[10] what emerges from these later additions to the editions and reprints of *Paradise Lost* reveals a contested poetic landscape of genre that was rife with political associations and rivalry.[11]

In the same year that *Paradise Lost* was first published, Dryden's essay of literary criticism, *Of Dramatick Poesie*, and his own heroic poem on an historical subject, *Annus Mirabilis: The Year of Wonders 1666*, appeared. When Dryden

visited Milton to request permission to adapt *Paradise Lost* as a drama in rhyme,[12] *The Fall of Angels and Man in Innocence*, which circulated in manuscript and was later published in 1677 as *The State of Innocence and Fall of Man* but never performed,[13] he was both poet laureate and historiographer royal. While it is tempting to view this literary encounter retrospectively as so many other fictionalized meetings of poetic successors, that is, a rising star paying tribute to a waning moon or to attribute any animosity to politics and their changed circumstances,[14] what is at stake for both of these writers in these discussions of genre is their place in literary history. Just as Torquato Tasso's discussions of literary genre set out to glorify his *magnum opus*, *Gerusalemme Liberata*, as the rightful modern successor (or rival) among the Italians to ancient epic over and above Ludovico Ariosto's *Orlando Furioso*, which he dismissed as romance,[15] so the controversy over literary genealogy and genre in English poetry served a similar purpose. Milton's expressed disdain for modern tastes, innovations of style, and use of rhyme in poetry underscores his attempt to assert his English epic as the true successor to the ancients over Spenser's *The Faerie Queene*.[16] Dryden's use of Milton, his reworking of *Paradise Lost* and his later tribute to Milton in the Epigram to the 1688 edition, which likewise sets Milton in comparison to Homer and Vergil,[17] attest to his respect and admiration for the poet, even if he tempered his enthusiasm from what he considered others' 'Idolatry' (*Preface to Sylvae* 1685: xxix).[18] Nevertheless, Dryden's celebration of modern and, in particular, English innovation to the ancient precepts of genre contravenes Milton's aspirations by throwing Milton's legacy into question and, instead, places himself at the forefront of a new era of English poetry.[19]

According to Milton's early biographers and extant early drafts, *Paradise Lost* was initially sketched as a tragedy, *Adam Unparadized*.[20] Milton's decision to fashion the material as an epic must have been a long-considered one. When Dryden requested to turn Milton's masterpiece into an opera, he was proposing not only to take the path not chosen (tragedy instead of epic) but also to turn Milton's unrhymed verses into heroic couplets. Although Dryden had argued in *Of Dramatick Poesie* through the character of Neander that these two genres had 'great affinity', since both present the actions, passions, and traverses of Fortune of noble subjects, whose aim is to delight and benefit mankind through its ethical teaching, he asserted that tragedy was superior to epic because it presented a more lively image of human nature through performance 'viva voce' (47, cf. Aristotle *Poetics* 1449b).[21] In the same section, he also claims superiority of rhyme over blank verse: 'Heroick Rhime is nearest Nature, as being the noblest kind of modern verse [...] Blank Verse is acknowledg'd to be too low for a Poem; nay more, for a paper of

verses' (46–7). Given these earlier claims, then, Dryden's 'adaptation' can be viewed as a challenge by his improving upon the original concept in a more fitting 'kind' and 'diction' or an attempt to popularize *Paradise Lost* by making it more accessible.

The fierce debate over rhymed verse in tragedy and epic captures the divergent literary paths that Dryden and Milton envisioned for English poetry and its latent political associations. Milton's distaste for rhyme was not new; in fact, in his treatise *Of Education* (1644), he places the 'sublime art' of poetry at the summit of learning: 'This would make them soon perceive what despicable creatures our common rimers and play writes be, and shew them, what Religious, what glorious and magnificent use might be made of Poetry both in divine and humane things' (6). Milton already seems to have had his *Paradise Lost* in mind, as he opens the work by claiming that (2):

> The end then of learning is to repair the ruins of our first parents by regaining to know God aright, and out of that knowledge to love him, to imitate him, to be like him, as we may the neerest by possessing our souls of true vertue, which being united to the heavenly grace of faith makes up the highest perfection.

Dryden's request to 'tag' Milton's verses, which Marvell derides at length in his poem to the 1674 edition, line 50, also stems from his arguments for rhyme in *Of Dramatick Poesie* as the area in which English poetry might surpass the ancients (46). His praise of rhyme as the 'Genius of the Age' to which the nobility are favourable, citing the fact that 'no serious Plays written since the Kings return have been more kindly receiv'd by them' (46), could perhaps have suggested the politically laden imagery of 'ancient liberty' and 'modern bondage' in Milton's *The Verse* (1668).

The reorganization of the books and defensiveness of the prefatory material to the 1674 edition attest to Milton's perceived vulnerability not only in his lack of rhyme but also in his choice of genre. As Rajan (1983: 110) has observed, the initial division of *Paradise Lost* into ten books supports a dramatic structure of five acts of two books each, whose emphasis falls on the victory of Satan in the fifth act over Christ's victory in the third. Although the restructuring of the poem into 12 books in 1674 ameliorates this orientation by aligning it to Vergil's epic and places renewed emphasis on the Messiah's triumph in book six, nevertheless, Milton's divine characters threaten to surpass the only two humans in the epic, Adam and Eve, and their story. Indeed, Barrow's poem attempts to celebrate this shift from the earthly sphere in his praise of the characters of Michael and Lucifer and of the battles that rage in the heavens (lines 17–26). For Barrow, this divine warfare only heightens the suspense and glory of the moment

when the Messiah's appearance in heaven signals his victory over the rebel angels and reaffirms his ultimate triumph (lines 27–38). Dryden's proposed reorientation to the human drama would eliminate any concern of a heroic Satan and shift the focus back to Adam, but by necessity of the limitations of the dramatic genre, his opera would divorce the Fall from its cosmic context and omit any lengthy philosophical or theological exposition for those actions.

At the opening of book eight in the 1667 edition, which is book nine in the 1674 edition, Milton signals the inclusion of tragic within his epic and reveals the reasons for his decision to transform *Adam Unparadized* into a universal epic, when he marks the shift in mode from heroic to tragic as he narrates man's Fall (*Paradise Lost*, bk 9, lines 1–19):

> No more of talk where God or Angel Guest
> With Man, as with his Friend, familiar us'd
> To sit indulgent, and with him partake
> Rural repast [...]
> > I now must change
> Those Notes to Tragic; foul distrust, and breach
> Disloyal on the part of Man, revolt,
> And disobedience: On the part of Heav'n
> Now alienated, distance and distaste,
> Anger and just rebuke, and judgment giv'n [...]
> > Sad task, yet argument
> Not less but more Heroic then the wrauth
> Of stern Achilles on his Foe pursu'd
> Thrice Fugitive about Troy Wall; or rage
> Of Turnus for Lavinia disespous'd,
> Or Neptun's ire or Juno's, that so long
> Perplex'd the Greek and Cytherea's Son.

Using language that recalls humankind's loss of the Golden Age and the company of the gods in the ancient poets, Milton evokes the loss of innocence of the pastoral world and its consequent shift to the warlike Iron Age. At the same time, however, he likens this 'Tragic' turn to the wrath of Achilles in Homer's *Iliad* and to Turnus' rage in Vergil's *Aeneid*, both momentous shifts in his models of ancient heroic epic that narrate the destructive consequences of human action. The latter of the two similarly signals such a 'turn' by a second invocation (*Aen.* 7.37–45).[22] Although these lines may have suggested the suitability of its subject for tragedy, Milton also hints at the reason for his change in genre from tragedy to epic. In referencing Achilles' pursuit of Hector (*Iliad* 22.131–207), Milton emphasizes

the capaciousness of epic over tragedy to include the irrational or what inspires awe (θαῦμα). According to Aristotle in his *Poetics*, citing this very scene from the *Iliad*, what would be ludicrous on stage goes unnoticed in epic (1460a). Likewise, epic rivals tragedy in its narration of immense suffering, that is, in its ability to be rich in pathos (πάθος) (1459b). In his allusion to Odysseus' and Aeneas' suffering at the hands of Neptune and Juno in Homer's *Odyssey* and Vergil's *Aeneid*, respectively, Milton draws attention to the ability of epic to capture this richness in suffering equal to, if not surpassing, tragedy. For Milton, the Fall requires a second invocation to sing of matters of 'higher Argument' that will, by extension, raise the genre itself *above* heroic epic (bk 9, lines 42–4), that is, his epic is higher than his models of Homer and Vergil because of its grand and universal subject, which is not of knights and wars (bk 9, line 28), but rather of the suffering of all humankind and the *just* anger of God for our disobedience in contrast to the vengeful wrath of Neptune and Juno.

In *Paradise Lost*, Milton subsumes not only tragic elements but also other genres into his universal epic. Some scholars have interpreted it as an intermediary work, citing the first line of *Paradise Regained* (1671), 'I, Who e're while the happy Garden sung', which alludes to the poetic trajectory outlined by Vergil (in the lines preserved by Donatus and Servius) and echoed by Spenser in the opening of the *Faerie Queene* (lines 1–9)[23]:

> Lo I the man, whose Muse whilome did maske,
> As time her taught, in lowly Shepheards weeds,
> Am now enforst a far unfitter taske.
> For trumpets sterne to chaunge mine Oaten reeds,
> And sing of Knights and Ladies gentle deeds;
> Whose prayses having slept in silence long,
> Me, all too meane, the sacred Muse areeds
> To blazon broad emongst her learnéd throng:
> Fierce warres and faithfull loves shall moralize my song.

In this view, *Paradise Lost* is either pastoral and georgic or just georgic, and *Paradise Regained* is the true epic for which *Paradise Lost* lays the foundation. There are a number of possible reasons for such a statement, not the least of which is the fact that his previous poem did sing of *the* happy garden, that of Eden, but even the suggestion of succession speaks to the two poems' complementary and chronological subjects. Even the opening lines of *Paradise Regained* allude to the first line of *Paradise Lost*, 'Of Man's first disobedience' (*Paradise Regained*, lines 1–7):

I Who e're while the happy Garden sung,
By one mans disobedience lost, now sing
Recover'd Paradise to all mankind,
By one mans firm obedience fully tri'd
Through all temptation, and the Tempter foil'd
In all his wiles, defeated and repuls't,
And *Eden* rais'd in the wast Wilderness.

Whereas the focus of *Paradise Lost* is on the Temptation in the garden and the Fall of Man, so *Paradise Regained* celebrates Christ's resistance to Temptation by Satan and the reclamation of Heaven and immortality for humankind. No doubt Milton views the subject of the Fall as less heroic than the triumph of its undoing: 'inspire, / As thou art wont, my prompted Song, else mute, / And bear through highth or depth of natures bounds / With prosperous wing full summ'd to tell of deeds / Above Heroic' (*Paradise Regained*, lines 11–15). Just as the invocation of book nine in *Paradise Lost* expressed the elevation of the epic genre to fit a loftier theme than what preceded and what was in his ancient models, so Milton likewise asserts the divine argument as once again exceeding the limits of 'kind'. Much as Vergil calls upon Allecto to inspire his narration of the wars Aeneas faced in Italy in his second invocation: *maior rerum mihi nascitur ordo, / maius opus moveo* ('Greater is the story that opens before me; greater is the task I essay', *Aen*. 7.44–5), likewise Milton acknowledges that the temptation of Christ surpasses that of our first parents. Not only is the temptation greater but so is its consequence: Christ's victory undoes the punishment of Adam and Eve's failure. Apart from its subject matter, however, these two poems are strikingly different. *Paradise Regained* is shorter (only in four books instead of ten or 12). Instead of multiple heroes and episodes, it has a central hero and adversary, and its language is markedly simpler. While it follows more rigidly the narrow confines of epic genre, as outlined in Tasso's *Discorsi del poema eroico*, its ostensible simplicity betrays its ambitious design, as Patterson (1983: 200–3) has argued. Does the difference between *Paradise Lost* and *Paradise Regained* necessarily reveal an evolution of Milton's understanding of epic or does the differing subject of the two poems dictate its capaciousness, as the division of epic into diffuse or brief in his *Reason of Church-government* explains (38–9)?[24]

While there are both georgic and tragic elements in *Paradise Lost*, what makes Milton so successful is his ability to employ generic allusions as the context demands and integrate them into the unity of his epic. As we have already noted, the opening to book nine of *Paradise Lost* conveys the Fall and subsequent loss of Paradise in language evoking the similar loss of the Golden Age and the

introduction of *labor* in the first book of Vergil's *Georgics*. Beyond this opening imagery, the descriptions of Eden likewise suggest a garden of abundance (*Paradise Lost* bk 9, lines 205–12), whose tending is more for diversion than out of necessity. As Adam explains of God to Eve in an inversion of Vergil's Jupiter: 'Yet not so strictly hath our Lord impos'd / Labour [...] For not to irksom toile, but to delight / He made us, and delight to Reason joyn'd' (*Paradise Lost* bk 9, lines 235–6, 242–3; cf. *Georgics* 1.121–5). Milton deliberately evokes this Vergilian intertext to problematize the question of knowledge and labour. For Vergil, Jupiter introduces 'irksom toile' (*improbus labor*) and oppressive want (*urgens egestas*, 1.145–6) to spur ingenuity in humankind by 'sharpening our minds with care' (*curis acuens mortalia corda*, 1.123) but, for Milton, knowledge is not a result of labour but part of humankind's raison d'être. Such an admission, however, does not necessarily dictate that *Paradise Lost* is georgic any more than the early drafts of *Paradise Lost* as a tragedy make it so.

The presence of *Samson Agonistes* in the same publication as *Paradise Regained* in 1671 invites questions of genre about each of the works and their relation to *Paradise Lost*.[25] More importantly, Milton's prefatory remarks to *Samson* appear to renew the literary debate of genre with Dryden, especially given the fact that Dryden's most successful tragicomedy *Marriage-à-la-Mode* appeared in the same year. Following a separate title page that quotes Aristotle's *Poetics*, Milton begins his 'Of that sort of Dramatick Poem which is call'd Tragedy' with the following pronouncement that seems to imply that Milton concedes Dryden's point about its superiority over epic in *Of Dramatick Poesie*, not because of its 'livelier presentation of human nature' but because of its didactic ethical value (3):

> Tragedy, as it was anciently compos'd, hath been ever held the gravest, moralest, and most profitable of all other Poems: therefore said by Aristotle to be of power by raising pity and fear, or terror, to purge the mind of those and such like passions, that is to temper and reduce them to just measure with a kind of delight, stirr'd up by reading or seeing those passions well imitated.

In the qualification of tragedy 'as it was anciently composed', Milton aligns himself once again with the ancients, 'this Tragedy coming forth after the ancient manner' and renews his contempt for modern English playwrights and the contemporary fashion of intermingling tragedy and comedy (4), an innovation which Dryden had profusely praised as contributing 'to the honour of our Nation, that we have invented, increas'd and perfected a more pleasant way of writing for the Stage than was ever known to the Ancients or Moderns of any

Nation, which is Tragicomedie' (*Of Dramatick Poesie* 28).[26] Not only does Milton object to the interruption of sad and grave subject matter with comic interludes and to the intermingling of noble and vulgar personages, which such hybridity creates, but he also attributes its invention to the playwrights' desire to gratify their audience (4). In his view, by currying favour with short-lived delight, they have corrupted and overtaken the ability of its genre to edify. Milton distances himself farther from this practice (and Dryden's success) by asserting that his drama was never intended to be performed (5). Therefore, he has not divided his drama into acts and scenes, but also presumably written without consideration for the limitations of the stage. Of the moderns, Milton admits only the Italians as models because they follow the ancient example (4–5). Otherwise, he follows the perceived ancient 'conventions': uniformity of plot, disposition of the story according to verisimilitude and decorum, and the circumscription of time to the space of one day (5). Just as Milton explained the use of blank verse in *Paradise Lost* as more in line with the ancient epic poets Vergil and Homer, so his verse in *Samson* is not rhymed but composed of the many meters of the ancient Greek chorus. Having abandoned the tragic project of *Paradise Lost* in favour of epic, Milton intends to show in *Samson Agonistes* the ends and means which English tragedy should endeavor to achieve.

Dryden's adaptation of *Paradise Lost* sheds light on what he perceived to be Milton's confrontation with issues of genre, and he revisits these concerns in the discussions of heroic poetry that preface his later works. Despite Dryden's marked difference from Milton as a poet, his criticisms renew the concern for the place and future of English poetry in literary history that he discussed in *Of Dramatick Poesie*. In spite of its early detractors, Dryden's *State of Innocence* circulated in manuscript, of which he claims 'many hundred Copies' were 'dispers'd abroad, without my knowledg or consent', and was published in nine editions between 1677 and 1700.[27] Dryden's 'adaptation' addresses many of his criticisms of *Paradise Lost* by the shift in genre: the focus of its plot is on the two human characters, of which Adam is the clear hero and whose 'fault' is his excessive love of Eve. Dryden also seemingly turns the tragic tale of the Fall into a happier event by shifting the focus to humankind's immortality and winning of heaven without narrating its devastating costs.[28] His prefatory remarks to the opera praise *Paradise Lost* as 'one of the greatest, most noble, and most sublime POEMS, which either this Age or Nation has produc'd' (vii). Yet his 'defense' of Milton focuses on the perceived 'faults' in the poem's boldness of expression and poetic license, while treating those 'Criticks' with equanimity who prefer tragedy and poetry which 'describes most lively our Actions and Passions; our Vertues, and our Vices; our Follies, and

our Humours' (xv) and who, by inference, may favour Dryden's operatic version. His measured defence of Milton should, however, be placed in the larger context of his condemnation of ignorant poetic critics who only seek to find fault rather than to judge well. In his preface to the *Sylvae* (1685), he expresses his dismay at the lack of discernment among the youth (v):

> [...] most of our ingenious young Men, take up some cry'd up English Poet for their Model, adore him, and imitate him as they think, without knowing wherein he is defective, where he is Boyish and trifling, wherein either his thoughts are improper to his Subject, or his Expressions unworthy of his Thoughts, or the turn of both is unharmonious.

Later in the same preface, he applies this judgment to *Paradise Lost* when he praises Milton's 'height of Invention' and 'strength of expression' but criticizes his 'antiquated words' and the 'harshness of their sound' (xxviii). Discernment instead of 'Idolatry' requires the ability to see a poem's merits as well as its faults. Dryden's criticism of Milton's choice of genre and blank verse for *Paradise Lost* becomes more explicit in the dedications to his later translations (Satires 1693; Vergil 1697) and his stake in the literary history of heroic epic becomes clear when he acknowledges his own epic aspirations. In the dedication to his translation of the satires of Juvenal and Persius (*Discourse of Origin and Progress of Satire*, 1693), Dryden singles out Spenser and Milton as the best examples of English heroic verse, yet he faults Milton for his choice of subject, the 'Losing of our Happiness', which is not the 'prosperous' event of a heroic poem and for the paucity of human in relation to the many divine characters (viii). Dryden expands on the criticism of Milton's language from the *Sylvae*, that is, the periodic flats among the elevations and use of antiquated words and attributes Milton's choice of blank verse to his inability to rhyme (viii–ix). After his lengthy review of ancient and modern epic in a preface to a work of satire, Dryden finally admits his own ambitions to write a Christian epic in English, for which he had been 'long labouring' in his imagination, but which he has abandoned because of his age and lack of patronage through the 'Change of the Times' (xiii). Dryden's epic aspirations are not unlike Milton's sentiments in *The Reason of Church-government*, in his choice of a Christian hero and of a battle from English history. Interestingly, Dryden distances himself from his previous work for the stage, to which he claims his 'Genius never much inclin'd' (xiii). In the dedication to his translation of the works of Vergil (1697), Dryden exclaims that 'A Heroick Poem, truly such, is undoubtedly the greatest Work which the Soul of Man is capable to perform' (203), but his 'File of Heroick Poets' includes only three: Homer, Vergil,

and, as a very distant third, Tasso – a change from his tributary epigram in the 1688 edition of *Paradise Lost*. He explains his exclusion of Milton from this select crowd by revisiting his main complaints: 'if the Devil had not been his Heroe, instead of Adam; if the Gyant had not foil'd the Knight, and driven him out of his strong hold, to wander through the World with his Lady Errant: and if there had not been more Machining Persons than Humane, in his Poem' (208). For Dryden, apart from its language and lack of rhyme, Milton's epic falters by allowing poetic fancy (supernatural argument and immaterial substances) to overshadow the human drama.

Although Dryden's adaptation of *Paradise Lost* was by all accounts successful in its popularity – perhaps even more so initially than Milton's poem was for a time – nevertheless, Dryden's focus on the human drama reveals his own poetic preoccupations rather than simply Milton's 'faults' and points to their divergent poetic paths. Dryden makes Adam's Fall universal in its relatability rather than a negative exemplar of human disobedience and turns the divine machinery into theatrical spectacle, thus retaining its focus on the human characters. For Barrow and Marvell, Dryden failed to understand the reason for Milton's ultimate choice of epic over tragedy for *Paradise Lost*: 'So that no room is here for writers left, / But to detect their ignorance or theft' (Marvell *On Paradise Lost*, lines 29–30). For Milton, the human drama of the Fall must be placed in the larger universal context of God's gift of freedom, or in Barrow's words, the victory of Christ's 'limitless love' (*sine fine* [...] *amor*, lines 13–14). Only epic's capaciousness (*The Reason of Church-government* 38–39) can attract, in Johnson's words on Milton, 'all forms and things to itself, into the unity of its own IDEAL'. Milton's use of genres in his epic, then, becomes the means not only to encompass all reality in the unity of its multiplicity, but also to engage with his literary predecessors through allusions that problematize or enhance its meaning, as, for example, noted above in the relationship between knowledge and labour in paradise through the allusion to Vergil's *Georgics*. Dryden had made a similar acknowledgment of epic in his praise of Ovid, 'who in the Epique way wrote things so near the Drama', particularly in matters of love and desire (*Of Dramatick Poesie* 17). Dryden criticizes the emphasis in *Paradise Lost* on the devil's human-like flaws (a criticism which Marvell perceived as made in 'ignorance'), the seeming inevitability of human failure in the temptation and, by extension, the replacement of the hero with the Son of God instead of a flawed but virtuous human. The paragon of heroic virtue in *Paradise Lost* is not Adam but Christ, who offers to pay the penalty for man's Fall through his becoming man and suffering death (*Paradise Lost* bk 3, lines 227–65): 'So dearly

to redeem what Hellish hate / So easily destroy'd, and still destroys / In those who, when they may, accept not grace' (bk 3, lines 300–2). For Milton, his epic aims to impart the knowledge of God and to instill in humankind virtue that, combined with heavenly grace, 'repairs the ruins of our first parents' (*Of Education* 2; cf. 6, *Preface to Samson*). In so doing, Milton seemingly places poetry in the service of religion rather than as an end in itself and, to Dryden at least, Milton turns away from an engagement with the present in favour of a dialogue with the literary past.

Scholars like Lewalski (1985, 2009) have admirably teased out many of the political and cultural associations of Milton's use of genre in *Paradise Lost* and argued that this is a subversive response to the political and cultural currents of his time. While Milton's disdain for contemporary writers and fashions certainly supports this view, his debate with Dryden points to a higher literary aspiration for *Paradise Lost* that places his epic in a literary genealogy that stretches back to Homer. Martindale (1986) and Kilgour (2012) have rightly illuminated many of the ways in which Milton's intertextual allusions to his ancient predecessors are far more meaningful than has hitherto been acknowledged. What remains to be done is to continue to explore Milton's use of genre through activating these intertextual allusions in a way that makes us better readers of *Paradise Lost* and of the ancient authors.

Georgic as Genre

The Scholarly Reception of Vergil in Mid-Eighteenth-Century Britain

Juan Christian Pellicer
University of Oslo

With one exception, no single work of seventeenth- or eighteenth-century classical scholarship appears to have left any directly attributable mark on the many contemporary British poets who imitated Vergil's didactic poem, the *Georgics*. The crucial exception is the prefatory 'Essay on the *Georgicks*' by the essayist, poet, and Latinist Joseph Addison in Dryden's celebrated translation in *The Works of Virgil* (1697). Before the appearance of Addison's essay, scarcely any criticism of the georgic genre existed in English. Addison introduced Vergil's poem to the wider public single-handed and his influence outlasted the eighteenth century (Chalker 1969: 17).

Unlike pastoral, georgic had provoked no seventeenth-century *querelle* between 'Ancients' and 'Moderns' about the genre and its proprieties. (On the debate about pastoral in France and England, see Congleton 1952.) Indeed, as the literary critic, poet and Latin scholar Joseph Warton observed at the head of his 'Reflections on Didactic Poetry' (1753), antiquity itself 'left us no rules or observations concerning this species of poetry' (Warton 1753: 393, cf. Benson 1724: xviii). The early eighteenth-century reader could turn from Addison to his appreciative Oxford colleague Joseph Trapp, whose lectures on poetry, including one on didactic verse, were published in Latin in 1711–19 and in English translation in 1742. Trapp's copiously annotated translation of the *Eclogues* and *Georgics* (1731) refers most frequently to the salient commentators of the previous century, Juan Luis de La Cerda and Charles de la Rue ('Ruaeus'), and it may be said that, mediated through subsequent translations and commentaries, it was ultimately these Jesuit scholars, together with the French translators and commentators Jean Regnault de Segrais and François Catrou (another Jesuit), who taught eighteenth-century Britons to

read the *Georgics*.[1] Craig Kallendorf observes that 'the most popular [Renaissance] commentaries on the *Georgics* focused on variety, on the wide range of subjects discussed in the poem and Virgil's versatility in treating them' (Kallendorf 2015: 170) and it is precisely this tradition that Addison broadcasted to his readers throughout the eighteenth century.

The stubborn fact remains, however, that beyond Addison, the impact of any specific classicist on eighteenth-century British georgic poets is hard to discern in any detail. John Dyer, whose formal georgic *The Fleece* (1757) is the most ambitious of its kind, was among the subscribers to the generously annotated 1741 edition of the *Eclogues* and *Georgics* by the botanist and Latinist John Martyn. But as one might expect, one looks in vain for any giveaway trace of Martyn's scholarship in the textual detail of *The Fleece*. This is, I suggest, because the influence of Latin scholarship on conceptions of the georgic as genre is necessarily of a general character. One way to assess the impact of Vergilian scholarship on English poetry is to examine the areas in each of these discourses where scholars and poets are most clearly seen to encounter similar issues, and to compare their responses. Commentaries and translations of Vergil are the natural place to look. The aim of this chapter is to look beyond Addison to trace the complex network of influence between Vergilian scholarship and English poetry in the mid-eighteenth century, focusing on the oft overlooked interactions between classical scholars and translators – John Martyn, William Benson, Joseph Warton, Edward Holdsworth – and poets.

Towards a history of the British georgic

To gain an idea of the confluence of the scholarly and poetic receptions of the *Georgics* at mid-eighteenth century, I propose to turn to Warton's translation and commentary in the first volume of the *Works of Virgil* published by Robert Dodsley in 1753.[2] First, however, it might be helpful to survey, however briefly, the current historiography of the British genre. There are several narratives of the rise and fall of British georgic in the eighteenth century.[3] Classical scholarship, in the form purveyed in commentaries and editions, currently plays a leading role in none of them, though various contemporary perceptions of georgic in classical scholarship as well as agricultural literature have been compared in a series of studies by Frans De Bruyn (1997, 2004, 2005). Historians of the genre have been faced with the task of explaining, first, how an unprecedented spate of poetic imitations of the *Georgics* came to be written in the first two-thirds of the century, together with many works

less formally indebted to the genre; and secondly, why the georgic seems to have run out of steam quite suddenly around mid-century and settled into a low-energy state from which it never subsequently emerged. The existing explanations for the rise of the British georgic (and of didactic poetry in general) stress several seventeenth-century trends and innovations, including the development of the 'New Science' and its supporting institutions, notably the Royal Society; the cultural reappraisal of physical labour and especially of the interplay of rural and urban economies in an increasingly commercial society (see especially Low 1985); and various refinements of neoclassicism in scholarship and the arts.

In retrospect it is easy to see why British georgic thrived in a culture that celebrated scientific innovation and, even more fundamentally, strove to reconcile its own ideals of moral progress with the positive as well as negative implications of technological advance. This culture set about redefining its own civic values in an atmosphere of heated yet relatively tolerant political and religious debate, with an unrivalled freedom of the press. Moreover, the publishing boom after the lapse of the Licensing Act in 1695 nourished a literary culture that thrived on the experimental mixing of genres. All these tributary causes of the success of British georgic incline towards over-determination, and the same holds true of many of the causes offered for its decline. Since georgic is quintessentially a 'mixed' and absorptive genre, its various elements were easily drawn into other forms of literature, not least in prose, so the form lost definition in the process (De Bruyn 1997). The factual content of georgic poems could never seriously rival the authority of scientific prose, which easily jeopardized the genre's distinctive balancing act between the demands of form and substance (Pellicer 2003). Moreover, the public ideals that British georgics typically propounded, notably those of political and social cooperation under the aegis of commercial empire, came under strain in the latter half of the century, especially with the loss of the American colonies. There were more purely literary reasons too. The play between heightened diction and its mundane referents courted bathos. The status of classical imitation sank as new notions of originality gained ground. Related to this, and capping it all, Vergil's high status depreciated by small but steady decrements throughout the century, while the universal veneration of Homer only intensified (Caldwell 2008).

Eighteenth-century critical readings of Vergil's *Georgics*

These are some of the background narratives for the 'rise and fall' of georgic. Eighteenth-century georgic itself, however, was at once a more circumscribed

and more fragmentary, disjointed affair than any sweeping narrative might be taken to imply. That is to say, the debate on Vergil's *Georgics* in the first half of the eighteenth century was not only remarkably varied in its range of subjects but was also confined to a relatively small set of literary men. Because georgic seems so characteristic of the spirit of the age, it is easy to make great claims for its centrality in eighteenth-century literary and scientific culture. It is also easy to overstate the importance of any single aspect of Vergil's eighteenth-century reception. The occasional debates over the practical soundness and scientific accuracy of Vergil's precepts, for instance, highlight many of the period's key preoccupations, but they may also be viewed as storms in a teacup. The heatedness of a few controversialists, notably the agriculturalists Jethro Tull and Stephen Switzer in a flurry of exchanges in the 1730s, easily gives an exaggerated impression of the issue's urgency. Certainly, Vergil's agricultural precepts had numerous defenders, but the eighteenth-century commentators and translators who took pains to assess the factual content of the *Georgics* did so in the context of a remarkably wide-ranging scholarly process of elucidation, and their pronouncements on Vergil's agricultural lore and scientific observations should be taken in this broad context. John Martyn's edition of the *Georgics* provides a case in point. Its ambitions are much wider than one might infer from its treatment by Frans De Bruyn as an example of translations 'whose purpose is scientific or whose aim is to promote agricultural improvement' (De Bruyn 2005: 153). Martyn (1699–1768) was Professor of Botany at Cambridge and confesses in his Preface that his edition is distinguished by his own professional expertise.[4] But Martyn was also a respected classicist. He was a 'stereotype of the eighteenth-century absentee professor' (Allen 2004) whose medical practice in London left ample time for his literary pursuits, which in middle and later life centred on his editions of Vergil.[5] Martyn's *Georgicks* is by no means a narrowly utilitarian or scientific-minded commentary, but a traditional scholarly edition of impressive comprehensiveness. Martyn's edition represents an approach to Vergil that spares no effort in explaining the informational content of the *Georgics* by reference to up-to-date science and the available current experience as well as ancient commentary. In this respect, however, Martyn is not peculiar to his own age: in fact, in this regard, he would not seem out of place among modern editors. R.A.B. Mynors, the twentieth-century editor whose outlook most resembles Martyn, cites him several times, as indeed does Richard Thomas, the other major Anglophone editor of the *Georgics* in the late twentieth century. Martyn's *Georgicks* is a classical scholar's edition as well as a scientist's, though Martyn, like most of his contemporaries, distinguishes less sharply than most scholars

today between these areas of knowledge. Frans De Bruyn finds in Martyn 'a fundamental clash of methodological principles between two intellectual discourses (science and literary scholarship) yoked uneasily together on the printed page' (2005: 159). Martyn's own contemporaries appear to have felt no such awkward tension; nor, I think, would most commentators of the *Georgics* today. It is Martyn's encyclopaedic approach, if not his specific example, that made georgic a viable genre for eighteenth-century poetry—for a time.[6]

The question of Vergil's authority and value as an agricultural writer has been discussed since antiquity, and the didactic aim and scientific accuracy of georgic poetry remain contested issues. The twentieth-century agricultural historian M.S. Spurr concludes that Columella, Pliny, and other ancient writers on agriculture were justified in taking Vergil's precepts seriously as factual arguments. However selective in his choice and treatment of topics (selectivity itself being unexceptional in ancient agricultural writing), Vergil 'ensured that his agricultural information was correct' (Spurr 2008: 40). Seneca's famous incidental comment about the *Georgics* – that Vergil wrote not to instruct farmers but to delight readers, aiming for decorum rather than accuracy (*Ep.* 86.15) – was made in the specific context of criticizing Vergil on an agricultural point, namely whether beans and millet should be sown in spring or summer (Spurr 2008: 16–18). But Seneca's general statement need not be taken to undermine Vergil's agricultural expertise (though there are many other Vergilian errors he might have mentioned had they been *à propos*) so much as to observe Vergil's basic priorities. It has proved difficult for anyone to maintain a hard line on this question, and the eighteenth-century commentators seem exemplary in their open-mindedness. Even Vergil's account of the *bugonia*, a miraculous Egyptian method for generating bees from the putrefying carcass of a ritually bludgeoned bullock (Verg. G. 4.281–314), cannot be dismissed as a mere indulgence of artistic needs. However 'chimerical' the idea itself (since a rotting ox never did and never will give birth to bees) the method 'was attested by all ancient authorities, with the significant exception of Aristotle' (Wilkinson 1997: 268–9). Yet since it transparently serves as pretext for Vergil's elaborate aetiological episode of the loss and renewal of Aristaeus's bees, which includes the famous inset narrative of Orpheus and Eurydice, the precept also supplies the sharpest-drawn case for considering the specifically poetic purposes of Vergil's didactic material. Eighteenth-century commentators were not only aware that 'insects cannot be generated by putrefaction' (Warton 1753: 364n.), they were also less troubled by that fact than editors in our own time. It should not, then, be supposed that serious inquiry into Vergil's precepts ever entailed

reading the *Georgics* naïvely as 'a precise set of instructions for the farmer' (De Bruyn 2004: 662).

Nevertheless, eighteenth-century commentators are sometimes represented (unjustly, on the whole) as reading the *Georgics* in precisely this way. To illustrate 'the eighteenth-century commitment to a scientific reading of Virgil', De Bruyn (2004: 666) cites William Benson, whose translation of *Georgics* II (1724, in polemical dialogue with Dryden's) includes a lengthy Preface. While it is true that 'Benson makes a broad claim for the applicability' of Vergil's precepts, De Bruyn (2004: 666) fails to observe Benson's fundamental complaint, namely that the *Georgics* suffered neglect from ignorant preconceptions about its didactic cast. Too many people, Benson claimed, never got round to reading the *Georgics* because they assumed it was 'a Book of Husbandry only' (Benson 1724: xv). 'There cannot be a greater Mistake than this Opinion', Benson continues. 'Husbandry is far from being the greater Part of this Work' (Benson 1724: xv). For Benson there is a distinction but no opposition between rhetorical embellishment and learning:

> It would be an endless Task to produce Instances to shew that the *Georgics* abound with the brightest Ornaments of Rhetoric and Oratory, and to prove their Author to have been deeply vers'd in Geometry, Astronomy, Physic, History, true and fabulous, the Heathen Mythology and Morality. It may be affirm'd that they are the best fill'd Store-House of all Manner of Knowledge that *Greece* and *Rome* could furnish.
>
> Benson 1724: xv

It is Vergil's variety that most impresses Benson, who castigates anyone he suspects of taking a narrower or a meaner view. Benson's 'broad claim' for Vergil's didactic value rests on his own view that the sheer variety of Vergil's precepts transcends any parochial claim to utilitarian relevance. (Vergil's precepts 'are so various, that they are adapted to every Country, in one respect or other', Benson 1724: xvi).[7] Indeed, Benson argues, if Vergil's precepts were adopted wholesale, the *Georgics* 'would be of Use but to a small Part even of *Italy* itself' (Benson 1724: xvi). It is in no limited sense, then, and not primarily on utilitarian grounds, that Benson takes the *Georgics* as the classic of all Europe.

As De Bruyn observes, Benson's comments on *Georgics* I.84–93 'were to become a flashpoint in the contention between Switzer and Tull', which touched on whether the reasons Vergil gives for burning stubble made any sense (De Bruyn 2004: 667; the debate is discussed on pp. 673–6). The quarrelsome series of exchanges between the rival agriculturalists in the 1730s, though focused on

the specific question of whether Vergil's precepts on soil management and plant nutrition were scientifically sound (Switzer defended Vergil against Tull although the two agriculturalists were mainly bent on scoring points against each other as proponents of modern science) also had wider implications on the instructiveness of the *Georgics* on farming. While the skirmish does illustrate some ways in which Vergil could be drawn into battles over agricultural practice, it should be noted that the specific exchange between the two agriculturalists left no trace on either English poetry or classical scholarship. Robert Dodsley, who devoted the second book of his georgic *Agriculture* (1753) to expounding Tull's theories of soil nutrition, unsurprisingly omits any mention of burning stubble and makes no reference to Tull's attack on 'Virgilian' husbandry (Pellicer 2003).

Nor was the exchange between Tull and Switzer remembered by subsequent commentators of Vergil such as Martyn or Warton. After all, as Martyn demonstrates (1741: 20–1), puzzlement about Vergil's passage about stubble-burning already had a long tradition in the commentaries. Vergil suggests four alternative reasons why stubble-burning may be good for the soil (Verg. *G.* 1.86–91). Two of these explanations are mutually contradictory. The common reading, Martyn explains (1741: 20) is that Vergil proposes four 'different and even contrary' solutions to the same problem. Martyn reviews, but politely rejects, a Renaissance tradition of removing the difficulty by taking Vergil to propose 'four cures for so many [respective] causes of barrenness [in soils]', citing Nicholas Grimald ('Grimoaldus' to whom is attributed a 1591 Latin paraphrase of the *Georgics*) and Gregor Bersman ('Bersmanus', whose Latin commentary of Vergil's works was published in 1581), the latter via La Cerda. Martyn then explains that 'Virgil is generally thought not to have intended to speak of burning the ground itself, but only of burning the stubble' for the fertilizing virtues of its ash (citing Pliny, Servius, and Grimald), and observes that Dryden and Trapp have translated the passage in this sense. But perceiving the problem in that, besides producing fertilizing ash, Vergil clearly supposes that heat will act on the ground itself, Martyn approvingly cites William Benson's alternative proposal (Benson 1725: 'Notes' *ad* line 123 of Dryden's translation, n.p.) that 'Virgil speaks of two different Things, of burning the Soil it self before the Ground is plough'd, and of burning the Stubble after the Corn is taken off from arable Land'. 'This', Martyn concludes, 'seems to be the most natural interpretation' (1741: 21).

Benson's suggestion did not gain lasting endorsement. Mynors and Thomas each (*ad* Verg. *G.* 1.84–93) table several competing observations, for instance that the didactic procedure of offering multiple causes is a Lucretian trope and that the whole passage illustrates the principle of balancing elemental contraries,

familiar in ancient physics. Mynors cites, even tentatively entertains, Tull's provocative remark that the effect of Vergil's agnosticism is 'utterly unbecoming the character of a philosopher who pretends *rerum cognoscere causas*' ('to know the causes of things', my translation; Tull 1733: 41; see De Bruyn 2004: 675). What characterizes each editor's commentary on this passage is a degree of agnosticism not unlike Vergil's, despite their common commitment to make factual sense of his precepts. This is precisely what these modern editors have in common with Martyn's commentary: a sense of scholarly detachment, an unwillingness to sound doctrinaire, an awareness that the passage on stubble-burning must serve poetic ends as well as obey factual imperatives and, above all, a wish to construe Vergil in the most favourable light that is also consonant with historical and scientific fact. In other words, Martyn is scarcely more narrowly or exclusively bent than modern editors – or indeed than his contemporary William Benson – on establishing the scientific basis of Vergil's poem or promoting its agricultural utility. For all the perceived urgency of agricultural improvement and the growing prestige of its discourses, eighteenth-century commentators (even the most 'scientific') were not generally the zealous proselyters of science they are sometimes imagined to have been.

As always, exceptions prove the rule. The Latin scholar and poet Edward Holdsworth (1684–1746), for instance, who was reputed to understand Vergil 'better than any man living' (Warton 1753: 224), wrote *A Dissertation upon Eight Verses in the Second Book of Virgil's Georgics*, published posthumously in 1749. As Holdsworth's title page explains, Vergil 'is vindicated, from several mistakes, which all his Commentators and Translators have imputed to him, either directly, or consequentially'. The lines in question are Verg. G. 2.65–72, on raising some kinds of trees (hazel, ash, poplar, oak, palm and fir) from *plantae* (i.e., sprouts or suckers) though Holdsworth argues that Vergil is not speaking about raising trees from suckers, but instead of cultivating them by transplanting fully grown plants (so Holdsworth glosses *plantae*) as well as the prospect of raising other trees by grafting (arbutus on walnut, apple on plane, chestnut on beech, and oak on elm). Vergil's lines present two problems: (a) some of the trees he apparently says are raised from suckers have already been observed by him to grow instead from seed (e.g., poplars and oak, Verg. G. 2.13, 16) or were well known not to grow from suckers, and (b) several of the grafts Vergil proposes would have been known to be extremely unlikely, if not impossible. Commentators still find the lines challenging. Holdsworth's solutions to the two difficulties are interesting not so much for their specific suggestions but for their basic assumptions. In brief, Holdsworth's reading of Verg. G. 2.65–8 (1749: 5–16) takes *plantae*

not as suckers but as grown plants for transplanting, a reading that has not found acceptance in modern editions. His reading of Vergil's lines on grafting (*G*. 2.69–72), namely that Vergil 'has purposely chosen such instances, as do not any of them come within the common rules of grafting' (Holdsworth 1749: 16), curiously anticipates Richard Thomas's idea of Vergil's 'deliberate falsehoods' (*ad* Verg. *G*. 2.32–4), with the difference that Holdsworth takes Vergil's intention rather to indulge than to chasten his ideally well-informed reader. There are at least three things to observe about the assumptions of Holdsworth's intervention. First, he assumes the importance in a georgic of the poet generally knowing his facts: if one found Vergil to be frequently and seriously mistaken, he observes, this would be 'no small Objection' (Holdsworth 1749: 2). But secondly, Holdsworth takes scientific accuracy to matter more for literary reasons than for utilitarian ones, because factual errors are not merely wrong in themselves but, more importantly, they confuse the poem's logical structure. It is more troubling, he argues, to suspect Vergil of an error that bears on the logical arrangement of his poem than to merely find him wrong about horticultural facts, because the former

> concerns him as a Poet, on which his character certainly depends, more than on being a Gardener. He is generally, I believe, very exact even in the most minute things; and I scarce imagine he shou'd be mistaken in so many articles together, as he is here charged with: yet, supposing him now and then to slip, or occasionally to differ from others in such matters, this wou'd be of no great importance; but to be confus'd and perplex'd in his Method, touches him in a more tender point.
>
> Holdsworth 1749: 5

Holdsworth's object, then, is not 'to defend Virgil as a poet worth reading on the grounds of his being a farmer worth imitating' (Bucknell 2013: 337) but to defend Vergil as an author of didactic epic whose 'character' depends on the coherence of his poetic 'method'. Finally, it is worth noticing that Holdsworth's horticultural observations were gracefully received, not only by Joseph Warton, a translator of a decidedly 'literary' bent, but equally by the 'scientific' authority Holdsworth had politely criticized, namely the botanist *and* classicist John Martyn (Warton 1753: 224–7; cf. Richard Rawlinson's Preface in Holdsworth 1749: vii).

In other words, the study of ancient literature was a broad church. It was precisely that capaciousness of interpretive interest that fostered eighteenth-century British georgic in the first place; it could be argued that, from around mid-century, the acceleration of the universal trend towards specialization

and professionalization contributed to stunting the genre's growth. Moreover, the sheer breadth of interest among readers of the *Georgics* can only have made it harder for Vergilian imitators to succeed aesthetically. The high premium placed on Vergil's linguistic beauty by the very commentators who also commended his scientific accuracy amounted to a significant raising of the bar. The *Georgics* became a byword for poetic difficulty, the triumph of style over substance, not because the substance was deemed trivial but, on the contrary, because it was known to be demanding. Valuing the *Georgics* above the *Aeneid* became a mark of the connoisseur. Dryden's boast that the *Georgics* is 'the best Poem by the best Poet' (dedication to Chesterfield, in Dryden 1987: 5.137) became something of a cliché of self-congratulation on the possession of exquisite taste.[8]

Indeed, the creative tension in Vergil between his high poetic register and his mundane subject matter is the main theme of the assault on Dryden's translation mounted by his rival translators Luke Milbourne (1698) and William Benson (1724, 1725), who each complained that Dryden coarsened his original to an intolerable degree (Davis 1999). While Benson accused Dryden of ignorance in agricultural matters, he conceded that (albeit with considerable forbearance) this fault might be excused as a sin of omission. Benson's position is close to that of Holdsworth, for whom Vergil's character, we have seen, depended on his being a poet 'more than on being a Gardener'. Dryden's cardinal offence, however, was unpardonable inasmuch as his 'voluntary and flagrant' stylistic transgressions went 'against the whole Character of *Virgil*. Mr. *Dryden*'s Translation makes a most solid, polite, chaste, religious Writer, trifling, unmannerly, fulsome, and profane' (Benson 1724: xx). This is a matter not of technical knowledge but of style. Classical commentators and polemical translators alike, not least those who most insisted on the factual imperative of didactic verse, promoted the view that georgic decorum is an extremely delicate balancing act. In this light, comparisons between Vergil and the physician-poet James Grainger, author of *The Sugar-Cane* (1764), were unlikely to appear flattering to the latter, not merely because his learned footnotes on flora and fauna crowd the bottom half of the handsome quarto page, but rather because they highlight the disjunction of heightened style and lowly subject matter that is already painfully apparent in his verse. At one point, Grainger enjoins the muse to sing the 'nectar'd sweets' of cassia pods as a laxative to 'relieve the bowels from their lagging load' (*The Sugar-Cane* 4.516–17, Gilmore 2000: 159). In his Preface, Grainger observes apologetically 'It must be confessed, that terms of art look awkward in poetry' (Gilmore 2000: 89). But that was hardly the main trouble with Grainger.

His lip-service to Addison's earlier injunction against 'terms of art' in georgic disingenuously ignores a truth universally acknowledged and by no one more fully appreciated than contemporary scholars, namely that Vergil had overcome precisely this difficulty by stylistic virtuosity.

Joseph Warton's 'Essay on Didactic Poetry' (1753)

Yet when we turn to Warton's 'Essay on Didactic Poetry' we find no gloom about the current prospects of vernacular didactic. Warton's prefatory essays and explanatory notes in his translation of Vergil (1753, with the *Aeneid* translated by Christopher Pitt) give a good indication of the standing of each of the three Vergilian genres in the mid-eighteenth century. A clergyman and poet like his father Thomas Warton the elder (1688–1745, Oxford Professor of Poetry 1718–28) Warton was also an acute and wide-ranging literary critic. He was not a classical scholar beyond his training at Winchester and Oxford, but this, of course, was a rigorous education in Latin literature and his notes also make frequent reference to the work of his friends Edward Holdsworth and another eminent classical scholar, Joseph Spence. Warton's 'Essay on Didactic Verse' is the work of a translator who cares enough about Vergil's factual accuracy to annotate the passage we have discussed on planting and grafting (Verg. *G.* 2.65–72) by quoting whole pages of Holdsworth's *Dissertation* (Warton 1753: 224–7), and who also holds Vergil's chief glory to be his style (without which his subject is 'barren' and 'naked', Warton 1753: 406). For Warton there is no opposition between factual accuracy and stylistic bravura. Warton admires John Philips's *Cyder* (1708) for its artful Vergilian digressions (Warton 1753: 399–400) and John Armstrong's *The Art of Preserving Health* (1744) for its author's choice of a topic of universal interest (Warton 1753: 395). Once the poet has chosen his topic, however, 'only such rules relating to it should be selected, as will bear to be delivered gracefully; and to be enliven'd with poetical imagery' (Warton 1753: 396). As Warton's phrasing suggests, his views on georgic are openly indebted to Addison, whom he frequently echoes as well as quotes at length, and to whom he adds little except by illustration, as well as by the fact that he goes beyond the *Georgics* and reviews the whole canon of didactic verse.[9] Though Warton only sparingly cites parallel passages from British poets in his annotation of Vergil,[10] his essay on didactic poetry suggests a stronger sense of continuity between ancient and modern didactic, which is presented as a viable and thriving genre.

Two contemporary didactic poems excite Warton's admiration.[11] One has already been mentioned, namely Armstrong's *The Art of Preserving Health*. The other, published in the same year, 1744, is Mark Akenside's *The Pleasures of Imagination*. Both poets are physicians, a vocational convergence that became increasingly common in the course of the century and may be said to have culminated in the figure of Erasmus Darwin (Priestman 2012: 415). Armstrong and Akenside both herald a turn in the second half of the eighteenth century towards the late Republican poet Lucretius, author of the didactic poem *De rerum natura* ('On the Nature of Things') as a classical model for didactic epic. Pope's *Essay on Man* (1733–4), which engages critically with Lucretius's scepticism, is the most lastingly important text in this connection, and Richard Payne Knight's six-book *Progress of Civil Society* (1796) is the most formally 'Lucretian' as well as philosophically sceptical didactic poem of its century (Priestman 2012: 412–15). The qualities for which Warton celebrates Lucretius are his 'force and fire' (Warton 1753: 422). 'No poet seems to have felt more strongly than Lucretius', whose keynote is the 'sublime' (Warton 1753: 421, xii). At several points Warton compares Vergil unfavourably to 'his master' (Warton 1753: 253). On Vergil's description of spring at *G.* 2.323–45 he observes that although 'Virgil tries hard to excell Lucretius . . . I am afraid it cannot be said that he has done it' (Warton 1753: 248). Commenting on Vergil's description of the plague (*G.* 3.478–566) in which 'he puts forth all his strength to endeavour to excel Lucretius's sixth book on the plague at Athens', Warton concedes Vergil indeed succeeds in the endeavour, but not 'so far . . . as some critics imagine' (Warton 1753: 324). Vergil is occasionally found to come short of Lucretius even in sensibility: of *G.* 2.523 (*interea dulces pendent circum oscula nati*, 'meanwhile his dear children hang upon his kisses'), Warton finds Vergil's model, Lucr. 3.895–6 (*nec dulces occurrent oscula nati / praeripere*, 'no longer will your sweet children race to win the first of your kisses'), 'still more tender and natural' (Warton: 1753: 268). In short, it is the Lucretian qualities in Vergil that Warton most admires. Warton's variation on Dryden's praise of 'the best poem by the best poet' is itself bold and passionate, much in the manner he himself admires in Lucretius:

> Indeed of all authors, either ancient or modern, Virgil seemeth to be the most perfect in his style; I mean in the poems he lived to finish. There is a profusion of the most daring metaphors and most glowing figures, there is a majesty and magnificence of diction throughout the Georgics, that notwithstanding the marvellous harmony and grandeur of the Greek versification, is scarcely equalled by Homer himself.
>
> Dedication to Lyttelton, Warton 1753: iv–v

Warton approvingly quotes Addison on the vividness of Vergil's animating descriptions, concluding that 'we may justly therefore apply to him what Aristotle thought so high a commendation of Homer: that he hath found out LIVING WORDS' (Warton 1753: v).

> In short, the Georgics are the highest flight of Virgil, and the master-pieces of his genius. Some of the transitions with which they are adorned, are the boldest and most daring imaginable, and hold very much of the enthusiasm of the ancient lyrics; and I think one may venture to affirm, that this poem contains more original unborrow'd beauties, and is more perfect in its kind as a Dicactic, than the Aeneid as an Epic poem.
>
> Warton 1753: viii

Classical scholarship and the georgic as genre

Warton's esteem for 'the enthusiasm of the ancient lyrics' and poetic originality is not only characteristic of his own taste, but also heralds that of the second half of his century. This sublime version of Vergil is harder than ever to emulate, and impossible to imitate. The turn-of-the-century vogue for close (and frequently humorous) imitation of the classics had largely passed and by the final third of the century close imitations of either Vergil or Lucretius are thin on the ground.

These circumstances only increase the difficulty of tracing the influence of classical scholarship on either the Vergilian georgic or the wider didactic genre.[12] The vernacular didactic easily detached itself from its classical backgrounds. A contributing reason may be eighteenth-century classicists' relative lack of attention to the biographical circumstances that attended the genesis of the *Georgics*. Whereas Warton's prefatory 'Life of Virgil' (Warton 1753: 1–34) gives detailed accounts of the composition of the *Eclogues* (4–16) and the *Aeneid* (19–29), it offers less detailed information on the composition of the *Georgics* (17–18). The brief biography in Martyn's edition of the *Georgics* is even brisker, omitting Vergil's sojourn at Naples: Vergil 'cultivated his own lands near Mantua, till he was about thirty years of age, when he appeared at Rome, and was soon received into the favour of Augustus Caesar' (p. viii). These eighteenth-century commentators of Vergil inherited the 'plots' or master-narratives of their Renaissance forebears, at any rate about the *Eclogues* and the *Georgics*:

> For Renaissance commentators, the plot of the *Eclogues* revolved around Virgil's quest for patronage. The most popular commentaries on the *Georgics* focused on

variety, on the wide range of subjects discussed in the poem and Virgil's versatility in treating them. Criticism of the *Aeneid* revolved around "purity" both as it refers to Virgil's sexual purity and the careful polishing of the text, which was licked into shape as a she-bear licks her cubs.

<div align="right">Kallendorf 2015: 170–1</div>

Given the paucity of biographical details that classical scholars could offer about the composition of the *Georgics* (they can offer more today, but not that many), a basic plot is typically offered instead. In the biographical narratives of Benson, Martyn, and Warton, Vergil initially rallied to the political cause of resurrecting 'the ancient spirit of Husbandry' after the ravages of the civil wars, and then set about composing the poem in the most exquisitely 'varied' literary manner (Benson 1724: x; Martyn 1741: ix–x; Warton 1753: 16–17). This plot, which is prominent too in Addison's *Essay*, is discernible behind all formal georgics in the eighteenth century. It features (and is partly the source for) the distinctive contrast between practical concerns and poetic ambitions so familiar in the genre's reception. Like the trope of 'variety' itself, however, the plot or myth is too general to be traced to this or that scholarly commentary. Nor does there appear to occur any radical shift in the general conception of the *Georgics* among eighteenth-century classical scholars that makes itself felt in the configuration of the genre among the contemporary British poets.

I return to my opening observation, namely that classical scholarship failed – if that is the word – to generate a controversy about the nature or definition of georgic comparable to seventeenth- and eighteenth-century debates about pastoral and epic. It may be argued that this absence of dogmatism contributed to leaving conceptions of the georgic genre in a relatively amorphous state. But the generative properties of theoretical debate about genre are much less evident than the advantages of generic flexibility and capaciousness, for instance in the confidence and apparent ease with which William Cowper could develop a six-book meditative poem, *The Task* (1785), from the germ of a light-hearted idea for a spoof didactic poem on the historical progress, not of civil society, but of the sofa.

It must be the sheer comprehensiveness of classical scholars' approach to the *Georgics*, not their small-scale controversies over the referential or factual point of Vergil's precepts, that recommended the genre to eighteenth-century British poets. But the scarcity of available hard evidence is chastening. As long as we only know, say, that John Dyer owned Martyn's edition of the *Georgics*, but not what Dyer thought about Martyn's edition, and remain unable to demonstrate how its specific influence is reflected in *The Fleece*, our speculation must remain

tentative. Even in cases where more is known about the poet in question, evidence about the impact of scholarly works tends to be scarce. Despite scholars' minute investigation of Wordsworth's reading of Vergil editions, for instance (Wu 1990; Graver 1996), the grounds are only occasionally strong enough to attribute Wordsworth's ideas about Vergil or his understanding of Vergilian genres or passages to the influence of any specific edition. Since the argument that eighteenth-century classicists promoted Vergil on the grounds of his practical utility is often contradicted by the evidence, one should also be cautious about attributing any perceived utilitarian understandings of georgic among eighteenth-century poets to classical scholars. The problem of how to take Vergil's precepts is of course not peculiar to the eighteenth century, but perennial. One thinks of Niall Rudd's anecdote about two twentieth-century authorities on the *Georgics*, R.A.B. Mynors and L P. Wilkinson, both asked about the progress of their own work in the late sixties. Mynors remarked that little scholarship on the *Georgics* had appeared in recent years 'because Latinists know nothing about *bees*'. A week later, Wilkinson was asked about his own forthcoming book. 'Not much has appeared in English of late', he observed, 'and that's because people have this odd idea that to write about the *Georgics* one has to know about *bees*' (x–xi). As Rudd remarks, 'those opposite approaches ... are, of course, complementary' (Wilkinson 1997: xi). It is arguable that they always were and, that in the eighteenth century, too, they were generally understood that way.

What seems clearest to me is that the increasingly comprehensive as well as appreciative scholarly evaluation of the *Georgics* during the first half of the eighteenth century raised the stakes considerably for any poet who wished to emulate Vergil. Only a fearsomely talented poet could hope to achieve what Warton admired in the *Georgics*, namely a combination of sublime inventiveness and virtuosic craftsmanship. When highly talented poets did imitate Vergil, as Cowper did in *The Task*, it was as a model for a copious variety of style and topical concern. In this respect, at least, poets and scholars appear to have been unanimous.

Rhyme and Reason

The Homeric Translations of Dryden, Pope, and Morris

Lilah Grace Canevaro
University of Edinburgh

Prolegomenon

Alexander Pope in the preface to his translation of Homer's *Iliad* (1715–20) writes: 'his measures, instead of being fetters to his sense, were always in readiness to run along with the warmth of his rapture, and even to give a farther representation of his notions, in the correspondence of their sounds to what they signify'd. Out of all these he has deriv'd that harmony, which makes us confess he had not only the richest head, but the finest ear in the world' (Shankman 1996: 10). As for the Homeric poems' characteristic epithets, Pope 'cannot but attribute these also to the fruitfulness of his [Homer's] invention' (Shankman 1996: 9). The tenor of these remarks and the assumption of a single author – Homer – make clear that Pope's *Iliad* is a translation Before Wolf.

In 1795 Friedrich August Wolf published his *Prolegomena ad Homerum*, which would come to be known as one of the founding works of classical philology as a discipline.[1] In its scientific rigor, its historicity and its concern for minutiae, philology was to be a discipline fundamentally at odds with poetry. As Turner (1997: 123) puts it, '[p]hilologists wrested Homer from the world of poets and literature and placed him at the mercy of modern scientific criticism, just as they wrested the Christian scriptures from the realm of sacred reverence'. The eighteenth century saw the crystallisation of the so-called 'Homeric Question' or, rather, questions: did Homer really exist? Were the *Iliad* and *Odyssey* composed by one man? When were the Homeric poems written down, and can we ever get back to their original form?[2] In this chapter I will treat Pope's *Iliad* and Dryden's 'The Last Parting of Hector and Andromache' (1693) as valuable sources for an

unquestioned Homer, as attempts to, in Pope's own words, 'keep alive that spirit and fire which makes his chief character' (Shankman 1996: 20). I will focus on these writers' treatment of particular features which would come to be recognized as characteristic of oral poetry: namely epithets and formulae. Both Dryden and Pope were composing in the rhyming heroic couplet and it is the rhyming elements that will be central to my analysis as they come at the line end: the most common placement for oral-traditional metrical formulae.

If rhyme is, as Oscar Wilde wrote, 'the one chord we have added to the Greek lyre,'[3] then can it perhaps capture something of which later after-Wolf translations, specifically those in free verse, have lost sight? When post-Wolf translators revive the rhyming couplet (I use William Morris' *Odyssey* as a case study) in what ways does their use of the rhyme scheme differ from that of their predecessors? And the broader questions: to what extent have shifts in Homeric scholarship affected the way we approach not only current translation practices but also, retrospectively, existing translations and their place in English literary history? What impact does poetic form, specifically rhyme, have on the genre of a translation and our recognition of it? What difference does it make to all of these issues when the translator is not only a poet, but also a literary critic?

Dryden, Pope, and the Heroic Couplet

Wolf's *Prolegomena* was a watershed, a nodal point on the continuum of classical scholarship. His book made waves not only in the scholarly but also the literary community: Goethe, for example, decided to write an epic of his own, now that he would no longer be overshadowed by Homer.[4] However, this is not the whole picture and my opening gambit of classing translations as 'Before' or 'After Wolf' was intended as something of a provocation. As Anthony Grafton (1981) has shown, there were, in fact, *prolegomena* to Wolf's *Prolegomena*. The ideas Wolf put forward were based heavily on existing Biblical scholarship. He articulated a strain of classical scholarship which had its roots in antiquity and had gradually gained strength over the course of the eighteenth century. It would be reductive, then, to treat Pope and Dryden as necessarily naïve readers of Homer – there was a commotion in scholarship, and we cannot assume they were unaware of it. Furthermore, the positive reaction to Wolf's work was not unanimous. Not everyone was convinced in one fell swoop – even Goethe gave up on his epic, returning to his old belief in the Homeric poems' unity and perfection. Elizabeth

Barrett Browning, in her 1856 epic *Aurora Leigh*, has the title character Aurora directly reject Wolf's edition of Homer in her exploration of the content and form of (female) epic poetry: 'Wolff's an atheist: / And if the Iliad fell out, as he says, / By mere fortuitous concourse of old songs, / Conclude as much too for the universe' (*Aurora Leigh* 5.1254–7).[5] The arguments of the Wolf school were not conclusive and there was room for manoeuvre.

In such a setting, we might see Pope as a last bastion of an earlier image of Homer – a stalwart champion of the so-called 'Prince of Poets' in an age of change. Lynch (1982: 11) goes so far as to claim that '[t]he period marks not just the end of an old Homer and the birth of a new, but the death of a personal involvement with the literature of the past in favor of a more distanced and anthropological approach. Pope is the last translator of Homer to have a stake in the ancient world.' One might point out that personal and anthropological approaches are neither necessarily mutually exclusive nor question what it means for a translator to 'have a stake in the ancient world.' But what is clear is that Pope expresses a connection to Homer, a commitment to his genius, his *existence* – and that is what changes in this period. In his preface, Pope brooks no argument. For him, Homer is not some nebulous tradition, oral poetry which at some point was committed to writing: he was a man who 'had the greatest *Invention* of any writer whatever' (Shankman 1996: 3).

Both Dryden and Pope compared their impressions of Homer with their impressions of Vergil. Dryden writes:

> I have found by Trial, *Homer* a more pleasing task than *Virgil*, (though I say not the Translation will be less laborious). For the *Grecian* is more according to my Genius, than the *Latin* poet. In the Works of the two Authors we may read their Manners, and natural Inclinations, which are wholly different. *Virgil* was of a quiet, sedate Temper; *Homer* was violent, impetuous, and full of Fire.[6]

Similarly, Pope writes: '*Homer*, boundless and irresistible as *Achilles*, bears all before him, and shines more and more as the tumult increases; *Virgil*, calmly daring like *Aeneas*, appears undisturb'd in the midst of the action; disposes all about him, and conquers with tranquility' (Shankman 1996: 11). Both translators use the epic poems to learn about their poets: a strategy with a long pedigree as it formed the backbone of the ancient biographical tradition,[7] but which, come Wolf, would soon be considered redundant – at least on the Greek side. As Wolf himself puts it, 'I little envy the facility – not to say credulity – of any who still seem to think that they read Homer and Hesiod as whole and pure as, for example, the Romans Virgil or Lucretius.'[8]

But in formulating such a comparison, Pope makes an important point. He writes: '*Homer* makes us hearers, and *Virgil* leaves us readers' (Shankman 1996: 8). Robert Fagles in the preface to his 1990 translation of the *Iliad* comments on Pope's distinction between Homer and Vergil: 'So the great translator of Homer, no doubt unknowingly, set at odds the claims of an oral tradition and those of a literary one, as we would call the two traditions now' (Fagles 1990: ix). It seems that Pope was onto something. Eighteenth-century Homeric studies planted the seeds of oral–traditional theory, a field of study which would later be taken over by the luminaries Milman Parry and Albert Lord and would become the real turning point in our understanding of epic poetry.[9] The main tenet of the theory is that the Homeric poems were originally composed and transmitted orally. The implications for our interpretation of the poems are too many to mention here, but we might focus on one: the function of formulae. Formulaic elements in Homer range from individual epithets to entire type scenes repeated more or less verbatim. Athena is 'grey-eyed', Apollo 'swift-footed', descriptions of dressing and hospitality follow a set pattern and speeches are introduced in a limited number of standard ways. In an oral setting, such stock elements can function to structure a rendition, giving a rhapsode fixed points around which to recompose in performance; they also provide hooks for the audience. Another function performed by formulae is a metrical one. The Homeric poems were composed in dactylic hexameter and stock phrases, in particular noun–epithet pairings, could be used to fill a metrical gap. For example, Achilles is described as 'swift-footed' when he needs to fill up seven syllables (πόδας ὠκὺς Ἀχιλλεύς) but as 'godlike Achilles' (δῖος Ἀχιλλεύς) when he needs to squeeze into five.[10]

Our understanding of these noun–epithet pairings has fluctuated over time. Before Wolf, they were generally considered to be a quirk of Homer, therefore their particular purpose in any given situation was considered important, as symptomatic of Homer's genius. Pope writes that the use of epithets in the Homeric poems 'heighten'd the *diction* [. . .] it assisted and fill'd the *numbers* with greater sound and pomp, and likewise conduced in some measure to thicken the *images* [. . .] I cannot but attribute these also to the fruitfulness of his [Homer's] invention, since (as he has manag'd them) they are a sort of supernumerary pictures of the persons or things to which they are join'd' (Shankman 1996: 9). After Wolf, however, and even more so after Parry and Lord,[11] they were often interpreted (and even dismissed) as mechanical elements of an anonymous oral tradition. Then, in the latter part of the twentieth century, the debate came full circle when scholars (John Miles Foley arguably foremost amongst them) again began to emphasize *particular* uses. Richard Martin in his introduction to

Lattimore's translation of the *Iliad* sums up the current position: 'The formulaic system is neither mechanical nor empty. It simply embodies an unfamiliar aesthetic: rather than the exquisite, right word, specially selected for each passage (a Romantic poetic requirement), epic style creates audience expectations by consistent depiction—and then, for maximum effect, at key moments, violates the norm' (Lattimore [1951] 2011: 51). Commentators and literary scholars no longer dismiss formulae, but what do translators do with them, given their lack of familiarity to modern readers and their situatedness in a specific cultural context? Fagles, in his translation, treats them 'in a flexible, discretionary way, not incompatible with Homer's way, I think – especially when his formulas are functional as well as fixed – while also answering to the ways we read today' (Fagles 1990: x). In the nineteenth century, the Reverend Theodore Alois Buckley wrote an up-to-date introduction to Pope's *Iliad*, in which he summarized the latest scholarship on the Homeric Question. He declared: 'It would be absurd, therefore, to test Pope's translation by our own advancing knowledge of the original text. We must be content to look at it as a most delightful work in itself—a work which is as much a part of English literature as Homer himself is of Greek' (Buckley 1884: 29). I am not convinced that we should deliberately ignore developments in classical scholarship to read Pope – to pretend to be naïve, as it were. As I have suggested in relation to Grafton's re-reading of Wolf and his predecessors, it is likely that Pope himself was not as naïve as we might think. But it may be true that our 'advancing knowledge', our attempts to make Homer 'answer to the ways we read today', could be obscuring our appreciation of the original in some respects: in particular, as I hope to show, in aesthetic terms.

The passage on which I shall focus my analysis in this section comes from Book 6 of the *Iliad*. Hector is about to head into battle, but his wife Andromache entreats him to stay back. The passage I shall be discussing is the first part of Hector's reply. There is nothing special about the passage in terms of meter or formulae – nothing I will say here is unique to this passage. But Dryden only translated Book 1 and part of Book 6 of the *Iliad*, which limits the comparative material available. In fact, Pope comments on this sad state of affairs, though his remark seems more than a little barbed: 'It is a great loss to the poetical world that Mr. *Dryden* did not live to translate the *Iliad*. He has left us only the first book and a small part of the sixth; in which if he has in some places not truly interpreted the sense, or preserved the antiquities, it ought to be excused on account of the haste he was obliged to write in' (Shankman 1996: 20).

τὴν δ' αὖτε προσέειπε **μέγας κορυθαίολος Ἕκτωρ·**
'ἦ καὶ ἐμοὶ τάδε πάντα μέλει, γύναι· ἀλλὰ μάλ' αἰνῶς
αἰδέομαι Τρῶας καὶ **Τρῳάδας ἑλκεσιπέπλους,**
αἵ κε κακὸς ὣς νόσφιν ἀλυσκάζω πολέμοιο.
οὐδέ με θυμὸς ἄνωγεν, ἐπεὶ μάθον ἔμμεναι ἐσθλός
αἰεὶ καὶ πρώτοισι μετὰ Τρώεσσι μάχεσθαι,
ἀρνύμενος πατρός τε **μέγα κλέος** ἠδ' ἐμὸν αὐτοῦ.
εὖ μὲν ἐγὼ τόδε οἶδα κατὰ φρένα καὶ κατὰ θυμόν·
ἔσσεται ἦμαρ ὅτ' ἄν ποτ' ὀλώλῃ **Ἴλιος ἱρή**
καὶ Πρίαμος καὶ λαὸς **ἐϋμμελίω Πριάμοιο·**
ἀλλ' οὔ μοι Τρώων τόσσον μέλει ἄλγος ὀπίσσω,
οὔτ' αὐτῆς Ἑκάβης οὔτε **Πριάμοιο ἄνακτος**
οὔτε κασιγνήτων, οἵ κεν πολέες τε καὶ ἐσθλοί
ἐν κονίῃσι πέσοιεν ὑπ' **ἀνδράσι δυσμενέεσσιν,**
ὅσσον σεῖ', ὅτε κέν τις **Ἀχαιῶν χαλκοχιτώνων**
δακρυόεσσαν ἄγηται, ἐλεύθερον ἦμαρ ἀπούρας.

<div align="right">

Iliad 6.440–55 (my emphasis)[12]

</div>

Highlighted are the noun–epithet pairings. They are formulaic phrases, each repeated a number of times in the *Iliad*: μέγας κορυθαίολος Ἕκτωρ appears twelve times (κορυθαίολος Ἕκτωρ alone occurs 37 times); Τρῳάδας ἑλκεσιπέπλους three times; μέγα κλέος three times in the *Iliad*, five times in the *Odyssey*; Ἴλιος ἱρή an impressive 22 times (plus two mentions in the *Odyssey*); ἐϋμμελίω Πριάμοιο four times (in all cases the entire line is repeated); Πριάμοιο ἄνακτος eight times (and once in the *Odyssey*); ἀνδράσι δυσμενέεσσιν nine times in the *Iliad*, six times in the *Odyssey*; and Ἀχαιῶν χαλκοχιτώνων 22 times (plus twice in the *Odyssey*). The obvious trend to extrapolate is that all but one of these eight examples come at the end of a line (μέγα κλέος being the exception). How does this compare to, in the first instance, modern free-verse translations? I focus here on the translations by Robert Fagles and Richard Lattimore, as those arguably most familiar to readers, most used by students and most widely circulated.[13]

> Then <u>tall Hektor of the shining helm</u> answered her: "All these
> things are in my mind also, lady; yet I would feel deep shame
> before the Trojans, and the <u>Trojan women with trailing garments</u>,
> if like a coward I were to shrink aside from the fighting;
> and the spirit will not let me, since I have learned to be valiant
> and to fight always among the foremost ranks of the Trojans,
> winning for my own self <u>great glory</u>, and for my father.

For I know this thing well in my heart, and my mind knows it:
there will come a day when <u>sacred Ilion</u> shall perish,
and Priam, and the people of <u>Priam of the strong ash spear</u>.
But it is not so much the pain to come of the Trojans
that troubles me, not even of <u>Priam the king</u> nor Hekabe,
not the thought of my brothers who in their numbers and valor
shall drop in the dust under the hands of <u>men who hate them</u>,
as troubles me the thought of you, when some <u>bronze-armored</u>
<u>Achaian</u> leads you off, taking away your day of liberty,
in tears. [...]"

> Lattimore ([1951] 2011: 183), lines 440–56, free six-beat lines

And <u>tall Hector</u> nodded, <u>his helmet flashing</u>:
"All this weighs on my mind too, dear woman.
But I would die of shame to face the men of Troy
and the <u>Trojan women trailing their long robes</u>
if I would shrink from battle now, a coward.
Nor does the spirit urge me on that way.
I've learned it all too well. To stand up bravely,
always to fight in the front ranks of Trojan soldiers,
winning my father <u>great glory</u>, glory for myself.
For in my heart and soul I also know this well:
the day will come when <u>sacred Troy</u> must die,
Priam must die and all his people with him,
<u>Priam who hurls the strong ash spear</u> [...]
 [...] Even so,
it is less the pain of the Trojans still to come
that weighs me down, not even of Hecuba herself
or <u>King Priam</u>, or the thought that my own brothers
in all their numbers, all their gallant courage,
may tumble in the dust, crushed by <u>enemies</u> —
That is nothing, nothing beside your agony
when some <u>brazen Argive</u> hales you off in tears,
wrenching away your day of light and freedom!"

> Fagles (1990: 210), lines 521–41, free five-/six-beat lines

In both the Lattimore and Fagles translations, the Trojan women with their trailing garments and Priam of the strong ash spear are put at the end of the line – although in Fagles, each takes an entire line all for itself. The hateful men are placed at the end, but sacred Ilion is not, nor is lord Priam. Great Hector of the shining helmet is put at the beginning of the line by Lattimore, and Fagles splits

up the epithets, with 'tall', for μέγας, at the beginning of the line, and κορυθαίολος, translated 'his helmet flashing', at the end. The bronze-clad Achaians are in the middle of a line in Fagles and in Lattimore run over to the following line. Both translations render the noun–epithet pairings fairly literally, but in adopting standard English word order the translators are often forced to abandon that of the Greek. While this does succeed in making the translations comprehensible and accessible, when it comes to formulae something is lost. Noun–epithet pairings placed at the ends of lines are not, the scholarly *communis opinio* rightly says, simply a metrical filler. Aside from the contextually specific relevance which twentieth-century scholars put back into the arena, formulae also have an aesthetic value. κορυθαίολος Ἕκτωρ is repeated 37 times in the Homeric poems, Ἴλιος ἱρή and Ἀχαιῶν χαλκοχιτώνων 24 times apiece – they become memorable hooks, like a chorus or refrain coming round again and again. They help to establish a pattern of responsion between different passages in the poem – a responsion that is both semantic and metrical. The Homeric hexameter is made up of six feet, each of which can be a dactyl or a spondee though the last two feet, more often than not, follow the structure dactyl-spondee. All the line-ending pairs in our passage take this form. Further, the Homeric hexameter often avoids matching up the beginning of a word with the beginning of a metrical foot: but when they do coincide, it is again towards the end of a line, such as in Ἴλιος ἱρή, δυσμενέεσσιν or χαλκοχιτώνων. To put it simply, there is a tendency for the hexameter to become progressively more metrically fixed as it approaches the cadence and noun–epithet formulas play an important role in this.

So what, then, does the rhyming couplet have to offer – if anything?[14]

The chief reply'd: That post shall be my care,
Not that alone, but all the works of war.
How would the sons of *Troy*, in arms renown'd,
And *Troy*'s proud dames whose garments sweep the ground,
Attaint the lustre of my former name,
Should *Hector* basely quit the field of fame?
My early youth was bred to martial pains,
My soul impels me to th' embattl'd plains:
Let me be foremost to defend the throne,
And guard my father's glories, and my own.
Yet come it will, the day decreed by fates;
(How my heart trembles while my tongue relates!)
The day when thou, Imperial *Troy!* must bend,
And see thy warriors fall, thy glories end.

And yet no dire presage so wounds my mind,
My mother's death, the ruin of my kind,
Not *Priam*'s hoary hairs defil'd with gore,
Not all my brothers gasping on the shore;
As thine, *Andromache!* thy griefs I dread;
I see thee trembling, weeping, captive led!

<div align="right">Pope, Iliad (1715–20), lines 560–79 (Shankman 1996: 310)</div>

To whom the Noble *Hector* thus reply'd.
That and the rest are in my daily care;
But shou'd I shun the Dangers of the War,
With scorn the *Trojans* wou'd reward my pains,
And their proud Ladies with their sweeping Trains.
The *Grecian* Swords and Lances I can bear:
But loss of Honour is my only Fear.
Shall *Hector*, born to War, his Birth-right yield,
Belie his Courage and forsake the Field?
Early in rugged Arms I took delight;
And still have been the foremost in the Fight:
With dangers dearly have I bought Renown,
And am the Champion of my Father's Crown
And yet my mind forebodes, with sure presage,
That *Troy* shall perish by the *Grecian* Rage.
The fatal Day draws on, when I must fall;
And Universal Ruine cover all.
Not *Troy* it self, tho' built by Hands Divine,
Nor *Priam*, nor his People, nor his Line,
My Mother, nor my Brothers of Renown,
Whose Valour yet defends th' unhappy Town,
Not these, nor all their Fates which I foresee,
Are half of that concern I have for thee.
I see, I see thee in that fatal Hour,
Subjected to the Victor's cruel Pow'r:
Led hence a Slave to some insulting Sword:

<div align="right">Dryden, 'The Last Parting of Hector and Andromache' (1693), lines 101–26
(Chambers, Frost and Dearing 1974: 428–9)</div>

Pope does not claim to be producing a literal, word-for-word translation and in fact argues: 'Upon the whole, it will be necessary to avoid that perpetual repetition of the same epithets which we find in *Homer*' (Shankman 1996: 18). In reading Dryden's and Pope's translations, it is not so easy to find great Hector of the

shining helmet or the bronze-clad Achaians – adherence to the Greek is, more often than not, sacrificed in favour of flowing English verse – and even the characteristic formulae might be lost in translation. However, I want to suggest that this flowing English verse captures something that a more literal translation cannot. In using an end-rhyme scheme, both poets draw attention to the ends of their lines and always finish on a metrical hook. The rhyme is a prominent marker of poeticity in its English-language context: a trigger for genre recognition, which free verse lacks.[15] Similarly, poeticity in the archaic context is marked by metre and by formulaic diction,[16] and it is at the line end, in particular, where these two elements work together to mark out genre. Occasionally the rhyme corresponds to the noun–epithet line end, as in the case of the Trojan women:

> Pope: How would the sons of *Troy*, in arms renown'd,
> And *Troy*'s proud dames whose garments sweep the ground,
> Dryden: With scorn the *Trojans* wou'd reward my pains,
> And their proud Ladies with their sweeping Trains.

But my point is that it is not only when Pope and Dryden are being faithful to the Greek text that their translations capture something of Homer. I suggest that, in choosing the rhyming couplet, they reproduce something intrinsic to the Homeric hexameter. For one thing, the heroic couplet is based on a principle of creative tension, by which 'couplets formally involve a careful pairing of oppositions or balances but no formal resolution' (Hunter 1996: 266).[17] Each couplet has four units, with each line divided in two both by a caesura and by a grammatical relationship that implies cause and effect. Just so is a Homeric hexameter line split (somewhere) in the middle by a caesura, and the elements falling on either side might be in dialogue. In our passage, for example, the Trojan men are placed on one side, the Trojan women on the other; Hecabe on one side, and Priam on the other. Such a structure can draw even more attention to the line ends: in the first line of our passage, great Hector of the shining helmet takes up the entire second half of the hexameter, the caesura falling just before μέγας.

In the rhyming couplet, the rhyming words are key to the focus and emphasis of the line. Hunter (1996: 266) comments (on Pope's 'The Rape of the Lock', but it also applies here): 'A pretty good close analysis of what is going on in the poem on a value level could be done just on the basis of rhyme words, irrespective of normal syntax or even of plot.' One of the central themes of the Homeric passage is the μέγα κλέος, the great glory or great renown, that was the only exception to

the line-end placement of noun–epithet pairings. Hector refuses to stay back from the fighting because he would be ashamed: ashamed of losing face with his people and ashamed of undermining his father's and his own renown. At the end of the passage Hector says that the thing he fears most is that Andromache will be dragged off by the Achaians. The ostensible chivalry and selflessness, however, is undermined by the following lines in which Hector goes on to envisage a scenario in which Andromache is spotted weaving at another loom and a passer-by says of her 'look at that woman who used to be Hector's wife'. Part of the hero's concern is that this would not be a great advertisement for his own *kleos*. And this importance of reputation is reflected in the choice of rhyme words by both Pope and Dryden:

> Pope: Attaint the lustre of my former name,
> Should *Hector* basely quit the field of fame?
> Dryden: With dangers dearly have I bought Renown,
> And am the Champion of my Father's Crown.
> [...]
> My Mother, nor my Brothers of Renown,
> Whose Valour yet defends th' unhappy Town.

If we were to look only at the line ends, only at the rhyme words (name/fame, Renown/Crown, Renown/Town), we would already be thinking about reputation and power, about the ties of family and city. The placement of these key words in the rhyme scheme makes them mnemonic hooks. This is not a direct parallel for the Homeric hexameter: if a principle of economy can ever have been thought to encapsulate Homeric formulae, such formulae can hardly be 'key words' as such. Yet, they are working hard to establish semantic and metrical responsion across the expanse of the epic: to make characters and situations memorable and coherent and to mark out a genre, a poetics. Whether by rhyming key words or by metrical repetition, both the rhyming couplet and the Homeric hexameter highlight poeticity at their line ends.

I have thus far grouped together Pope and Dryden, as two poets employing the same rhyme scheme. This is, in a way, overly simplistic: there are, of course, differences in their usage of the heroic couplet. But whether one comes closer to relaying in translation the aesthetics of the Homeric meter – and which one that might be – is up for debate (and is, essentially, subjective). Lynch (1982: 4) maintains that 'Pope's couplets do more violence to the movement of Homer's poetry. [...] Each couplet has a self-sufficiency that forces the reader to pause at

its close. Dryden moves with a narrative energy similar to Homer's. [...] [T]he enjambment [...] requires the reader to move past the first line in order to complete the syntax.' It should be noted, however, that according to Higbie (1990: 66), around 75 percent of Homer's lines can stand alone (i.e., have no necessary enjambment but are syntactically independent) – a construction which scholars from Parry 1929 on have shown to be conducive to oral composition and performance. Surely, then, Pope's pauses do not really do much 'violence' to the Homeric flow, but rather enact another feature of oral composition in his written rhyme scheme. Fagles (1990: 18), in his argument against 'full formularity' in oral composition, writes: 'A poet composing in a strict, demanding meter is bound to repeat syntactical combinations in identical positions and the stricter the meter, the higher the incidence of such repeated patterns. English has no meters as precisely demanding as Homer's, but Alexander Pope, to take an example, is rich in lines that by strict Parryite standards would qualify him as an illiterate bard.' Though problematic as it is based on speculation, I suggest that this is a potentially useful comparison as it highlights the importance of metrical scheme for our interpretation of a poem, its genre, its performance context – and our search for its author.

Pope writes in the preface to his *Iliad*: 'Nothing is more absurd or endless, than the common method of comparing eminent writers by an opposition of particular passages in them, and forming a judgment from thence of their merit upon the whole' (Shankman 1996: 11). The scope of a single chapter has confined me to absurdity; but I hope to have demonstrated that rhyme is indeed, as Oscar Wilde put it, a chord that the English poets added to the Greek lyre. It is a way of replicating the flow of the dactylic hexameter, and of marking poeticity in its context. Wolf and his successors have shown us that we are not on safe ground in talking about Homer the person, let alone his rich head and fine ear, as Pope describes them. Yet, as Pope puts it, the Homeric poems 'roll along as a plentiful river, always in motion, and always full; while we are born away by a tide of verse, the most rapid, and yet the most smooth imaginable' (Shankman 1996: 10). In producing literal, free-verse translations, we may have left the smooth river far behind. Perhaps some lessons learned from the rhyming couplet can help us get back there.

Pope: Poet and Critic

So far in this chapter I have focused on the heroic couplet in Pope and Dryden and its relationship to Homeric translation. With Alexander Pope, we are

perfectly placed to move now to offer some explicit reflections on the nexus between poetry and literary criticism, genre, and classical scholarship which informs this volume. Pope's *Essay on Criticism*, published in 1711, is a poetic didactic essay that looks back to classical authorities and gives advice to poets and to critics on poetry, in poetic form – the form of the heroic couplet, in fact. It remains to be noted that both Dryden and Pope engaged not only in writing poetry but also in literary criticism – and an examination of this *Essay* can help us to interrogate the distinctions, or indeed connections, between the two activities.

In Part 1 of his *Essay*, Pope warns:

One science only will one genius fit;
So vast is art, so narrow human wit:

<div align="right">Pope, Essay on Criticism, 60–1</div>

Being both poet and critic is essentially problematic, as (according to Pope) man has the capacity to perfect but one craft. Where, then, does this leave Pope? Is he the exception that proves the rule? Or is one activity more central to his thought than the other? In his *Essay* he suggests a hierarchy between poetry and criticism:

Then criticism the Muse's handmaid prov'd,
To dress her charms, and make her more belov'd;
But following wits from that intention stray'd;
Who could not win the mistress, woo'd the maid;
Against the poets their own arms they turn'd,
Sure to hate most the men from whom they learn'd.

<div align="right">Pope, Essay on Criticism, 102–7</div>

The critics come second to the poets, abandoning (or being abandoned by) the Muse and turning on their teachers. Pope even comments specifically on literary criticism within classical scholarship and depicts its deleterious effect on the classical works themselves:

Some on the leaves of ancient authors prey,
Nor time nor moths e'er spoil'd so much as they:

<div align="right">Pope, Essay on Criticism, 112–13</div>

He describes the ideal critic, setting up a paradigm to emulate, and claims that such critics did exist in the classical world:

But where's the man, who counsel can bestow,
Still pleas'd to teach, and yet not proud to know?

Unbias'd, or by favour or by spite;
Not dully prepossess'd, nor blindly right;
Though learn'd, well-bred; and though well-bred, sincere;
Modestly bold, and humanly severe?
Who to a friend his faults can freely show,
And gladly praise the merit of a foe?
Blest with a taste exact, yet unconfin'd;
A knowledge both of books and human kind;
Gen'rous converse; a soul exempt from pride;
And love to praise, with reason on his side?
Such once were critics; such the happy few,
Athens and Rome in better ages knew.

<div align="right">Pope, Essay on Criticism, 631–44</div>

Yet literary critics, in their turn, have questioned Pope's own poetic credentials. Matthew Arnold, for example, in his essay 'The Study of Poetry' (1880), argues: 'though they may write in verse, though they may in a certain sense be masters of the art of versification, Dryden and Pope are not classics of our poetry, they are classics of our prose'. This raises a question relevant to this study: to what extent is poetry defined and demarcated by 'versification'?[18] Alfred S. West in his 1896 introduction to, and commentary on, Pope's *Essay* includes the chapter 'Was Pope a Poet?' in which he isolates the main poetic problem here: 'The *Essay on Criticism*, like the *Essay on Man*, is a didactic poem, and some writers have denied that a didactic poem is a poem at all. For a didactic work is intended to convey instruction, and pleasure, not instruction, is the immediate end of poetry' (West [1896] 2014: 16–17). Interestingly, this statement is accompanied by the following footnote: '"Delight is the chief if not the only end of poesy: instruction can be admitted but in the second place; for poesy only instructs as it delights." (Dryden, *Defence of Essay on Dramatic Poesie*).' Arnold brings our two poet-critics into alignment; West brings one to bear on the other; indeed Pope borrows ideas and phrases from Dryden's literary–critical prefaces throughout his *Essay*.

The *Essay on Criticism* is, just like Pope's *Iliad* translation, composed in heroic rhyming couplets and from within this scheme Pope reflects on poets' use of meter and rhyme and critics' assessment of it. He chastises those critics who 'by numbers judge a poet's song' (337), 'Who haunt Parnassus but to please their ear' (341), who 'equal syllables alone require' (344). He cites some clichéd 'still expected rhymes' (349):

Where'er you find 'the cooling western breeze',
In the next line, it 'whispers through the trees':

If 'crystal streams with pleasing murmurs creep',
The reader's threaten'd (not in vain) with 'sleep'.

<div align="right">Pope, Essay on Criticism 350–4</div>

The implication of this is that although he writes in rhyme himself, he would never have recourse to such 'unvaried chimes' (348). Homer and Dryden both appear (the latter in, this time, his role as poet rather than critic) as counterpoints following this critique of rhyme for rhyme's sake:

'Tis not enough no harshness gives offence,
The sound must seem an echo to the sense.
[…]
When Ajax strives some rock's vast weight to throw,
The line too labours, and the words move slow;
[…]
The pow'r of music all our hearts allow,
And what Timotheus was, is Dryden now.

<div align="right">Pope, Essay on Criticism 365–6, 371–2, 382–3</div>

Pope uses the rhyming couplet in his didactic poetry, in his Homeric translation, and in his own (mock-)epic writings. It is not, then, the meter or rhyme scheme that marks generic distinctions in his work, but more thematic criteria. Similarly, within the corpus of archaic Greek poetry: the hexameter was the unifying factor, within which 'genres' (or sub-genres, or 'modes')[19] could be distinguished. But as Arnold, so Aristotle:

οὐχ ὡς κατὰ τὴν μίμησιν ποιητὰς ἀλλὰ κοινῇ κατὰ τὸ μέτρον προσαγορεύοντες· καὶ γὰρ ἂν ἰατρικὸν ἢ φυσικόν τι διὰ τῶν μέτρων ἐκφέρωσιν, οὕτω καλεῖν εἰώθασιν· οὐδὲν δὲ κοινόν ἐστιν Ὁμήρῳ καὶ Ἐμπεδοκλεῖ πλὴν τὸ μέτρον, διὸ τὸν μὲν ποιητὴν δίκαιον καλεῖν, τὸν δὲ φυσιολόγον μᾶλλον ἢ ποιητήν·

Thus they do not call them poets in virtue of their representation but apply the name indiscriminately in virtue of the metre. For if people publish medical or scientific treatises in metre the custom is to call them poets. But Homer and Empedocles have nothing in common except the metre, so that it would be proper to call the one a poet and the other not a poet but a scientist.

<div align="right">Aristotle, Poetics 1447b</div>

The relationship between versification and poetry; the question of utility versus pleasure; the marking of genre by meter or theme: these are persistent debates in classical scholarship, in literary criticism – and in poetry itself.

IV Rhyme Revisited: William Morris' *Odyssey*

The rhyming couplet in Homeric translation did not die out completely with Wolf. In 1887 a translation of the *Odyssey* in two volumes was published by the English poet and designer William Morris and he chose to revive this rhyme scheme: rather than adopting the heroic couplet, he used a longer line of his own invention, based on anapaests.[20] There was no dearth of *Odyssey* translations at this time: from Worsley's Spenserian stanzas and Lovelace Bigge-Wither's accentuated blank verse in the 1860s, to Du Cane and Palmer's translations in the early 1880s, Morris was vying with plenty of contemporary versions. Morris' translation met with mixed reviews.[21] Oscar Wilde praised it, as 'of all our English translations this is the most perfect and the most satisfying',[22] whilst Mowbray Morris disparaged it: 'By this clumsy travesty of an archaic diction, Mr. William Morris [...] has overlaid Homer with all the grotesqueness, the conceits, the irrationality of the Middle Ages'.[23] Most relevant to this chapter, Morshead felt there was a metrical gap which Morris' translation filled: 'The couplets of Pope, the Spenserian stanzas of Worsley and Conington, form the high-water mark of what can be done [...] but the antitheses, the forced pauses, of the one, and the festooning of the separate stanzas, by the other, cancel a quality of the original'.[24] In this section I consider why Morris went back to the rhyming couplet and how he innovated on it. I ask how successful his translation was both as English literature and as a form of classical scholarship, and how it squared with the post-Wolf idea of a questioned Homer. According to Wilde, '[h]ere we have a true work of art, a rendering not merely of language into language, but of poetry into poetry'.[25] Wilde continues, describing Morris' translation as 'not the fidelity of a pedant to his text but rather the fine loyalty of poet to poet'[26] and Morris himself makes the very same claim in a letter of 1875: 'I have translated as a poet and not as a pedant'.[27] Can Morris' use of the rhyming couplet be seen as symptomatic of a retreat from philology to poetry? How does this fit with Morris' education, approach, and goals and to what extent does it set his work apart from the unabashedly literary–critical activity of Dryden and Pope?

Mowbray Morris continues his invective against Morris' medievalism: 'this grotesque manner was natural and common to the Elizabethan writers, and to Chapman in particular; with Mr. Morris it is but an extreme form of that affectation which plumes itself on despising the thoughts, manners, and needs of its own time, and is, in effect, the most odious shape that false culture can assume'.[28] William Morris can be described, in many aspects of his life and work, as a man out of his time – whether looking back to a Chaucerian England or the

Iceland of the Old Norse Sagas or considering a utopian future like that envisaged in his novel *News from Nowhere*. And yet, he was simultaneously immersed in his time, sensitive to its problems and embroiled in its politics. Morris' daughter, May, writes: 'Between the publication of Sigurd in the year 1877, and completion of the Odyssey in 1887, towards the end of August, much has happened. Ideas that lay at the back of my father's mind all through life have now come to the front and demand to be heard; his criticism on the life around him finds expression.'[29] At this point, Morris was fully engaged in the socialist cause, giving speeches at mass protests and writing for the *Commonweal*, and he hoped that he might make 'a few pounds' from his *Odyssey* to fund his political pursuits. Indeed, the writing of his *Odyssey* translation often had to be fitted around and slotted into his extra-literary activities: 110 lines written on a journey from London to Edinburgh in September 1886; two hours' work on it between lectures in Glasgow; 50 lines on the return crossing after a heavy programme of speech-making with the Dublin Branch of the Socialist League. 'That whole summer he travelled with his Homer in his knapsack, pulling it out like an enormous piece of knitting to occupy himself *en route*' (MacCarthy 1994: 541). It is, of course, compellingly apposite that the *Odyssey*, of all poems, should be written during one's travels – but it is even more relevant that this particular poetic enterprise was interwoven with a political one. Though engrossed in Homeric epic and attempting to capture archaic diction, it is wholly inaccurate to say that Morris despised the needs of his own time. Rather than an 'affectation' of 'odious shape', his archaizing move can be read as part of a larger pattern of viewing modernity *through* antiquity. It is worth noting that at the same time as he was translating the *Odyssey* Morris was writing his novel *A Dream of John Ball* – a story about medieval Levellers – used to reflect on the modern age and the socialist cause. Like *News from Nowhere*, the narrative frame is one of time travel. Whereas *News from Nowhere* takes us forward, *A Dream of John Ball* takes us back –yet, in both cases, it is the present day that is cast in a bleak light. Morris does not 'despise' the needs of his own day: he critiques them, through the comparative lens offered by other times and other cultures.[30]

Morris' ability to look back and forward whilst simultaneously engaging with his own time is reflected in his approach to the classics and, in particular, to epic poetry. Composing poems that stretched to 42,000 lines apiece (in the case of *The Earthly Paradise*, the longest narrative poem in the English language), Morris was himself an epic poet: he saw himself as operating within a tradition that included Homeric and Vergilian epic as well as the Norse sagas. As MacCarthy (1994: 54) notes, 'Morris's view of the classics was eccentric and possessive. He

was always deeply stirred by the thought of epic tale-tellers, seeing himself as a part of that tradition. Later in his life he would set about translating *The Aeneid* and *The Odyssey* with a kind of nonchalance derived from loving them so much and knowing them so well'. Similarly, Boos (1984: 26) writes: 'Morris was nearly unique among Victorian poets in his view of the *poet as historian*: not a romantic individual, but one among a *community* of artists, living and dead, who have borne the immense responsibility of narration and creation'. He inserts himself into a tradition, taking on the mantle of epic storyteller. Asked by the *Pall Mall Gazette* to come up with his list of the hundred best books, Morris chose 'the kind of book which Mazzini called "Bibles"'[31] including Homer, Hesiod, the English Bible, the *Edda, Beowulf,* the *Kalevala, Shah-nameh,* the *Mahabharata* and the *Nibelungenlied.* In the notes to his list he wrote: 'They are in no sense the work of individuals, but have grown up from the very hearts of the *people*'. This a key point, to which I shall return. Interestingly, Morris left his list at 54. Vaninskaya (2010: 65) speculates that Morris was committed to filling up the 46 remaining spaces himself, with individually produced bibles of the people.

Morris did not champion Homer the man – Dryden and Pope's Homer of 'rich head' and 'fine ear' – but rather Homer the tradition, in line with Wolf and with the emerging oral–traditional approach to epic poetry. And yet, somehow, he still favoured the rhyming couplet. There must, therefore, be more to this scheme than capturing the 'spirit' or intention of an original author, as Pope would profess. I suggest that we therefore reconsider the rhyming couplet here in terms of its potential for traditionality, and for genre recognition. I also suggest that we consider the relevance of the rhyming couplet to Morris at that particular time. He had, after all, written poetic 'Scenes from the Fall of Troy' much earlier in his life (including that of the parting of Hector and Andromache), but did not compose them in the metrical scheme of his later *Odyssey* – a poem that, I shall argue, was more poetically and politically informed.

Wilde comments on the rhyme scheme of Morris' *Odyssey*: 'in his desire for rushing and ringing meter, he has occasionally sacrificed majesty to movement, and made stateliness give place to speed; but it is really only in such blank verse as Milton's that this effect of calm and lofty music can be attained, and in all other respects blank verse is the most inadequate medium for reproducing the full flow and fervour of the Greek hexameter'.[32] This recalls Pope's statement with which I started, that Homer's own dactylic hexameter is able 'to run along with the warmth of his rapture' and reinforces my earlier point about the value of rhymed over unrhymed lines in translating Homer. Morris channels the Homeric hexameter through his own couplets: couplets with a longer line than the Augustan heroic

meter, closer in length, in fact, to the Homeric line. In Wilde's words, not only is rhyme 'the one chord we have added to the Greek lyre,' but Morris' use of it has shown 'that our English speech may be a pipe through which Greek lips can blow'. Interestingly, though, Wilde also calls Morris' *Odyssey* 'rather Norse than Greek'. It would seem that, to Wilde at least, the traditional feel of this translation is not restricted to one tradition, but can convey something of the 'essence' of epic poetry. Importantly, Morris translated the *Odyssey* in the same meter he had used for his 1876 *The Story of Sigurd the Volsung and the Fall of the Niblungs*. Through this metrical unity, Morris marks out a genre: a genre of epic poetry that crosses cultures, much like his list of best books.

Morris' approach to formulae is strikingly modern. Earlier in this chapter I sketched a development from reverence for formulae because of the looming figure of Homer, through a refocusing on them as economical oral–traditional building blocks, to a later drive to reemphasize the importance of particular uses. Morris is post-Wolf (not just chronologically but, as we have seen, in his allegiance with traditionality), yet he claimed that part of the *Odyssey*'s 'great simplicity' is that it has no redundant words, no words without a precise meaning.[33] Formulae are not treated as needlessly repetitive, but as having weight. Indeed, this fits with Morris' approach to epic, as the weight of formulae is the accumulated weight of tradition.

The search for the essence of epic, for the story, is something that characterizes Morris' education – both his classical studies at Oxford and his later forays into Icelandic. Writing from Oxford, Morris groaned: 'My life is going to become a burden to me, for I am going, (beginning from Tuesday next) to read for six hours a day at Livy, Ethics, &c. – please pity me.'[34] Yet, as MacCarthy (1994: 54) argues, 'his hatred of the classics in fact was only nominal. He did not hate the classics, but he loathed how Oxford taught them'. Similarly, Morris' teacher in Icelandic, Eiríkr Magnússon, describes how his pupil was averse to memorizing grammatical paradigms – because his interest lay elsewhere. 'No, I can't be bothered with grammar', Morris said to his instructor, 'I want the literature, I must have the story.'[35] And yet his professed grammatical aversion did not preclude a deep interest in – and affinity for – words and language. MacCarthy (1994: 291) describes Morris' Icelandic translation as 'a word-game, an Anglo-Icelandic Scrabble, which often had the two of them [Morris and his teacher] chortling with delight'. It seems to me that Morris played a similar game with Homeric translation, both paying close attention to and playing with the Greek original. Morshead, in his 1888 review of the second volume of Morris' *Odyssey*, challenges those critics who attacked Morris' 'mannerisms':

My strong impression is that half these 'mannerisms' [...] are more careful approximations to Homer's manner than some critics have discerned. As to the "Phaeacians oar-fain" (p. 232, l.36) for Φαιήκεσσι φιληρέτμοισι what is the objection? We speak of a person as "heart-sick", of Carlyle as "world-weary", without scruple or blame; why may not the Phaeacians be "oar-fain"? Homer calls them so by a compound, not a periphrasis. Suppose "oar-fain" is not elsewhere used in English literature—well, somebody once used "heart-sick", or "world-weary", for the first time.

This encapsulates perfectly Morris' approach to translating Homeric noun–epithet formulae. He recognizes the compound as being characteristic of Homeric adjectives and faithfully renders it with a compound also in English when possible. He is criticized for stretching what is possible, as many of these English compounds are his own coinages – but his loyalty to Homeric language and patterning is clear. The fact that he coins new terms to represent the most fundamental elements of ancient epic diction is not a jarring incongruity but rather representative of Morris' active engagement with – and insertion of himself into – the epic tradition. And after all, there are sufficient *hapax legomena* in the Homeric poems to suppose a certain number of coinages there too.

Let us examine Morris' approach to Homeric translation through one selected passage. As a complement to the parting of Hector and Andromache, I have chosen part of the reunion of Odysseus and Penelope (Book 23): the test of the bed, another pivotal and poignant scene. To probe and prove the identity of her restored husband, Penelope gives him a task that Odysseus would know to be impossible: to move their marital bed, which he had built around a tree and thus fixed in place.

ὣς ἂρ ἔφη πόσιος πειρωμένη· αὐτὰρ Ὀδυσσεὺς
ὀχθήσας ἄλοχον προσεφώνεε κεδνὰ εἰδυῖαν·
'ὦ γύναι, ἦ μάλα τοῦτο ἔπος θυμαλγὲς ἔειπες.
τίς δέ μοι ἄλλοσε θῆκε λέχος; χαλεπὸν δέ κεν εἴη
καὶ μάλ' ἐπισταμένῳ, ὅτε μὴ θεὸς αὐτὸς ἐπελθὼν
ῥηιδίως ἐθέλων θείη ἄλλῃ ἐνὶ χώρῃ.
ἀνδρῶν δ' οὔ κέν τις ζωὸς βροτός, οὐδὲ μάλ' ἡβῶν,
ῥεῖα μετοχλίσσειεν, ἐπεὶ μέγα σῆμα τέτυκται
ἐν λέχει ἀσκητῷ· τὸ δ' ἐγὼ κάμον οὐδέ τις ἄλλος.
θάμνος ἔφυ τανύφυλλος ἐλαίης ἕρκεος ἐντός,

Odyssey 23.181–90

This is Morris' translation in rhyming couplets:

> Thus she spake to prove her husband; but Odysseus, grieved at heart,
> Spake thus unto his bed-mate well-skilled in gainful art:
> "O woman, thou sayest a word exceeding grievous to me!
> Who hath otherwise shifted my bedstead? Full hard for him should it be,
> For as deft as he were, unless smoothly a very God come here,
> Who easily, if he willed it, might shift it otherwere.
> But no mortal man is living, how strong soe'er in his youth,
> Who shall lightly hale it elsewhere, since a mighty wonder forsooth
> Is wrought in that fashioned bedstead, and I wrought it, and I alone.
> In the close grew a thicket of olive, a long-leaved tree full-grown."

And, for comparison, Fagles' 1996 translation of the same passage:

> Putting her husband to the proof—but Odysseus
> blazed up in fury, lashing out at his loyal wife:
> "Woman—your words, they cut me to the core!
> Who could move my bed? Impossible task,
> even for some skilled craftsman—unless a god
> came down in person, quick to lend a hand,
> lifted it out with ease and moved it elsewhere.
> Not a man on earth, not even at peak strength,
> would find it easy to prise it up and shift it, no,
> a great sign, a hallmark lies in its construction.
> I know, I built it myself—no one else ...
> There was a branching olive-tree inside our court".

I have intentionally chosen a passage with relatively few formulaic noun-epithet pairings (κεδνὰ ἰδυῖαν five times in the *Odyssey*, τανύφυλλος ἐλαίης four times), as I would like to move away from my earlier mode of analysis and consider Morris' translation from a broader perspective. The first general observation to make is that the translation is, in fact, very literal – unlike those of Pope and Dryden. Despite his professed aversion to grammar, Morris traces the Greek text closely.[36] One compelling example from word choice is 'bed-mate': an interesting translation for ἄλοχον here, as though it loses many of the connotations of 'wife' it is both more etymologically accurate and captures the essence of the test itself (the bed is the great sign). But it is in terms of word order that Morris' translation really excels – and differs from the heroic couplets that we have considered. Morris does not follow Dryden and Pope in placing key concepts at the rhyming line end, but rather follows Homer's ordering. For example, the concept on which

this passage hinges is the μέγα σῆμα – the great sign which the bed constitutes, Morris' 'mighty wonder'. This is not placed at the end of the line, the emphatic position within this rhyme scheme (Fagles chooses to topicalize it) but is followed by an emphatic, if superfluous, 'forsooth' – just as τέτυκται completes the final two feet of the Homeric hexameter. Similarly, the line end χαλεπὸν δέ κεν εἴη is rendered as 'full hard for him should it be', keeping the verb at the very end, by contrast with Fagles' 'impossible task' which grabs the attention yet omits the verb entirely. And again, θεὸς αὐτὸς ἐπελθὼν is translated as 'a very God come here' – much more faithful to the end-stopped structure of the Homeric hexameter than Fagles' run-on 'unless a god / came down in person' and with no attempt to relocate the god to emphatic position at the rhyming end of the line. Perhaps the most striking adherence to the original arrangement is evident in the fact that the end of the final couplet I have quoted from Morris does not coincide with the end of the narrative unit, but the natural break in sense cuts through the couplet. In taking the Morris quotation to the end of the rhyme pair, therefore, the other versions quoted stop *in medias res*.

So, what does all this tell us about Morris' approach to Homeric translation? In his review of the first volume of Morris' *Odyssey*, Morshead presented the conundrum: 'the question of the true meter for translating Homer, like the question of free will, "finds no end, in wandering mazes lost".'[37] Why did Morris choose the rhyming couplet, and why did he invent a form different from the heroic couplet used by Pope and Dryden? I argued in Part II that Pope and Dryden employ the heroic couplet in a way that is not entirely faithful to Homer's Greek in the sense of being a word-for-word translation, but that they use the tools offered by this metrical scheme (antithesis and balance, word order, and especially emphatic positioning) to capture the flow of the Homeric hexameter. This fits with the overarching aim of capturing the 'warmth of Homer's rapture'; his 'notions'; his 'rich head' and 'fine ear'. It was a way of uncovering and presenting the intention of an (assumed) author. Morris, by contrast, produced a much more literal, line-by-line and word-for-word translation, shaping the rhyming couplet (even lengthening it to something different from and indeed more than the heroic couplet) to fit the Greek word order and not the other way round. What mattered to Morris was not Homer's intention but the story that grew 'from the very hearts of the people'. He saw himself as part of the epic tradition – contributing to it through his own poetic compositions, but also transmitting it, acting as a conduit for it, bringing Homeric epic (as well as Vergilian and Icelandic) to new audiences. These two projects – composition and translation – were very different for Morris and his literal rendering of the Homeric text is

indicative of that separation. We might contrast, for example, his *Life and Death of Jason*: a poem on a classical theme, but clearly a literary reworking and not a straight translation. We can trace here a spectrum of poetic activity, which maps onto varying levels of engagement with and proximity to a (classical) poetic inheritance. However, in using a metrical scheme that had much in common with and yet was not the heroic couplet, Morris makes the point that he is placing himself in the tradition of Homer – and *not* the tradition of Dryden and Pope.

The story of the people mattered to Morris more keenly than ever during his Odyssean period, as it was also the time of his most intense socialist engagement. His choice of metrical scheme, then, is likely to have been coloured primarily by his poetic principles: his longing for the story and his prizing of tradition. As Wilde wrote: 'Of all our modern poets, Mr. William Morris is the one best qualified by nature and by art to translate for us the marvellous epic of the wanderings of Odysseus. For he is our only true story-singer since Chaucer; if he is a Socialist, he is also a Saga-man.'[38] It is no coincidence that, as I already noted above, Morris had used this particular kind of couplet already in *Sigurd*.[39] The rhyming couplet was chosen, not as a way to find Homer, but as a way to unite the modern reader with 'the very hearts of the people' from which the epic tradition grew – much as *A Dream of John Ball* leads us from modernity to the medieval past. For Morris, the rhyming couplet was another way to travel in time. As Whitla (2004: 84) puts it, for Morris 'the act of translation is a political act of cultural recuperation'. MacCarthy (1994: 563) notes that '[h]e was not, after all, in the academic rat-race' – currents in classical scholarship were not the main impetus behind his translation practices. Though Pope's dictum '[o]ne science only will one genius fit' surely applies to writer–politician–designer Morris far less than to most, it was poetry, rather than literary criticism, that emerges as his foremost 'science'. Yet, as an educated, cultured and classically trained man with a lively correspondence, he was not unaware of academic debates nor did he refrain from commenting on them. Disengagement from classical scholarship sits as uncomfortably with Morris as with Pope. As Morris remarks in his *Political Writings*: 'modern research has made Homer a dim and doubtful shadow to us, while it has added clearness to our vision of the life of the people of that time, who were the real authors of the Homeric poems'.[40] Morris' meter, his translation practice, expresses what he believes scholarship to have discovered: the people as poet.

From Epic to Monologue

Tennyson and Homer

Isobel Hurst

Goldsmiths, University of London

For poets in the nineteenth century who were attempting to develop forms that might compete with the ubiquitous and popular genre of the novel, the challenge of writing epic was particularly fraught. Allusions to the classical tradition might exclude some readers, yet an increasing demand for translations proved that there was an appetite for authors such as Homer and Vergil in English. Reworkings of episodes from classical epic and tragedy are prominent in Victorian literary and popular culture (in forms such as theatrical burlesques, cartoons, and children's books as well as poems, paintings and dramatic performances). Some of the most enduring responses to Homer from this period are Tennyson's 'Ulysses' 'The Lotos-Eaters' and 'Oenone'. These poems take the epic tradition in a new direction by presenting the voices of individual characters without any narrative framework, much as the dramatic monologue resembles a Shakespearean soliloquy without a dramatic context. In 'Oenone' Tennyson follows a model established by Ovid in the *Heroides*, giving a voice to a female character whose story, previously told in Quintus of Smyrna's *Posthomerica*, is already an embellishment of Homer's authoritative version of the Trojan War. Having experimented with the choric song as a collective voice of resistance to the demands of society in 'The Lotos-Eaters', in 'Ulysses' Tennyson creates an innovative and distinctive voice for the hero in a monologue only a fraction of the length of a single book of Homer. In these poems Tennyson encapsulates epic themes, presenting them in a form that places the reader as an auditor within the world of the poem to create a modern adaptation of the oral tradition.

The form Tennyson employs in 'Ulysses' and 'Oenone', the dramatic monologue, is both modern and classical: it has been described as 'the primary Victorian

genre' (Armstrong 1993: 12) and 'the most significant poetic innovation of the age' (Slinn 2002: 80), yet critics have also connected the dramatic monologue with the Theocritan idyll and with Ovid's *Heroides* (Sinfield 1977; Pattison 1979; Markley 2009). Tennyson's choice of the Homeric hero Ulysses/Odysseus as the central figure of his most celebrated classical dramatic monologue suggests that the *Odyssey* itself is a significant precursor. The *Odyssey* models the adaptation and reworking of established narratives for new audiences, supplementing the version told by the anonymous narrator with the perspectives of individual characters: Odysseus and others tell and retell the story of the Trojan War and the hero's journey home, embellishing or concealing details to suit a particular occasion. Jeremy M. Downes identifies the poem as an exemplar of the 'radical discontinuity' inherent in the epic genre: 'rather than a single identifiable *Odyssey*, innumerable *Odysseys* present themselves' (1997: 1). The dramatic presentation of character makes the Homeric poems peculiarly appropriate sources for monologues, since the heroes speak out 'fluently and coherently', so that rhetorical prowess can be as significant to the hero's story as his physical strength (Minchin 2007: 5). Such speeches are often public performances in which the hero exhorts or rebukes his followers, articulating the values of his warrior society, or offers a narrative of his adventures in response to the hospitality of others. The Victorian dramatic monologue, a performative utterance addressed to a silent or possibly absent and imagined auditor, allows for the expression of internal conflict and anxiety, rage or doubt by positioning controversial or anti-social sentiments as the words of a speaker other than the poet. There is no narrator who might direct the reader's interpretation of a speaker, so the poet sets up contradictions and uncertainties to suggest that the speaker's self-representation may be deceptive. By choosing a speaker who is already a familiar figure from the Homeric poems, Tennyson can subvert the reader's expectations and introduce shades of introspection and melancholy undertones to the character. Speaking through Oenone or Ulysses also allows Tennyson to approach the prestigious genre of epic from a modern perspective of scepticism about heroism, both challenging and paying tribute to notable literary precursors such as Homer, Vergil, Ovid and Dante and implicitly placing himself as their equal.

Homer and the Victorians

Homer attained a singularly prominent status in the Victorian reception of ancient Greece. Frank M. Turner describes it as a 'truism for nineteenth-century

commentators' to describe the *Iliad* and *Odyssey* as 'the Bible of the Greeks [...] with myths, heroes and historical narratives wherein lay both a store of moral precepts and the foundation of a sense of cultural unity' and notes that critics like Matthew Arnold found parallels between the cultural functions of the texts, based on 'the reading of the Bible in British schools and the reading of Homer in ancient Greek schools' (1981: 140–1).[1] Those who read a small stock of classical texts repeatedly in their schooldays might retain a lifelong habit of readily translating the poems aloud to entertain family and friends instead of reading a novel or contemporary poem, and quoting or adapting those texts from memory (Joseph 1982: 105–15). For Arnold, the *Iliad* and the *Odyssey* were 'the most important poetical monument existing'. He begins *On Translating Homer* (1861) by noting that he had considered writing his own translation 'as instruction spreads and the number of readers increases' and had therefore spent one or two years reading and rereading 'a poet whom I had already long studied' (1960: 97). John Talbot observes that Victorian debates about the form that translations of Homer and Vergil should take significantly increased the number of new translations and 'helped to consolidate Homer's high place in the English literary consciousness' (2015: 57).

Doubts about the authorship of the epics (the Homeric question) and the authenticity of the books of the Bible (historical criticism), originating in German historical and philological scholarship, provoked intense reactions among poets. Friedrich August Wolf, in *Prolegomena ad Homerum* (1795), argued that the *Iliad* and *Odyssey* were not long poems written by a single author but rather collections assembled by a later editor from short ballads composed and performed by oral poets.[2] Given the prominence of ballads in the Romantic aesthetic and the emergence of experimental hybrid forms such as Wordsworth's and Coleridge's *Lyrical Ballads* (1798), the idea that Homer could be allied with folk poetry might seem a promising one. However, in a passage in Elizabeth Barrett Browning's *Aurora Leigh* (1856) (explored further in Emily Hauser's chapter in this volume), the heroine brands Wolf 'a kissing Judas' and 'an atheist' (5.1246, 1254) for questioning the existence of a single author of the *Iliad* and *Odyssey* and declares the idea that the epics came into existence over a long period of time and without a guiding hand to be as unsettling as the controversy over scientific challenges to the biblical account of creation:

And if the Iliad fell out, as he says,
By mere fortuitous concourse of old songs,
Conclude as much, too, for the universe.

5.1255–7

Robert Browning's 'Development' (1889) articulates a similar sense of dislocation on learning that there might be 'No actual Homer, no authentic text' (71). However, this is only one stage in the poem's representation of an ongoing fascination with the *Iliad* and *Odyssey* in various forms, beginning with childhood games based on the story of the Trojan War, Alexander Pope's translation of Homer, reading the poems in Greek and finally engaging with the question of the poems' authorship and the discoveries of archaeologists such as Schliemann. Towards the end of the Victorian period the distance between poetry and scholarship increased, Meilee Bridges argues, with a 'dialectic emerging [...] between scholarly criticism of Homeric epic and contemporary literature's imaginative, affective, and ludic responses to and representations of reading ancient Greek poetry' (2008: 166). The American classicist Herbert Weir Smyth, in his 1887 review of *Homer* by Richard Claverhouse Jebb, claims that the 'literary temperament of English scholars, the aesthetic judgment of English poets, have alike militated in favor of "a master-hand at the centre of the work"' (1887: 474). The closeness between English literature and classical scholarship that Smyth alludes to here insinuates itself into his own language in the first sentence of the review: 'All scholars, not only the initiated, but also those who have still to penetrate more deeply into Homer's demesne, will welcome the appearance of this volume' (474). 'Homer's demesne' evokes one of the most notable of the nineteenth-century readers who sought an initiation into Greek literature by means of translations, commentaries and classical dictionaries. In the sonnet 'On First Looking into Chapman's Homer' (1816), Keats celebrates the 'loud and bold' translation that empowered him to 'breathe' Homeric air: 'Oft of one wide expanse had I been told / That deep-brow'd Homer ruled as his demesne.'

Before the professionalization of university scholarship in the late nineteenth century, influenced by the German model, much influential criticism was written by learned amateurs such as William Ewart Gladstone, a Member of Parliament, Cabinet member and later Prime Minister. As Cornelia Pearsall has demonstrated in her monograph *Tennyson's Rapture* (2008), Gladstone was a significant interlocutor for Tennyson on the subject of Homer, having carried on a lengthy debate by letter with their mutual friend Arthur Hallam on the qualities of Ulysses (both Gladstone and Hallam refer to the Homeric hero as 'Ulysses' rather than 'Odysseus') and later debating with Tennyson on the poet's translation of some passages from the *Iliad* (150–77). Gladstone published periodical articles and a substantial three-volume work, *Studies on Homer and the Homeric Age* (1858). Turner claims that Gladstone's writings on Homer

'constituted the single most extensive body of Victorian Homeric commentary' (1981: 160). Readings and criticism of the Homeric epics in the Victorian period often illuminate the extent to which classically educated men saw themselves as the equals of the Greeks and applied their understanding of ancient Greek culture to contemporary society. While Parliament debated and passed major changes in the legislation concerning marriage and divorce (the Matrimonial Causes Act of 1857, which made divorce a civil procedure no longer requiring an Act of Parliament to dissolve a marriage), Gladstone was contemplating the role of women in marriage in relation to the lack of any precedent for divorce in Homer:

> Nor have we any instance where a wife is divorced or taken away from her husband, and then made the wife of another man during his lifetime. The froward Suitors, who urge Penelope to choose a new husband from among them, do it upon the plea that Ulysses must be dead, and that there is no hope of his return: a plea not irrational, if we presume that the real term of his absence came to even half the number of years which Homer has assigned to it (1858: 2.481–2).

Gladstone goes on to argue that the plot of the *Odyssey* represents probably the most 'stringent application of the doctrine of indissolubility' of marriage based on desertion in any period, and that Penelope's aversion to the idea of remarriage is a 'comely monument' to the Heroic Age (2.489).

Gladstone's reading of the *Odyssey* makes much of the hero as a devoted husband, father and monarch, a 'prisoner' of the selfish and 'sensual' Calypso, who 'sees him pining in wretchedness for his home and family from day to day; and well knows the distress that his absence must cause to a virtuous wife and son, as well as the public evils, sure to arise from the prolonged absence of a wise and able sovereign' (2.338). In 'Homeric Characters in and out of Homer' (1857), Gladstone claims that Odysseus is one of three Homeric characters to have been 'mangled by the later tradition much more severely than any others' (235). He contends that Homer 'makes Ulysses a model of the domestic affections for heroes' as a counterbalance to his calculating nature, and that Vergil and Euripides are responsible for emphasizing the worst features of the character (239). His description of Odysseus after his return to Ithaca is manifestly different from the restless and discontented figure in Tennyson's poem: 'Ulysses, after a long course of severe discipline patiently endured, has awarded to him a peaceful old age, and a calm death, in his Ithaca barren but beloved, with his people prospering around him' (1858: 2.393).

The Epic tradition

The difficulty of defining epic as a genre, given significant differences in form and theme between the texts most prominently labelled as such, especially in the post-classical era, encourages the idea of a tradition in which the epic can take a variety of forms. The *Iliad* and the *Odyssey* establish such divergent approaches to the heroic ideal that they inspire competing traditions of 'epic, with its linear teleology' and 'romance, with its random or circular wandering' (Quint 1993: 9). In *The Idea of Epic* (1991), J.B. Hainsworth distinguishes epic from related genres such as tragedy, romance, 'primitive song' and history in terms of form, moral purpose, and content or spirit (1–2). Hainsworth emphasizes the diversity of epic, and the problems with attempting to characterize different forms of the epic by resorting to the creation of 'subgenres' like 'heroic epic, historical epic, romantic epic, primary epic, or literary epic', since those subgenres often intersect (5). Such intersections arise partly from the competitiveness of epic poets, who attempt to subsume and exceed the works of their predecessors – Vergil reworks the *Iliad* and the *Odyssey* from a Roman perspective while also alluding to a sophisticated Alexandrian distrust of epic; both Dante and Milton invoke Homer, Vergil and Ovid as cherished precursors, while insisting on the superiority of Christian virtues to classical models of heroism (which Milton associates with Satan). For English authors, the prospect of attempting to outdo *Paradise Lost* was as daunting as the notion of competing with Homer had been for Hellenistic poets such as Callimachus. How to write poetry that would represent a serious engagement with the tradition of epic poetry, without necessarily reproducing the form of Homeric or Vergilian epic was a challenge that preoccupied poets. Some notable examples do not represent an attempt at twelve or twenty-four books of heroic epic but select a few identifiably epic features such as hexameter verse or extended similes, or narrative set pieces such as the visit to the underworld or a storm at sea and rework them in parodic or unconventional forms. For example, Alexander Pope's mock-epic poems *The Rape of the Lock* (1714) and *The Dunciad* (1728) artfully transform the set pieces of epic into social and literary conflicts. Byron's 'epic satire' *Don Juan* (1819) belittles epic themes and mannerisms, pointing out the absence of heroism in the contemporary world.

Among the long poems of the nineteenth century, several of the most celebrated belong to a continuing tradition of epic influence and also to Romantic innovativeness in the creation of hybrid genres: Wordsworth's autobiographical *Prelude* (1850), Tennyson's Arthurian *Idylls of the King* (1859–85), Elizabeth

Barrett Browning's novel epic *Aurora Leigh* (1856) and Robert Browning's narrative made up of dramatic monologues, *The Ring and the Book* (1868–9). Of these poets, Tennyson came closest to writing the 'Arthuriad' that Milton had planned but did not complete, but the *Idylls of the King* was not the unified and confident epic that might have been expected to crown Tennyson's poetic career. Alfred Austin, in *The Poetry of the Period* (1870), scornfully described the four *Idylls* published in 1859 as 'exquisite cabinet pictures; but that is all', 'four charming and highly finished fragments or driblets' (6–7). In addition to the perceived fragmentariness of the *Idylls*, Tennyson's mediaevalism could also be regarded as a weakness, since the question of whether a poet ought to write about the modern world is one that particularly troubled poets and critics in the Victorian period. In *Epic: Britain's Heroic Muse, 1790–1910* (2008), Herbert F. Tucker demonstrates that numerous epics engaged with contemporary life as well as with British history and legend. The increasing popularity and seriousness of prose fiction made the novel a formidable competitor, as Clough's review of Matthew Arnold's 1853 *Poems* suggests:

> Studies of the literature of any distant age or country; all the imitations or *quasi*-translations which help to bring together into a single focus the scattered rays of human intelligence; poems after classical models, poems from Oriental sources, and the like, have undoubtedly a great literary value. Yet there is no question, it is plain and patent enough, that people much prefer 'Vanity Fair' and 'Bleak House'.
>
> Armstrong 1972: 34

Classically educated poets often chose to approach the epic tradition obliquely and in hybrid or fragmentary forms. There was an ambivalence about the genre amongst those whose education had been dominated by reading and translating classical epic: Colin Graham suggests that some poets believed 'epic was no longer possible or desirable, even potentially embarrassing and crude' (1998: 3). Clinton Machann comments that 'the long poem with overt or implied pretensions to the genre of epic' was a particularly challenging form for Victorian poets. Machann takes Matthew Arnold as an example of the 'conflicted' poet, since he attempted to 'recapture a classical poetry of the "grand style" in dramatic and epic narrative verse' and 'rejected his own best efforts to compose long poems', such as *Empedocles on Etna* (2010: 4). As Stephen Harrison observes in 'Some Victorian Versions of Greco-Roman Epic', poets such as Arnold, Tennyson and Clough employ 'various strategies of diversification and miniaturisation' (2007: 21): in 'Ulysses' (1842), *The Bothie of Tober-na-Vuolich* (1848) and 'Sohrab

and Rustum' (1853) these poets respond to Homer and Vergil through experiments in translation, mock-heroic verse and the use of formal features such as extended similes and epic formulae.

Tennyson concluded that the way for a poet to make his mark might be 'by shortness, for the men before me had been so diffuse, and most of the big things [...] had been done' (H. Tennyson 1897: 1.139). There were classical precedents in the epyllion and the idyll, forms which allowed for romance, humour, a focus on unheroic figures and social observation.[3] Robert Pattison notes that Tennyson was influenced by Hellenistic poets such as Theocritus, Callimachus, Bion and Moschus, whose sophisticated and erudite poems display eclectic borrowings from earlier literature. Callimachus and Theocritus engage with the question of how to emulate Homer without producing inferior imitations of the *Iliad* and *Odyssey*. In 'appropriating the machinery of the Homeric epic for the study of psychological states', poems such as Theocritus's *Idyll* XI anticipate Tennyson's classical poems (Pattison 1979: 19–21). Tennyson's 'English Idyls'[4] include 'The Epic' and 'Morte d'Arthur' (Tennyson 1987: 2.1–19), the first of which is a frame poem explaining the survival of the second, a fragment of twelve-book Arthurian poem. The 'Morte d'Arthur' is saved from the flames after the poet Hall decides to burn his epic (as Vergil is said to have wanted the *Aeneid* to be destroyed) because he thinks both form and content anachronistic:

> 'He thought that nothing new was said, or else
> Something so said 'twas nothing—that a truth
> Looks freshest in the fashion of the day:
> God knows: he has a mint of reasons: ask.
> It pleased *me* well enough.' 'Nay, nay,' said Hall,
> 'Why take the style of those heroic times?
> For nature brings not back the Mastodon,
> Nor we those times: and why should any man
> Remodel models? these twelve books of mine
> Were faint Homeric echoes, nothing-worth,
> Mere chaff and draff, much better burnt'.

30–40

A crucial aspect of the epic tradition is the poet's display of skill in the handling of inherited materials. Hainsworth distinguishes between the collaborative form of traditional heroic poetry, influenced by the demands and reactions of the audience as well as the singer's own artistry, and the more sophisticated form of primary epic. In the *Iliad*, the poet does not simply present a story (the tale of Troy) but interprets the events in relation to a theme, the

devastating anger of Achilles (1991: 8). Homer's omniscient and omnipresent narrator may be described as objective, not subjective or ironically distanced from the author. It is in the later development of secondary or 'literary epic' that the poet begins to 'add a private note to his public voice' (Hainsworth 1991:10). The notion of multiple or 'further' voices undermining the narrator is particularly associated with readings of Vergil (Lyne 1987: 224). However, in *Homeric Soundings* (1992), Oliver Taplin argues that the *Iliad* is not 'objective' or lacking in 'ethical colouring'; rather, Homer avoids 'explicit evaluation' or didactic 'moralizing' by the narrator and conveys implicit evaluation through focalization (6). The distinction Taplin identifies here is a significant one in relation to Victorian literature: the moralizing narrator who explicitly directs the reader's response appears intermittently in novels such as Thackeray's *Vanity Fair* (1848), Dickens' *Bleak House* (1853) and George Eliot's *Middlemarch* (1872) and more frequently in less complex narratives. The dramatic monologue, however, has no narrator separate from the speaker, so the reader must be alert to any implicit evaluation or ethical colouring in the speaker's self-presentation.

The Homeric epics lend themselves to reworkings in dramatic genres because speeches by the characters make up more than half of each poem. Jasper Griffin notes the 'high proportion' of speech in the two poems (55%); in the *Odyssey*, speech makes up more than two-thirds of the poem (68%). Griffin alludes to Plato's insight that Homer was 'the first and greatest of the tragic poets' and argues that 'without the example of Homer, showing the heroes and heroines of myth conversing in dialogue in a high style, Attic tragedy would never have come into existence in the form that it did', a hypothesis that would have 'grave implications' for later dramatists such as Seneca and Shakespeare (2004: 156) and thus for the dramatic monologue. While Tennyson's 'Ulysses', a dignified and eloquent speech by a great figure who has been involved in significant action, might be seen as an offshoot of the tragic tradition Griffin is describing here, other dramatic monologues inspired by Homer emphasize the domestic and comic aspects of the poem. Griffin emphasizes the diversity of speech in Homer: 'Not only gods and heroes speak, but also women, servants, and people not fit to be imitated by a gentleman; while even the heroes do not limit themselves to edifying and up-beat utterances, but complain, squabble, tell lies, insult one another, criticise the gods, and lament their fate' (2004: 158). The Homeric poems therefore (particularly the *Odyssey*) offer a precedent for the Romantic extension of literary representation to humble or even disreputable characters, encouraging the reader to examine domestic actions as carefully as the battles of heroes – like the reworkings of Greek tragedy in the novels of George Eliot or Thomas Hardy. Poems which

respond to the *Odyssey* can take up the voices of women or the anonymous companions of the hero or represent Odysseus himself in an unflattering light.

The dramatic monologue and its antecedents

A form which is recognized as distinctively Victorian yet manifestly connected to earlier literature, the dramatic monologue gives the poet a way to offer homage and critique to significant precursors much as poets like Milton did in their epics. It has long been recognized that Tennyson and Browning developed the dramatic monologue independently in the 1830s, with such early examples as Tennyson's 'St. Simeon Stylites' (written in 1833 and published in 1842), and Browning's 1836 poems 'Johannes Agricola in Meditation' and 'Porphyria's Lover'. The genre builds on Romantic and Victorian fascination with Shakespeare's soliloquies, although the absence of any dramatic context or other speakers means that the dramatic monologue tends to focus on conveying strong emotion or abnormal psychology. The monologue represents not solitary musings spoken aloud but a speech addressed to an auditor (whose voice is not heard in the poem), which may reveal more than the speaker intends.

Critics have also noted similarities between the Romantic ode and the Victorian dramatic monologue: Robert Langbaum's notion of 'the poetry of experience' breaks down the boundaries between lyrical, dramatic, and narrative genres (1957: 53). While 'the image of a dramatized "I" acting in a concrete setting' connects poems such as Keats's 'Ode to a Nightingale', Arnold's 'Dover Beach', and Browning's 'My Last Duchess', the speaker of the dramatic monologue is more likely to be read as separate from the poet than the speaker of a lyric poem (Rader 1976: 131). Tucker argues that Tennyson and Browning developed the dramatic monologue because they felt Romantic lyricism to be outdated (1985: 227). The dramatic monologue suits the tendency of Victorian poets towards introspection, questioning, and perplexity, while the persona or mask affords them some privacy. Browning, criticized for excessive subjectivity in his early poems, could claim objectivity by representing the subjectivity of the Duke of Ferrara or Mr Sludge, the fraudulent medium. That the poet is speaking as a character allows Browning to explore abnormal or criminal psychology and Tennyson to luxuriate in melancholy while simultaneously inviting the reader to judge the speaker. An interest in extreme mental states is characteristic of the genre, which developed simultaneously with advances in scientific theories of the mind (Faas 1988).

The separation between poet and speaker allows for dramatic irony: the poet manipulates the speech to create revelations that appear to be unintentional on the part of the speaker. Although the dramatic monologue is a pleasurable poetic form, critics emphasize that it requires work from the reader to establish an interpretation by negotiating 'a range of ambiguities' (Hughes 2010: 15). Langbaum's influential account of the dramatic monologue suggests that the reader of a poem such as 'My Last Duchess' experiences a tension between 'sympathy' for the speaker and 'moral judgement' and suspends judgement of Browning's Duke (who might have caused his wife to be murdered) to appreciate the speaker's power (1957: 83). Cynthia Scheinberg notes that not all readers will find the Duke's authority as attractive as Langbaum (1997: 177). The uncertainty of the reader's response to the speaker's superficially casual yet forceful assertion of absolute power over his former Duchess and his potential bride (whose father's envoy is revealed to be the auditor within the poem) has inspired many contrasting readings of the poem. Alan Sinfield comments that the reader of a dramatic monologue is confronted with 'a divided consciousness. We are impressed, with the full strength of first-person presentation, by the speaker and feel drawn into his point of view, but at the same time are aware that there are other possible, even preferable, perspectives' (1977: 32). Tucker claims that the form is so effective because 'the extremity of the monologist's authoritative assertion awakens in us with great force the counter-authority of communal norms' (1985: 228).

While much criticism of the dramatic monologue focuses on the genre as a product of the nineteenth century, some scholars have argued that a poem spoken by a character who is not the poet is anticipated in other genres or poetic forms, such as 'the complaint, the epistle and the humorous colloquial monologue' (Sinfield 1977: 42). A. Dwight Culler regards the dramatic monologue as a descendant of *prosopopoeia* and monodrama (1975: 368). Ovid's *Heroides*, epistles in elegiac couplets each attributed to a single mythical character and addressed to an absent lover, exhibit qualities like those of dramatic monologues. The female speakers are implicitly other than the poet, allowing for the creation of dramatic irony and a critique of each speaker's self-representation (her language may undermine the ostensible purpose of her utterance). Duncan F. Kennedy suggests that Ovid's 'marked deviations from the Homeric account' call attention to 'the subjectivity of the "writer's" viewpoint, which is a central feature of the form' (1984: 418–21). The poet can draw attention to his virtuosity in adapting traditional materials: Florence Verducci argues that Ovid's 'wit in conception, no less than in language' highlights 'the poet's creative presence in

the poem', a 'dispassionate, intellectual, emotionally anaesthetizing presence' (1985: 32).

Like Tennyson's much-criticized early 'lady poems', lyrics such as 'Mariana' and 'Oenone' (Christ 1987: 385), the *Heroides* focus on women deserted by their lovers and in despair. The first 15 of the 21 *Heroides* all have female speakers and seem to receive no response, but the last six poems enter into dialogues, pairs of letters in which the man writes the first letter and the woman responds. A.A. Markley stresses the 'diversity of the women's voices' despite the similarity of the emotional situations in the poems, a 'remarkable degree of variation' achieved by reworking 'a wide range of motifs and details from each character's story' (2009: 116–17). Several of the pairings in the *Heroides* include characters from the Homeric poems, such as Penelope writing to Ulysses, Briseis to Achilles, and Helen to Paris. In poem 16, Paris seeks to persuade Helen that his love for her was ordained by Venus, who has already promised Paris that Helen will be his wife. Helen responds in the next poem. The poet creates irony by setting the speaker's emotion against 'external factors that are known to the reader but not to the speaker. We have almost a tragic sense of people caught up in situations that are beyond their knowledge and certainly their control' (Sinfield 1977: 47). Tennyson's fascination with such figures is a notable feature of his early poetry. Oenone's depiction of her suffering, 'My heart is breaking, and my eyes are dim, / And I am all aweary of my life' (31–2) anticipates the refrain of Mariana (a character from Shakespeare's *Measure for Measure*): 'She said, "I am aweary, aweary, / I would that I were dead!"'[5]

Ovid and Tennyson both represent characters and episodes in unexpected ways by articulating the emotional responses of female characters who are peripheral and largely silent in the Homeric poems. Sara Mack observes that in the *Heroides* 'Ovid makes us look behind the usual version of the tale to see what is omitted—that is, what became of the people who just happened to be in the hero's way' (1988: 19). Penelope does not speak in Tennyson's 'Ulysses', but the hero's contemptuous reference to his 'agèd wife' may suggest that Tennyson is alluding to the *Heroides* as well as the more overt reference to Dante's *Inferno* (Markley 2009: 119). Penelope in *Heroides* 1 is lonely and cynical about the likelihood of Ulysses' fidelity to her during the 20 years of his absence. Although he occupies her thoughts to such an extent that she writes a letter to him every time a stranger comes to Ithaca, she does not anticipate a happy reunion. She imagines him disparaging his 'rustic' wife and tries to warn her husband that she has grown old while he has been away.

Her letter draws attention to the discord created by war for those left at home. Lawrence Lipking argues that 'the poetry of abandoned women is highly subversive', since such poems disrupt heroic narratives, 'call[ing] attention to the faithlessness of warriors and heroes, the insignificance of mere activity' (1988: 3–4).[6]

Tennyson's interest in Ovid's *Heroides* is also suggested by the poem 'Oenone' (1987: 1. 419–33), about a character who is decidedly peripheral to the Trojan War (the wife whom Paris abandons for Helen). In *Heroides* 5, Oenone writes to Paris to complain of his mistreatment of her, to remind him that when they met he was an outcast and her inferior, to recapitulate the suffering that resulted from the Judgement of Paris, to warn him of Helen's fickleness and the danger to Troy and to beg him to return to her. Laurel Fulkerson suggests that Ovid's poem is 'sophisticated despite Oenone's apparent ingenuousness', while noting that other critics represent Oenone's lament as ineffective, undermined by her 'inability to fashion herself' as a tragic or elegiac heroine (2009: 55–6). Tennyson's 'Oenone' differs from an epistle or dramatic monologue in the first 21 lines, which are not spoken by Oenone but by a third-person speaker who describes the landscape and the sorrowing heroine. The rest of the poem is presented as a song in which Oenone laments Paris's treatment of her and longs to die. Linda H. Peterson, noting Christopher Ricks's identification of Tennyson's 'Oenone' as an epyllion or minor epic that begins with a pastoral lament, comments that such 'generic grafting' 'raises the question of the relation of feminized lyric to masculine epic and, by extension, of women's role in epic action' (2009: 35). As part of her complaint, Tennyson's Oenone tells the story of the three goddesses Hera, Pallas Athena and Aphrodite, each seeking to be named the fairest and competing to offer inducements to Paris. Hera emerges from a golden cloud to offer 'royal power, ample rule / Unquestion'd' (109–10), the closest a mortal can come to godlike supremacy; the cold and earnest Pallas replies with a different version of 'sovereign power' based on 'Self-reverence, self-knowledge, self-control' (142–3); the lusciously beautiful Aphrodite wins by promising Paris 'the fairest and most loving wife in Greece' (183). Even before Aphrodite speaks, Oenone begs Paris to award the prize to Pallas but he will not hear. Redpath observes that Tennyson 'tells graphically the whole story of the Judgement of Paris (to which Ovid only alludes), and endorses Oenone's condemnation of Paris's choice of sensuous love' over the self-knowledge and self-control that Pallas offers (1981: 117). In the last stanza of the poem, Oenone determines to go to Troy and talk to Cassandra, whose visions of impending fire and battle best match Oenone's own 'fiery thoughts' (242).

Tennyson's classical poems and their relation to classical scholarship

Tennyson's poems on classical subjects include 'The Hesperides' (1832), 'Oenone' and 'The Lotos-Eaters' (first published in 1832, and revised in 1842), 'Ulysses' (written after Arthur Hallam's death in 1833 and published in 1842), 'Tithonus' (1860), 'Lucretius' (1868) and 'Tiresias' (1885). Some of these poems, such as 'Tithonus' and 'Tiresias', were partly written at the same time as 'Ulysses' and redrafted many times. He also wrote a 'Specimen of a Translation of the Iliad in Blank Verse' and 'Achilles over the Trench' (Tennyson 1987: 2. 651, 653–7). While Tennyson was fascinated by Homer, some contemporary readers stressed that his own poems were more closely aligned with a writer of literary epic such as Vergil than with what Matthew Arnold described repeatedly in *On Translating Homer* as Homer's 'perfect plainness and directness' (1960: 116). Arnold describes Tennyson's poetry as '*un-Homeric*' in its 'extreme subtlety and curious elaborateness of expression' and thought: 'In Homer's poetry it is all natural thoughts in natural words; in Mr. Tennyson's poetry it is all distilled thoughts in distilled words.' He quotes lines 16–17 of 'Ulysses' as an example of verse that has been 'quoted as perfectly Homeric' but argues that the 'subtle sophistication of the thought' lacks the 'perfect simplicity' of Homer (Arnold 1960: 204–5). The critic John Churton Collins, in *Illustrations of Tennyson* (1891), described Vergil and Tennyson as 'the most conspicuous representatives' of a 'school which seldom fails to make its appearance in every literature at a certain point of its development', poets who derive their material 'not from the world of Nature, but from the world of Art. The hint, the framework, the method of their most characteristic compositions, seldom or never emanate from themselves' (1891: 6). Although Tennyson resented Collins' laborious identification of classical parallels in his poems, Robert Pattison suggests that the source of his resentment was not the suggestion that Tennyson (like Vergil and Milton) incorporated many borrowings from earlier poets, but rather Collins' failure to appreciate the art with which Tennyson employed his allusions to earlier texts (1979: 8).

 Studies of Tennyson's classical influences (Pattison 1979; Markley 2004; Markley 2015) demonstrate that the poet's reading of ancient texts encompasses canonical poetry such as Homer's *Iliad* and *Odyssey*, Vergil's *Aeneid* and Lucretius's *De Rerum Natura*, as well as less familiar works like Claudian's *De Raptu Proserpinae* and Quintus of Smyrna's *Posthomerica*.[7] Tennyson's pastoral inclinations derive partly from the *Idylls* of Theocritus and the *Eclogues* of Vergil; echoes of pastoral elegy and Greek and Latin lyrics are pervasive in Tennyson's

long elegiac poem *In Memoriam A. H. H.* (1850), in which the poet mourns the death of his friend Arthur Hallam. The ambivalence about epic that Graham finds in the Victorian period is anticipated and skilfully articulated by Greek and Latin poets; Tennyson's epic ambitions are tempered by his partiality for Sappho, Catullus, and Propertius, who use elegiac conventions to provide a 'cogent, if unsystematic criticism of the epic genre' (Sullivan 1993: 145). Ovid's irreverent innovations as epic poet and elegist, to name only two of the genres he reinvents (Harrison 2002), contribute to a generic hybridity anticipating that of Romantics such as Byron, who was a potent influence for Tennyson's generation (Elfenbein 1995).

Andrew Lang observes that Tennyson was assisted in the preparation of his 1842 volumes by his brother-in-law, Edmund Lushington, who was Professor of Greek at Glasgow University from 1838 (1901: 37). That Tennyson envisioned his classical poems in the context of contemporary scholarship is suggested by the dedication of two such poems to the classicists R.C. Jebb and Benjamin Jowett: he paired 'To Professor Jebb' with 'Demeter and Persephone' (1889) and 'To the Master of Balliol' (Jowett) with 'The Death of Oenone' (1892). Jebb had suggested the *Homeric Hymn to Demeter* as a text Tennyson might find congenial; for Jowett, the poet returned to the theme of the nymph deserted by Paris in a poem he considered 'even more strictly classical in form and language' than 'Oenone' (H. Tennyson 1897: 2. 386). He drew on Book 10 of Quintus of Smyrna's *Posthomerica*, selecting an episode often read as an epyllion within the epic. These eminent classical scholars were closely connected with the literary world, friends with Tennyson and Browning as well as many other writers, and they were also engaged in disseminating classical literature to a wider audience. They published translations and commentaries such as Jowett's *The Dialogues of Plato translated into English with Analyses and Introductions* (1871) and Jebb's edition of the tragedies of Sophocles with text, critical notes, commentary and translation (1883–96). 'To the Master of Balliol' (Tennyson 1987: 3. 219–20) offers Jowett a brief respite from his labours on revisions to the third edition of his *Plato*, asking him to read 'a Grecian tale re-told', a story that 'Quintus Calaber / Somewhat lazily handled of old' (5–8).[8] Jebb had shown his appreciation of Tennyson's classicism by translating 'Tithonus' into Latin verse (Jebb 1873). The poem was written in 1833 as a 'pendant' to 'Ulysses' and later revised for publication in William Makepeace Thackeray's *Cornhill Magazine* in 1860. In a letter to the Duke of Argyll, Tennyson described the incongruity of placing the poem 'at the tail of a flashy modern novel', a questionable assessment of Anthony Trollope's *Framley Parsonage* (Tennyson 1981: 252). 'Tithonus' is spoken by an isolated and

alienated figure who longs for oblivion, matched not with an 'agèd wife', but rather with an ageless goddess whose eternal radiance cruelly accentuates his own extended physical decline.

The potent temptation of mental and physical inertia is prominent in 'The Lotos-Eaters'. Odysseus (not named in the poem) speaks only briefly at the beginning, telling his crew to have courage as they approach an unknown island. The sense of alienation from home and family aligns the lotos-eating mariners with the disaffected Ulysses of the monologue (written in 1833 and also published in the 1842 volume). The Choric Song reveals that escapist lotos-eating and the pleasurable sensations afforded by the island do not free them from fear and pain: despite fond memories of home, they shrink from encountering the adult sons who will have displaced them in their absence. Tennyson examines a similar fear in a modern context in 'Enoch Arden' (1864), in which a shipwrecked sailor returns home after more than a decade to find that his wife has remarried and had another child. Enoch does not reveal his identity until he is near death and refuses to let his family be informed until he is dead (Tennyson 1987 2. 625–51). Tennyson thwarts the narrative of *nostos* and reunion for this Victorian Odysseus and 'The Lotos-Eaters' extends indefinitely one of the delays and digressions that characterize the first half of the *Odyssey*. The lotos-eaters perceive themselves as 'horrendously posthumous to their social world, already part of history and art, somebody else's fictions' (Armstrong 1993: 89):

> Dear is the memory of our wedded lives,
> And dear the last embraces of our wives
> And their warm tears: but all hath suffer'd change:
> For surely now our household hearths are cold,
> Our sons inherit us: our looks are strange:
> And we should come like ghosts to trouble joy.

<div align="right">114–19</div>

These lines appear in the 1842 version of the poem but were not in the original (Redpath 1981: 118). The choric song, with alternating celebration of the island's beauty and intense frustration about the cruelty of the world and the indifference of the gods, follows the tragic form of strophe and antistrophe, allowing for conflicting emotions with no easy resolution. Christopher Decker remarks that Tennyson's episodic poems are 'self-contained and fragmentary': despite endings marked by overt 'closural gestures', the poems withhold the ending of their narratives (2009: 58). According to Homer, Odysseus forces his men to leave the island and journey back to Ithaca, but Tennyson's poem resists

closure, as the lotos-eaters sing 'O rest ye, brother mariners, we will not wander more' (173).

Tennyson's 'Ulysses' is obliquely connected with Homer's *Odyssey* by an allusion to Tiresias's prophecy, which forms part of Odysseus's visit to the Underworld. Tiresias tells Odysseus that he may not be able to evade the anger of Poseidon; even if he does return to Ithaca, he will have lost his ship and companions and will have to kill Penelope's suitors. Then, Tiresias continues, he must set out again until he finds men who know nothing of the sea and do not eat salt. He will die in old age, far from Ithaca. Tennyson's poem represents the aged hero at home long after the action of the *Odyssey* is concluded, and not yet fully prepared to embark on the new voyage that Tiresias prophesied. Ulysses himself seems to have forgotten the visit to the Underworld, since he talks of finding 'the great Achilles, whom we knew' in the 'Happy Isles' of Elysium (63–4).[9] The poem questions the ideal of *kleos* and the heroic code which promotes a glorious life and an early death, a notion that Achilles bitterly condemns in the *Odyssey*. Such a death is supposed to be compensated by survival in the songs of the poets, yet the line 'I am become a name' suggests that Ulysses has achieved renown without sacrificing long life or family (11). Like the *Odyssey*, Tennyson's poem seeks alternative models of heroism, and the hero's facility with language, his ability to enhance his own reputation, is a considerable part of his power:

> Much have I seen and known; cities of men
> And manners, climates, councils, governments,
> Myself not least, but honour'd of them all;
> And drunk delight of battle with my peers,
> Far on the ringing plains of windy Troy.
>
> 13–17

These lines allude to and embellish the description of Odysseus at the beginning of the *Odyssey*, the man of many ways; his knowledge of many countries and men. The epithet 'windy' for Troy is another Homeric reference, showing the speaker's mastery of the stories that have been told about him (Tennyson 1987: 1.616).

Tennyson complicates the characterization of the speaker by drawing on sources other than the *Odyssey* in his version of the hero as an older, dissatisfied king who finds his home remote and uncivilized and his family dull. That the Homeric echoes are interwoven with other allusions to the epic tradition is well established: Tennyson himself listed *Odyssey* 11.100–37 and the 26th canto of Dante's *Inferno* as sources for the poem (Tennyson 1987: 1.613–20). In addition,

Cornelia Pearsall cites Edward FitzGerald's anecdote that Tennyson wept when he read about Sinon and the wooden horse that caused Troy's fall in Book II of Vergil's *Aeneid* (2008: 164). Tennyson's admiration for Vergil is undoubted: his poem 'To Vergil: Written at the Request of the Mantuans for the Nineteenth Centenary of Vergil's Death' begins with praise to Vergil as the Roman Homer and concludes with a declaration of Tennyson's longstanding love for the poet. In his notes, the poet indicates that the line 'I am a part of all that I have met' (18) is an allusion to Aeneas's *quaeque ipse miserrimus vidi / et quorum pars magna fui* (*Aeneid* 2.5–6) ('terrible things I saw myself, and in which I played a great part'). Yet Tennyson chooses as his speaker not the noble Trojan who would go on to found the Roman Empire, but the tricky and selfish Odysseus. There is little regard for *pietas* in 'Ulysses' except in the muted praise of Telemachus as a suitable leader for Ithaca. Ulysses cruelly condemns his own people as a 'savage race' (4) and disparages the 'barren crags' (2) they inhabit. His disdain suggests that the journey home that dominates the first half of the *Odyssey* was a mistake and that he feels no responsibility towards his people. Matthew Rowlinson notes that he 'seems to be imagining between himself and his subjects not just differences of class, but bizarrely, cultural and even racial differences' (1992: 267). When Ulysses highlights Telemachus's praiseworthy qualities he does so only to stress the distance between the tediously reliable son and his aspiring and discontented father:

> Most blameless is he, centred in the sphere
> Of common duties, decent not to fail
> In offices of tenderness, and pay
> Meet adoration to my household gods,
> When I am gone. He works his work, I mine,
>
> 39–43

Ulysses' readiness to abandon his responsibilities to his son has been explained by the poet's son Hallam Tennyson as an allusion to one of the poems of the Epic Cycle, the *Telegony* by Eugammon of Cyrene. Both poems show the hero staying at home for many years before he feels 'the craving for fresh travel' and sets off with new companions who are 'of the same heroic mould as the old comrades' – as Christopher Ricks notes, this last detail is intended to meet the objection that Ulysses could not have been addressing his original companions, who are all dead (Tennyson 1987: 1. 613–4). In the *Telegony*, Odysseus not only leaves his kingdom to Telemachus, he then does the same to his youngest son before going back to Ithaca.[10] Tennyson would not have expected every reader to know the surviving fragments and summaries of the Epic Cycle as well as they might know

Homer, and a knowledge of plot of the *Telegony* is not necessary to understand Ulysses' dismissive attitude towards his son and kingdom. Nevertheless, classicists might pride themselves on recognizing the obscure parallel while others picked up the more obvious allusion to Dante.

In the *Inferno*, Ulisse (Odysseus) is an anti-hero who appears in a flame, joined forever to his co-conspirator Diomedes, in the eighth pit of the eighth circle of hell, disturbingly close to the central point where Lucifer is enclosed in ice. The Greek heroes are among those being punished for fraudulent counsel and the ruse of the wooden horse is their principal offence.[11] Despite the implications of Ulysses' position, however, Dante allows him an eloquent speech about his restless desire to explore the world. Tennyson's version of Ulysses is mediated by Dante's portrayal of dangerous yet appealing intellectual aspiration and contempt for domesticity. This Ulysses set off on his final voyage after winning his freedom from Circe, and did not return to Ithaca, because family affection could not rival his desire to 'explore the world, and search the ways of life / Man's evil and his virtue' (*Inferno* XXVI, 97–8, trans. H.F. Cary). Ulysses sailed out in a small boat with a few companions, going past the Pillars of Hercules on a course forbidden to man; having passed Mount Purgatory, the ship was caught up in a whirlwind and all the sailors drowned. Before they embark on this final and disastrous boundary-crossing expedition, Ulysses persuasively exhorts his men to spend the rest of their lives exploring unknown territories and pursuing virtue and knowledge.

In Tennyson's poem, the hero's desire for exploration is similarly motivated by an awareness of the end of life approaching, a feeling that heroes must strive continually to maintain their status by seeing as much of the world as they can, or simply a compulsion to move forward. Like Dante, he allows Ulysses to reveal his dangerous arrogance and recklessness in a speech which invites the reader's sympathy while leaving the speaker's credibility open to question:

> 'Old age hath yet his honour and his toil;
> Death closes all: but something ere the end,
> Some work of noble note, may yet be done,
> Not unbecoming men that strove with Gods.
> [. . .] Come, my friends,
> 'Tis not too late to seek a newer world.
> Push off, and sitting well in order smite
> The sounding furrows; for my purpose holds
> To sail beyond the sunset, and the baths
> Of all the western stars, until I die'.
>
> 51–4, 56–61

The stirring rhetoric is undercut both by the allusions to other texts and by uncertainty about whether the aged speaker is in any position to resume his heroic exploits. The whole speech may be a fantasy addressed to an imagined audience (the dead mariners) whom the speaker has no power to command. The forward movement that the speech so eloquently recommends is counterpointed by a feeling of weariness and inertia. Tennyson wrote that 'Ulysses' 'was written soon after Arthur Hallam's death, and gave my feeling about the need for going forward, and braving the struggle of life perhaps more simply than anything in "In Memoriam"' (H. Tennyson 1897: 1. 196). The supremely quotable lines about exploration, discovery and the desire to keep moving forward become questionable in context. Even if the mariners who were all lost in the Homeric story are still alive and able to accompany the hero, the final voyage leads only to death. The *Odyssey* acts as a precedent to suggest that the hero's boastfulness and refusal to accept his limitations ends in disaster for his companions more often than for himself. Allowing Ulysses to speak in supremely persuasive language about the glorious endeavour he is planning, while ironically undercutting his rhetoric by suggesting the disaster that lies ahead, reveals the ethos of heroic individualism to be selfish and destructive.

The dramatic monologue as a form of classical reception

Once Tennyson and Browning had established the dramatic monologue, it became a potent form for giving a voice to those whose voices were unheard in literature or history, allowing poets to articulate ideas that they could not otherwise express with such force. Poets such as Swinburne employed the monologue form to shock readers and to unsettle their ideas about gender and sexuality. Women writers found Greek tragedy and epic fruitful sources for dramatic monologues with female speakers, allowing them to express rage about their frustrated ambitions, the continuance of a sexual double standard and the injustices of a patriarchal society, by appropriating characters such as Medea, Clytemnestra and Cassandra. Glennis Byron maintains that women poets played 'a primary role in establishing and defining that line of development which has proven most enduring: the use of the monologue for purposes of social critique' (2003: 84). Such poems include Augusta Webster's 'Medea in Athens' and 'Circe' (1870), Mary Elizabeth Coleridge's 'Alcestis to Admetus' (1908) and Amy Levy's 'Xantippe' (1881). The shift from epic to monologue does not end with the Victorian period, but still has a significant influence on contemporary responses

to the classical tradition. Following Tennyson's example, modern poets have favoured the dramatic monologue as a form which allows them to enter into dialogue with a canonical text, often in a subversive spirit. Reworking an episode from the *Odyssey* or Ovid's *Metamorphoses* allows for a creative and critical response to ancient texts, attentive to modern concerns and bringing peripheral characters to the fore. Giving a voice to Penelope, Telemachus, Circe or even the dog Argos, as Linda Pastan does in 'Re-Reading the *Odyssey* in Middle Age' (1988) continues to be a useful strategy for engaging with classical texts and scholarship and extending their appeal in a concise and pleasurable poetic form.

The Elizabethan Epyllion

From Constructed Classical Genre to Twentieth-Century Genre Propre

Silvio Bär
University of Oslo

Even as the sun with purple-colour'd face
Had ta'en his last leave of the weeping morn,
Rose-cheeked Adonis hied him to the chase.
Hunting he lov'd, but love he laugh'd to scorn.
 Sick-thoughted Venus makes amain unto him
 And like a bold-fac'd suitor 'gins to woo him.

This is the beginning of Shakespeare's *Venus and Adonis* (1593), a poem about Venus' unrequited love for the beautiful youth Adonis who, unfortunately, prefers hunting over sex.[1] The poem's model is, recognizably, Ovid's *Metamorphoses*, where the same story is told, in much shorter form, at 10.519–739. Along with similar poems such as Shakespeare's *The Rape of Lucrece* (1594) and Marlowe's *Hero and Leander* (1598), *Venus and Adonis* is among the best-known examples of a genre of mythological (and mostly erotic) narrative poems that were exceedingly popular in England during the 1590s, but whose life span encompassed a much longer period. It began with the first printed English translation of Book 3 of Ovid's *Metamorphoses* from 1560, published under the title *The Fable of Ovid treting of Narcissus* (anonymous) and three poems in the 1560s.[2] After its climax in the late Elizabethan period (Queen Elizabeth I, reigned 1558–1603), the composition of this type of narrative poetry continued well into the Jacobean era (King James I, reigned 1603–1625). During the Caroline era (King Charles I, reigned 1625–1649) another two such poems were written and published (Cowley's *Constantia and Philetus* [1630] and Shirley's *Narcissus or*

The Self-Lover [1646]). It can therefore be safely maintained that this genre was not only 'one of the most characteristic forms of the 1590s', as Brown (2004: 102) aptly puts it, but that its popularity and productivity lasted for a period of approximately 80 years.[3]

Today, this genre is commonly referred to by literary critics and literary historians as the 'Elizabethan epyllion' or the 'Elizabethan minor epic' (in this chapter, I will use the abbreviation EE for the sake of convenience).[4] The goal of this chapter is to trace the history of scholarship on the EE in line with the history of the term 'epyllion' as it was consolidated and narrowed in classical scholarship of the nineteenth century. Whereas the history of scholarship on the ancient 'epyllion' has been well examined, there is no equivalent study on the question as to when, how and why the term was adapted in English literary history. In what follows, I will therefore, in essence, argue that whereas the invention of the ancient 'epyllion' is a matter of the early nineteenth century, the designation of the EE as 'epyllion' occurred considerably later. It is only when, in an influential publication from 1931, the concept of the ancient 'epyllion' was extended to the idea of Ovid's *Metamorphoses* as a series of 'epyllia' that the same term became attractive and viable for English philology because of the overall Ovidian nature of the EE. Furthermore, it will be demonstrated that the year 1958 marks a turning point for the dissemination of the term: following a seminal publication in 1958, there was a sharp upswing in the usage of the term, which since then has become standard in English literary history and criticism. However, contemporary scholarship tends to lack reflection and awareness regarding its history. This deficit, in turn, is also in parts due to the fact that classical philology still tends to adhere to the idea of the ancient 'epyllion' as a genuine and stable genre.

* * *

It has long been noted in classical scholarship that the term 'epyllion' is not an ancient literary term, but a much more recent coinage. Although there is, to this day, a tendency to claim that the term as such should be kept because of its supposed usefulness to 'describe a genuine type of poem' (Hollis 2006: 141), there are numerous arguments that speak against this stance and instead clearly indicate that the ancient 'epyllion' is, fundamentally, an anachronistic genre that coincided with the invention of the term by classicists around 1800. The arguments against the assumption of such an ancient genre are complex but can, essentially, be divided into two areas. For one thing, the fact that ancient literary criticism did not think of 'small(er) epic' as generically different from 'long(er)

epic' does not support the assumption from a historical point of view – indeed, authors of epic poems were uniformly referred to as ἐποποιοί ('producers of epic') in antiquity.[5] For another, it does not make sense to differentiate between ancient 'epic' and 'epyllion' because the demarcation between the two genres is considerably more blurry than most of the common definitions imply.[6] In fact, those texts that classical scholars tend to regard as 'epyllia' vary greatly in length – that is, from a few dozen to over a thousand lines – and they are also far from constituting a homogeneous group of texts either in terms of periodization or subject matter.[7]

The word 'epyllion' as a scholarly *terminus technicus* is attested for the first time in Ilgen's (1796: 355, 671) edition of the *Homeric Hymns* with reference to the *Homeric Hymn to Hermes* and the *Batrachomyomachia*.[8] From then on, it spread in classical philology and became fashionable as a convenient designation for any 'small(er)' epic poem.[9] As Tilg (2012: 45) points out, 'the original idea of "epyllion" in classical studies from the late eighteenth to the mid-nineteenth centuries was more inclusive than our narrow definition today'; indeed, it is only in the second half of the nineteenth century that the term's use became gradually constricted. First, an increasingly centripetal idea of *the* 'epyllion' focused on the characteristics of *Carmen* 64 ('The Marriage of Peleus and Thetis') by the Roman poet Catullus.[10] Subsequently, the concept was, centrifugally, re-applied to Hellenistic poetry (based on the stereotype of Catullus as the direct literary heir to the Hellenistic poets). Heumann (1904) cemented this idea for the first time; however, it was Crump's (1931) thesis on *The Epyllion from Theocritus to Ovid* which became most influential both in Classics and also, as we shall see, in English philology. The reason for Crump's success in the history of scholarship is complex. First, the fact that her monograph was written in English facilitated its reception beyond the field of Classics. Secondly, she was the first scholar to unequivocally draw a direct line from the Greek (Hellenistic) 'epyllion' to the Roman (neoteric) 'epyllion' and was thus the first to imply an uninterrupted (almost teleological) development to this supposed genre. Thirdly, she provided a neat and tidy catalogue of criteria for what she considered to be typical of *the* ancient 'epyllion' (Crump 1931: 22–3) – which, as Trimble (2012: 75) shrewdly observes, 'possesses a seductive combination of abstraction and authority' as 'sitting where it does, at the beginning of a book that covers such a wide sweep of literary history, it commands trust'. Crump's criteria have been copied and repeated ever since, for example in the entry on 'Epyllion' in *The Oxford Classical Dictionary* (Courtney 1996) and in Merriam's (2001) study of the 'epyllion' in antiquity. Finally, and perhaps most importantly, Crump puts considerable

weight on Ovid and emphasizes the idea of the *Metamorphoses* as a series of 'epyllia' (Crump 1931: 195–242), which helped to prepare the ground for later English scholars to link the EE generically with the ancient 'epyllion'. For obvious reasons, this is not the right moment here to discuss, let alone to decide, whether Crump's view and her definitions are correct (as indicated, I think that they are, for the most part, not). What is important, though, is the fact that the combination of these factors led to a proliferation and even a certain popularization of her ideas both within and outside the realms of Classical scholarship.[11] We shall return to Crump's influence later in this chapter.

In contrast to the ancient 'epyllion', the idea of the EE as a coherent genre of generically related poems that interact with each other and share the same cultural and literary circle, seems undisputed and undisputable. Although there may, of course, be disagreement about the inclusion of one or the other text,[12] it cannot be doubted that both the periodization (with its peak in the 1590s) as well as the shared subject matter (with a focus on mythological and erotic stories that were mostly, though not solely, taken from Ovid's poetry) are reason enough to think of the EE as a relatively stable poetic genre with sufficient common characteristics.[13] Although it is, as Ellis (2003: 4) puts it, '[unknown w]hether the Elizabethans viewed these poems as a group', it is, in my view, possible, if not very likely, that they did. However, it can be said with irrefutable certainty that they did not call them 'epyllia'. Although the term 'epyllion' is attested a few times in the sixteenth century by some authors of Latin hexameter poems,[14] there is no evidence whatsoever that suggests that it may have spread to designate other types of poetry that were written in vernacular languages. However, contrary to what might perhaps be expected, the proliferation of the term in classical scholarship in the course of the nineteenth century did not trigger its application to the EE – despite the leading position that Classics had as a discipline at the time. As a matter of fact, there is only little – albeit illuminating – evidence for the use of the term outside classical philology in the nineteenth century. One such exception was Karl Elze (1864: 177–268), who applied the term 'Epyllien' to Sir Walter Scott's narrative poems that were written between 1805 and 1817 (such as, for example, *The Lay of the Last Minstrel* [1805], *The Lady of the Lake* [1810] and *Harold the Dauntless* [1817]). This usage – unique as it is – clearly testifies to the broad applicability of the term at that time. A few decades later, Körting (1910), in his history of English literature, broadened the term's usage by applying it again to Scott's narrative poems (365), but also to those of Lord Byron (such as, for example, *The Corsair* [1814] and *The Prisoner of Chillon* [1816]) (387). Most strikingly, however, he was, by all accounts, the first to call two

representatives of the EE 'Epyllien', namely, Cowley's *Tragicall History of Piramus and Thisbe* and *Constantia and Philetus* (292). Several aspects are of interest here: first, the seemingly casual use of the term without any introduction or explanation; secondly, the fact that Körting used the term to designate two late EE (published in 1628 and 1630, respectively) which contemporary scholarship does not regard as central to the genre;[15] and, thirdly, the lack of an according usage for those EE which are today viewed as typical of the genre: Marlowe's *Hero and Leander* is simply called a 'Gedicht' (poem) (260), while Shakespeare's *Venus and Adonis* and *The Rape of Lucrece* are 'epische Dichtungen' (epic poems) (256). Interestingly, it was also Körting – who had called the narrative poems by Cowley, Scott and Lord Byron 'Epyllien' – who wrote an encyclopedia on the methodology of Roman philology, in which he defines the 'epyllion' as a subgenre of epic poetry ('Epische Dichtungen') and translates it as 'Verserzählungen' (verse narrations) (Körting 1884: 449). Thus, all aspects considered, it appears that the term 'epyllion' was used very broadly by both Elze and Körting, irrespective of the period to which the authors dealt with belonged –in essence, 'epyllion' seems to have been regarded as an appropriate term for almost any narrative poem.

In his *Handbook of Greek Literature* (widely read at the time), Rose (1934: 321) discusses Callimachus' fragmentarily preserved narrative poem *Hecale* as a prototypical 'epyllion' and then adds, at the end of the paragraph, a sentence saying that '[w]e shall find such poems in Theokritos also, and the genre survives, little changed, into modern work'. This remark is supplemented by a footnote that mentions Shakespeare's *The Rape of Lucrece*, along with Alfred Tennyson's 'Oenone' (1829), as two examples (Rose 1934: 321, n. 20). First and foremost, these show that Rose obviously had a very broad (and, one may perhaps add, indistinct) conception of the 'epyllion', similar to that of Elze and Körting. What is more important, though, is his idea that a direct, almost teleological line could be pursued from the ancient 'epyllion' to the EE (and beyond). As demonstrated above, this notion is already implied in Crump's (1931) monograph; although Rose does not reference this study, it does not seem far-fetched to assume that he will probably have known (and used) it. It is, however, not until 1958 that the term 'epyllion' finally begins to make proper headway in English philology. In an article entitled 'The Elizabethan Minor Epic', Miller (1958: 31) openly claims a direct line from the ancient 'epyllia', especially those from Ovid's *Metamorphoses*, to the EE:

> Literary scholars have commonly observed that the Elizabethan erotic mythological narrative poems such as Marlowe's *Hero and Leander* bear a

striking resemblance to the poems of Ovid, especially to his *Metamorphoses*. Indeed nowadays it is almost customary to refer to these verse narratives as Ovidian poems. And several scholars, discerning a more precise relationship between these Renaissance and Latin poems, have been aware that both groups belong to a class of Alexandrian Greek poems known as *epyllia*, or 'little epics.' To my knowledge, though, no one has undertaken to show in what sense the Elizabethan poems in question actually are *epyllia*, or what relationship they bear to the Alexandrian poems of the same class. To do so is the aim of the present study.

Unfortunately, Miller fails to reference those 'several scholars' in detail; his only source of information whom he mentions explicitly is Rose (1934: 321) – who, in turn, did not give any further references to support his claim. It might, however, be speculated that one of Miller's other sources may have been Wilkinson's (1955) study on Ovid, a study that contains chapters on Ovidian reception in the Middle Ages (366–98) and in the Renaissance (399–438). Wilkinson never explicitly calls the EE 'epyllia', but he uses the term in close connection when he refers to the EE as 'poems in stanzas or couplets which are akin to the Greco-Roman epyllia' (409). Miller's main model, however, is Crump (1931), whom he calls 'the foremost modern authority on this type of poem' (Miller 1958: 31). In essence, Miller's goal is twofold: for one thing, he attempts to demonstrate that the EE is a generic heir to the ancient 'epyllion'; this end is achieved by way of reference to Crump's authoritative catalogue of criteria and her conception of Ovid's *Metamorphoses* as a series of 'epyllia', as detailed above. For another, by claiming a direct lineage between the two genres, Miller also attempts to defend and ennoble the EE, as becomes evident in the final sentence of his article (38): 'The long-range effect of such a study, I would hope, would be to heighten appreciation and to refurbish the reputation of these Elizabethan poems, now all too often looked upon with condescension or scarcely concealed contempt.' In other words, what is at work here is the idea that the quality of a post-antique literary genre is automatically put on a higher scale if it can be proven to have developed from an ancient genre.

As a response, Allen (1958) published a short article in the same journal and in the same year to oppose Miller's claim. Allen had already written a longer article in 1940 in which he had thoroughly refuted the existence of the ancient genre of the 'epyllion' (his criticism was mostly targeted against Crump), dismantling, point by point, the constructedness of the genre and consequently claiming that 'we should banish from our critical vocabulary the term epyllion

and from our critical thinking the grouping of poems under that name' (Allen 1940: 25). In his subsequent short note, he summarized and restated his former criticism, but supplemented it with an evaluation of some more recent literature on the topic, 'fear[ing] that Mr. Miller has caught a tiger in his Classical comparison' (Allen 1958: 515). However, Allen's criticism did not land on fertile soil (which may in part have been due to its slightly condescending tone)[16] and the Millerian view subsequently spread and became mainstream in English philology.

As an example of the spreading influence of the 'epyllion', in the same year as Miller's article was published, Germaine Greer (known these days as a representative of the second-wave feminist movement) attended a seminar on 'The Epyllion' at the University of Melbourne. According to her lecture notes (today in the possession of the University Library of Melbourne), the seminar was held by an otherwise unknown 'Miss Walker' who, inter alia, discussed *Venus and Adonis, The Rape of Lucrece* and *Hero and Leander*. On the first page of Greer's lecture notes, on the fourth line from the top, there is a reference to Wilkinson's (1955) monograph which, as noted above, may have had an influence on Miller's (1958) introduction of the term 'epyllion' into English philology. Therefore, even if Walker may not have been familiar with Miller's article at that point (it was published in the same year as the lecture took place), she must have been familiar with the term 'epyllion' and will have found the transition of its application from ancient to Elizabethan poems unproblematic. This assumption is reinforced by the fact that the term 'epillion' (*sic*) stands on the following line, without further comment, immediately after the notation of Wilkinson's monograph; it may thus be safe to speculate that Walker mentioned the term as originating with Wilkinson. Furthermore, Greer's misspelling is illuminating since it testifies to the fact that she must have taken her note on auditive reception; this, in turn, demonstrates that Walker probably neither used the blackboard to introduce the term, nor did she provide much explanation as to its meaning and origin. Consequently, it can be concluded that Walker seems to have regarded 'epyllion' as an unproblematic and already fairly established term to describe the genre of the EE and she appears to have assumed that it could be introduced to undergraduates without further explanation.

Five years later, Donno (1963), in her important and much-used edition of no fewer than 13 EE, adopts an ambivalent stance towards the Millerian view: on the one hand, she chooses the title *Elizabethan Minor Epics* for her edition; on the other, she frequently uses the term 'epyllion' in her introduction. In a footnote, she explains and justifies its use (Donno 1963: 6, n. 3):

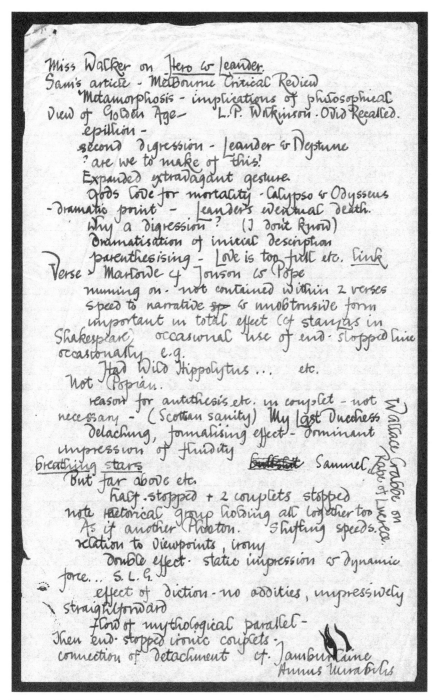

Fig. 8.1. The Epyllion [page 1], 1958. The Germaine Greer Archive, The University of Melbourne Archives, 2014.0044.00080.

The term 'epyllion' or 'minor epic' gained currency following the publication in 1931 of M.M. Crump's *The Epyllion from Theocritus to Ovid*. But scholars have pointed out that it was not a literary type recognized by the ancients and that its critical usage stems from the nineteenth century. [...] Whatever its propriety for certain examples of classical poetry, it is a particularly useful term for classifying the Elizabethan genre with its mingling of disparate elements.

I suspect that the wide dissemination of Donno's edition must have played a (if not the) decisive role in the subsequent standardization of the term 'epyllion' as a designation for the EE, since it became – and has remained – the standard edition, at least for some of the lesser-known EE. But how do contemporary scholars tend to deal with what we might term 'the epyllion question'? As demonstrated above, in contemporary classical scholarship there is a clear awareness that the term 'epyllion' as such is not ancient, but modern. In contrast, there seems to be little corresponding awareness in contemporary English philology – on the contrary, in most cases where 'epyllion' has been used in scholarship since the turn of the millennium to designate the EE (or specific representatives of the genre), the term is used without much (or any) further reflection.[17] For example, Alexander (2000: 101) writes, in his literary history (directed at a general audience of students of English):[18] 'Epyllion was fashionable in the 1590s; Shakespeare's effort, *Venus and Adonis*, is inferior to *Hero and Leander*, which Marlowe may have written as an undergraduate.' In a similar way, specialized studies on Elizabethan poetry and/or the EE tend to ignore this aspect. Brown (2004: 102–9), in a sub-chapter entitled 'The Epyllion and the Eroticization of Elizabethan Literary Culture', acknowledges the fact that the 'word epyllion derives from the Greek for small epic' (102–3) and argues that the genre itself is an innovation 'in answer to the criticisms which had been leveled against poetry in the 1570s and 1580s' (104). However, despite the fact that the author recognizes the term's origin from Ancient Greek and, at the same time, makes the genre's post-classical provenance unmistakably clear, she does not raise the question as to the term's source. A reader of Brown's chapter might thus be inclined to conclude (wrongly) that 'epyllion' was, in fact, a term that would already have been used by the authors of these EE poems. Along similar lines, Buté (2004: 260) revives the Millerian view of a direct line from the ancient 'epyllion' to the EE by stating that 'le *minor epic* élisabéthain est une résurgence de l'épyllion classique, qui s'est développé pendant la période alexandrine en Grèce'. Even further, Weaver (2012), the author of the most recent study on the EE, uses the term throughout his monograph without any reference to, or reflection on, its provenance and

terminological belatedness (nor does his bibliography contain any references to studies on the term's history).

Indeed, it is only on rare occasions that we catch a glimpse of some sort of awareness regarding the history and the constructedness of the term in recent critical writing, such as in Kahn's chapter, where she cites Lodge's *Scillaes Metamorphosis* as the first example of 'the emergent genre of the long mythological Ovidian poem' (2007: 75) – which is then, in parentheses, explained as 'later termed *epyllion* or brief epic'; or in Enterline's chapter on 'Elizabethan Minor Epic' in *The Oxford History of Classical Reception in English Literature* (2015), where the nineteenth-century origin of the term is acknowledged, but ancient 'epyllion', with all its stereotypes, is at the same time taken as an absolute truth.[19] The one example I was able to find of a more in-depth observation occurs in a recent study by Ellis (2003: 4):

> Not only did the epyllion not survive, it is not even clear that it existed as a genre in the first place. The label was first applied to classical poetry in the nineteenth century, and only later to English examples. Whether the Elizabethans viewed these poems as a group is unknown, as is whether they would have drawn any distinction between the epyllion and the Ovidian complaint, which (if in fact it is a separate genre) has had a longer life.

Beyond the question of terminological validity, the author here draws attention to the problem of the ancient genre of 'epyllion' as such. What is even more illuminating, though, is the way this problem is immediately linked to the question of the generic awareness of the EE by its authors and their contemporaries. In other words, the awareness of one problem in the history of scholarship triggers awareness of a related problem in a different area. Aside from these exceptions, however, it can, in sum, be stated that contemporary English philology seems to show comparatively little interest in – or awareness of – the origin and history of the generic term 'epyllion', as a result of which an unknowing reader might be inclined to draw wrong conclusions about its supposed use as early as the Elizabethan era.

<p style="text-align:center">* * *</p>

I opened this chapter with a quote from Shakespeare's *Venus and Adonis*, a poem about one-sided love. A quote from Marlowe's *Hero and Leander* would have been an equally appropriate alternative, as an example, not of unrequited love, but, rather, of eternal love beyond death. We may justifiably wonder which of the two stories might be better suited as a metaphor for the relationship between the

ancient 'epyllion' and the EE; but either way, it seems to me to be clear that the relationship is a complex one. To summarize, from a historical perspective, the idea of the ancient 'epyllion' is a modern construct: an anachronistic genre that was virtually invented around 1800. In contrast, the EE clearly constitutes a literary genre with a stable nucleus and a precisely pointed climax in the 1590s. In the first half of the nineteenth century, classicists applied the term 'epyllion' broadly to any Greek or Latin hexameter poem that was, in one way or another, conceived as (relatively) small, irrespective of its content and dating. After around 1850, though, the idea arose that 'epyllion' was a genre that was at home primarily (if not solely) in Hellenistic (Greek) and neoteric (Roman) poetry. Crump's (1931) thesis subsequently cemented this view, but also widened it because she popularized the idea that Ovid's *Metamorphoses* essentially consisted of a series of 'epyllia'. The EE, in turn, was referred to as 'epyllion' on only a few isolated occasions in the later nineteenth and earlier twentieth centuries. It was only in the wake of Crump's monograph that scholars of English philology began to see a common ground by perceiving the EE as an heir to the ancient 'epyllion' due to the connection made to Ovid; since 1958, this view has remained standard in English philology. It is, furthermore, insightful to note that contemporary English philology seems to take comparatively little notice of this problem, whereas classical philology is more informed and reflects this more. At the same time, the adherence in Classics to the idea that the ancient 'epyllion' did exist also feeds back onto the way scholars of English literary history look at the issue: for it is only on the basis of the assumption that the 'epyllion' constituted a stable literary genre with an uninterrupted and linear continuity from the Hellenistic to the Roman period (and beyond) that English literary criticism was able to pick up on this idea and expand it (teleologically) into the EE. The EE is therefore an exemplary case in point that demonstrates how a specific development in classical scholarship has shaped the perception of a genre in English poetry, and how blind spots are different in each discipline – but nevertheless intertwined. As far as future research is concerned, it might be rewarding (but would have gone far beyond the scope of this chapter) to investigate the entire 'history of the history of literature' in this respect, that is, to diachronically track the terminology that was used to refer to the texts which are regarded as EE today.[20]

Appendix: List of EE in Chronological Order[21]

1560 Anonymous: *The Fable of Ovid treting of Narcissus* **A**

1565 Thomas Peend (?–?): *The Pleasant Fable of Hermaphroditus and Salmacis* **C**

1566 Thomas Underdowne (1566–1587):
 The Excellent Historye of Theseus and Ariadne **C**

1569 William Hubbard (?–?): *Ceyx Kynge of Thracine and Alcione his Wife* **C**

1587 Abraham Fraunce (~1558–~1593):
 The Lamentations of Amintas for the Death of Phyllis

1589 Thomas Lodge (1558–1625):
 Scillaes Metamorphosis: Enterlaced with the Unfortunate Love of Glaucus
 A B D R

1592 Samuel Daniel (1562–1619): *The Complaint of Rosamond* **A R**

1593 William Shakespeare (1564–1616): *Venus and Adonis* **B R W**

1594 William Shakespeare: *The Rape of Lucrece* **W**
 Thomas Heywood (~1570–1641): *Oenone and Paris* **B D W**
 John Davies (1569–1626): *Orchestra* **W**
 Henry Willobie (1575?–1596?): *Willobie His Avisa, The first triall of Avisa* **A**
 Richard Barnfield (1574–1620):
 Hellens Rape: A light Lanthorne for light Ladies

1595 George Chapman (1559–1634): *Ovids Banquet of Sence* **A B D**
 Michael Drayton (1563–1631): *Endimion and Phoebe: Ideas Latmus* **B D R**
 Thomas Edwards (?–?): *Cephalus and Procris* **B D W**
 Richard Barnfield: *Orpheus His Journey To Hell* **C**

1596 Richard Lynche (?–?): *The Love of Dom Diego and Ginevra* **M**

1597 Michael Drayton:
 Rosamond to Henry, Henry to Rosamond: Englands Heroicall Epistles **A**

1598 John Marston (1576–1634):
 The Metamorphosis of Pigmalions Image and Certaine Satyres **B D R**
 Christopher Marlowe (1564–1593): *Hero and Leander* **A B D R W**
 George Chapman: *The Continuation of Hero and Leander* **A B D**
 Henry Petowe (1575/6–1636?):
 The Second Part of Hero and Leander, Containing their Further Fortunes **A B**

1600 John Weever (1576–1632): *Faunus and Melliflora* **B D**

1602 Francis Beaumont (1584–1616): *Salmacis and Hermaphroditus* **A D**
 John Beaumont (1583–1627): *The Metamorphosis of Tobacco*

1607 William Barksted (?–?): *Mirrha the Mother of Adonis: or, Lustes Prodegies* **M**

1610 Giles Fletcher (1586?–1623): *Christs Victorie and Triumph* **A**

1611 William Barksted: *Hiren: or The Faire Greeke* **M**

1613 Samuel Page (1574–1630): *The Love of Amos and ill* **M**

 H.A. (?–?): *The Scourge of Venus* **M**

1616 George Chapman: *The Divine Poem of Musaeus: Hero and Leander* **D**

1617 Dunstan Gale (?–?): *Pyramus and Thisbe* **M**

1624 Anonymous:

 A Pleasant and Delightfull Poeme of Two Lovers, Philos and Licia **M**

1628 Phineas Fletcher (1582–1650): *Venus and Anchises: Brittain's Ida* **D**

 Abraham Cowley (1618–1667): *Tragicall History of Piramus and Thisbe*

1630 Abraham Cowley: *Constantia and Philetus*

1646 James Shirley (1596–1666): *Narcissus or The Self-Lover* **D**

'Homer Undone'

Homeric Scholarship and the Invention of Female Epic

Emily Hauser

University of Exeter

In an important article written in 1986 – one of the first to seriously and critically address female epic as a genre and the 'anxiety of authorship' that surrounds it – Susan Stanford Friedman noted that 'epic ... has continued to invoke the inscriptions of gender implicit in Homer ... as father of [the] discourse' (Friedman 1986: 203). Epic's traditional focus on men and the deeds of men on the pattern of Homer, on race/nation formation (and hence 'fatherhood') and its circulation through male patterns of literary production (male bard to male audience) from Homer until at least the seventeenth century, have created a cultural association between Homeric epic, epic genre, and (western norms of) masculinity (Friedman 1986: 205).[1] Female epics – that is, epics written by women writers – have similarly interacted with Homer (and the criticism that surrounds him) as the foundational figure of the genre.[2] In this chapter I want to take the encoding of genre and gender norms around Homer in the history of epic, to look at how the development of female epic responds to and interplays with Homeric scholarship and the literary criticism of epic.[3]

Focusing on two major and influential texts in the history of the formation of female epic – Elizabeth Barrett Browning's *Aurora Leigh* (1856) and H.D.'s *Helen in Egypt* (1961)[4] – I suggest that each female epicist is deliberately interacting with, and defining herself in counterpoint to, a different landmark point in the history of Homeric scholarship. In particular, I will propose that the often-noted generic flexibility of female epic derives specifically from the authors' complex engagement with contemporary movements in Homeric scholarship.[5] Female epic – crossing between female-gendered authorship and the expectations of a traditionally masculine genre; engaging with Homer and yet always (and consciously) *not* Homer – has, by its paradoxical self-definition as both

female and epic, always been in conversation with classical scholarship and contemporary literary criticism, as a means to define and explore its place within the tradition. The anxiety experienced by female epic poets, then, I would argue, is not merely anxiety of influence, authorship or, as Friedman suggests, 'anxiety of genre', but rather, a potent mix of all three: a combined awareness of the constraints of female-gendered authorship, the male-gendering of epic genre, and, crucially, the weight of the influence and critical reception of Homer.[6]

I will begin, however, with a brief survey of the development of female epic and the general critical trends in its scholarship, for those unfamiliar with its often obscured and certainly marginalized history.[7] There is some debate as to what 'epic' means in relation to female-authored epic works – in the main because, as noted above, female epics tend to be largely hybrid in genre.[8] Friedman was the first to point out this generic hybridization in Barrett Browning and H.D., arguing that *Aurora Leigh* and *Helen in Egypt* combine elements of lyric and the novel along with epic conventions to create a new kind of female epic form.

My focus here, however, is less on the generic hybridity of female epic which has been addressed before, and rather on the ways in which female epicists have responded and reacted to the Homeric tradition and its scholarship in formulating their own perceptions of their work *as* epic in genre. If we take epic broadly – as Jeremy Downes does – to be a 'long poem … telling a story of communal (familial, tribal, local, or national) concern' (2010: 30), then we can say with fair certainty that the first female-authored epic appears in the seventeenth century with Lady Mary Wroth's prose epic, *Urania* (1621). This is followed by several more female epics in the eighteenth century, including, notably, Anna Seward's *Telemachus* in 1794 (a verse paraphrase of François de Fénelon's *Télémaque*) and, early in the nineteenth century, Mary Tighe's *Psyche, or the Legend of Love* (1805).[9] In 1856, Elizabeth Barrett Browning's epic *cum* verse novel, *Aurora Leigh*, became one of the key founding texts of female epic, both in terms of its (and its author's) success, and in its very self-conscious examination of the role and identity of the female epic poet. The twentieth century then saw a proliferation of female-authored epics, many of them consciously responding to *Aurora Leigh*, by northern American female poets, from H.D.'s *Trilogy* (1944–46) and *Helen in Egypt* (1961) to Sharon Doubiado's *Hard Country* (1982), Rita Dove's *Mother Love* (1996), and Anne Carson's *Autobiography of Red* (1998).

The study of female epic is still a relatively recent phenomenon, in accordance with its subject's (and authors') historic marginalization. As we have already

seen, Susan Stanford Friedman's 1986 article, 'Gender and Genre Anxiety: Elizabeth Barrett Browning and H.D. as Epic Poets' was one of the earliest works of scholarship to address female epic specifically and (importantly) from a comparative perspective, as its own sub-genre. This was followed in 1997 by a chapter by Jeremy Downes in his monograph on repetition and 'recursion' in epic poetry, 'Sleeping with the Enemy: Women and Epic' – a theme that was more fully fleshed out in his 2010 book, *The Female Homer*. Lynn Keller's *Forms of Expansion* (1997) and Adeline Johns-Putra's *Heroes and Housewives* (2001), along with Bernard Schweizer's edited volume on Anglo-American female epic (2006), form the only other scholarly attempts to explore female epic as a genre. As such – as Schweizer points out (2006: 11) – there is still much work to be done in the area. In particular, female epicists' (often fraught) relationship with their classical models and contemporary Homeric scholarship has often been ignored – perhaps in part due to their confinement to studies of English literature and the relative lack of contextualization within the larger framework of classical reception. It is this connection, then, between female epic, the longer Homeric tradition to which it reacts and responds, and contemporary critical debates around Homeric poetry (and thus, by implication, the definition of epic itself), which I will attempt to foreground here.

'That Wolff, those Platos': Elizabeth Barrett Browning and Friedrich August Wolf's *Prolegomena ad Homerum*[10]

In this section, I examine *Aurora Leigh* to show how Barrett Browning is exploring debates in Homeric scholarship – in particular, the controversy sparked by Friedrich August Wolf's 1795 *Prolegomena ad Homerum*, and his argument for a new vision for the composition and transmission of the Homeric poems – to define and understand her own position as a (female) author of epic poetry, and to bolster the generic definition of *Aurora Leigh* as an epic, which is a central focus of much of the metaliterary commentary in book 5.[11] Focusing on a passage in *Aurora Leigh* in which Aurora prominently discards her copy of Wolf's *Prolegomena*, I will suggest that Barrett Browning engages with Homeric scholarship to examine her own status as a woman and an epic poet, and to redefine the generic expectations surrounding female epic. In this way, I will suggest, it is possible to trace a fluid, dynamic and productive relationship between movements in Homeric scholarship, female epic poetry, and literary criticism surrounding epic.[12]

Barrett Browning and the Classics

Bailey (2006: 118) points out that *Aurora Leigh* can be read along the lines of a *Künstlerroman*, 'that sub-genre of the bildungsroman which traces the life and growth of an artist'.[13] Aurora Leigh – the title character – undergoes a transformative process as a woman poet, attempting to understand her place in the world as a woman and an author and to reconcile her poetic calling with her romantic attachment to Romney Leigh. Whilst to suggest that Aurora is a direct analogue for Elizabeth Barrett Browning herself would be facile, there are certain elements of the exploration of female identity, authorship and the opposition between poetry/individuality and duty/relationship within the epic which bear witness to Barrett Browning's development of her ideas around what it means to identify as a woman and an author.[14] Barrett Browning certainly engaged with classical models in her attempt to define female epic and her own position as a female epicist.[15] Her first epic, written at the age of only eleven, was a retelling of the Battle of Marathon and written explicitly in the tradition of Alexander Pope's 1715–1720 translation of Homer's *Iliad*: as Barrett Browning later wrote, 'the Greeks were my demi-gods, and haunted me out of Pope's Homer … and thus my great "epic" is simply Pope's Homer done over again, or undone' (Barrett Browning 1877: 159).[16] She had a thorough classical background, read Latin and Greek fluently and published translations of classical texts, including two translations of Aeschylus' *Prometheus Bound* in 1833 and 1845–50.[17] In a particularly evocative image in one of her letters to Robert Browning, discussing her seclusion and its disadvantages and benefits for her development as a poet, she describes herself as 'in a manner, as a *blind poet*' (Kintner 1969: vol. 1: 41, original emphasis).[18] Of course, the original blind poet was Homer himself, in a tradition that stretches back to the archaic *Homeric Hymn to Apollo*.[19] Barrett Browning thus connects herself directly, in the first person, to Homer – using the generic masculine 'poet' to neatly blur the gender gap between them. In another essay, probably written around 1820, Barrett Browning describes a child called 'Beth' – clearly intended as an analogue for her younger self – who 'was a poet herself … No woman was ever before such a poet as she w[oul]d be. As Homer was among men, so w[oul]d she be among women – she would be the feminine of Homer …' (Browning 1913: 293).

Discarding Wolf: *Aurora Leigh* 5.1246–57

The most striking example of Barrett Browning's engagement with Homeric scholarship, however, appears in her poetry.[20] Towards the end of the fifth book

of *Aurora Leigh*, which forms a digression on the proper subject and form of epic, Aurora is found as an established poet in London, but low on funds and in poor health. Desiring to travel to Italy and in need of the money to fund her travel, she contemplates selling her father's books. Unable to bear the thought of parting with her father's copy of Proclus, she turns instead to Wolf's *Prolegomena*:

> The kissing Judas, Wolff [sic], shall go instead,
> Who builds us such a royal book as this
> To honour a chief poet, folio-built,
> And writes above, 'The house of Nobody!'
> Who floats in cream, as rich as any sucked
> From Juno's breasts, the broad Homeric lines,
> And, while with their spondaic prodigious mouths
> They lap the lucent margins as babe-gods,
> Proclaims them bastards. Wolff's [sic] an atheist;
> And if the Iliad fell out, as he says,
> By mere fortuitous concourse of old songs,
> Conclude as much too for the universe.
>
> AL 5.1246–1257[21]

This is not a mere side-note or auxiliary to Aurora's upcoming journey. I want to suggest that Aurora's deliberate and impassioned discarding of Wolf, with its engagement with Wolf's scholarship on Homer and the epic author's identity – turning 'a chief poet' into a 'Nobody' – has important implications for Barrett Browning's understanding of her own epic authorship. First and foremost, it is crucial to note that it is not *Homer* which Aurora discards here – as Simon Dentith and Downes both suggest[22] – but a particular critical reading of Homer with which she disagrees.

The *Prolegomena ad Homerum* was one of the landmark works of Homeric scholarship at the turn of the nineteenth century and introduced a debate which would characterize Homeric scholarship for hundreds of years.[23] In brief, Wolf's major claim in the *Prolegomena* was for a new 'textual history' for the *Iliad* and *Odyssey* – a tracing of the origins, formation and transmission history of the Homeric epics.[24] Inconsistencies in the different textual traditions and variants in the scholia were taken as evidence that the Homeric epics were (a) composed orally, before the advent of writing; (b) not composed by a single author (and therefore not all by 'Homer'); and (c) formed of a collection of shorter poems, preserved by an oral tradition and later collected and edited into its present form. This collation, Wolf claimed, was initially performed by Pisistratus, the sixth-century BCE tyrant of Athens and was subsequently heavily edited by the

scholars of Alexandria, whose annotations and comments had been preserved and published a few years earlier by J.B.G. d'Ansse de Villoison in his 1788 edition of the Venetus A and B manuscripts of Homer's *Iliad*.[25]

Anthony Grafton argues persuasively that Wolf's propositions were hardly new – commentators as far back as Cicero had implied that the *Iliad* and *Odyssey* were orally composed and collated later by Pisistratus.[26] What *was* new was the fluency and cogency of Wolf's argument; his imaginative creativity in positing a history for the Homeric texts; and the extent of the impact of the *Prolegomena*, which 'for almost a century thereafter . . . was *the* book that any aspiring classicist had to master' (Grafton, Most and Zetzel 1985: 26).[27] By 1874, 17 years after the publication of *Aurora Leigh*, the responses to Wolf's *Prolegomena* were so many and so diverse that Richard Volkmann was able to produce an entire volume devoted to its history and criticism (Volkmann 1874). Its reception was just as vigorous in England as in Germany. Diane Josefowicz (2016) traces the movement in classical scholarship from Richard Porson's (Wolf-influenced) contributions to the 1801 Grenville Homer, a new critical edition of Homer, to Mark Pattison's 1865 essay on Wolf which ensured Wolf's place as 'a Victorian intellectual touchstone' (Josefowicz 2016: 821).[28] Pattison's essay, couched as a review of J.F.J. Arnoldt's 1861–62 analysis of Wolf's pedagogical beliefs, introduces Wolf's *Prolegomena* as already 'famous' and 'known to us in this country . . . in connection with a certain theory of the origin of the Homeric poems' (Pattison 1889: 337).

The rejection in *Aurora Leigh* of Wolf's philological and historicist model – where ancient oral poems were seen as modulated, adjusted, and curated by their tradition – allows Barrett Browning to postulate instead a personal vision of epic authorship. Through her rejection of Wolf's Homeric scholarship, Barrett Browning's epic poet becomes an individual named poet (i.e. not 'Nobody') whose work is both transcendent of its tradition (as opposed to 'folio-built') and divinely inspired (Homer's lines become 'babe-gods', as opposed to Wolf who is dubbed 'an atheist'). These epic characteristics are mirrored in the text of *Aurora Leigh* in several different ways. In terms of the individual named poet, the conflation of Aurora's identity with the title of the work – she is its eponymous heroine – foregrounds Aurora's name and poetic identity from the very beginning. Others have already noted Aurora's identity as 'epic bard' and 'prophet-poet' along the lines of the Homeric bard;[29] according to Bailey (2006: 122), 'her sense of authorship as a high calling partakes of both epic-bardic and Romantic-bardic paradigms'. Several times in *Aurora Leigh* Aurora refers to poetry as 'singing' and herself as a 'singer', suggesting that she is engaging with a

Homeric model of oral authorship, as for example at 4.1202 where Romney
Leigh tells Aurora to 'sing your songs'. In terms of transcendence of tradition,
there is a telling moment just before Aurora rejects Wolf's *Prolegomena*, in which
she discards some other books:

> I fear that I must sell this residue
> Of my father's books, although the Elzevirs
> Have fly-leaves overwritten by his hand
> In faded notes as thick and fine and brown
> As cobwebs on a tawny monument
> Of the old Greeks – *conferenda haec cum his* –
> *Corruptè citat – lege potius,*
> And so on in the scholar's regal way
> Of giving judgment on the parts of speech ...
>
> ... Ay, but books and notes
> Must go together.

AL 5.1217–1228

Coming only eighteen lines before Aurora's discarding of Wolf and as the first
books to be disposed of, these are both worthy of further examination and,
I would suggest, are deeply implicated in the subsequent rejection of Wolf's
Prolegomena. First of all, the labelling of her father's books as 'Elzevirs' is
significant: it identifies them as products of a celebrated Dutch publishing house
of the late seventeenth and early eighteenth centuries, whose most significant
volumes included two editions of the New Testament in Greek (1624 and 1633)
and, importantly, a 1656 edition of Homer's *Iliad* and *Odyssey*.[30] Whether
Aurora's Elzevirs are biblical or classical – and as we shall see later, the blurring
of these two categories here is not without significance – the essential point is
that their pedigree points them out as a specific edition in the transmission
history of an ancient text. Both the Elzevir New Testaments and the Elzevir
Homer were revised, edited and translated versions of the 'original' ancient texts
written in Greek: the Elzevir Homer, for example, was edited and translated by
the Dutch classical scholar Cornelis Schrevel[31] and included the Greek scholia
(commentary) of Pseudo-Didymus, that is, the body of scholia traditionally (and
erroneously) associated with the first-century BCE scholiast and grammarian
Didymus.[32]

Further than this, Barrett Browning describes the text as being 'overwritten'
with her father's 'faded notes': but the examples she gives us of the types of notes
written show that they are far more than simply summaries. *Conferenda haec*

cum his can be translated as 'this is to be compared with that'; *corruptè citat* as 'falsely cited'; and *lege potius* as 'read rather ...' These Latin phrases are highly marked, in that they are precisely those which classical scholars, commentators and editors of the Homeric texts commonly use; indeed, they are directly compared to 'cobwebs on a tawny monument / Of the old Greeks', emphasizing their classical pedigree. What these notes tell us, then – and supported by the later description of them as written 'in the scholar's regal way' – is that Aurora's books are, in fact, ancient texts, reprinted and edited in the seventeenth century and then annotated with contemporary scholarship. It is for this reason that 'books and notes / Must go together' – for what they represent is precisely that process of textual transmission and the reduction of the poem to a 'folio-built' scholarly tradition and commentary, which Wolf supported and which Aurora denies.

'The two fires of the Scriptures and Homer'

The blurring of this textual tradition as belonging to the Homeric texts or the Greek New Testament in the naming of her father's books as merely 'Elzevirs' is, as I have noted above, no accident. The oscillation between biblical and classical imagery – 'the two fires of the Scriptures and Homer', as Barrett Browning puts it in one of her letters (Barrett Browning 1899: 92) – is a key and often-noted element of Barrett Browning's writing.[33] Kerry McSweeney goes so far as to argue that 'the Bible [is] ... far and away the most important literary influence' on *Aurora Leigh* (Barrett Browning 1993: xxxiii), whilst Friedman suggests that '[Barrett Browning's] reputation as the best woman poet in Britain was based on a succession of experiments in a variety of genres associated with masculine authority', from Greek tragedy to the New Testament, Homer to Milton (Friedman 1986: 207–8).[34] In the Wolf passage in *Aurora Leigh*, the classical and the biblical are explicitly connected and interwoven through imagery. Wolf is called a 'kissing Judas' and then an 'atheist'; Homer's lines of poetry are called 'babe-gods', and the white margins of the text are compared to the milk 'from Juno's breasts'.

Yet there is more than simply imagery at play here. Grafton notes in the introduction to Wolf's *Prolegomena* that it 'was directly modeled on one of the most controversial products of German biblical scholarship of Wolf's time: J. G. Eichhorn's *Einleitung ins Alte Testament*' (Grafton, Most and Zetzel 1985: 20).[35] He goes on to summarize the similarities between Eichhorn's work and that of Wolf, fifteen or so years later:

Like Wolf, Eichhorn treated his text as a historical and an anthropological document, the much-altered remnant of an early stage in the development of human culture. Like Wolf, he held that the original work had undergone radical changes, so that the serious Biblical scholar must reconstruct 'the history of the text'.

Wolf's approach, then, is one of 'atheism' because it espouses a similarly historicist attitude to contemporary biblical scholars; and 'the Elzevirs' mentioned earlier at line 1218 are to be discarded, whether classical or biblical, because of the similarities of 'the scholar's regal way / Of giving judgment on the parts of speech' in *both*.[36]

Curating Homer: Proclus, Plato and Wolf

That this is a carefully curated model of classical and contemporary scholarly and literary critical debates around Homer and Homeric authorship is shown, not only by Wolf's *Prolegomena* and Aurora's father's Elzevirs, but also by the other books she chooses to discard. After disposing of her father's scholarly biblical/classical annotations (5.1217–28), Aurora continues with Proclus (1228–45); but she decides that she 'cannot, in such a beggared life, afford / To lose my Proclus – not for Florence even'. Wolf is discarded instead (1246–57); and the final victim is Plato ('That Wolff, those Platos: sweep the upper shelves / As clean as this, and so I am almost rich'). Even without Wolf, the choice of authors – Proclus kept, Plato discarded – is a blatant attempt to create a curated collection of Homeric criticism. Plato, of course, was one of the most famous early critics of Homer in his *Republic* (c. 380 BCE), and argued for the banishment of poetry, and Homeric poetry above all, as a false imitation of reality.[37] Proclus, on the other hand, was a Neoplatonist philosopher of the fifth century CE, much less well known than Plato, among whose works were a set of commentaries on Plato, including a series of essays in response to the *Republic*.[38] The sixth essay, in particular, contains a defence of Homer against the charges brought against him by Socrates in the *Republic*: in it, Proclus attempts to rehabilitate Homer by claiming that *both* Plato and Homer should be regarded as 'interpreters of the same truth about reality' (Lamberton 2012: 61).[39]

In this sense, the decisions Aurora makes as to which books to keep and which to discard create a distinctly curated collection of classical texts and subsequent scholarship, to form a particular vision of Homer as an author, and epic and its role. Plato, who banished Homer, is himself banished. Proclus, who defended Homer, is kept. Seventeeth-century editions printed by Elzevir,

along with their accompanying notes symptomatic of the 'folio-built' scholarship and tradition introduced in Wolf's *Prolegomena*, are all discarded as contrary to the preferred vision of the individual poet-genius, divinely inspired, whose poetry is transcendent of context and textual tradition.

Bastards and babe-gods: Patrilineal epic and Homeric scholarship

At the same time, Aurora's rejection of her *father's* Elzevirs – representing the philological biblical and classical tradition of scholarship and covered in scholia-like annotations – suggests a dismissal of a patrilineal tradition of masculine epic and scholarly commentary. Barrett Browning thus, through a complicated engagement with, and refutation of, contemporary scholarship on epic as a genre, prises Homer – whom she calls the 'father of poetry'[40] – from the patrilineal mechanisms of textual reception and commentary.[41] Instead, as other critics have noted, she places Homer within a maternal vision of epic poetry, refiguring the Homeric lines as 'babes' and the white margins of the page as 'breast-milk'.[42] Here the 'natural' image of poetry as an infant feeding at its mother's breast is intruded upon by the 'cultural' notion of hereditary legitimacy between a father and his children, as the male Wolf disowns Homeric poetry as a bastard.[43] Homer's epics, visualized through the maternal succession from Homer to his 'babe-gods' are displaced by Wolf's rejection of the Homeric lines, 'proclaim[ing] them bastards' – and then displaced once again, as Aurora in turn rejects Wolf. Wolf's analytical vision of Homer and the associations evoked by her father's scholarly editions of the Homeric text are thus both discarded, to be replaced by a new vision of female epic poetry: one which rests on a transcendent vision of the classical tradition, freed from the masculine constraints of her father's and Wolf's scholarship and false fatherhood, and which instead projects a new type of creative, divinely inspired authorship, visualized through the image of the maternal.[44]

II. 'Things remembered, forgotten, and re-assembled in different order': H.D. and the oral-formulaic theory of Milman Parry

Hilda Doolittle, known by her pen name H.D., was born in 1886 in Bethlehem, Pennsylvania, and later became part of a circle of American modernist poets who would shape the discourse of early-twentieth-century American poetry,

including William Carlos Williams, Marianne Moore, and, perhaps most notably, the poet and literary critic Ezra Pound.[45]

Helen in Egypt was written between 1952 and 1955 and published posthumously in 1961.[46] It was one of H.D.'s latest works in a wide-ranging corpus notable for its classical allusions, displaying a vast wealth of intertextuality with authors from Apollonius of Rhodes to Euripides, Homer to Theophrastus.[47] The epic is divided into three sections, 'Pallinode', 'Leuké' and 'Eidolon', which are, in turn, subdivided into seven, seven and six books, each of which contains eight lyric poems written in free verse, headed by prose captions.[48] Through the course of the poem we follow Helen, her meeting in Egypt with Achilles after his death, her explorations of her troubled past with Paris and Theseus and, ultimately, Helen and Achilles' union in the re-habilitation of the mother-figure, represented as a union of the goddesses Cypris (Aphrodite), Thetis, and Isis – and, of course, Helen herself.[49]

Rather than focusing specifically on moments of classical intertextuality – although these will come into my discussion – I want to suggest that H.D., like Barrett Browning, constructed her epic in dialogue with contemporary issues in classical scholarship.[50] I will argue that seeing *Helen in Egypt* through the lens of contemporary critical movements in the study of Homeric epic – in particular, the oral-formulaic theory of Milman Parry – provides a new perspective on the poem's major themes; that reading *Helen in Egypt* in counterpoint to Parry's research on Homeric orality sheds light on H.D.'s wider project and her re-definition of female epic. In contrast to Barrett Browning, however – and typically for the Imagist poet – this engagement is much more oblique. As Flack (2015: 10) points out, we cannot expect 'the scholarly precision' which is often assumed in studies of H.D.'s classical allusions: she, and other modernist poets like her, 'were more concerned with how readers might manage partial, incomplete, and failing knowledge than they were in creating assured pedantic readers'. Perhaps we might imagine that it is in this, as much as anything, that the 'improvisatory, unsystematic nature of modernist Homeric writing' reflects the oral theories of Milman Parry – where bards are seen as composing-in-performance on an already-known theme.

Milman Parry and the oral-formulaic theory

One of the landmark points of early-twentieth-century Homeric scholarship was the comparative oral research undertaken by Milman Parry in the 1920s and early 1930s.[51] Parry, an assistant professor of ancient Greek at Harvard, performed

comparative research in Yugoslavia to establish whether any evidence could be found for the feasibility of the memorization and composition of oral poetry at similar lengths to Homer. His major contribution was in his analysis of the formulaic structure of Homeric epic, with a particular focus on its epithets (such as Homer's 'wine-dark sea') which, he argued, were directly associated with its oral composition (Parry 1971). Parry's theories, further developed by his student Albert Lord, suggested a specific mechanism for the composition of oral epic: the assimilation of small elements of poetry, such as formulae (including epithets) or stock scenes, and then their re-organization in various patterns and configurations by different bards as the traditional stories were handed from one poet to another. These oral elements, which initially served a mnemonic function, were then preserved when the Homeric poems were transcribed into a written text.

Haubold (2007: 31) suggests that Parry's research on the orality of Homeric epic radically altered 'discourses of tradition and reception precisely in the context of shifting, and often conflicting, perceptions of Homeric epic as a text'. Discussing the effect Parry's work had on twentieth-century creative receptions of Homer, Haubold writes (2007: 44):

> A linear model of literary reception, where elements of Homeric epic are creatively imitated and adapted, is called into question by the competing and overlapping notions of the timeless text. Some [twentieth-century authors] knew Parry's theory in detail and engaged with it in sophisticated and sometimes disconcerting ways. Many did not, but even when we assume no direct knowledge, twentieth-century responses to Homer often resonate with Parry's concerns.

This 'resonance' with movements in Homeric scholarship and the major shift in the visualization of the Homeric text introduced by Parry is an important tool in reading H.D.'s *Helen in Egypt*. Most scholars interested in the classical intertext of the poem have focused on the opening prose caption to 'Pallinode' (Doolittle 1961: 1),[52] where H.D. traces the textual history of Helen's story, from the archaic lyricist Stesichorus' *Palinode* (in which Stesichorus famously defends Helen against the accusation that she went to Troy) to Euripides' *Helen* (412 BCE, which tells the story of Helen's discovery by Menelaus in Egypt after the Trojan War):[53]

> *We all know the story of Helen of Troy but few of us have followed her to Egypt. How did she get there? Stesichorus of Sicily in his* Pallinode [sic], *was the first to tell us. Some centuries later, Euripides repeats the story.*

This opening – as well as references in the text to Euripidean tragedy and comments in H.D.'s working notebook – has led Eileen Gregory to argue in her

1995 article (and later in her 1997 book, *H.D. and Hellenism*), that 'the major subtext of *Helen in Egypt* is not Homeric epic ... but rather Euripidean tragedy' (Gregory 1995: 84).[54] I want to argue, however, that this is to miss the fundamental force of the phrase 'we all know the story' with which the epic opens. That Homer is elided here as the origin of the story of Helen of Troy is, I want to suggest, part of both the latent power of the Homeric texts in their formation of the classical tradition[55] – so well-known that they do not even need to be referenced by name – as well as, and more importantly, an evocation of the tension between the source text and 'the story' of Helen, the narrative, the myth which is handed down through the vagaries of the textual tradition from Stesichorus to Euripides to H.D.'s own poem, '*the later, little understood* Helen' (p.1, original emphasis).

In what follows, then, I will argue that the subtext to *Helen in Egypt* is neither Euripidean tragedy (as Gregory posits) – but nor is it Homeric epic per se, or at least, not its *content* (as many major critics like Blau DuPlessis 1986: 111–12 have suggested).[56] Rather, I will suggest, the major focus is on the *textual* level, in response to Parry's oral theory: the tension between orality and textuality which opens up the problem of the 'reality' of Helen's story, and the slippage between her oral and textual re-creations – from the oral Homeric songs, to the written Homeric texts, to the lyric of Stesichorus and the spoken/sung drama of Euripides.[57]

H.D.'s interest in Homer and her engagement with classical literature and scholarship more generally have been much studied, most notably by Gregory in *H.D. and Hellenism*, but also by Flack in *Modernism and Homer*, who suggests that H.D. worked most closely to the classical tradition of all the modernist poets (Flack 2015: 165).[58] As Gregory (1997: 173) notes, 'the specificity of [her] references to Homer indicates that H.D. had a good acquaintance with both his epics in her early years';[59] though she did not know much Greek (at least not formally), she composed free translations of the first 100 lines of the *Odyssey*, as well as Euripides' *Ion*, *Iphigeneia in Aulis* and *Hippolytus*, consulting a combination of standard editions (with the help of a dictionary) and English and French translations.[60]

It was not only the content of classical poetry which interested H.D., however, but also classical scholarship. Flack suggests the importance of the classicist (and protégé of Gilbert Murray) James Alexander Kerr Thomson's readings of the *Odyssey* for H.D.'s interpretation of the *Odyssey*; Gregory analyzes her engagement with the literary critic Walter Pater and the Cambridge classicist, Jane Harrison; in an essay on Pausanias, H.D. refers to 'the great German, Willamowitz-Müllendorf [sic]'; and we know that she read the work of classicists

Arthur Verrall and Gilbert Murray in her studies of Euripides.[61] While H.D. does not specifically mention the work of Milman Parry,[62] we can be fairly certain that she was at least aware of its 'resonance' within Homeric scholarship and reception: not least because her close friend, literary colleague, and one-time fiancé, Ezra Pound, with whom she corresponded throughout her life,[63] certainly did know of Parry's work.[64]

Memory, recomposition and orality in 'Helen in Egypt'

The tension between oral memory and fixed script resonates throughout *Helen in Egypt*, and forms one of its central concerns amidst a host of other oppositions: Greece/Egypt; male/female; war/peace, epic/lyric, and so on.[65] In perhaps one of the most telling passages, H.D. refers to the contrast between the tension of a drama-in-progress, 'a story, a song' where the story is open-ended ('how will the story end?') and 'the already-written drama or script', where 'drama' is visualized as textual production, a pre-written script in which 'the players have no choice in the matter' (Doolittle 1961: 230):

> There is a story, a song 'the harpers will sing forever.' It is a play, a drama – 'who set the scene? who lured the players?' The players have no choice in the matter of the already-written drama or script. They are supremely aware of the honour that 'all song forever' has conferred upon them.

This is, in the first instance, an example of the often-noted generic flexibility of *Helen in Egypt*, fusing drama, song (lyric) and epic with apparent ease.[66] Yet it is not only about the fusion of generic categories here, but also the combination and complication of the 'already-written … script' and the oral 'song'. H.D., in other words, opens up the paradox of a *written oral poem*. That this paradox and tension between 'song' and 'script' is written through Homer is made evident by the fact that H.D. here paraphrases (in quotation) Helen's words to Hector in the *Iliad*, 'so that we, too, may be subjects of song for generations to come'.[67] The contrast between the prose caption at the start of the poem, and its self-referential quotation of the poem beneath – 'who set the scene? who lured the players?' (p. 231) – both plays out the history of Homeric scholarship and annotations/scholia, as we saw above, and draws attention to the opposition between the (contrasting) voices of the poet and commentator.[68]

At this point in the poem, the tension between orality/textuality, scholarship/poetry is as yet unresolved, 'a question asked / to which there was no answer' (p. 230). But the opposition and tension reaches its climax at an important

passage, near the poem's close, in which H.D. moves back to take a wide view of epic, its composition and proper subject. At this point, at the start of the last book of the final section, 'Eidolon', Helen has realized the nature of 'the ultimate' – but also, the 'price' at which that comes, in terms of the definition and circumscription of 'the epic' and the subjects which have been excluded from 'the story' (pp. 288–89):

> but what followed before, what after?
> a thousand-thousand days,
> as many mysterious nights,
>
> and multiplied to infinity,
> the million personal things,
> things remembered, forgotten,
>
> remembered again, assembled
> and re-assembled in different order
> as thoughts and emotions,
>
> the sun and the seasons changed,
> and as the flower-leaves that drift
> from a tree were the numberless
>
> tender kisses, the soft caresses,
> given and received; none of these
> came into the story,
>
> it was epic, heroic and it was far
> from a basket a child upset
> and the spools that rolled to the floor . . .

This passage is significant, in that it is the first time that 'epic' is mentioned specifically within the poem, suggesting its metaliterary significance as an examination of the genre. The classical intertexts of the passage are both overt and generically complicated. Towards the end of the excerpt quoted above, H.D. gives as an example of the 'million personal things' excluded from epic 'the numberless / tender kisses', which are described with a simile: 'as the flower-leaves that drift / from a tree were the numberless / tender kisses' (p. 289). This is a clear reference to one of Homer's most famous similes from *Iliad* 6.146–9, where the generations of mortals are compared to 'the leaves which the wind scatters to the ground'.[69] Paradoxically, H.D. uses a Homeric simile to describe something which, she argues, has been deemed inappropriate to epic. At

the same time, the subject of the simile – 'the numberless / tender kisses' – are also a classical intertext, this time referring to the *carmina* of Catullus – a first-century BCE Roman poet who was part of a group of 'new poets' who had self-avowedly cast off the Homeric (Greek)/Ennian (Latin) epic model. Catullus' poem 5, written in hendecasyllabics, famously requests from his lover Lesbia 'a thousand kisses, then a hundred; / then another thousand, and another hundred;' 'the sun may set and rise again; / but when once our brief light goes, / there is but a single night for sleeping;' therefore they will kiss and 'confound the number, so we will not know . . . / how many are our kisses'.[70] Not only are the 'numberless / tender kisses' in *Helen in Egypt* a clear reference to those of Catullus; the earlier passage in H.D.'s poem – 'a thousand-thousand days, / as many mysterious nights, / and multiplied to infinity' – recalls the day/night contrast of the opening to Catullus 5, and the anaphora of 'thousand . . . thousand' in the description of Lesbia's kisses.

This is, then, a highly marked passage in terms of both its definition of epic as a genre, and its classical intertextuality. The generic blending of Homer and Catullus in the refutation of epic subject matter both aligns H.D.'s project with other poets who countered Homer – like Catullus – and, paradoxically, appropriates Homeric language to conduct its refutation. These moments of intertextuality set the stage for H.D.'s most important investigation of Homeric scholarship and the mechanism of the textual tradition. Flanked by the Catullan 'thousand-thousand days' and the Homeric simile of the 'flower-leaves', we have the central definition of the mechanism by which the subject matter that was deemed unfit for epic was elided: 'the million personal things, / things remembered, forgotten, / remembered again, assembled / and re-assembled in different order' (p. 289).[71] On one level, this plays into the theme of memory which resonates throughout *Helen in Egypt*: a few pages after this passage, the entire poem closes with the line, '*a memory forgotten*' (p. 304, original emphasis), suggesting its centrality to the epic's concerns. On another level, the association between memory, re-composition and epic resonates particularly closely with Parry's theory of oral composition in Homer. Parry's discussion of the 'technique' of epic oral poetry is similar in its wording (Parry 1971: 20, emphasis mine):

> We are faced with the analysis of a technique which, because the bard knew it without being aware that he knew it, because it was dependent on his *memory* of an *infinite* number of details, was able to attain a degree of development which we shall never be in a position perfectly to understand.

The juxtaposition of 'memory' with 'an infinite number of details' seems to recall H.D.'s 'things remembered', 'multiplied to infinity' – that nexus of surplus, memory and detailed recall which Parry outlines as the province of the oral bard. Similarly, Parry discusses formulaic epithets (Parry 1971: 82–3, emphasis mine):

> Traces of originality remain, perhaps; but of an originality that does no more than *rearrange* the words and expressions of the tradition without important modifications. The poet's greatest originality in the handling of epithets would have been to use some noun-epithet formulae a little more or a little less.

The re-arrangement in a different order of formulae that have been stored in the poet's memory, as the greatest expression of a poet's originality, seems to come close to *Helen in Egypt*'s 'things remembered, forgotten, / remembered again, assembled / and re-assembled in different order'. In the union of *memory* and *re-assembly* – the two key facets of oral epic poetry as identified by Parry – in the passage that closes *Helen in Egypt*, then, we see a reflection or refraction of contemporary Homeric oral theory.

'What can a woman know?': H.D., William Carlos Williams and the gynogynetic text

The important point, however – and the ultimate paradox – is that these 'things remembered, forgotten', which make up the texture of Homeric poetry according to Parry's oral theory, are in fact the very elements which H.D. says did *not* 'come into the story' of epic. Just as a Homeric simile is paradoxically used to define the non-Homeric anti-'epic, heroic' subject matter, so a Homeric textual mechanism is used to describe the very process by which non-epic elements have been excluded from the epic tradition. But it is precisely the 'unity' of this apparent paradox which is the ultimate aim – or *telos* – of the text. When Helen undergoes her 'psychoanalytic' sessions with Theseus, she comes out realizing that there is 'no need to untangle the riddle, / it is very simple' (p. 192) ... 'they were one' (p. 238).[72] As we approach the epic's end, the unity of opposites is stressed more than ever: Cypris (Aphrodite), Isis and Thetis are aligned (pp. 178–79); opposites like 'day, night', 'wrong, right', and 'dark, light' *'meet finally in "Helen in Egypt"' and "Helen in Hellas forever"'* (p. 190, original emphasis), unifying difference in the fractal figure of Helen; ultimately, of course, Helen and Achilles, La Mort and L'Amour, come together as one, as both their own parents and their children, enshrined in the child Euphorion (p. 288). Critics have read this realization of

'the ultimate' and 'the One' at the poem's close as bringing together the various oppositions and polarities explored throughout the epic, as we saw above, breaking down the contrast between Greek and Egyptian, male and female, Achilles and Helen by 'rewrit[ing] the maternal back into an epic tradition that has tended to repress it' (Flack 2015: 186).[73] The maternal, in the rehabilitation of Thetis, Achilles' mother, as well as Helen's newly realized motherhood, becomes the solution to the antitheses and false oppositions which represented both unreality and the violence of war.

The emphasis on the maternal as the epic's solution is not, however, simply the union of male and female abstractions in the figures of Helen and Achilles, as most scholars suggest; it is, rather, a deliberate resolution between two modes of epic transmission, the male patrilineage of Homer and the matrilineal epic of H.D. – contrasting visions of epic lineage which were, in fact, explored by one of H.D.'s circle only a few years before she began work on *Helen in Egypt*. The poet and essayist William Carlos Williams – himself the author of an epic poem, *Paterson* (1946–1958) and writing 'during a period of concentrated work on the epic' (Kinnahan 1994: 81) – wrote a brief but important essay in 1946, published in the short-lived *Briarcliff Magazine* and titled 'Letter to an Australian Editor'.[74] The focus of the essay is a contrast between two different models of poetic authorship in relation to the tradition. The first is the 'classical' model, whereby poets 'strike back toward the triumphant forms of the past, father to father. No mother necessary'. This patrilineal and 'academic approach' takes the 'fixed classic forms' as both their subject and formal structure and 'leaps ages and places' in an 'androgynetic' relationship between past and present. The 'direct approach', on the other hand, avoids the 'sterility' of the first patrilineal approach, engaging with the 'fertility' of the 'forms [which] arise from society ... the fecundating men and women about [the poet] who have given him birth' – later called the 'supplying female'. 'The direct approach', Williams summarizes, '*is* the spectacle of our lives today, raised if possible to the quality of great expression by the invention of poetry'.

Williams was a college friend of both H.D. and Pound at Bryn Mawr; in a letter to her agent and friend Norman Pearson, H.D. mentions that she was first introduced to Williams through Pound.[75] Perhaps most interestingly of all for our purposes, however, in a letter dated 14 January 1947, H.D. explicitly writes to Pearson that she has received 'a Bryn Mawr edition [of the *Briarcliff Magazine*] on Williams' (Hollenberg 1997: 71) – that is to say, precisely the edition of *Briarcliff Magazine* in which Williams' 'Letter to an Australian Editor' was originally published.[76] We are, then, in a rare and fortuitous case, able to ascertain

that H.D. did indeed read Williams' essay on the differences between the patrilineal and matrilineal epic traditions – and it is possible to suggest that H.D.'s *Helen in Egypt* might have been directly responding to Williams' feminist literary critical theorization.

The most striking instance of the male/female, androgynetic/gynogynetic epic distinction occurs in fact in the passage analyzed above on the proper subject of epic: 'it was epic, heroic and it was far / from a basket a child upset / and the spools that rolled to the floor' (p. 289). As Flack has already commented, this is an evocative maternal/feminine image, 'using the figures of the abandoned child and maternal care to transform [the] heroic tradition' (Flack 2015: 186).[77] The epic/heroic/masculine is replaced with the maternal/feminine. But there is also a distinctive meaning to the 'spools' – in that weaving is both a markedly female activity, and, as has often been noted, one associated with the poet in Homer. When Helen first appears in the *Iliad* she is shown weaving a tapestry of the war, as if she herself is creating the events of the poem; heroes are often said to 'weave' plots; and the plot of the poem is called a 'thread'.[78] The domestic image of a child upsetting a weaving basket, as something not fitting for high epic, is thus again, by its paradoxical association with the image of weaving in Homer, transmuted into an argument for women's – and Helen's – association with the figure of the poet. A few pages later we have a specific defence and re-evaluation of what *female* epic might look like, spoken, with typical indirectness, in the form of an objection: 'could a woman ever / know what the heroes felt' (p. 293); 'what can a woman know / of man's passion and birthright?' (p. 294).

The ultimate irony, and redemption, of course, is that *Helen in Egypt* is spoken in the female voice (both of H.D. and Helen) and that the epic experience of Helen's journey within is framed (largely) through the eyes of a woman. As with *Aurora Leigh*, *Helen in Egypt* becomes metonymic for poetry itself as both the character of the epic and its title.[79] This is where the final union – between orality and textuality, scholarship and poetry – is enacted. Helen is described twice in the epic as 'the writing' – 'she herself is the writing' (pp. 22, 91)[80] – and she is consistently identified with the hieroglyphs which she alone can decode (Achilles calls her a 'hieroglyph' on pages 15, 16, and 17). But Helen is also connected to the voice: '*it is an heroic voice, the voice of Helen of Sparta*' (p. 176); and, even more suggestively, implying Helen's identity *as* the voice: '*again, the "voice" seems to speak for Helen*' (p. 178). Helen becomes the speaking script and the written voice – an emblem for the paradox of a poem that is both oral and written, masculine in genre and tradition, and female in identity and authorship.

In the union of Helen and Achilles and the 'birth' of Euphorion, then, we not only have the union of the male and female, and the collapse of the parent/child into the self but, at the same time, a new maternal lineage for the birth of the text, as introduced by Barrett Browning and theorized by Williams. At page 217, Paris comments in a discussion of the traditional mother–son lineages that 'this is the old story, / no new Euphorion'. By assimilating the 'story' with 'Euphorion', Helen and Achilles' child thus also becomes a figure for a new kind of epic 'story', born from the mother. And Helen's later discussion of Euphorion, in the line following the image of the child upsetting the wool-basket of female epic (p. 289), suggests that Euphorion is visualized along the lines of Williams' gynogynetic literary creations, springing directly from Helen's maternal creativity.

In the end, then, H.D. suggests, difference can be reconciled on both a surface and a structural level. On the surface, the differences between Egyptian and Greek, male and female are reconciled; on a structural level, the genres of epic, lyric, and drama are brought together; most importantly of all, the paradox of an oral and a written text, a male and a female epic, is resolved. The apparent problems of the Homeric text, the questions of authorship, gender, identity, textuality, transmission, memory and structure, are reduced in a 'new spirit-order' whereby the epic patrilineage is reversed, and Helen – the female script/female voice – becomes the mother of Achilles and Paris, her own myth, and her own epic text (pp. 217, 289–90). Creative maternity instead becomes a model for a new vision of epic creativity, where voice and script, male bard and female poet come together, 'remembered, forgotten, and re-assembled in different order'.

III. Conclusion

Female epic cannot be disassociated from its classical heritage, in its very generic identity *as* epic and the assumptions of masculinity and classicism that come with it. Even as authors like Barrett Browning and H.D. respond to and refine the epic genre, it is in constant dialogue with classical epic texts – in particular Homer – and, crucially, with the scholarship and literary criticism that surrounded the Homeric texts. Homeric epic does not exist as a mere source of content on which to draw for allusion and intertext, separable from its criticism and tradition, as many scholars including Friedman and Gregory seem to imply.[81] The Homeric text was never fixed; its fluidity – both in a tradition of commentary/excision, and in the transition from oral song to written – lies, I argue, at the heart of Barrett Browning's and H.D.'s re-readings and revisionings

of the epic tradition. The instability of Homeric textuality, the history of contested readings and alternative interpretations in classical scholarship from Wolf to Parry, provides a site in which female epicists can remould epic to their own concerns. In that space and openness in the tradition, we see Barrett Browning and H.D. creating a new vision of their identity as authors; positing new models for poetic creation; situating themselves within the canon in often complicated ways that signal both independence and allusion; and drawing on the image of the maternal to create a new lineage of creativity, positing the matrilineal as an alternative to the patriarchy of Homer.[82] In this sense, as Barrett Browning noted of her early response to Homer, female epic can be read as both a 'doing over' of Homer – as well as his undoing.

Generic 'Transgressions' and the Personal Voice

Fiona Cox
University of Exeter

In 1993, Charles Martindale's short monograph *Redeeming the Text: Latin Poetry and the Hermeneutics of Reception* changed the landscape of classical scholarship, particularly the field of classical reception. Martindale's aim was to challenge 'positivistic modes of interpretation (with their teleological assumptions) still dominant in Latin studies' (1993: xiii), by offering a mode of reading that focused upon the act of reception, the points of meeting between the reader and the classical text, which necessarily needed to take account of the journey that the text had taken as well as of the reader's personal and cultural background. For Martindale 'the interpretation of texts is inseparable from the history of their reception' (ibid.). One of the effects of his pioneering approach was to wrest the study of classical literature away from its fusty and patriarchal image by challenging its authority. Another was his laying the foundations of a far more personal approach to the study of classical literature. The main focus of this chapter will be upon the reception of classical literature within the works of the British poet and translator, Josephine Balmer. Balmer calls her poems 'transgressions', a term that highlights the hybrid nature of her responses to classical works, which are both translations and responses that recontextualize elements of the original within a new and deeply personal context. The generic indeterminacy of such poems – which are translations, adaptations and personal laments at one and the same time – highlights the networks of allusions that shimmer within the poems, often intensifying their melancholy. This has implications not only for the way in which we read Balmer, as we shall see, but also for our appreciation of works such as Livy's *Histories* – male-authored Roman historical prose – which find themselves employed to give voice to female-authored elegy at the start of the twenty-first century.

In *Piecing Together the Fragments*, Balmer invokes Parker and Willhardt to examine the way in which the 'cross-gendered poem' can destabilize

our preconceived notions about the differences between male and female (2013: 141):

> In an essay on the cross-gendered poem – that is, a poem written in a gender voice other than that of its poet-author – Alan Michael Parker and Mark Willhardt declared that, like transvestitism, such poems present a 'third term' which can undermine assumptions about male/female gender binary. This also holds true of a woman translator translating a male poet.

As we hear the duet of male original and female transgressor it becomes clear that such adaptations have implications not only for the gendering of the narrative voice, but also for the generic conventions that govern our understanding of the works we read. Writing a lament that draws heavily on classical epic is an act that mutes the 'heroic', 'imperial' notes of epic that led it to be thought of in conventionally male terms. As we shall see, Balmer's sonnets, her modern-day elegies, serve as a corrective to the limitations of so narrow and reductive a view of epic by highlighting what Parry famously depicted as the 'private voice of regret'.

Balmer's work demonstrates, moreover, that the meaning of a text is realized most richly when a reader allows it to challenge and engage with all the books and texts s/he has read or experienced, and which therefore form the bedrock of the thinking and feeling self.[1] Throughout his 1993 monograph Martindale shows an interest in the ways in which texts probe the beings of those who read them, so that an act of interpretation becomes an act of self-revelation. And, as our identities do not remain static, texts are capable of endless re-tellings, of being viewed anew from a variety of different perspectives. The price demanded by a dynamic and creative reading is, however, vulnerability. Towards the close of the volume Martindale observes (1993: 106):

> If this paradox can be lived with and reading can be construed as (potentially) dialogic in some such sense as this, then, perhaps, the word is not frozen, not dead, but capable of being redeemed and of redeeming, whenever a reader, accepting her own historicity, makes an act of trust, and commits herself to a text in all its alterity, takes, in other words, the risks – and they would be risks – of being read, of relationship. In such relationships who knows what could be found? Maybe only an absence. But there is always the possibility that, for some reader, somewhere, one day, it will prove to be the Love that moves the sun and the other stars.

The poet and translator, Rachel Hadas, who studied Classics at Harvard, is haunted by the absences sheltered in a particular line of the *Aeneid* 'quisque

suos patimur manes' (*Aen.* 6.743) ('Each bears his own ghosts.'), a phrase which she calls 'darkly luminous'.[2] For her these words indicate the loneliness of loss – since even a shared grief will be experienced differently by each individual. In an essay entitled 'Talking to My Father' she writes of her attempts to find her dead father again through his writing (he was a Classicist), to continue a conversation with him through his books. Of course, her efforts are doomed and she evokes in Virgilian terms the impossibility of reaching her father, even as she invests her re-reading of his books with the paradox of an absence that is achingly palpable: 'This, then, is the demanding ghost to whom these days I find myself reaching out; the ghostly retribution I am enduring; the shade I am suffering. I open my arms to embrace Moses, and he slips away. But the words are there.'[3] In another essay 'Invisibility' she uses the same phrase to evoke the pain of the absence of her husband, even as he remains with her physically, since he was lost to dementia. The contagion of his absence, his invisibility, spreads to her also, since colleagues and friends were no longer able to view her in quite the same way following her husband's diagnosis:

> Dementia, especially when it is linked, as George's is, to aphasia – is a guaranteed purveyor of ghostliness. I also think of what the dying Keats referred to as his own posthumous existence. Looping back to Vergil, I think of Aeneas carrying his father on his shoulders out of the ruins of Troy. It seems to me I've been carrying George for years now; even though he isn't at home any longer, I am still carrying him. The people I have met in the past year and a half, people whose husbands and wives and partners live in the same place that George does, are similarly carrying ghosts on their shoulders. To each his own, her own: *quisque suos patimur manes.*[4]

The recognition of the value of the personal voice amongst professional classicists has gained ground slowly but surely. Most recently Daniel Mendelsohn has explored his loving but conflicted relationship with his father in a book that is both a memoir and a study of the *Odyssey.*[5] That the book has been widely acclaimed is, perhaps, testimony to how widely the personal voice has become accepted. The contrast between the reception of his book, an account of what happened when his father became his student in his course on Homer, and the situation 20 years ago is striking, and becomes evident if we look at the rationale behind a book published in 1997. *Compromising Traditions: The Personal Voice in Classical Scholarship* (1997) is a collection of essays where personal approaches and stories are revealed alongside an analysis of the discomfort and embarrassment of revealing too much about oneself in scholarship or in the

classroom. Mendelsohn's writing both about the *Odyssey* and about his homosexuality contrasts starkly with Charles Rowan Beye's memories of the way in which classical texts were used to stifle personal stories: 'my generation's dislike of the personal voice theory stems, I think, from a profound need to use classics as a place to hide'.[6] Several of the essays in *Compromising Traditions* reveal that their authors have experienced 'impostor syndrome' – a conviction that they do not have the correct birthright for the rarefied world of classics departments. The title of Thomas van Nortwick's essay is highly revealing in this regard: 'Who do I think I am?' He opens his account by observing that: 'my title [...] could echo my bullying censor, who wants to know how I dare talk to professional classicists about personal issues. The latter fellow, like all bullies, is driven at bottom by fear: that I will appear vulnerable, that I will be revealed as self-indulgent, solipsistic, or – worst of all for the classicist – *mistaken*' (1997: 16). As van Nortwick explores the various reasons for classicists shying away from the personal voice, he acknowledges the potential for creating tension within the classroom, citing 'matters of propriety: you might embarrass the students who do not want to be asked either to talk about their lives or to respond to your life' (1997: 21). Yet it is, in part, through encouraging such a personal response amongst new readers that the classics has been rescued from the past and enabled to speak in new voices; van Nortwick observes that 'if the work of art is to have any significance beyond the museum, it must engage us now. All we have are the stories, and they must make their way into the present' (1997: 23).

Significantly, this development has coincided with a burgeoning of poets, also turning to the classical world, to explore their personal histories. Amongst the most well-known of these are Seamus Heaney, whose responses to and translations of Vergil, in particular, granted him access to both a literary and personal underworld;[7] or Louise Glück, who used allusions to Homer's *Odyssey* in her poetic recounting of her divorce (2012: 307–63). The flowering of classical reception within contemporary poetry has generated interest in the ancient world and has enabled the classics to be known more widely, as they are revitalized in the writings of those who previously had felt themselves to be outsiders to this emblem of a predominantly male, privately educated world. And of course, as source texts enter both the fabric and the narrative of these changed lives, they themselves become radically altered. One of the ways in which this is most visible is in the generic conventions that are flouted, metamorphosed, and reworked. As Glück performs a poetic postmortem on her marriage as a female poet in the late twentieth century, exploring the selves she

was before and after her divorce, she recontextualizes one of our earliest examples of epic, a genre that is conventionally masculine and devoted to celebrating the male-dominated activities of warfare and travel.[8] To find such a work reworked to explore domestic discord both introduces the imagery of warfare into the anatomy of marital separation and reminds us of the *Odyssey*'s focus upon the importance of home and stability at home.

One of the most powerful personal responses to classical poetry in recent years has been Anne Carson's *Nox*, a work which combines a meditation upon the act of translation with her translation of Catullus CI, the poem where Catullus laments his brother's death. As Carson bears Catullus's grief into the twenty-first century, she not only translates his words, but also draws upon him to explore her sorrow at her own brother's death. In her efforts to find the boy he had been – almost as elusive in life as in death – she found herself slipping between different genres and different formats. Her book is a memory album – a small boy in a swimming costume gazes at us from an old family photograph, frozen into the past. The book is also a compendium of dictionary definitions of the individual words of Catullus's poem. Above all, perhaps, it is an elegy for her brother, both the lost boy from childhood and the adult with whom she was seldom in contact. But in her frustration at the impossibility of wresting her brother back from the darkness and commemorating him in stars, Carson shifted from elegy to history:

> I wanted to fill my elegy with light of all kinds. But death makes us stingy. There is nothing more to be expended on that, we think, he's dead. Love cannot alter it. Words cannot add to it. No matter how I try to evoke the starry lad he was, it remains a plain, odd history. So I began to think about history.[9]

And yet poring over her brother's few letters, thinking about Herodotus, tracking her brother's existence to various locations all also failed to restore him: 'All the years and time that had passed over him came streaming into me, all that history. What is a voice?'.[10] For Carson, the act of trying to find her brother within his own words (an act that Hadas also performed in her grief for her father) is akin to the act of translation, of conveying the essential spirit of a work in a second language: 'Because our conversations were few (he phoned me maybe 5 times in 22 years) I study his sentences the ones I remember as if I'd been asked to translate them.'[11] The act of translation is akin to the work of grief, since both activities entail stumbling through the shadows in search of an elusive ghost or a non-existent word that can embody the absolute essence of the original. Carson beautifully equates the frustration attendant upon both activities:

Nothing in English can capture the passionate, slow surface of a Roman elegy. No one (even in Latin) can approximate Catullan diction, which at its most sorrowful has an air of deep festivity, like one of those trees that turns all its leaves over, silver, in the wind. I never arrived at the translation I would have liked to do of poem 101. But over the years of working at it, I came to think of translating as a room, not exactly an unknown room, where one gropes for the light switch. I guess it never ends. A brother never ends. I prowl him. He does not end.[12]

Carson not only anticipates Hadas' efforts to disinter the dead from the lines that they wrote, but also her 'transgressions' and to talk with them, but her blurring of generic boundaries and an instinctive turn to classical poetry in her navigation of grief all also align her with the British poet and classicist, Josephine Balmer.

Eleven years after Martindale's *Redeeming the Text* and seven years after the publication of *Compromising Traditions*, the poet and translator, Josephine Balmer, published *Chasing Catullus,* a volume composed of what Balmer calls 'transgressions', a term which defines her blend of original poetry and translations from ancient poetry. Balmer, who had to fight to be able to take Greek at A-level,[13] read Classics at University College, London, and has maintained her interest in classical scholarship throughout a career devoted to publishing transgressions and translations of classical poetry. In an interview with Lorna Hardwick she described the ways in which classical scholarship underpins her creative practice (2010):

Yes, I think – coming at it from a literary point of view, but I did also do a lot of scholarship as well and I think it's very important to do both. Even though my translations might often look like they're very, very free and far wide of the text, I have done an awful lot of scholarship in order to get there. [...] I always think of it a bit like a painter, an abstract, who does very, very close, detailed studies, figurative studies, before approaching their abstract work. So I would start with a literal translation. Then on the facing page of a big note book I would write down all the points that I've read in commentaries that might help, because you are trying to excavate meaning from the text and obviously that meaning is not static – it's fluid.

As the 'personal voice' slowly gained ground within classical scholarship,[14] so Balmer more often explored deeply personal experiences and emotions via her responses to classical poetry. She charts the changing landscape within the worlds of classics as well as her own personal development as a poet in her volume *Piecing Together the Fragments* (2013), where she situates herself within

a long line of (frequently overlooked) female translators of the classics, while also articulating her highly original and distinctive approach to translation/ transgression. It is interesting that she borrows Beye's image of hiding in the classics as the title for the chapter that depicts the most personal of her volumes to date: 'Finding a Place to Hide: *Chasing Catullus: Poems, Translations, and Transgressions*'.[15]

Balmer describes *Chasing Catullus* as 'a journey into the border territory between poetry and translation, offering versions of classical authors interspersed with original poems, re-imagining epic literature, re-contextualizing classic poems, redrawing the past like the overwriting of a palimpsest' (2004: 9).[16] The transgressions of the volume consist of Balmer selecting passages from ancient literatures that spoke to her emotional state and translating them into this new context. The result is both a 'translation' and a new poem. She observes that she has 'always been interested in using sources out of context, in finding new, often unexpected places for them'.[17] It was only via these transgressions that Balmer could approach the horror of her niece's death from cancer at the age of seven. 'Finding a place to hide' within the lines of ancient Greek or Latin poetry both offered the consolation of griefs that have been acknowledged for millennia and shielded her from too harsh an exposure, while negotiating her own loss. Like Emily Dickinson she was able to 'tell all the truth but tell it slant' by engaging the imagery and language of ancient authors to convey sorrow at the loss of a small girl at the end of the twentieth century. In the Preface to *Chasing Catullus* she explains her rationale behind this decision (2004: 9):

> For just as classical writers rewrote and translated ancient myth in order to express dangerous emotions – passion, fear and dissent – so classical translation can provide us with other voices, a new currency with which to say the unsayable, to give shape to horrors we might otherwise be unable to outline, describe fears we might not ever have had the courage to confront.[18]

Furthermore, these highly personal moments do not look back exclusively to classical poetry, but they are also shaped by later literary works that have formed Balmer, both as a reader and as a writer. T.S. Eliot's *Four Quartets* pervade the language of grief that she employs. The result is a searingly beautiful anthology that situates the reader precariously between ancient and contemporary worlds; revitalizing understudied lines of classical verse while depicting a world in the grip of death, which explores the rights of access to this classical heritage while contributing to the new and burgeoning movement in contemporary poetry of women writers using the classics to explore their personal voice. The name

Balmer gives to her blog is 'The Paths of Survival', a title that not only suggests her own strategies of coming to terms with personal tragedy, but that also highlights the way in which classical texts need to infiltrate contemporary literary works, if they themselves are to continue to survive and to speak to our present.

It is unsurprising, then, that when tragedy struck for a second time, Balmer should instinctively turn to classical texts to help her to articulate and accommodate a new grief.[19] A new sonnet sequence, entitled *Letting Go* (2017), charts her sorrow at the sudden death of her mother, who suffered a fatal heart attack, just moments after speaking to Balmer on the phone. Paradoxically, as Balmer explores her grief through multiple allusions to male-authored texts, she revitalizes the traditionally female-dominated genre of elegy from the ancient world.[20] Through such creative acts, the penning of modern elegy, she modulates our understanding of a conventionally male-dominated genre such as epic, by highlighting the dimensions of sorrow and loss that are so often associated with female characters, such as Euryalus' mother, Andromache, Dido, and Creusa. The title of the anthology, *Letting Go*, evokes Cecil Day-Lewis's poem 'Walking Away', which explores a father's conflicting emotions at the sight of his son ready to step away from him into an adult, independent world. Lewis, himself a celebrated translator of Vergil, catches the poignancy of worlds ending in the final stanza, which acknowledges how each of us must allow our loved ones to part from us:

I have had worse partings, but none that so
Gnaws at my mind still. Perhaps it is roughly
Saying what God alone could perfectly show –
How selfhood begins with a walking away
And love is proved in the letting go.

The difficulty of acceptance, of letting go, is explored by Balmer in a sonnet entitled 'Lost' (after Verg. *Aen.* 2.735). The small, single-word title evokes the helplessness of the newly orphaned, longing for a parent's support and guidance in a world that has lost its bearings. It is no accident that Balmer should look back at this point to one of the most plangent books of the *Aeneid*, Book 2, which evokes the loss of a world, an entire kingdom gone up in flames. This epic world of warfare and heroism serves to illustrate the catastrophic effect of an individual, personal loss – a grief that will irrevocably change the landscape of Balmer's life. At first sight it may seem paradoxical that the predominantly male voice of empire building might articulate a woman's domestic, personal loss; however, Balmer's capacity to find comfort within Vergil's lines, to see a recognition of a

comparable sorrow, may serve to remind her readers of the fact that classical epic itself offers powerful explorations of grief for parents. Odysseus descends into the Underworld to find the ghost of his mother, while Aeneas needs to speak one last time with his father's shade, to find the fortitude to fulfil his mission.

The lines of Vergil to which Balmer responds recount Aeneas' realization that he has lost his wife, Creusa, in the burning city. On returning to look for her he discovers that she has died.[21] Balmer, in an act of what she calls 'cross-gendering' voicing,[22] assumes the role of Aeneas. But, of course, Balmer is crossing genres as well as genders. Once again, this act of converting a male-authored text (especially from a male-dominated genre) into an elegy penned by a woman highlights the plasticity of the *Aeneid*, its capacity to voice sorrows that transcend millennia, gender and genre. In his desperation to find Creusa, Aeneas quite literally runs back down unfamiliar, dark streets (Verg. *Aen.* 2.737–40):

> *Dum sequor et nota excedo regione viarum,*
> *heu misero coniunx fatone erepta Creusa*
> *substitit, erravitne via sua lapsa resedit,*
> *incertum; nec post oculis est reddita nostris*

> Byways led me running
> Beyond the streets of the familiar city.
> And there my wife, Creusa, – no! – was stolen
> By fate, or strayed, or else collapsed, exhausted.
> Who knows? We never saw her anymore.

Balmer's poem opens with the lines (2017: 13):

> Up to that point, I was still in the dark.
> I was retracing steps, staring down paths
> I saw as ours, not knowing she had been
> ripped from us already.

This opening entails a temporal dislocation. She writes of how she was 'still in the dark' 'retracing steps', but this is surely when she looks back to the self, who is unaware of the fact that her mother has been struck by her heart attack. Where Aeneas desperately speculates about what could possibly have happened to Creusa, wondering whether she *lapsa resedit*, Balmer knows with quiet certainty that her mother 'sat down to rest' after the phone call. The not knowing that besets Aeneas, as he tries to discover Creusa's fate, is transmuted in Balmer's 'transgression' to the period of ignorance between someone's death and the discovery of it, which can only be recognized after the event. She evokes the time

of 'not knowing she had been / ripped from us already'. The violence of the phrase 'ripped from us' looks back to the Latin *erepta*, as it appears in Vergil's description of Creusa's ghost appearing to Aeneas: *heu misero coniunx fatone erepta Creusa / substitit* (*Aen.* 2.738–9). Where Aeneas returns desolate to the group of family and friends, all waiting for news, Balmer looks into the future and acknowledges the gap that will always now be attendant upon reunions or family gatherings. In his grief Aeneas lashes out at all those around him: *quem non incusavi amens hominumque deorumque, / aut quid in eversa vidi crudelius urbe* ('I spared no god or man in my wild curses. Nothing in that whole city's fall was crueller,' *Aen.* 2.745–6). In Balmer's account the chaos is not of a sacked city, but of a house busied and defamiliarized by the urgency and equipment of paramedics, trying to restore life. Where Aeneas cursed the gods and men, Balmer's targets are more specific: 'I bargained with gods I did not worship: / I blamed, I begged ambulance men, medics.' The alliteration of the sequence of verbs 'I bargained', 'I blamed', 'I begged' conveys a sense of mounting panic and evokes the image of urgently running down paths of hope in one's mind, only to reach a dead end and to have to set off again. These labyrinthine paths echo the dark streets tracked by Aeneas. Movingly, Balmer prepared herself mentally for battle, as she 'tried to put on armour', a gesture that mimics Aeneas' actions: *cingor fulgentibus armis* ('bright in my weapons').[23] The warfare in Troy is translated into the twenty-first century, into the minds of those hoping against hope that loved ones might be saved. The desperate repetition of 'they had, they had [...]' not only demonstrates Balmer's efforts to believe that the paramedics had somehow saved her mother, but also evokes the fragility, the transience of a life that could not be saved. It is an emotional echoing of the episode, later in Book 2, where Aeneas attempts to embrace Creusa, but is only able to snatch at thin air.[24] And, of course, there is no response to the repeated insistence of 'they had, they had [...]'. Realization crept over Balmer in 'silence, dread'. Once again, this evocation looks back to the terror-charged stillness of the Trojan streets, where Aeneas panics at the quietness, dreading the sound of Greek footsteps, while longing for the appearance of Creusa to break his solitude: *horror ubique animo, simul ipsa silentia terrent* ('the very silence filled my heart with terror,' *Aen.* 2.755).

Balmer returns to *Aeneid* 2 in a later poem in the volume, whose title 'Let Go' (after Verg. *Aen* 2.768–94) echoes the title of the volume as a whole. This poem soothes the raw grief of 'Lost', as Balmer's mother appears in a dream to comfort and encourage her grieving daughter. The last night of Troy is transposed in this poem into a wretched succession of misery-filled nights, during which Balmer

'called her name in vain again / And again'.[25] The enjambement echoes Aeneas' fruitless calling to Creusa while mirroring the persistence of the action: *maestusque Creusam / nequiquam ingeminans iterumque iterumque vocavi* ('uselessly filling up the road with grief, / Ceaselessly calling out Creusa's name,' *Aen.* 2.769–70). Where Aeneas literally fills the sound of the Trojan streets with Creusa's name, Balmer metaphorically speaks of the 'ruined cities' that she has filled with her grieving. Vergil vividly depicts Aeneas' terror on seeing Creusa's spectre: *ipsius umbra Creusae / visa mihi ante oculos et nota maior imago./ obstipui, steteruntque comae et vox faucibus haesit* ('the sad apparition of Creusa / Came to me, taller than the living woman. / Shock choked my voice and stood my hair on end,' *Aen.* 2.772–4), whereas in Balmer's account of her dream, the arrival of her mother soothes her fears. Instead of appearing in an alarmingly enlarged form, her mother slips into the dream as an especially vivid version of herself, 'smarter than ever', sporting bright lipstick and a 'jaunty, matching hat / like warrior plume'.[26] In this context the 'jaunty hat' is suggestive of a cheerful, fearless openness, yet it also cleverly glances back to the helmets sported by those fighting in the Trojan war.

Much of the Vergilian passage that serves as a model for this sonnet is taken up with Creusa's last words to Aeneas, where she attempts to soften his grief and to put him in good heart for the challenges ahead. She alerts him to his divine mission and warns him not to allow his grief to distract him: *longa tibi exsilia et vastum maris aequor arandum* ('in your long exile you will plow a wide sea,' *Aen.* 2.780). As Balmer's mother assumes the role of Creusa in the dream, she modifies Creusa's message while also employing its imagery, urging her daughter to 'let go' of anger: 'or this exile of grief will be too long'. Where Creusa bids her final farewell, Balmer's mother promises that she will always be present, yet Aeneas' threefold efforts to embrace a ghost are repeated by Balmer with the same result (*Aen.* 2.792–4):

> *Ter conatus ibi collo dare bracchia circum*
> *ter frustra comprensa manus effugit imago,*
> *par levibus ventis volucrique simillima somno.*

> Three times I threw my arms around her neck.
> Three times her image fled my useless hands,
> Like weightless wind and dreams that flit away.

In Balmer's hands Vergil's simile becomes a reality – the ghost is not just like a dream but is part of a dream. 'I tried and tried and tried to embrace her / but, like a thought on waking, she was gone.' The enjambement allows her to suspend the

moment of disappointment – fleetingly the hope of physical, human contact is evoked before being dashed, a device that thus mirrors Aeneas' thwarted embraces. All these failed embraces are, of course, repetitions endlessly re-enacted of the original loss. Through this manoeuvre Balmer follows in the footsteps of Milton, who also evoked his desperate attempts to hold the dream of his dead wife, in a poem where the moment of loss occurs between the phrases 'I wak'd' and 'she fled':

> Her face was veiled, yet to my fancied sight
> Love, sweetness, goodness in her person shin'd
> So clear as in no face with more delight,
> But oh! as to embrace me she inclin'd
> I wak'd, she fled, and day brought back my night.
>
> <div align="right">Milton, Sonnet 23</div>

Balmer has written movingly of how her engagement with both classical literature and classical scholarship brought her back to writing after the loss of her niece (2013: 184):

> But gradually, through the dark fog of bereavement, I began to write again in the only way I found that I could: through the prism of classical literature – and its translation. Similarly it is interesting that classicist Thomas van Nortwick has recorded how his study of Greek literature, particularly Homer, helped him to come to terms with the early death of a beloved nephew. As he asks himself: 'What can Greek literature teach me about the role of gifts in the life of a spirit?'

Both van Nortwick and Balmer have responded powerfully to the consolations of ancient literature, consolations that are, perhaps, all the more eloquent for being articulated thousands of years ago; they thus remind us that human beings have always suffered losses, yet these, as devastating and catastrophic as they are, both teach us what it means to be mortal and fragile, while also offering the hope of commemorating those we love through art. Poems written out of grief for those who left this earth thousands of years ago have forged their own 'paths of survival'. Such paths are intertextual, deepened and strengthened by their journeys through the works of poets such as Milton and Eliot, whose own private griefs modulate the ways in which we read ancient literature. Balmer's sonnets of mourning stand at the end of a very long anglophone tradition of responding through grief to these works.[27]

Moreover, Balmer shows us that the literary models for these sonnets of mourning do not necessarily need to be laments themselves. In *Piecing Together the Fragments* she observes that 'Clive Scott has noted how sometimes a reading

of an ancient text, via translation, becomes a form of writing away from its original source text' (Balmer 2013: 171). The poem 'Ice' in *Letting Go* looks back not to classical poetry, but to Roman history. It is written 'after Livy, *Histories*, 21.36–7'. The original passage recounts the heartsick exhaustion of both men and elephants, trapped on a snowy Alpine ridge, before managing to carve a path through snow and ice that led to the gentler plains below. The fear, the sheer misery of cold, the bleakness of the passage spoke to Balmer in 'the dreadful first few months of grief in the terrible cold and snowy winter of 2010/11 when my mum died'.[28] Where Hannibal and his men were trapped on the ridge for just four days, Balmer expands time in the first line of her sonnet: 'All winter the earth tipped from under us', a line which also makes explicit the sense of precariousness and fragility of being trapped on a snowy cliff. The predicament of literally hanging on to the edges of a mountain is used to evoke the profound destabilization and disorientation prompted by grief, evoked so powerfully at the beginning of Cecil Day Lewis's volume *A Grief Observed*: 'No-one ever told me that grief felt so much like fear. I am not afraid, but the sensation is like being afraid. The same fluttering in the stomach, the same restlessness, the yawning. I keep on swallowing' (Lewis 1966: 1). When Balmer glimpses the lives of those who are not in the grip of fear, it is notable that she emphasizes the adjective 'solid': 'most lived their lives on solid, fertile ground'. And this solid ground is transposed from the flatlands of the Italian Alps to the lambent, gentle landscape of the Sussex downs 'lit by lowered sun'. She contrasts her own predicament in the last line of the sonnet: 'For now we were trapped. Out of reach. Ice-bound.'

Not only does 'Ice' recall the words of Lewis, but it also evokes that most English of carols: 'In the Bleak Midwinter'. Balmer's phrase 'new snow had drifted on old' recalls the relentless fall of snow depicted in Christina Rossetti's lines: 'Snow had fallen, snow on snow / Snow on snow.' But, of course, the 'bleak midwinter' of Rossetti's verse symbolizes spiritual emptiness and desolation, as much as depicting a frozen English landscape. While Balmer was able to see that others could lead lives touched by sunlight on solid earth, she herself was cut off from such experiences, frozen in grief, 'ice-bound'. The transposition of Livy's account of brutal, military rigours into the most personal and private experience of grief leads to an intensification of the keenness of the soldiers' travails. Though exhausted and battered by their experiences, Hannibal's men are at least able to access the milder landscape: *inferiora vallis apricos quosdam colles habent rivosque prope silvas et iam humano cultu digniora loca. ibi iumenta in pabulum missa et quies numiendo fessis hominibus data* ('lower down one comes to valleys and sunny slopes and rivulets, and near them woods, and places

that begin to be fitter for man's habitation. There the beasts were turned out to graze, and the men, exhausted with toiling at the road, were allowed to rest,' Livy *Histories* 21.36–7).[29] It is only in a later poem, entitle 'Gradient' (after *Histories* 21.37) that Balmer edges painfully, 'inch by inch', away from her all-encompassing, frozen grief back to the world of the living. The process is slow and precarious 'We [...] were still on thin ice', she observes, before arriving at a place that began to seem bearable: 'Here we rested. At last this seemed somewhere / we could live. A softer landscape, gentler.'

As well as appropriating a male-authored text to write deeply personal poetry and contributing very powerfully to a shift in classics as a discipline, a shift that slowly but surely, is acknowledging the value of the personal voice, Balmer is also recognizing the power of decontextualizing and reworking classical texts that risk being so familiar to us that we take them for granted. She observes that she has: 'always been interested in using sources out of context, in finding new, often unexpected places for them'.[30] In a response to Elena Theodorakopoulos' observation that in 'Ice', 'the first person introduces the ordinary soldiers' perspective into this in a way that Livy would never quite dare' (Balmer 2017b). Balmer argues that her recontextualization inserts her into a tradition of female authors who have transgressed both gendered and generic boundaries in their reworkings of history and epic: 'But using male military history to invoke female experience harks back to Sappho's use of Homeric imagery and language and I liked the thought of tapping into that' (Balmer 2017b). As she probed her experiences of grieving for her mother, she was haunted by Livy's description of Hannibal crossing the Alps. While one might have expected her to turn again to classical poetry rather than Roman history, she explains that while it is 'not so much "myth" but history', this episode is 'history that has now become mythic so we recognise the context'.[31] Balmer's response to Livy enhances the mythic qualities of the episode, and enables it to speak to a wider audience by giving it a resonance that extends far beyond its original context. Once again, just as with the extracts from *Aeneid* 2, Balmer is selecting celebrated passages of Roman history, of male-dominated warfare, to articulate highly personal and complex emotions. In *Piecing Together the Fragments* she described her decision to do this as a response to her niece's death: '[a]ll in all, the reality was too painful, too shocking, and ultimately too private, to be portrayed any other way except through the shifting filter of classical literature' (Balmer 2013: 186). Paradoxically, the need to channel her emotions through the screen of classical texts has resulted in poems exquisitely poised between the quiet restraint of expression and the rawest of emotions that they depict. These most English of poems,

reaching back to the ancient world through Rossetti, Lewis, Milton and Lewis, emulate the discipline and self-control that has shaped classical studies in the Western world, even as they speak of the rawest of losses and the most personal of experiences.

In the *Oxford Handbook to Elegy* Karen Weisman offers a hauntingly beautiful evocation of elegy as a genre that positions its readers between the world of the past, inhabited by people who have now become ghosts, and the world of the present, whose atmosphere is an aching loss (2010: 1):

> When taken in the more contemporary sense as the framing of loss, elegy can be pulled between the worlds of the living and the dead, between the present life of sorrow and the vanished past of putative greater joy. Between the extremes of life and death, joy and sorrow, the receding past and the swiftly moving present, falls the elegy as we know it today.

In this formulation Balmer's deeply personal songs of grief, her elegies, not only recontextualize fragments from classical texts, whose pathos is sharpened and highlighted by their homes within a new creation and different genre, but they also offer a meditation on the past and our relationship with the past. The shades that ghost Balmer's poetry are not only those whom she has lost and for whom she grieves but are also the voices sheltered within classical literature to whom she has offered her 'paths of survival'.

Notes

Introduction

1 See Martindale (2013) for an overview of the tendencies and developments in reception studies over the course of the past 20 years, and some ideas and suggestions regarding the potential of the field for the future. A hallmark for the theorizing of reception studies was the collected volume edited by Martindale and Thomas (2006).

2 The term 'classical' is here understood in a wide sense, referring to Greek and Latin antiquity (as opposed to the Middle Ages and the modern era) and the literature produced at that time.

3 Regarding the latter aspect, Martindale (2013: 172) rightly posits that '[w]ith reception there are always at least three and generally many more (ourselves reading Milton reading Virgil . . .), where all the points also include the mediating texts subsumed within them ("ourselves" reading "Milton" reading "Virgil". . .), and texts can speak to texts on a basis of equality, without a hierarchy necessarily being imposed on any of the points'. See also Porter (2006: 1–65).

4 See, for example, the mammoth five-volume project *The Oxford History of Classical Reception in English Literature*, four volumes of which have been published (vol. 1, Copeland 2016; vol. 2, Cheney and Hardie 2015a; vol. 3, Hopkins and Martindale 2012; vol. 4, Vance and Wallace 2015), while the final volume is forthcoming. With regard to poetry, classical reception studies has tended to focus on the Elizabethan era, and the eighteenth and nineteenth centuries (cf. e.g. the overview of the influences of Greece and Rome in Victorian literature provided by Hurst 2010); cf., however, also the recent monograph by Jacobson (2014), who also takes into account the pre-Elizabethan developments.

5 We may – or may not – agree with such an extreme stance as that taken by Kaiser (1974: 32), who posits that 'there are no genres at all; genres are but fake concepts' ('[e]s gibt gar keine Gattungen; Gattungen sind lediglich Scheinbegriffe'). The 'fluidity' of the concept of literary genre(s) applies as much to antiquity as it does to the modern period; cf. Farrell (2003).

6 The fact that Fiona Cox (Chapter 10 in this volume) addresses the work of a contemporary poet and scholar demonstrates that this dialogue is very much ongoing.

7 For overviews of, and important contributions to, genre studies, see Bawarshi and Reiff (2010), Beebee (1994), Frow (2006), Frye (1957), Rosmarin (1985). See also the

special issues of *New Literary History* (vol. 34, issues 2 and 3) devoted to genre, published in 2003.

8 The translation is from Halliwell (1995). On the complex question of genre theory in Renaissance literature, see the brilliant study by Colie (1973).

9 On genre in antiquity, see Farrell (2003), Depew and Obbink (2000), and Conte and Most (2012). See also Ford (2002: 250–71).

10 The translation is from Padelford (1905).

11 Bawarshi and Reiff (2010) give Northrop Frye's *Anatomy of Criticism* (1957) as an example of a neoclassical critical work.

12 This idea is, basically, in line with Hans Robert Jauß' statement, advanced in his influential essay 'Literaturgeschichte als Provokation der Literaturwissenschaft' (1972), that any genre is, in essence, a construction based on a reader's horizon of expectation with which he/she perceives a text.

13 See n. 3 above. It should be added that several of the contributions in Cheney and Hardie's (2015a) volume do refer to scholarship and criticism (e.g. see the chapters by Helen Cooper and Gordon Braden, among others), but that the volume's goal is keyed towards connecting genre in classical poetry with genre in Renaissance literature, viz., as a literary rather than a critical-cultural move.

14 On generic hierarchy see e.g. Fowler (1979: 100–9).

15 'In keinem Fall gibt es *die* Geschichte einer Gattung, sondern immer bloß *eine* Geschichte einer Gattung [. . .]' (author's emphasis).

1 Classical Pieces

1 Such denigrations of medieval classicism have been most notably advanced by Ernst Robert Curtius and Gilbert Highet. See especially Curtius (1953) and Highet (1949).

2 For example, Copeland (1991); Gerber (2015); Minnis (1988); and Simpson (2002).

3 See OED s.v 'classic, *adj.* and *n.*'. Available at: www.oed.com. Porter (2005: 1–65) provides a more extensive account of the anachronistic use of the term 'classical' and its relevant applications.

4 See Copeland (2016a: 1–3).

5 A common introduction for Priscian's grammatical textbook, *Institutiones grammaticae*, explains this notion of grammar most succinctly: *grammatica autem dicitur quasi literalis scientia, id est scientia tradita de literis. Ars autem ista utulis ualde est et nulla potest sciri absque ista et magis necessara quam dialectica.* 'Grammar, moreover, means as it were "knowledge of letters," that is, "knowledge transmitted about letters." This art, moreover, is very useful – and no art can be known apart from it – and it (it is) more indispensable than dialectic.' Translation by Wheeler (2015: 84–5).

6 Orme (2006: 64–73)

7 Copeland (2016b); Copeland (2016c); Orme (2006: 86–127); Purcell (1996); Woods (2010); and Woods (2016).

8 Translation by Nims (2010: 26).

9 Translation by Barney, Lewis, Beach and Berghof (2006: 62).

10 Camargo (1983); Copeland (2016c); Wagner (1983); and Woods (2016).

11 Woods (2009); and Ziolkowski (2009a).

12 Although *imitatio* was never removed from the curriculum, Ziolkowski (2001: 306–7) observes a slight reduction in its practices during the twelfth and thirteenth centuries, when perceptive rhetoric grew in stature.

13 Ziolkowski (2001: 296–7) specifically relates modern post-Romantic distrust of imitation to Plato's distaste for *mimesis* (imitation) in the *Republic* because of its distance from ideal forms.

14 Woods even discovered that one of the most popular schoolroom exercises required young boys to compose speeches by adopting the persona of Dido, queen of Carthage and abandoned lover of Aeneas. Ziolkowski (2001: 302); and Woods (2015).

15 Woods and Camargo (2012); and Woods (2009).

16 Woods (2013: 335) suggests, '*Reading* medieval definitions emphasizes their inelegance and obscures the usefulness of repetition and etymological resonance for students who were *listening* to them instead.'

17 Admittedly, commentary traditions did exhibit disparities in their interpretive strategies, such as the spread of allegorical interpretations in Ovid's corpus, yet the grammatical treatments of classical literature, on which this chapter focuses, exhibited fewer such variations. Nevertheless, for more about the diachronic developments of grammar training, see especially Copeland and Sluiter (2012).

18 Woods (2013: 334).

19 'Elegy' appeared in Middle French around 1500 and then in English around 1521. 'Epic' emerged in French around the end of the sixteenth or beginning of the seventeenth century, and then in English in 1583. 'Genre' surfaced latest among these terms and was used in reference to 'a particular style or category of works of art' in 1770. See OED s.v. 'elegy, *n.*,' 'epic, *n.* and *adj.*,' and 'genre, *n.*'. Available at: www.oed.com.

20 For more about the medieval genre of fables, see especially Allen (2005).

21 According to Honorius Augustodunensis, 'Tragedies deal with war, as in Lucan; comedies sing of wedding celebrations, as with Terence; satires record reproofs, like those of Persius; and lyrics sound forth odes, that is, praises of the gods of kings, with hymnic voice, and Horace is an example of this kind of poet.' Kelly (1993: 113); and Augustodunensis (1854) 1243CD and 1245C.

22 Kelly (1993: 113); and Munari (1977).

23 Admittedly, the word (originally from Greek) did not appear in English until 1632, but it did circulate in Latin texts. See OED s.v. 'ekphrasis, *n.*'. Available at:

www.oed.com. For more about the relative infrequence of vernacular English adaptations of Latin forms despite their prevalence in classroom traditions, see Copeland (2016a: 1–3).

24 For example, Vatican City, Biblioteca Apostolica Vaticana, MS Vat. lat. 1511, ff. 125v, 126r, 132r, and 145r; Vatican City, Biblioteca Apostolica Vaticana, MS Vat. lat. 1575, f. 95v–96r; Vatican City, Biblioteca Apostolica Vaticana, MS Vat. lat. 1593, f.13v–14r; and Vienna, Österreichische Nationalbibliothek, MS Vindobonensis Palatinus 3114, f. 110r.

25 For example, Mainz, Stadtbibliothek, MS Hs. I 558, a 1459 copy of Alexander de Villa Dei's commentary on the opening books of Vergil's *Aeneid*, includes definitions of orthography and prosody as well as lists of rhetorical features such as pleonasmus and tautology, ff. 150r and 239v.

26 Minnis (1988: 9–39); Irvine (2006); and Ziolkowski (2009b). Minnis again wrote about the issue of authorship and authority in medieval translations in Minnis (2009).

27 Rawlinson B 214 is a poetic anthology copied by John Wylde, precentor of Waltham Abbey, Essex. Boffey and Thompson (1989: 301); Federico (2016: 95–6); Macray (1862: 540–5); McKinley (1998: 46, 62–3, 68); and Rigg (1977: 285, 322–4). The illustrations, such as the diagram detailed herein, were inserted after the manuscript was compiled. For more about mythographic illustrations, see Lord (2011: 271–5).

28 Although not identifying scholastic consensus explicitly, Frank Coulson and James Clark mention these general *accessus* attributes in Coulson (1987: 153); and Clark (2011: 14).

29 Academic introductions began circulating consistently with classical texts in England during the eleventh century, but they reached their peak of circulation between 1350 and 1450. By the fourteenth century, they even gained independent circulation as collections of *accessus ad auctores*. See Coulson (1987: 153); and Clark (2011: 14).

30 Ziolkowski and Putnam (2008: xxxiv, 623–6).

31 Coulson (1986: 104); and Coulson (2011: 54).

32 Allen (2013: 7–9); Hugyens (1954).

33 Ghisalberti (1946: 42–3).

34 For example, Kelly (1997).

35 Stephen Wheeler edits and translates this passage in Wheeler (2015: 64–5).

36 Dronke (1979: 225–6)

37 Wheeler edits and translates this passage in Wheeler (2015: 56–7).

38 Wheeler edits and translates this passage in Wheeler (2015: 66–7).

39 Shumilin (2014: 8); and Marti (1941: 247–51).

40 Shumilin (2014: 7) considers such mixtures a 'violation of the poetic law, which prohibits putting "mere history" into verse,' but the following commentary examples demonstrate a more fluid approach to treating poetry and history.

41 John Lydgate mentions this distinction in works like *The Fall of Princes*, in which Lydgate presents a consistent distrust of rhetorical ornamentation as interfering with a text's veracity, but he still writes such points in poetic meter. See Otter (1996: 1–2); and Shumilin (2014: 21).

42 Fulgentius explains his own pragmatic approach to mythology in the prologue for the first book of his mythography: see Whitbread (1971: 40–2). For more information about Fulgentius's approach, training, and background, see Hays (2003); Hays (2007); and Zeemen (2016).

2 'Poetry is a Speaking Picture'

1 On the humanist curriculum of the late sixteenth-century and seventeenth-century universities, together with its socio-cultural ideology of 'virtue through education', see O'Day (1982: 77–130); McConica (1986: 645–715); Feingold (1997: 211–357). On Latin and English literary history, note also the pertinent comment of Alastair Fowler: 'Almost all Elizabethan criticism of any seriousness and weight was written in Latin. Yet no one would imagine this, to look at the literary histories' (Fowler 1958: 1).

2 See e.g. the reaction of the Vice-Chancellor of Cambridge to the suggestion of the Privy Council in 1592 that a comedy in English for the entertainment of the Queen be provided: 'how fitt wee shalbe for this that is moued, haveinge no practize in this Englishe vaine, and beinge (as wee thincke) nothinge beseeminge our Student*es*, specially oute of the Vniu*er*sity: wee much doubt [. . .]' (*Records of Early English Drama* [*REED*], Cambridge, 1.347, 1592).

3 On neo-Latin criticism, and neo-Latin intellectual culture more generally, I am indebted to the work of J.W. Binns (see Binns 1990 and esp. Binns 1999, who also includes in his publication of treatises on poetry the post-Elizabethan *Artis poeticae versificatoriae encomium* of Caleb Dalechamp, in his *Exercitationes duae* [London, 1624]). As Binns (1972: 153–9) records, some additional important examples of neo-continental theory were printed in England: Johann Buchler's *Sacrarum profanarumque phrasium poeticarum thesaurus* was first printed in London in 1624, with regular reprints in the following three decades, while the similarly popular *Prolusiones academicae, oratoriae, historicae, poeticae* of Famianus Strada were also popular, printed first at Oxford in 1631.

4 See Binns (1990: 141–59).

5 See Binns (1990: 143).

6 Binns (1990: 143): in terms of engagement with literary theory alone, he notes Gentili's use of a broad range of ancient authorities, drawing on Aulus Gellius, Velleius Paterculus and Macrobius in addition to the central figures Plato, Aristotle

and Horace. Gentili also draws upon Fracastoro, Scaliger, Patrizi, Zabarella, and Riccoboni, in addition to Averroes and his own brother Scipione's critical remarks in his commentary on Tasso's *Gerusalemme Liberata*. Binns concludes that Gentili's work, like the other Latin treatises on poetry printed in England, '[is] a major channel for the transmission to England of the best continental thought about critical theory.'

7 See the collection of critical essays in Smith (1950), which range from Roger Ascham to Ben Jonson.

8 On the Renaissance fusion of Horace and Aristotle into a single rhetorical construct, fuelled by a surge of interest in these authors and a cross-fertilizing commentary and critical tradition, see e.g. Vickers (1988).

9 I am not the first to make this suggestion: see also Warren (2010: 150); Craigwood (2010).

10 There is no room here for broader discussion of the differences and distinctions, but for discussion of the scope and aims of the works of Puttenham and Webbe respectively see Whigham and Rebhorn (2007) 38–45; Hernández-Santano (2016: 1–52).

11 See Warren (2010).

12 Here Sidney is working closely from Scaliger (as Maslen 2002: 143 notes).

13 All quotations of the *Apology* come from Maslen (2002); text (based on the Oxford 1593 edition) and translation of Gentili's *Commentatio* are from Binns (1972).

14 'It is also evident from what has been said that it is not the poet's function to relate actual events, but the kinds of things that might occur and are possible in terms of probability or necessity. The difference between the historian and the poet is not that between using verse or prose; Herodotus' work could be versified and would be just as much a kind of history in verse as in prose. No, the difference is this: that the one relates actual events, the other the kinds of things that might occur. Consequently, poetry is more philosophical and more elevated than history, since poetry relates more of the universal, while history relates particulars' (Arist. *Poetics* ch. 9, trans. Halliwell 1995).

15 Binns (1972: 231, 252). After some further reflections on painting, truth and history, Gentili sums up: 'The material of the poet is the universal verisimilar, not the particular true. But I go no deeper into that debate. I conclude only that, whether a poet is like a painter in both respects, or like him only when each of them feigns verisimilar things, the relationship between the poet and the painter is very close' (Binns (1972: 253)). On Sidney's language of pictorialism, which engages with very deep-set ideas about the illusionist energy of art and literature reaching back to Aristotelian *energeia* see e.g. Rigolot (1989).

16 See Hathaway (1962: 129–58); Halliwell (2002: 151–230) offers fuller discussion of literature and learning in the Aristotelian context.

17 Cf. esp. *Apology* 90/9–11, 22–5, 37–42.

18 'Truly, Aristotle himself, in his discourse of poesy, plainly determineth this question, saying that Poetry is *philosophoteron* and *spoudaioteron*, that is to say, it is more philosophical and more studiously serious than history. His reason is, because poesy dealeth with *katholou*, that is to say, with the universal consideration, and the history with *kathekaston*, the particular: 'now', saith he, 'the universal weighs what is fit to be said or done, either in likelihood or necessity (which the poesy considereth in his imposed names), and the particular only marks whether Alcibiades did, or suffered, this or that.' Thus far Aristotle: which reason of his (as all his) is most full of reason' (*Apology* 92/8–21).

19 Contrast the much less assertive relationship with Aristotle in Puttenham's *Art of English Poesy*, and his distinct preference to regard poetry in aural rather than visual terms, even when engaging with the rhetorical concept of *enargeia* (see esp. 1.4.98–99, 3.1.222 and for further discussion Whigham and Rebhorn (2007: 44–5).

20 See Binns (1972: 231, 252.)

21 Maslen (2002: 5–14). For further exploration of the 'active' virtue of Sidney's authorship (above all his *Arcadia*) see esp. Hager (1991) and Worden (1994).

22 Cf. *Apology* 105/25–102 (which argues for the compatibility of active service in war with poetry) with the *Commentatio's* military exempla (Binns 1972: 239, 259): as Binns notes, both Sidney and Gentili use the same example drawn from Cicero's *Tusculan Disputations* (I.ii.3) here.

23 On the Italian Aristotelian Zabarella (1533–89), who claimed to be the first to claim poetry as part of logic, see Edwards (1969); Binns (1972: 239) cites Diogenes Laertius' *Zeno* 23 here.

24 Gentili may also have had Seneca in mind, for the 95th Letter to Lucilius – the second part of a pair of letters which offer Seneca's most lengthy and comprehensive approach to the techniques of moral education – is a rejection of the notion that 'preceptorial' philosophy is enough to promote upright conduct and give perfect wisdom, and an assertion of philosophy's contemplative but also active nature: *Philosophia autem et contemplativa est et activa: spectat simul agitque. Erras enim si tibi illam putas tantum terrestres operas promittere: altius spirat* ('But philosophy is both contemplative and active; it watches and at the same time acts. You are certainly mistaken if you think that philosophy offers you only mundane assistance; it aims higher' (*Ep.* 95.10).

25 See esp. Kristeller (1985).

26 In the dedicatory letter to *De Legationibus* Gentili recalls that this treaty developed out of a speech on an embassy delivered at Oxford (probably in January 1585) before Sidney and Leicester: see Craigwood (2010: 86).

27 See Craigwood (2010) (quote: Craigwood 2010: 89).

28 'But just as it would be impossible for a painter who was only a copyist, no matter how skilfully he might wield his brush, to reproduce to the life and in full detail the

work of a master artist, so I am not inclined to believe that the manner and style of my description of your brilliant qualities have been such as to exclude the possibility of my having omitted a large number of them, and barely outlined many others; nor do I fail to recognize that in every case my delineation fails to do justice to the original.' Trans. Laird (1924).

29 Gentili would intervene more directly in this debate on the propriety of acting, sending a copy of his *Commentatio* to the Puritan scholar John Rainolds in July 1593, and entering into a boisterous literary conversation with Rainolds, which would be published as *De actoribus et spectatoribus* and *De abusu mendacii* (both 1599).

30 On Gager, also a neo-Latin poet and fellow of Christ Church, see esp. Sutton (1994a, 1994b). His other extant plays are *Meleager* (first performed at Christ Church in February 1582, again in 1585, and printed in 1593) and *Dido* (first performed in 1583). Gager was also a key figure in Oxford's response to the death of Sidney, responsible for editing the encomiastic funerary collection in Latin that was published by the (still new) Oxford University Press in 1587.

31 On the controversy see Sutton (1994b); Walker and Streufert (2008: 33–8).

32 William Gager's letter to Rainolds, July 31, 1592, in Sutton (1994b: 271–2).

33 Gager's famous more general statement of the function of university drama stresses both the opportunity to become more familiar with the Classics and the character-building function of the plays: 'We doe it [i.e. put on plays] to recreate owre-selves, owre house, and the better parte of the Universitye, with some learned Poeme or other; to Practyse owre owne style eyther in prose or verse; to be well acquantyed with Seneca or Plautus; honestly to embolden owre yuthe; to trye their voyces and confirme their memoryes, to frame their speeche; to conforme them to convenient action; to trye what mettell is in everye one, and of what disposition they are' (Sutton: 1994b 263). On the homiletic function of academic drama see Norland (2009, esp. 19–45, 46–68); the essays of Schenk and Walker (2008) offer discussions of plays which stress in addition the marked religious, political, or socio-cultural ambitions of the university plays.

34 The quote is from Norland (2009: 189); see too Sutton (1994a: 3–6).

35 For positive verdicts see esp. Binns (1970). On the Renaissance Ulysses, Stanford (1974); Defaux (1982, esp. 23–68, 153–63); Coffin (2008).

36 On this term see Dewar-Watson (2007: 24–7); Allen (2015).

37 For further discussion about the broad spectrum of tragicomedy see esp. the essays in Maguire (1987); McMullen and Hope (1992); Mukherji and Lyne (2007).

38 Cf. the preface to Fletcher's *The Faithful Shepherdess* (London, 1610): 'A tragi-comedie is not so called in respect of mirth and killing, but in respect it wants deaths, which is inough to make it no tragedie, but brings some near it, which is inough to make it no comedie.' On the 'providential vision' of tragicomedy and its mirror-relationship with the pessimistic worldview of Elizabethan tragedy

see e.g. Neil (2007: 156). Guarini himself stresses that tragicomedy replaces Hellenic 'fate' with Christian providence (cf. Henke 2007: 46).

39 Note esp. the game-playing with recognition at *UR.* I.327–40, where Telemachus remarks that 'it is a wise son who knows his own father'; Penelope 'recognizes' Ulysses (falsely) at *UR.* III.894 and successfully at V.1961; Philaetius wonders whether his own master looks like the beggar before him at *UR.* IV.1233–5. On role-playing, disguise, and providential recognition in tragicomedy see e.g. Hyland (2011). Emphasis not only on Penelope's chastity but also Ulysses' suspicions about her virtue is also more prominent in the play than in the *Odyssey*: see esp. *UR.* I.384–5 and III.1049–72 for Ulysses' worries (and cf. *Od.* 11.178). The sexual criminality of the wicked handmaid Melantho is also much expanded, and there is clear contemporizing influence in the attention given to the plot to murder Telemachus (which owes more to Legge's *Richardus Tertius* than Homer, as Sutton (1994a) ad IV.1479–1524, remarking the similarity between the debate of Catesby and Buckingham in *Richardus Tertius* (I.v.i, 1245–1332), notes). On male jealousy and female sexuality in tragicomedy more broadly see e.g. Loomba (1987: 93–117); Cohen (1992); McLuskie (1992); Hutson (2007).

40 Allen (2015). See also Binns (1991: 127–31); Sutton (1994a: 4–5).

41 Cf. also the dedication to the academic reader in *Meleager*, in which Gager (drawing allusively upon Horace's strictures against mixed genres in *Ars Poetica*) remarks that he omitted the final incident in Ovid's version of the Meleager story—the transformation of Meleager's sisters into birds—because this would rob the author of the tragedy of a truly tragic effect.

42 See esp. the chorus concluding the second Act (*UR.* II.728–7), which accuses the youth of 'this island' of degeneracy and excess, with Sutton (1994a) ad loc. (who also notes intertextual parallels with critique of contemporary youth in Gager's poems XVIII and XLVII); also *UR* IV.1600–5. Gager has also refashioned Eurymachus as an Elizabethan fortune-hunter, happy to marry Penelope for her kingdom, while conducting an affair with the young Melantho (*UR.* III.1073–1120): on which see more below.

43 Cf. Stanford (1974: 177–89); Coffin (2008).

44 Binns (1972: 233); cf. *Apology* (100/9–10).

45 For further links between the *De Iure Belli* and the *Commentatio* see Warren (2010).

46 Translations are from Sutton (1994a), adapted.

47 For the rare *versipellis/vorsipellis* see Plautus, *Bacch.* 658 (in its metaphorical sense) and *Amphit.* 123 (in its true sense) with Zwierlein (1992: 286). Sutton (1994a) comments ad *UR.* I.118, '*versipellis* [...] really designates someone with the magical ability to change his appearance.'

48 Ulixes is a by-word for cunning in Plautine comedy: see e.g. the boast of the 'clever slave' Chrysalus, (*ego sum Ulixes, Bacch.* 940): Peniculus is for Menaechmus 'my

Ulixes', the man who has brought about his downfall (*Menaech.* 902); Simo accuses Pseudolus of outdoing Ulixes in cunning (*Pseud.* 1244).

49 The classic discussion of revenge tragedy's tension with Christian teaching on revenge is Campbell (1931); on the relationship between systemic unfairness and the private justice of revenge see most recently Hutson (2007: 262–96); Woodbridge (2010).

50 Cf. Sutton (1994a) ad loc., quoting Boas (1914: 211): 'the bloody-mindedness of this monologue owes much more to Seneca than to Homer. It also goes a long way towards pulling *Ulysses Redux* into the orbit of the contemporary revenge play.' Contrast *Od.* 20.5–20, 35–43. For the influence of Seneca on early modern vernacular drama see esp. Braden (1985); Miola (1992); Kerrigan (1996).

51 *Plagis tenetur praeda dispositis mea, / Quas nulla tam proterva perrumpat fera,* UR V.1614–6; compare *plagis tenetur clausa dispositis fera,* Sen. *Thy.* 491.

52 *Clausos, inermes, saucios dabimus neci,* UR V.1626.

53 On Leiodes see esp. *Od.* 22.310–30, where Odysseus too makes Leiodes' desire for Penelope a capital offence, while recognizing that Leiodes is no friend of the suitors.

54 Cf. Sen. *Thy.* 971–2 with Schiesaro (2003: 101–2); *Med.* 982–6.

55 Cf. esp. *Od.* 22.244 (where Agelaus is marked out as among the best of the suitors 'outstanding in valour' (οἱ γὰρ μνηστήρων ἀρετῇ ἔσαν ἔξοχ' ἄριστοι) and *Od.* 22.248–55, where he rouses the suitors to battle with an appeal to the aristocratic *kleos*-code, the hope of winning glory by killing Odysseus in battle (κῦδος, *Od.* 22.253).

56 Though overshadowed by Grotius' 1625 *De Iure Belli et Pacis,* Gentili's *De Iure Belli* is the first secular/humanist treatment of international relations, and largely concerned with practical issues (the legitimate conduct of war, rather than the legitimacy of war *per se*). On Gentili's *De Libri Tres* see esp. Piirimäe (2010); Kingsbury (1998).

57 See *De Libri Tres* 1.20 (and cf. 1.3, 1.4).

3 A Revolutionary Vergil: James Harrington, Poetry, and Political Performance

1 On the topic of freedom in Harrington's translations, see Connolly (2005: 114).

2 Caldwell (2008: 32): 'Just as readily as he draws upon the monarchist Vergilian tradition, however, Harrington topples its poetic and political authority by puncturing the mysticism and allegory on which that authority depends.'

3 Schäffner (1999: 4): 'Based on identified regularities, texts can be categorised into text-types, genres, text-classes. Text-typological, or genre conventions, are culture-specific and can change over time, which makes genres relevant for translation studies' and *passim* in her introduction.

4 Norbrook (1999: 364–5) even suggests that Harrington 'Vergilianized republicanism' and 'republicanised Vergil'.

5 Hammersley (2013: 357): 'Though he did speak in *Oceana* of the advantages of popular government, his fundamental belief was that it was the balance of property within a particular nation that determined the form of government that ought to be adopted there.'

6 As Proudfoot remarks: 'Speech after speech of Vergil is represented by a few words giving the general substance and no more. The result is a rapid narrative in which incident counts for a good deal more than it does in Vergil – a hasty chronicle from which interest of character, situation, and the graces of rhetorical persuasion are altogether lost' (1960: 148).

7 See, for example, Seider (2013: 29–30) on the role of memory in shaping past, present, and future in the *Aeneid*.

8 For a comprehensive survey of Harrington's political and ideological context, see Pocock (1977: 15ff). For a survey of Harrington's life before 1656, see Pocock (1977: 1ff).

9 Pocock (1977: 15)

10 Norbrook (1999: 358 and ff.). See Stark, Chapter 4 in this volume.

11 Proudfoot (1960: 152); cf. Schwartz pp. 59–61, where Meliboeus' language as translated and sharpened by Harrington represents more of a republican than royalist position.

12 Hammersley (2013: 356n12) provides a good survey of recent work on Harrington and royalists.

13 See Hammerlsey (2013, 358ff) for a further discussion. Harrington, in fact, dedicated *Oceana* to Oliver Cromwell, even though he tried to suppress the work. After the restoration of Charles II, Harrington was arrested and thrown into prison, charged with conspiracy. In prison, he suffered a breakdown, and remained unproductive after his release.

14 Cotton (1991: 11) asserts that Greenleaf's interpretation of Harrington derives from the 'Counter-Renaissance' tradition, while Pocock's rests upon the tradition of civic humanism. See Greenleaf (1964: 233–48, 283–7), Pocock (1957: 124–7), (1975: 383–400), (1977: 1–152).

15 Nelson (2004: 87ff).

16 For the text, see Pocock (1977: 155).

17 The translation is from Nelson (2004: 88).

18 Harrington (1659: A4R-V). For each letter given, Harrington quotes the Latin with book and verse number cited in footnotes at the bottom of the page.

19 In his preface to Vergil's *Eclogues*, for example, Servius points out that Vergil *per allegoriam agat gratias Augusto vel aliis nobilibus, quorum favore amissum agrum recepit* ('*through allegory* thanks Augustus or other nobles by whose favor he got his land back' [translation and emphasis my own]). Serv. *in Ecl.* praef. p. 2 Thilo.

20 Thomas (2001: 93).

21 In particular, on this theme, Burrow (1997: 22): 'Chaucer introduces the idea that Vergil is the poet to be imitated by those who are eager to press their own claims for a place in the House of Fame, but who fear they might belong on its threshold.' For a useful survey of Vergil in English translation, see Burrow (1997: 21–37).

22 Caldwell (2008: 3).

23 Burrow (1997: 25). As Burrow points out, Stanyhurst's vision wished to create a new type of English – he was an Irish exile in Leiden (having become Catholic four years earlier) when his translation appeared – which distanced itself from an English tradition. As seen here in language and politics, Caldwell (2008: 4) remarks how in both ethics and politics, 'the *Aeneid* was a storehouse of history and civic example for Renaissance England'.

24 See Gillespie (1992: 66–7) for 45 translations or imitations published between 1660 and 1700, immediately after Harrington's translations.

25 Like Harrington, Fanshawe was close to the Royalist cause: he became Prince Charles' secretary of war in 1644. Fanshawe dedicated Book 4 to Charles, and clearly connects Rome's and England's civil wars at the end of the volume, concluding with a transformation of Anchises' famous maxim of advice to Aeneas into a message for his own time (Burrow (1997: 26)):

'Breton remember thou to governe men
 (Be this thy trade) And to establish Peace,
 To spare the humble, and the proud depresse.
 The Prince of Peace protect your Highnesse most excellent life.'

26 Power (2010: 189).

27 Caldwell (2008: 21).

28 Caldwell (2008: 31): 'In the 1650s it was simply too dangerous for Royalists to employ Vergil, the established poet of imperial power, even in a translation with disguised commentary on contemporary problems. There were only two Vergil translations during this decade, both fragments and both ultimately hamstringed in offering traditional Vergilian consolation.'

29 See for example Carminati *et al.* (2006: 205), where they focus on 'the question of genre recognition and the question of the cognitive mapping of one of the surface features that determines generic categorisation' when applied to reading poetic texts. This discussion is particularly useful when understood in the context of the aims of this volume.

30 See Canevaro, Chapter 6 in this volume.

31 Kirby Smith (1998: 85).

32 Davis (2013: 153–4) has argued that Harrington was sensitive to questions of literary style from the time of *Oceana*'s publication in 1656. While some have described *Oceana* as a work that does not appear to be sensitive to concerns of literary

fashioning, Davis argues 'There is more to Harrington the literary stylist than this would suggest. His interest and versatility in the practice of genre are well known. He was a published poet who had shared the page with John Milton, a lyricist who had set words to the music of Henry Lawes and a translator of Vergil.'

33 'Following the Restoration, it was clear that the closed heroic couplet, which gave the effect of classical balance and restraint, was going to be the norm for the most serious poetry. Jonson had long since shown what could be done with it in his poem on Shakespeare, the greatest tribute ever paid by one poet to another, unless one counts Vergil's adaptation of Homer as a tribute. In some sense the heroic couplet was simply the next step in the rediscovery of Chaucer's meter. But some poets were already uncomfortable with it, and Milton . . . chose blank verse over the couplet for *Paradise Lost.*' Kirby Smith (1998: 89).

34 Kirby Smith (1998: 84–5) 'By the end of the seventeenth century poets were already so desperate to wriggle free of the increasingly end-stopped heroic couplet that they snatched at any name that carried the weight of ancient approbation and that seemed to allow more freedom.'

35 Connolly (2005: 114).

36 Clark (1898: 289).

37 Harrington (1659: A3R).

38 Harrington (1659: A4R). This story about the centurion is in Servius' commentary on *Eclogue* 9.1 (*Vergilius postquam paene occisus est ab Arrio centurione*, 'Vergil was nearly killed afterward by the centurion Arrius'), Serv. *In Ecl.* 9 p. 108 Thilo.

39 Fairclough & Goold (1999) *ad loc.* All *Eclogues* translations from Fairclough & Goold (1999).

40 '*VSQVE ADEO TVRBATVR AGRIS*: *turbamur* ('we are disturbed') has nothing to differentiate it for good or ill. And with a spirit of ill-will he attacks the times of Augustus in a hidden way. Certainly, the true reading is *turbatur* ('it is being disturbed'), so that it is impersonal, which pertains to everyone in a general way: for the expulsion of the Mantuans was collective. For if you read *turbamur*, it seems to refer to a few people' (Serv. *Ecl.* 1.11–12). See this and an expanded discussion in Gibson (2010: 42). Harrington's inaccurate translation here makes the verb seem less forceful and less Vergilian in the context of tumultuous civil war (cf. *tota bella per orbem* at Verg. *Georg.* 1.505); I am grateful to the anonymous reader of this chapter for this helpful reference.

41 Connolly (2005: 120).

42 Harrington (1659: A4V).

43 Lombardo (2005) *ad loc.*

44 Connolly (2005: 122–3).

45 Connolly (2005: 123) offers a productive and detailed discussion of this transformation.

46 Waller and Godolphin (1658: ll. 335–8).

47 Waller and Godolphin (1658: ll. 303–6).

48 Power (2010: 194). Clark (1898: 288–95) notes that Harrington was present on the scaffold when Charles I was beheaded at Whitehall on 30 January 1649.

49 Harrington (1659: A4R).

50 Proudfoot (1960: 148): 'the poem loses its epic standing and becomes instead a mere narrative'.

51 Connolly (2005: 114).

4 The Devouring Maw

1 See Ide and Wittreich (1983); Lewalski (1985).

2 In Milton's time, the word 'kind' refers to genre; for a detailed explanation, see Lewalski (2001: 4).

3 All quotations of Milton are from the cited edition rather than a modern critical edition; see also *At a Vacation Exercise in the College* (1628).

4 Cf. the opening of Herodotus' *Histories* (2–4): μήτε ἔργα μεγάλα τε καὶ θωμαστά, τὰ μὲν Ἕλλησι, τὰ δὲ βαρβάροισι ἀποδεχθέντα, ἀκλεᾶ γένηται ('so that the great and wondrous deeds displayed by the Hellenes and the Barbarians not be without fame'). All translations from Greek and Latin are my own.

5 Comments from Aristotle's *Poetics* are frequently conflated with similar sentiments from Horace's *Ars Poetica*; see Cronk (1999) and Javitch (1999a).

6 Cf. the opening of Homer's *Iliad* (μῆνιν [...] Ἀχιλῆος), *Odyssey* (ἄνδρα), and Vergil's *Aeneid* (*arma virumque*).

7 E.g., William Davenant's (1606–68) *Gondibert* (1651); Abraham Cowley's (1618–67) *Davideis* (1656) and *Civil War* (1679).

8 At the time, Homeric and Vergilian authorship for these poems was generally accepted, e.g., Joseph Justus Scaliger's 1573 edition of the *Culex* only questioned its status as juvenilia, and drawing on Spondanus' Greek text and Aldus Manutius' Latin translation *Homeri Quae Extant Omnia* (1583; reprinted 1606), George Chapman translated into English the *Batrachomyomachia* alongside the Hymns and Epigrams in *The Crowne of All Homers Workes* (1624); see St. Louis (2006) and Braund (2011).

9 Milton compares himself to Tiresias in Sophocles' *Oedipus Rex* (and to the prophet Jeremiah and John the Evangelist) in *The Reason of Church-government urg'd against Prelaty* (1642: 34).

10 See especially Dodds (2009).

11 See especially Lewalski (2009).

12 See the account of John Aubrey in Darbishire (1932: 7).

13 See Churchill (1906).

14 Both Milton and a young Dryden served under Cromwell and processed at his funeral in 1658. Despite writing a eulogy for Cromwell, *Heroic Stanzas* (1658),

Dryden subsequently celebrated the restoration of the monarchy and the return of Charles II in his poem, *Astraea Redux* (1660).

15 See Javitch (1999b).

16 See Bloom (1975: 126).

17 'Three Poets, in three distant Ages born, / Greece, Italy, and England did adorn. / The First in loftiness of thought surpass'd, / The Next in Majesty; in both the Last. / The force of Nature could no farther goe: / To make a Third she joynd the former two.'

18 'Miltons *Paradise Lost* is admirable; but am I therefore bound to maintain, that there are no flats amongst his Elevations, when 'tis evident he creeps along sometimes, for above an Hundred lines together? cannot I admire the height of his Invention, and the strength of his expression, without defending his antiquated words, and the perpetual harshness of their sound? 'Tis as much commendation as a Man can bear, to own him excellent; all beyond it is Idolatry' (*Preface* xxviii–xxix).

19 See Benet (2016).

20 See Darbishire (1932: 12, 72).

21 Dryden assumes the opposite position in his prefatory remarks that precede *The State of Innocence and Fall of Man*: 'Heroick Poetry, which they contemn, has ever been esteem'd, and ever will be, the greatest work of humane Nature' (ix), and he assumes the position of defending Milton's work against his critics; see further discussion below.

22 See further below.

23 See Weller (1999); Lobis (2014).

24 'Whether that Epick form whereof the two poems of Homer, and those other two of Vergil and Tasso are a diffuse, and the book of Job a brief model (38).'

25 See Shawcross (1983).

26 See the chapter by Buckley, Chapter 2 in this volume.

27 *The Author's Apology for Heroick Poetry, and Poetick Licence: The Preface* (vii); for its publication history, see Dodds (2009: 2).

28 See Benet (2016: 271–74, 277–82).

5 Georgic as Genre

1 Ruaeus' influence on Dryden is especially clear and well known; also that of Segrais (Thomas 2001: 139–40).

2 The first volume also contains Warton's translation of the *Eclogues*. Volumes 2–4 contain Christopher Pitt's translation of the *Aeneid*.

3 For a bibliography relating to the eighteenth century, see Pellicer 2015. On the beginnings of English georgic in the seventeenth century, see Low (1985) and Fowler (1986).

4 'I have been very particular in my criticisms on the plants mentioned by Virgil: that
 being the part, in which I am best able to inform him, and which, I believe, has been
 chiefly expected from me' (Martyn 1741: xvii).

5 After the *Georgicks*, an edition of the *Bucolicks* appeared in 1749, and a fragmentary
 Aeneids [sic] was published posthumously.

6 In time, the very idea of vernacular georgic came to seem an anomaly, as indeed it
 seemed to Samuel Johnson in the later eighteenth century. In Penelope Lively's novel
 The House in Norham Gardens (1974), a character describes his own 'unreadability'
 to others (caused, he observes, by the fact that he confuses their system of
 categorization): 'I'm a book about electrical engineering, but written in blank verse'
 (Lively 2004: 93). The coincidental description of vernacular georgic implies as good
 an explanation as any of why the genre ceased to seem viable.

7 In another article De Bruyn writes, 'The argument that Virgil's pronouncements are
 systematic and logical ran counter to a widespread critical understanding in the
 eighteenth century of the *Georgics* as a poem whose distinguishing features are
 digressiveness and variety' (2005: 154). But the argument that Vergil's precepts are
 intelligible and reasonable in terms of practical experience did not necessarily run
 'counter to' the common understanding of Vergil's variety and capaciousness.

8 Proust's allusion to Vergil's Aristaeus in the 'Ouverture' of *Swann's Way* is an
 extravagantly recondite sign by which to represent the sheer sophistication of
 Swann's world, indicating the degree to which that world is beyond the grasp of
 Marcel's great-aunt at Combray. With affectionate satire, Proust pointedly contrasts
 Ali Baba, the homely figure of exoticism that *would* be recognized in the provincial
 world of Combray, observing that Oriental character's depiction on the family's
 biscuit plates (Proust 1989: 1.19).

9 As John Chalker remarks, reading Trapp and Warton on didactic poetry it becomes
 clear that they see the *Georgics* through Addisonian spectacles (Chalker 1969: 17).

10 Besides several references to Pope, Warton 1753 cites Thomson (203, 232, 314–15,
 316), Philips (215–16), and Somervile (316).

11 He appears to have decided that Thomson's *Seasons* is beyond the remit of his essay
 on didactic poetry, if not his annotation of the *Georgics*, since *The Seasons* is more
 descriptive than prescriptive. Warton wrote his essay before the appearance of his
 own publisher Dodsley's georgic poem *Agriculture* (1754) as well as Dyer's *The Fleece*
 (1757), so naturally does not mention these works either.

12 The influence of Joseph Spence's mythographical work *Polymetis* (1747) on Erasmus
 Darwin appears to be a promising topic (see Priestman 2012: 417) but falls outside
 the scope of this chapter.

6 Rhyme and Reason

1 On Wolf's work and its importance to Homeric studies see, in particular, Grafton (1981), Grafton's (1985) introduction, Di Donato (1986), Bertolini (1987).

2 For overviews of the Homeric Question, see Turner (1997) and Fowler (2004).

3 'The Critic as Artist: Part I' in *Oscar Wilde, the Major Works*, Oxford (1989: 244).

4 See Grafton (1981: 110). On the Homeric Question and contemporary German literature and literary criticism, with a particular focus on Goethe, see Wohlleben (1967).

5 On the development of female epic in connection to classical scholarship, see Hauser, Chapter 9 in this volume.

6 From the preface to his *Fables Ancient and Modern*, 1700. Edition: Kinsley (1958), lines 141–6.

7 See e.g. Lefkowitz (2012) and work currently being conducted within the Durham-based ERC project 'Living Poets'. Available at: https://livingpoets.dur.ac.uk/w/Welcome_to_Living_Poets (last accessed 16 December 2017).

8 *Kleine Schriften in Lateinischer und Deutscher Sprache* 1.166, quoted in translation by Grafton in his introduction to Wolf's *Prolegomena* (Grafton 1985: 16).

9 See, in particular, Lord (1960), Parry (1987).

10 This is to simplify drastically the issue. For a detailed analysis of Homeric formulae, see the series of articles by Mark W. Edwards published in *Oral Tradition* (Edwards 1986, 1988, 1992).

11 Though not necessarily *by* them: Parry's later writings, in particular, show a consciousness of the relative flexibility and meaningfulness of oral epithets.

12 In this chapter, the *Iliad* text used is the Teubner edition of M.L. West (vol. 1 1998, vol. 2 2000), and the *Odyssey* text is that of H. van Thiel (1991).

13 There have, of course, been a number of more recent translations of the *Iliad*, such as that by Stephen Mitchell (2011, five-beat line) and, more recent still, that by Caroline Alexander (2015, free verse) – but these have yet to establish quite the same purchase as go-to translations.

14 I am well aware that, in this part of my discussion, I am swimming against the tide, given how widely the rhyming couplet has been disparaged as a way to translate Homer. The scheme certainly has its problems: end-rhymed couplets are arguably more closed than the hexameter line, for example (though see below on Homeric enjambment). Indeed, I began my thinking on this topic by playing devil's advocate. But I soon became convinced that there are arguments against dismissing this scheme entirely and am hoping to engage, if not convert, the sceptical reader.

15 Hanauer (1996). On (sub-)genre recognition, see Fowler (1982), Furniss and Bath (1996).

16 On genre and meter see further below.

17 Connelly (1988: 359) attempts to use this oppositional structure of Pope's *Iliad* to uncover Pope's ideology, arguing that '[a]ny writer takes for granted certain opposing

themes and terms in order to give definition to what would otherwise be unclear. Pope's couplets with their characteristic rhetoric seem especially suited for generating oppositions, and so his versification facilitates a study of his assumptions'.

18 In line with the main aims of this volume, I confine my discussion here to the intersection between literary criticism and classical scholarship as it applies to versification. One could pursue the question also in cognitive terms: see for example Carminati, Stabler, Roberts and Fischer (2006: 205), who set out research in which 'one of the key findings has been that the categorization of a text as a poem is determined primarily by its linguistic and textual features [. . .]. Such features include use of rhyme.'

19 Fowler (2003). On the changing fate of poetic genres, with reference to Pope, see Fowler (1979). On the ancient genre of didactic see further Canevaro (2014) and Sider (2014). For more on the criticism of didactic poetry, see Dalzell (1996).

20 Morris did begin a translation of the *Iliad* (see Whitla 2004), but it was left unfinished and unpublished. The *Iliad* was to be translated in the same meter as *Sigurd* and the *Odyssey*.

21 It continues to do so today. I hope the anonymous reviewer of this chapter will not mind me relaying her/his comment on 'the sheer mind-blowing, consciousness-altering awfulness of William Morris' translation'.

22 *Pall Mall Gazette*, 26 April 1887 (review of Volume 1).

23 *The Quarterly Review*, October 1888. Silvio Bär draws my attention to the recent German translation of the *Iliad* by Raoul Schrott, who describes all previous translations of the poem as 'travesties' (Schrott 2008: xxxi).

24 *Academy*, March 1888, xxxiii: 143–4 (review of Volume 2).

25 *Pall Mall Gazette*, 26 April 1887 (review of Volume 1).

26 *Pall Mall Gazette*, 24 November 1888 (review of Volume 2).

27 *Letters* vol. 1: 275.

28 *The Quarterly Review*, October 1888.

29 In her introduction to *The Collected Works of William Morris* vol. 13: xv.

30 On the 'meeting of past and future in William Morris' see Frye (1982).

31 *Letters* vol. 2.B: 515.

32 *Pall Mall Gazette*, 26 April 1887 (review of Volume 1). Morris himself had a strong view on Milton's poetry: 'the union in his works of cold classicalism with Puritanism (the two things which I hate most in the world) repels me so that I *cannot* read him' (*Letters* vol. 2.B: 517).

33 MacCarthy (1994: 562).

34 *Letters* vol. 1: 23, to Cormell Price 29 September 1855.

35 Recounted by Eiríkr Magnússon in the preface to *The Stories of the Kings of Norway (Heimskringla)* (Magnússon 1905). See also *The Collected Works of William Morris*, vol. 7: xvi–xvii, in which May Morris relays the account given to her by Magnússon of their working method: 'Owing both to other literary occupations and to pressure

of business engagements Morris decided from the beginning to leave alone the irksome task of taking regular grammatical exercises.'

36 Although there are some inaccuracies: 'well-skilled in gainful art' seems to be a mistranslation of the Greek.

37 *Academy*, April 1887, xxxi: 299.

38 *Pall Mall Gazette*, 26 April 1887.

39 Indeed, *Sigurd* was in this sense sandwiched between *Odyssey* versions: in 1873 Morris wrote a draft invocation to the *Odyssey* which, although radically altered in the 1887 version, was already composed in the characteristic rhyming anapestic hexameters.

40 *Political Writings* 277–8.

7 From Epic to Monologue

1 On the relationship between Homeric and biblical scholarship, see further Hauser chapter 9 in this volume.

2 On Wolf, see also Canevaro and Hauser, Chapters 6 and 9 in this volume.

3 For a discussion of the epyllion, see Bär, Chapter 8 in this volume.

4 Tennyson used the term 'English Idyls' for a series of poems written between 1832 and 1842 and later used the spelling 'Idylls' for the *Idylls of the King* (O'Donnell 1988: 125).

5 This refrain is repeated at lines 11–12, 24–5, 35–6, 47–8, 59–60 and 71–2 before the conclusion of the poem with a despairing couplet at lines 83–4: 'She wept, "I am aweary, aweary, / Oh God, that I were dead!"' (Tennyson 1987: 1. 205–9).

6 There are precedents for this disruption in Dido's lament in Book 4 of Vergil's *Aeneid*, the tragic culmination of an episode that threatened to obstruct Aeneas' destiny and the future of Rome, and in Andromache's poignant commentary on the cost of the heroic code for the women who are on the losing side in a war (*Iliad* 6).

7 See Baumbach and Bär (2010).

8 Quintus of Smyrna, until around 1800 often referred to as Quintus Calaber.

9 In Quintus of Smyrna's *Posthomerica*, Achilles dwells on the Island of the Blessed.

10 In the *Telegony* Odysseus travels to Thesprotia, where he marries and has another son before fighting a war in which his wife is killed and leaving the kingdom to his son Polypoetes. He returns to Ithaca, where Telegonus, the son of Circe and Odysseus, is looking for his father. Telegonus kills Odysseus with a spear made by Hephaestus and tipped with poison from a stingray (thus fulfilling Tiresias' prophecy that death would come to Odysseus out of the sea).

11 Dante could not have read Homer's poem, and the prominence of Vergil as his source for the story of the Trojan War is underlined by the figure of Vergil, Dante's guide to the underworld, being the one to speak to Ulysses.

8 The Elizabethan Epyllion

1 The text is quoted from Reese's (1968) edition.

2 Cf. Alexander (1967: 8–9) and the edition of the three earliest poems from the 1560s by Chiari (2012). Lodge's *Scillaes Metamorphosis* (1589) is often, but imprecisely, regarded as the genre's first representative (cf. e.g. Kennedy 2007: 16–17 and Enterline 2015: 253).

3 See the Appendix at the end of this chapter, which comprises a good three-dozen titles. The actual production (potentially including some lost, or hitherto unpublished, texts) may even have been considerably higher.

4 Further, less common, terms of designation are 'Elizabethan verse romance' (Reese 1968), 'Elizabethan erotic narrative' (Keach 1977) and 'Elizabethan erotic verse' (Ellis 2003). Because of the decidedly Ovidian texture of most of the EE, terms such as 'Ovidian epyllion' (cf. e.g. Cheney 2007: 7; Maslen 2003: 92) and 'Ovidian romance' (Bradbrook 1964: *passim*) are sometimes also used. Cf. also Hulse (1981: 16–17) for further terms.

5 Cf. Cameron (1995: 268–9).

6 For some standard definitions, see e.g. the entries in *The Oxford Classical Dictionary* (Courtney 1996) and *Der Neue Pauly* (Fantuzzi 1998).

7 For a detailed discussion of these problems, cf. Allen (1940); Allen (1958); Bär (2015: 23–34), with further references. For a more 'epyllion'-friendly evaluation, cf. e.g. Vessey (1970).

8 The latest and most profound discussion of the history of scholarship of the ancient 'epyllion' is provided by Tilg (2012) (see 34–7 for Tilg's discussion of the first attestation of the term by Ilgen). See, furthermore, Most (1982) (in parts outdated by Tilg 2012), as well as Bär (2015: 34–9) for an overview and further references.

9 Tilg (2012: 47–54) provides an annotated list of all attestations of the term in classical scholarship between 1796 and 1855.

10 On this aspect of the history of scholarship of the ancient 'epyllion', cf. the in-depth study by Trimble (2012).

11 This is not least proven by the fact that Crump's book was reprinted by Bristol University Press in 1997.

12 For reflections on the scope of the genre, see e.g. Hulse (1981: 16–34) and Demetriou (2017: 47–52). See also n. 2 above.

13 There are only a few examples of decidedly non-Ovidian EE, the most prominent of which is Marlowe's *Hero and Leander* (the main source of which is Musaeus' *Hero and Leander*; see Baldwin 1955 and Braden 1978: 55–153). For a discussion of further non-Ovidian EE, see Demetriou (2017). On Ovid(ianism) in English Renaissance poetry, see e.g. Smith (1952: 64–130); Keach (1977); Bush (1963: 69–88); Bate (1993); Burrow (2002); Chiari (2012: 10–18). On the importance of Ovid in the

Renaissance in general, see e.g. Wilkinson (1955: 399–438). On the complex question of genre theory in Renaissance literature, see the brilliant study by Colie (1973).

14 See Tilg (2012: 33–4, 47).

15 Cowley is not mentioned as an 'epylliast' in the chapter on 'Elizabethan minor epic' in *The Oxford History of Classical Reception in English Literature* (cf. the list compiled by Enterline 2015: 269, n. 1).

16 He consistently calls Crump 'Miss Crump' (Allen 1940: 3, 4, 13) and Miller 'Mr. Miller' (Allen 1958: 515–16). The combination of an honorific with a last name often functions as a marker of social and, at times, also ironic distance; here Allen may have used it to establish a hierarchy between himself and the scholars against whom he argues.

17 Cf. n. 4 above for some examples of alternative terminology.

18 See the preface (Alexander 2000: 1): 'This history offers a map to the thousands of people who study English today.'

19 Enterline's (2015: 253) definition of the ancient 'epyllion' seems to be almost copy-pasted from the definition given in *The Oxford Classical Dictionary* (Courtney 1996), which, in turn, is entirely based on Crump (1931).

20 I wish to thank my co-editor Emily Hauser for her most valued feedback on an earlier version of this chapter, as well as Sofia Heim, Johannes Nussbaum and Ursina Füglister for their bibliographical assistance.

21 The following list comprises all EE that I could find as being referred to as 'epyllion' and/or 'minor epic'. **A** = included in the edition by Alexander (1967). **B** = discussed in the monograph by Brown (2004). **C** = included in the edition by Chiari (2012). **D** = included in the edition by Donno (1963). **M** = included in the edition by Miller (1967). **R** = included in the edition by Reese (1968). **W** = discussed in the monograph by Weaver (2012).

9 'Homer Undone'

1 Richard Martin, in his overview of 'epic as a genre' in the *Companion to Ancient Epic*, describes the traditional view of epic as '"cultivated" writing done by elite males, usually in the service of developing a nation-state' (Martin 2005: 10). Alison Keith goes further, identifying epic in the ancient world as 'composed by men, consumed largely by men, and centrally concerned with men. The ancients knew of no female epic poets' (Keith 2000: 1). On gender and genre in ancient epic, see generally Keith (2000: 18) and compare Dentith (2006: 104), who traces the history of epic 'as an overwhelmingly male form' to Homer's *Iliad*. For examples of modern receptions of the masculinity of epic, see e.g. Woolf (1989: 77): 'there is no reason to think that the form of the epic . . . suit a woman any more than the [masculine] sentence suits her';

Pound (1968: 216): epic is 'the speech of a nation through the mouth of one man';
Borges (2000: 49): 'the important thing about the epic is a hero – a man who is a
pattern for all men'. See further Dentith (2006: 98), Downes (1997: 19) and (2010: 18,
21), Friedman (1986: 203–5), Johns-Putra (2006a: 155) and Schweizer (2006: 1). Of
course, as Keith points out, one of the most famous exceptions to the assumption of
Homer's male identity was Samuel Butler's *The Authoress of the Odyssey* (1897), in
which he suggested that the *Odyssey* was written by a woman because of the
frequency and the sensitivity of the portrayal of female characters. I do not discuss
Butler here, in keeping with my focus on female-authored epic and given that he
post-dates one of my case studies; but see further Dougher (2001).

2 The study of female epic is still a relatively recent phenomenon, in accordance with
its subject's (and authors') historic marginalization: see Downes (1997) and (2010),
Friedman (1986), Johns-Putra (2001) and Schweizer (2006).

3 On the intersection between gender and genre in women's writing in English, and
the history of scholarship in gender/genre studies, see Stone (1987: 101–2 and
101 n.1). For gender and genre in *Aurora Leigh*, see n. 12 below.

4 My choice of texts is a conscious 'revisioning' of Susan Stanford Friedman's ground-
breaking article on genre and gender in female epic and is thus as much a nod to
scholarship on female epic as to female epic itself. (It is also, of course, at the same
time, a recognition of the seminal importance of these two texts in the tradition of
female epic.) *Aurora Leigh* is generally acknowledged as the first major female verse
epic in the English literary tradition: see Friedman (1986: 207). Downes (2010: ch. 3)
identifies possible precursors to Barrett Browning, although many are doubtful as
Downes is, as he himself admits (p. 28), very free in his classification of epic: can we,
for example, really see Proba's Virgilian *cento* as an epic in its own right (p. 39)? A
notable (possible) exception is Mary Tighe's *Psyche, or the Legend of Love* (1805),
which can be seen as 'one of the earliest attempts in English to write a female epic'
Chakravarti (2006: 99) – but, as Chakravarti notes, Tighe's *Psyche* did not earn its
place in the literary canon. It is therefore not treated here, as not having influenced
the development of female epic as a genre to the same extent as Barrett Browning's
Aurora Leigh. For a list of examples of female epic, see the Appendix to Downes
(2010) and the chapters in Schweizer (2006).

5 The generic hybridity of female epic, between the genres of epic, lyric, and the
novel in particular, has often been noted: see most notably Friedman (1986) and
Schweizer (2006: 14) and also Bailey (2006: 120), Dentith (2006: 94–97), Downes
(2010: 30–31) and Stone (1987). On the formal flexibility of female epic (that is, the
variability between prose and verse), see Schweizer (2006: 11–12), Swedenberg
(1944: 155).

6 See Friedman (1986: 203) on the 'anxiety of poetic genre' among female epic poets,
responding to Gilbert and Gubar (1979) on female authors' 'anxiety of authorship';

on the 'anxiety of influence' see Bloom (1997) and in Elizabeth Barrett Browning's writing, see Stone (1995: 55).

7 For the history of female epic, see Downes (2010: ch. 3) and Schweizer (2006: 12–13), though note that Downes' definition of what constitutes female epic is somewhat looser than my own.

8 See also Chapter 7 in this volume, page 123.

9 On Wroth, Seward and Tighe see the relevant chapters in Schweizer (2006): Cavanagh (2006), Johns-Putra (2006b) and Chakravarti (2006).

10 The quotation is from *Aurora Leigh* 5.1258; the text of *Aurora Leigh* used throughout is the 1993 Oxford World's Classics edition by Kerry McSweeney (Barrett Browning 1993).

11 Barrett Browning's self-definition of *Aurora Leigh* as an epic in several instances throughout the poem is central to my reading: most famous is the passage in book 5.213–216, 'Never flinch, / But still, unscrupulously epic, catch, / Upon the burning lava of a song / The full-veined, heaving, double-breasted Age . . .'). As already mentioned, however, and as Friedman (1986) shows, *Aurora Leigh*'s generic intertexts also include the novel (amongst other genres, including lyric and mock-epic); I will focus here on Barrett Browning's use of Homer, in particular, to bolster the epic credentials of her work. On *Aurora Leigh* as epic, see, among others, Bailey (2006: 117–18), Dentith (2006: 94–97), Hurst (2006: ch. 3, esp. 114 and 124–25), Laird (1999: 365), Mermin (1989: 183), Stone (1987: 125–26), Tucker (2008: 377). For the generic hybridity of female epic generally, see above, n. 5. On the generic hybridity of *Aurora Leigh* in particular, see Bailey (2006: 120), Dentith (2006: 95) (*Aurora Leigh* as a 'generic combinatory'), Downes (1997: 216), Downes (2010: 276–89), Friedman (1986), Hurst (2006: 101, 122, 126–27), Stone (1987: 103–4, 115, 125–27).

12 On the 'dialectic . . . between scholarly criticism of Homeric epic and contemporary literature's imaginative, affective, and ludic responses to and representations of reading ancient Greek poetry', see Bridges (2008: 166). See Bridges (2008) throughout for the relationship between Victorian literature and Homeric epic; see also, on Homer and the Victorian period generally, Harrison (2013), and on Homer/Hellenism and women writers, see Hurst (2006) and Fiske (2008). For a survey of the interrelationships between women and scholarship/criticism in the nineteenth century, see Laurence, Bellamy, and Perry (2000). On the interaction between gender and genre in *Aurora Leigh*, see Byrd (1999), Friedman (1986), Hurst (2006: 108–13), Stone (1987: 115–27).

13 See also Friedman (1986: 208 and 225 n. 21), Gilbert (1984: 195), Gilbert and Gubar (1979: 575), Stone (1987: 115), Stone (1995: 136–37).

14 See Friedman (1986: 208): '*Aurora Leigh* ... is also an intensely personal account of a
 woman writer's inner conflicts ... Private lyric provided a safe workshop in which
 [Barrett Browning] forged the self later projected into Aurora.' See also Dentith (2006:
 84): 'there seems little invitation in the poem to distinguish [Aurora's] opinion from
 that of the "E.B.B." who appended her signature to the Dedication, informing her
 cousin John Kenyon, and the world at large, that this was the poem "into which my
 highest convictions upon Life and Art have entered".' See also Falk (1991), Hurst (2006:
 109), Showalter (1982) ('*Aurora Leigh* ... is one of the few autobiographical discussions
 of feminine role conflict', pp. 22–3), Stone (1987: 124) and Stone (1995: 136).

15 See Dentith (2006: 3) on nineteenth-century writers more generally and their
 'consciousness of the antiquity of epic as a genre'.

16 On Barrett Browning and her (fraught) relationship with her classical models, see
 Hurst (2006: ch. 3) and especially pp. 116–18 on Barrett Browning's *Battle of
 Marathon*; on which see also Downes (2010: 153), Friedman (1986: 207). On Pope's
 Homer, see Chapter 6 in this volume by Lilah Grace Canevaro.

17 On Barrett Browning's classical background, see Hurst (2006: 104–8), Mermin (1989:
 19–21), Stone (1995: 19–20) and J. Wallace (2000); see also Drummond (2006),
 Hardwick (2000: 32) and Prins (2017: 59–115) on Barrett Browning's translations of
 Prometheus Bound. For an exploration of classical intertexts in Barrett Browning's
 works, see Hurst (2015); and on women's classical education in the nineteenth
 century, see Fiske (2008: 1–23) and Hurst (2006: 52–100). For Victorian women's
 translations of Greek tragedy, see Prins (2017).

18 Hurst (2006: 111) also makes this point and adds the connection of the image of the
 blind poet to Milton.

19 *Homeric Hymn to Apollo* 172–3: τυφλὸς ἀνήρ, οἰκεῖ δὲ Χίῳ ἔνι παιπαλοέσσῃ τοῦ
 μᾶσαι μετόπισθεν ἀριστεύσουσιν ἀοιδαί ('He is a blind man, and dwells in rocky
 Chios: his lays are evermore supreme' [tr. Hugh Evelyn-White]). Note that Robert
 Browning, in his 1889 poem 'Development', terms Homer the 'Blind Old Man, /
 Sweetest of Singers' – on which see Bridges (2008: 167–73).

20 Contrast Hurst (2006: ch. 3), who suggests that Barrett Browning turns from
 philology to poetry to re-approach female epic (though see p. 105, where Hurst
 comments that 'the poem offers an insight into what a woman with poetic ambitions
 might feel about her relationship to the masculine literary tradition'); for
 perspectives on Barrett Browning as a (classical) scholar, see Hurst (2006: 101) and
 J. Wallace (2000), especially p. 329 on Barrett Browning as 'the most scholarly
 woman poet of the nineteenth century'; see further n. 17 above. On Victorian
 women writers and the classical world more generally, see Comet (2013), Fiske
 (2008) and Hurst (2006).

21 The text here is Barrett Browning (1993), although it is interesting to note that in the
 Harvard manuscript (MS Lowell 5) Barrett Browning spells Wolf's name correctly

(i.e. without the reduplication of the 'f') throughout. On this passage, see Downes (1997: 230–1); see also Bridges (2008: 181 n.6), Dentith (2006: 98–102), Tucker (2008: 381 n. 59), Stone (1995: 156–7), J. Wallace (2000: 347–8). Contrast Barrett Browning's rejection of Wolf with that of her husband Robert Browning in 'Development' (1899); see Bridges (2008: 167–73).

22 Dentith (2006: 98) writes that Aurora rejects 'Wolf's splendid edition of Homer'; Downes (1997: 231) suggests that she sells Homer to 'finance her epic status.'

23 See, among the vast literature on the subject, Fowler (2005), Graziosi (2002), and Nagy (1996). On the influence of Wolf and debates around the identity of Homer, see Dentith (2006: 4–10); see further the chapters by Canevaro and Hurst in this volume.

24 For text and commentary on Wolf's *Prolegomena*, see Grafton, Most and Zetzel (1985). For further reading, see the 'Bibliographical Essays' at the back of Grafton, Most and Zetzel (1985: 249–54); see in particular Grafton (1981), Pattison (1889), Volkmann (1874). On Wolf's background, see Grafton, Most and Zetzel (1985: 3–4); for his scholarship and scholarly influences, see Grafton (1981).

25 On Pisistratus, see the *Prolegomena to Homer* chapters 7, 33 (Grafton, Most and Zetzel 1985: 57, 137); on Villoison, see Grafton, Most and Zetzel (1985: 7 and 8 n. 15).

26 Given in Grafton, Most and Zetzel (1985: 5), citing the *Prolegomena to Homer* chs. 18, 33.

27 Compare Grafton (1981: 109); on the impact of the *Prolegomena*, see Grafton (1981: 110–19), Jenkyns (1989: 22, 207–8).

28 On Wolf's reception in England in the nineteenth century, see also Dentith (2006: 18–23), Fiske (2008: 65, 71–5).

29 Bailey (2006: 122), Stone (1995: 145).

30 On the early history of the Elzevirs (also spelled Elseviers), see Davies (1954), Willems (1880) (the standard nineteenth-century account). For the 1656 Homeric edition, see Willems (1880: 307–8 [no. 1202]).

31 Schrevel's 1656 Elzevir edition was titled in both Greek and Latin (given at Willems 1880: 307): Ὁμήρου Ἰλιὰς καὶ Ὀδυσσεία, καὶ εἰς αὐτὰς σχόλια, ἢ ἐξήγησις Διδύμου. *Homeri Ilias et Odyssea, et in easdem scholia sive interpretatio Didymi. Cum latina versione accuratissima, indiceque graeco locupletissimo rerum ac variantium lection<um>. Accurante Corn. Schrevelio* ('The *Iliad* and *Odyssey* of Homer, and the accompanying scholia (or commentary) of Didymus. [Repeated in Latin.] With a most accurate Latin version, and a detailed Greek index of objects and varying readings. Edited by Cornelius Schrevel.') Note that all translations given are my own, unless otherwise indicated.

32 See Dickey (2007: 18–21).

33 Houston (2013: 6, 73–97), Mermin (1989: 70, 128), Stone (1995: 145–9, 153–4).

34 See also Comet (2013: 115).

35 See also Grafton (1981: 120–6), and Barrett Browning (1993: 351 *ad* 5.1246–57). See also Chapter 7 in this volume, page 119.

36 It is interesting to note that the Elzevir New Testaments were particularly important as the origin of the term *textus receptus* ('received text' or the succession of printed versions of the Greek New Testament, originating with Erasmus' 1516 edition) in the reception history of the New Testament, thus also implicating them in the biblical textual tradition: see Jarrott (1970: 121 n. 14).

37 The bibliography on this topic is vast. See, in particular, Halliwell (2002) on Plato's theory of *mimesis* ('imitation'); see also Asmis (1992) and Murray (1996).

38 For text and notes, see Lamberton (2012).

39 On Proclus' defence of Homer, see Lamberton (2012: xxvi–xxx), and see further Sheppard (1980).

40 Barrett Browning (1899: 381); see also Barrett Browning (1899: 125) on 'Homer's supremacy.'

41 For Barrett Browning's own classical education with her brother in comparison to Aurora's education by her father, and on Barrett Browning's association of 'Greek grammar with male scholars', see Hurst (2006: 106–7); see also Stone (1987: 117) and J. Wallace (2000: 338–9, 345): 'the classical tradition, symbolised by [Aurora's] father's library, represents an unavoidable, material weight which must be negotiated, exploited and transformed'.

42 Presaging Hélène Cixous' image of women's writing 'in white ink' (Cixous 1976: 881) (as Marjorie Stone notes, Stone 1995: 158). On the prevalent imagery of breasts and maternity in *Aurora Leigh*, see Dentith (2006: 99), Gilbert (1984: 203), Stone (1995: 157–8), and compare the passage at *AL* 5.214–22. Note also Bailey (2006: 135 and 137 n. 9), who suggests that the nine books of *Aurora Leigh* can be compared to the nine-month gestation period for humans, suggesting another birth/creation metaphor represented by the text as a whole.

43 Compare Dentith (2006: 102): 'Wolf's treachery is to refuse to recognise that there is a legitimate line of maternal succession from Homer to his baby-gods: again the transmission of the heroic is refigured in unembarrassedly feminine terms.'

44 Perhaps the most famous instance of Barrett Browning's instantiation of a female literary tradition is in an 1845 letter she wrote to the literary critic Henry Chorley in a discussion of the paucity of 'poetesses' in the past: 'The divine breath . . . why did it never pass, even in the lyrical form, over the lips of a woman? . . . I look everywhere for grandmothers and see none. It is not in the filial spirit I am deficient, I do assure you – witness my reverent love of the grandfathers!' (Barrett Browning 1899: 232). For a feminist reading of Barrett Browning's work, see, among others, Byrd (1999), Friedman (1986), Mermin (1989: 183–224), Stone (1987), Stone (1995: 172–6).

45 The major critical works of scholarship on H.D., her life and work include Collecott (1999), DuPlessis (1986), Friedman (1975), Friedman (1981), Friedman (1990b), Gregory (1997) and Guest (1984); and see also the collected essays in Bloom (1989), Christodoulides and Mackay (2011) and Friedman and DuPlessis (1990). For H.D.'s relationship with Pound, see Korg (2003) and Flack (2015: 188–95).

46 Major works of scholarship on *Helen in Egypt* include Barbour (2012), Flack (2015: 177–88), Friedman (1986), Gelpi (1989), Gregory (1995), Gregory (1997), Hart (1995), Hokanson (1992), Murnaghan (2009).

47 For a comprehensive list of classical allusions/intertextuality in H.D.'s poems, see the Appendix to Gregory (1997: 233–58); see further Flack (2015: 171–7).

48 On the prose captions, see Barbour (2012).

49 See also Flack (2015: 177), Friedman (1990b: 302–3), Barbour (2012: 483).

50 For instances of H.D.'s reception of Barrett Browning's *Aurora Leigh* in *Helen in Egypt*, see Downes (2010: 187) – 'certain details of *Helen in Egypt* ... appear to "think back" to *Aurora Leigh*' – and Friedman (1986).

51 Parry's essays were published in French in the 1920s and 1930s, and collected and published posthumously in English translation by his son, Adam Parry, in 1971.

52 All references to the text are to the 1961 New Directions edition, with introduction by Horace Gregory.

53 On this aspect of *Helen in Egypt* see especially Gregory (1997: 218–31), and also DuPlessis (1986: 111–12). On the figure of Helen in classical literature generally, see Austin (1994), Blondell (2010), Gumpert (2001: 3–100); and on Stesichorus' *Palinode*, see Austin (1994: 90–117), Beecroft (2006), Nagy (1990: 419–23).

54 Compare also Barbour (2012: 472), Gregory (1997: 281–332), and Flack (2015: 172 and n. 23). Note that, as Friedman (1995) describes, H.D.'s 1924 poem 'Helen' was originally drafted on the back cover of Theodore Buckley's 1875 translation of *The Tragedies of Euripides*, suggesting her close connection both to Euripides and to the Greek literary tradition at large.

55 On the importance of Homer for modernism and the usefulness of Homer in defining/identifying modernist poetry, see Flack (2015). H.D.'s reworking of Homer here also, of course, ties into other modernist reworkings of Homer, as in, for example, Joyce's *Ulysses* (on which see Zajko 2005) and Pound's *Cantos*, on which see Flack (2015: 25–58). See further n. 64 below.

56 Note that Gregory also suggests a Homeric intertext for H.D.'s work, (Gregory 1997: 173–4). Compare also the Appendix to Gregory (1997), where the *Odyssey* and *Iliad* are given as sources for H.D.'s poems, but only in terms of content.

57 The generic hybridity of H.D.'s *Helen in Egypt* between epic and lyric has already been noted by Friedman (1986). See also Flack (2015: 164), and n. 5 above. For a reading of H.D. with attention to the question of orality/phonetics, see Morris (2003: 19–55); Barbour (2012: 466) suggests that *Helen in Egypt* can be read as a fusion of

'poetry and prose as well as oral and textual consciousness', but does not make the link to the oral/textual debate in Homeric studies. On the orality versus the textuality of Homer, see Lord (2000) and Nagy (1996); on poetry vs. prose in H.D's *Helen in Egypt*, see Barbour (2012: 486), Hokanson (1992: 332–4).

58 Compare Gregory (1997: 1), 'no other modern writer is more persistently engaged in classical literary exchange'. For an introduction to H.D's classical education, see DuPlessis (1986: 17) and E. M. Wallace (1987).

59 See further Gregory (1997: 279 n. 47). In her earlier article, Gregory states that 'there is no evidence that H.D. re-read Homer after about 1920' (Gregory 1995: 85), but in notes on an unnumbered page of H.D's working notebooks for *Helen in Egypt*, in which she keeps notes on Graves' *Greek Myths* (Gregory 1995: 109), it is clear that H.D. is at least rehearsing the Iliadic story as re-told by Graves, with the names of Apollo, Chryseis and so on occurring here.

60 See the Appendix to Gregory (1997: 238). On H.D's knowledge of Greek, see Flack (2015: 9) and Gregory (1997: 54–6); and on her translations from Greek, see Flack (2015: 10, 165, 168). On H.D. and Pound's translations, see Babcock (1995); see also Gregory (1995: 85–6) on her early attempt at a translation of Euripides' *Helen*.

61 Flack (2015: 11) (on J.A.K. Thomson), Gregory (1997: 73) (on Wilamowitz) and chs. 3 and 4 (on Walter Pater and Jane Harrison), Gregory (1995: 85 n. 5) (on Verrall and Murray).

62 The only scholar I can find to directly connect Parry and H.D. is Morris (2003: 48), but she does not suggest a direct influence or delve into its potential implications.

63 See Korg (2003) and n. 66 below.

64 On Pound's knowledge of Parry see Flack (2015: 39). Note that H.D. calls *Helen in Egypt* her 'cantos' in her letters to Pearson (Hollenberg 1997) and compares the epic directly to Pound's *Cantos* (on which see Flack 2015: 178 n. 36), 'suggesting that she saw her work as parallel and responsive to Pound's epic'.

65 On memory in *Helen in Egypt*, see Hart (1995), and in H.D's poetry generally, see Baccolini (2003); on the interrelationship between memory and H.D's interest in psychoanalysis see Friedman (1981: 59–67); on the poem's antitheses, see n. 54 above.

66 See Gregory (1995) and Gregory (1997: 218–31) on intertextuality with Euripides, and see also n. 54 above. On the generic flexibility of *Helen in Egypt*, see n. 57 above.

67 ὡς καὶ ὀπίσσω ἀνθρώποισι πελώμεθ᾽ ἀοίδιμοι ἐσσομένοισι, Hom. *Il.* 6.357–8.

68 For an alternative interpretation, see Barbour (2012), who focuses on the oral/textual, poetry/prose opposition.

69 φύλλα τὰ μέν τ᾽ ἄνεμος χαμάδις χέει, Hom. *Il.* 6.147. It is interesting to note that φύλλον can mean leaf or petal in Greek, suggesting H.D's 'flower-leaves;' see LSJ s.v. φύλλον.

70 *basia mille, deinde centum; / dein mille altera, dein secunda centum*, Catull. 5.7–8; *soles occidere et redire possunt; / nobis cum semel occidit brevis lux, / nox est perpetua una dormienda*, 4–6; *conturbabimus illa, ne sciamus / ... tantum esse basiorum*, 10–12.

71 See Downes (2010: 214) for a discussion.

72 On H.D. and Freud, see Chisholm (1992), Friedman (1981: 17–49), Friedman (1987), and Friedman (2005); for a psychoanalytic reading of *Helen in Egypt*, see Edmunds (1994: 95–148).

73 See further Hollenberg (1991: 175–204) on the theme of motherhood in *Helen in Egypt*.

74 For an introduction to Williams' 'Letter', see Schmidt (1991), and see the discussion at Kinnahan (1994: 81–2); for the text (a 1991 reprint of the 1946 original), see Williams (1991).

75 Hollenberg (1997: 12 n. 14) on Williams as a college friend of H.D. and Pound, and Hollenberg (1997: 86) for the letter to Pearson in which H.D. says that she was introduced to Williams through Pound.

76 See Schmidt (1991: 4) and Hollenberg (1997: 111 nn. 15–16).

77 On *Helen in Egypt* as a feminizing epic and Helen's 'conflict with patriarchy' see Friedman (1986); see also Friedman (1975), Friedman (1981: 253–72) and Friedman (1990a) on H.D.'s creation of a 'women's mythology' and her resurrection of 'matriarchal values' (375), and Hollenberg (1991) on creativity and maternal/childbirth metaphors in H.D.'s corpus, in particular 3–30. On motherhood as a theme in *Helen in Egypt*, see Gelpi (1989).

78 On the long-noted connection between weaving and poetry in Homer, see Bergren (1983: 79), Blondell (2010: 19), Pantelia (1993: 494), and Worman (2001: 30 and n. 37) for additional bibliography.

79 See Flack (2015: 180).

80 See Barbour (2012: 16–17).

81 As, for example, in the Appendix to Gregory (1997: 254–5); see also n. 56 above.

82 I noted above Barrett Browning's famous comment, 'I look everywhere for grandmothers and see none' (Barrett Browning 1899: 232). Later, in *A Room of One's Own* (1928), Virginia Woolf would make a similar remark: female novelists 'had no tradition behind them, or one so short and partial that it was of little help. For we think back through our mothers if we are women' (Woolf 1989: 64). Friedman notes that H.D. alludes to reading Woolf's *A Room of One's Own* (Friedman 1990b: 389 n. 22).

10 Generic 'Transgressions' and the Personal Voice

1 See Bakhtin (as cited by Martindale 1993: 30): 'At every moment of the dialogue, there are immense and unlimited masses of forgotten meaning, but [. . .] as the dialogue moves forward, they will return to memory and live in renewed form. [. . .] Nothing is absolutely dead: every meaning will celebrate its rebirth.'

2 Hadas (2015: 106). All translations from the *Aeneid* will be Ruden's (2008).

3 Hadas (2015: 34). The passage, of course, evokes *Aen.* 2.792–4.

4 Hadas (2015: 108–9)

5 Mendelsohn (2017)

6 Beye (1997: 154)

7 For a discussion of Heaney's personal involvement with Vergil see Martindale (1997: 3) and Hardie (2013: 46–49).

8 On the masculinity of epic as a genre, see Hurst and Hauser, Chapters 7 and 9 in this volume.

9 Carson (2010: Section 1.0)

10 Ibid. at Section 5.2.

11 Ibid. at Section 8.1. See Theodorakopoulos (2012: 158): 'When she speaks of trying to piece together her memories of her brother, it becomes clear that he shares in the elusiveness of ancient texts.'

12 Carson (2010: Section 7.1)

13 See Balmer (2012: 264): 'I managed to persuade my school Latin teacher to teach a small class of Greek although she had not studied the language herself since university. I later had to study Greek 'A' level at a nearby boys' school (which at least was only over the road unlike Anna Swanwick's trip to Germany). Even then, in the mid–1970s, there still appears to have been a gender divide in access to a classical education.'

14 See Balmer's observation that 'classicists have long felt uneasy with personal statements as opposed to what is seen as more objective scholarship' (2013: 4).

15 See Balmer's observation (2013: 186): 'And in these poems, too, as in many others in the sequence, appropriating these different, classical selves allowed me to communicate the horror of the situation without directly narrating it, providing the "profound place to hide" that Charles Rowan Beye has seen in the field; a slippage of self-construction and self-image, affording a means to be of myself and yet out of the self.'

16 I cite this passage in my discussion of *Chasing Catullus* in Cox (2011: 38–39).

17 In notes e-mailed to the author.

18 Discussed in Cox (2011: 39).

19 See Balmer (2017b) where she discusses this anthology with Fiona Cox and Elena Theodorakopoulos. My reading of the poems from *Letting Go,* discussed in this chapter, expands on the ideas that I first explored in that context.

20 See Holst-Warhaft (1992: 1): 'What is common to laments for the dead in most "traditional" cultures is that they are part of more elaborate rituals for the dead, and that they are usually performed by women.'

21 Balmer had used the story of Creusa in *Chasing Catullus* in a poem 'Creusa' that explores the situation from Creusa's point of view. She explains in the preface to this volume that 'in "Creusa" this dialogue is more explicit, not just between the Trojan

hero Aeneas and his dead wife, but between Vergil's original text and my rewriting of it. My aim here was not only to blur the difference between original and translation but to make it unimportant, until the reader – or even the writer – can't distinguish between the two' (2004: 9–10). See my discussion of this observation and of the poem (Cox 2011: 42–44).

22 In notes e-mailed to the author.

23 See Balmer (2017b), where Elena Theodorakopoulos comments movingly on this point.

24 *Ter conatus ibi collo dare bracchia circum; / ter frustra comprensa manus effugit imago, / par levibus ventis volucrique simillima somno* (*Aen.* 2.792–4). 'Three times I threw my arms around her neck. / Three times her image fled my useless hands, / Like weightless wind and dreams that flit away.'

25 In Balmer (2017b) Theodorakopoulos observes that the repetitions and plurals used by Balmer in this sonnet imply dreaming.

26 It is interesting that A.S. Byatt also uses *Aeneid* 2 as a vehicle to depict *revenants* in the world of the present, and that her 'ghost', a figure who owes much to Creusa and much to Dido, should also appear in a glamorous, beautiful form. 'She was wearing black shiny sandals with very high, slender heels. Her toenails were painted scarlet. Her legs were young and long. She wore a kind of flimsy scarlet silk shift, slit up the thigh, with narrow shoulder straps. [. . .] She had a sharp, lovely face, with red lips in a wide mouth, and long black lashes under lids painted to look bruised" (Byatt 2003: 251–52). For a discussion of the Vergilian world in this short story, see Cox (2011: 135–51).

27 Milton's sonnet offers an obvious example but consider also the classical imagery in Ted Hughes' *Birthday Letters,* in Wilfred Owen's war poetry, in *The Waste Land* or in Heaney's attempts to recover the memory of his father through poetry.

28 Notes sent via e-mail to the author.

29 All translations from Livy are by Foster (1929).

30 In notes e-mailed to the author.

31 In notes e-mailed to the author.

References

Introduction

Bawarshi, A.S. and M.J. Reiff (2010), *Genre: An Introduction to History, Theory, Research, and Pedagogy*, West Lafayette: Parlor Press.

Beebee, T.O. (1994), *The Ideology of Genre: A Comparative Study of Generic Instability*, University Park: Pennsylvania State University Press.

Cheney, P. and P. Hardie, eds. (2015a), *The Oxford History of Classical Reception in English Literature*, vol. 2, Oxford: Oxford University Press.

Cheney, P. and P. Hardie (2015b), 'Introduction' in P. Cheney and P. Hardie (eds.), *The Oxford History of Classical Reception in English Literature*, vol. 2, Oxford: Oxford University Press, 1–26.

Colie, R.L. (1973), *The Resources of Kind: Genre Theory in the Renaissance*, Berkeley, Los Angeles and London: University of California Press.

Conte, G.B. and G.W. Most (2012), 'Genre' in S. Hornblower, A. Spawforth and E. Eidinow (eds.), *The Oxford Classical Dictionary*, 4th edn., Oxford: Oxford University Press, 609–10.

Copeland, R., ed. (2016), *The Oxford History of Classical Reception in English Literature*, vol. 1, Oxford: Oxford University Press.

Depew, M. and D. Obbink, eds. (2000), *Matrices of Genre: Authors, Canons, and Society*, Cambridge MA: Harvard University Press.

Derrida, J. (1980), 'The Law of Genre' *Critical Inquiry* 7(1): 55–81.

Devitt, A.J. (2000), 'Integrating Rhetorical and Literary Theories of Genre' *College English* 62(6): 696–718.

Farrell, J. (2003), 'Classical Genre in Theory and Practice' *New Literary History* 34(3): 383–408.

Ford, A. (2002), *The Origins of Criticism: Literary Culture and Poetic Theory in Classical Greece*, Princeton: Princeton University Press.

Fowler, A. (1979), 'Genre and the Literary Canon' *New Literary History* 11(1): 97–119.

Frow, J. (2006), *Genre*, London: Routledge.

Frye, N. (1957), *Anatomy of Criticism: Four Essays*, Princeton: Princeton University Press.

Gillespie, S. (2011), *English Translation and Classical Reception: Towards a New Literary History*, Chichester and Malden: Wiley-Blackwell.

Halliwell, S., trans. (1995), *Aristotle: Poetics*, Cambridge MA: Harvard University Press.

Hardwick, L. (2003), *Reception Studies*, Oxford: Oxford University Press.

Hardwick, L. and C. Stray, eds. (2008), *A Companion to Classical Receptions*, Chichester and Malden: Wiley-Blackwell.

Hopkins, D. and C. Martindale, eds. (2012), *The Oxford History of Classical Reception in English Literature*, vol. 3, Oxford: Oxford University Press.

Hurst, I. (2010), 'Victorian Literature and the Reception of Greece and Rome' *Literature Compass* 7: 484–95.

Jacobson, M. (2014), *Barbarous Antiquity: Reorienting the Past in the Poetry of Early Modern England*, Philadelphia: The University of Pennsylvania Press.

Jauß, H.R. (1970), 'Literaturgeschichte als Provokation der Literaturwissenschaft' in H.R. Jauß, *Literaturgeschichte als Provokation*, Frankfurt a.M.: Suhrkamp.

Kaiser, G.R. (1974), 'Zur Dynamik literarischer Gattungen' in H. Rüdiger (ed.), *Die Gattungen in der Vergleichenden Literaturwissenschaft*, Berlin and New York: De Gruyter, 32–62.

Martindale, C. (2013), 'Reception – A New Humanism? Receptivity, Pedagogy, the Transhistorical' *Classical Receptions Journal*, 5(2): 169–83.

Martindale, C. and R.F Thomas, eds. (2006), *Classics and the Uses of Reception*, Malden: John Wiley & Sons.

Padelford, F.M., trans. (1905), *Select translations from Scaliger's Poetics*, New York: H. Holt.

Porter, J. (2006), *Classical Pasts: The Classical Traditions of Greece and Rome*, Princeton: Princeton University Press.

Rosmarin, A. (1985), *The Power of Genre*, Minneapolis: University of Minnesota Press.

Vance, N. and J. Wallace, eds. (2015), *The Oxford History of Classical Reception in English Literature*, vol. 4, Oxford: Oxford University Press.

Zymner, R. (2003), *Gattungstheorie: Probleme und Positionen der Literaturwissenschaft*, Paderborn: Mentis.

1 Classical Pieces

Allen, E. (2005), *False Fables and Exemplary Truth: Poetics and Reception of Medieval Mode*, New York: Palgrave.

Allen, J.B. (2013), *The Ethical Poetic of the Later Middle Ages: A Decorum of Convenient Distinction*, Toronto: University of Toronto Press.

Barney, S.A., W.J. Lewis, J.A. Beach and O. Berghof, trans. (2006), *The Etymologies of Isidore of Seville*. Cambridge: Cambridge University Press.

Boffey, J. and J.J. Thomspon (1989), 'Anthologies and Miscellanies' in J. Griffiths and D. Pearsall (eds.), *Book Production and Publishing in Britain 1375–1475*, Cambridge: Cambridge University Press, 279–315.

Camargo, M. (1983), 'Rhetoric' in D.L. Wagner (ed.), *The Seven Liberal Arts in the Middle Ages*, Bloomington: Indiana University Press, 96–124.

Clark, J.G. (2011), 'Introduction' in J.G. Clark, F.T. Coulson and K.L. McKinley (eds.) *Ovid in the Middle Ages*, Cambridge: Cambridge University Press, 1–25.

Copeland, R. (1991), *Rhetoric, Hermeneutics, and Translation in the Middle Ages: Academic Traditions and Vernacular Texts*, Cambridge: Cambridge University Press.

Copeland, R. (2016a), 'Introduction: England and the Classics from the Early Middle Ages to Early Humanism' in R. Copeland (ed.), *The Oxford History of Classical Reception in English Literature*, vol. 1, Oxford: Oxford University Press, 1–19.

Copeland, R. (2016b), 'The Curricular Classics in the Middle Ages' in R. Copeland (ed.), *The Oxford History of Classical Reception in English Literature*, vol. 1, Oxford: Oxford University Press, 21–33.

Copeland, R. (2016c), 'The Trivium in the Classics' in R. Copeland (ed.), *The Oxford History of Classical Reception in English Literature*, vol. 1, Oxford: Oxford University Press, 53–75.

Copeland, R. and Sluiter, I. (2012), *Medieval Grammar and Rhetoric: Language Arts and Literary Theory, AD 300–1475*, Oxford: Oxford University Press.

Coulson, F.T. (1986), 'New Manuscript Evidence for Sources of the *Accessus* of Arnoul d'Orléans to the *Metamorphoses* of Ovid' *Manuscripta*, 30(2): 103–7.

Coulson, F.T. (1987), 'Hitherto Unedited Medieval and Renaissance Lives of Ovid (I)' *Mediaeval Studies*, 49: 152–207.

Coulson, F.T. (2011), 'Ovid's *Metamorphoses* in the School Tradition of France, 1180–1400: Texts, Manuscripts, Manuscript Settings' in J.G. Clark, F.T. Coulson and K.L. McKinley (eds.), *Ovid in the Middle Ages*, Cambridge: Cambridge University Press, 48–82.

Curtius, E.R. (1953), *European Literature and the Latin Middle Ages*, trans. W.R. Trask, New York: Pantheon Books.

Dronke, P. (1979), 'A Note on *Pamphilus*' *Journal of the Warburg and Courtauld Institutes*, 42: 225–30.

Federico, S. (2016), *The Classicist Writings of Thomas Walsingham: 'Worldly Cares' at St Albans Abbey in the Fourteenth Century*, York: York Medieval Press.

Gerber, A.J. (2015), *Medieval Ovid: Frame Narrative and Political Allegory*, New York: Palgrave.

Ghisalberti, F. (1946), 'Medieval Biographies of Ovid' *Journal of the Warburg and Courtauld Institutes*, 9: 10–59.

Hays, G. (2003), 'The Date and Identity of the Mythographer Fulgentius' *The Journal of Medieval Latin*, 13: 163–252.

Hays, G. (2007), 'Further Notes on Fulgentius' *Harvard Studies in Classical Philology*, 103: 483–98.

Highet, G. (1949), *The Classical Tradition: Greek and Roman Influences on Western Literature*, Oxford: Oxford University Press.

Hugyens, R.B.C., ed. (1954), *Accessus ad Auctores*, Berchem-Bruxelles: Latomus.

Irvine, M. (2006), *The Making of Textual Culture: 'Grammatica' and Literary Theory 350–1100*, Cambridge: Cambridge University Press.

Kelly, H.A. (1993), 'Interpretation of Genres and by Genres in the Middle Ages' in
P. Boitani and A. Torti (eds.), *Interpretations: Medieval and Modern: The
J.A.W. Bennett Memorial Lectures*, Cambridge: D. S. Brewer, 107–22.

Kelly, H.A. (1997), *Chaucerian Tragedy*, Cambridge: D.S. Brewer.

Lord, C. (2011), 'A Survey of Imagery in Medieval Manuscripts of Ovid's *Metamorphoses*
and Related Commentaries' in J.G. Clark, F.T. Coulson and K.L. McKinley (eds.),
Ovid in the Middle Ages, Cambridge: Cambridge University Press, 257–83.

Macray, W.D. (1862), *Catalogi Codicum Manuscriptorum Bibliothecæ Bodleianæ*,
Oxford: Bodleian Library.

Marti, B. (1941), 'Literary Criticism in the Mediaeval Commentaries on Lucan'
Transactions and Proceedings of the American Philological Society, 72: 245–54.

McKinley, K.L. (1998), 'Manuscripts of Ovid in England 1100–1500' in P. Beal and
J. Griffiths (eds.), *English Manuscript Studies, 1100–1700*, vol. 7, London: British
Library, 117–49.

Migne, J.P., ed. (1895), *Honorius Augustodunensis's De animæ exsilio et patria*, Turnhout:
Brepols.

Minnis, A.J. (1988), *Medieval Theory of Authorship: Scholastic Literary Attitudes in the
Later Middle Ages*, Philadelphia: University of Pennsylvania Press.

Minnis, A.J. (2009), *Translations of Authority in Medieval English Literature: Valuing the
Vernacular*, Cambridge: Cambridge University Press.

Munari, F., ed. (1977), *Mathei Vindocinensis Opera*, Rome: Edizioni di storia e
letteratura.

Nims, M.F., trans. (2010), *Poetria nova of Geoffrey of Vinsauf*, 2nd rev. edn., Toronto:
Pontifical Institute of Mediaeval Studies.

Orme, N. (2006), *Medieval Schools: From Roman Britain to Renaissance England*, New
Haven: Yale University Press.

Otter, M. (1996), *Inventiones: Fiction and Referentiality in Twelfth-Century English
Historical Writing*, Chapel Hill: University of North Carolina Press.

Porter, J.I., ed. (2005), *Classical Pasts: The Classical Traditions of Greece and Rome*,
Princeton: Princeton University Press.

Purcell, W.M. (1996), *Ars poetriae: Rhetorical and Grammatical Invention at the Margin
of* Literacy, Columbia: University of South Carolina.

Rigg, A.G. (1977), 'Medieval Latin Poetic Anthologies (I)' *Mediaeval Studies*, 39: 281–330.

Sanford, E.M. (1934), 'The Manuscripts of Lucan: *Accessus* and *Marginalia*' *Speculum*,
9(3): 278–95.

Shumilin, M.V. (2014), 'An ancient theory of interaction between fact and fiction in
poetic texts and Zono de' Magnalis' *accessus* to the *Aeneid*' *Enthymema*, 10: 5–25.

Simpson, J. (2002), *The Oxford English Literary History*, vol. 2: *1350–1547: Reform and
Cultural Revolution*, Oxford: Oxford University Press.

Wagner, D.L. (1983), 'The Seven Liberal Arts and Classical Scholarship' in D.L. Wagner
(ed.), *The Seven Liberal Arts in the Middle Ages*, Bloomington: Indiana University
Press, 1–31.

Wheeler, S.M., ed. and trans. (2015), *Accessus ad auctores: Medieval Introductions to the Authors (Codex latinus monacensis 19475)*, Kalamazoo: Medieval Institute Publications.

Whitbread, L.G., trans. (1971), *Fulgentius the Mythographer*, Columbus: Ohio State University Press.

Woods, M.C. (2009), 'Rhetoric, Gender, and the Literary Arts: Classical Speeches in the Schoolroom' *New Medieval Literatures*, 11: 113–32.

Woods, M.C. (2010), *Classroom Commentaries: Teaching the Poetria Nova across Medieval and Renaissance Europe*, Columbus: Ohio State University Press.

Woods, M.C. (2013), 'What are the Real Differences between Medieval and Renaissance Commentaries?' in M. Heyworth, J. Feros Ruys and J.O. Ward (eds.), *The Classics in the Medieval and Renaissance Classroom: The Role of Ancient Texts in the Arts Curriculum as Revealed by Surviving Manuscripts and Early Printed Books*, Turnhout: Brepols, 329–42.

Woods, M.C. (2015), 'Performing Dido' in G. Donavin and D. Stodola (eds.), *Public Declamations: Essays on Medieval Rhetoric, Education, and Letters in Honour of Martin Camargo*, Turnhout: Brepols, 253–65.

Woods, M.C. (2016), 'Experiencing the Classics in Medieval Education' in R. Copeland (ed.), *The Oxford History of Classical Reception in English Literature*, vol. 1, Oxford: Oxford University Press, 35–51.

Woods, M.C. and M. Camargo (2012), 'Writing Instruction in Late Medieval Europe' in J.J. Murphy (ed.), *A Short History of Writing Instruction: From Ancient Greece to Contemporary America*, 3rd edn., New York: Routledge, 114–47.

Zeemen, N. (2016), 'Mythography and Mythographical Collections' in R. Copeland (ed.), *The Oxford History of Classical Reception in English Literature*, vol. 1, Oxford: Oxford University Press, 121–49.

Ziolkowski, J.M. (2001), 'The Highest Form of Compliment: *Imitatio* in Medieval Latin Culture' in J. Marenbon (ed.), *Poetry and Philosophy in the Middle Ages: A Festschrift for Peter Dronke*, Leiden: Brill, 293–307.

Ziolkowski, J.M. (2009a), 'Performing Grammar' *New Medieval Literatures*, 11: 159–76.

Ziolkowski, J.M. (2009b), 'Cultures of Authority in the Long Twelfth Century' *Journal of English and Germanic Philology*, 108(4): 421–48.

Ziolkowski, J.M. and M.C.J. Putnam, eds. (2008), *The Virgilian Tradition: The First Fifteen Hundred Years*, New Haven: Yale University Press.

2 'Poetry is a Speaking Picture'

Allen, S. (2015), '*Ulysses Redux* (1591) and *Nero* (1601): *Tragedia Nova*' in E. Dutton and J. McBain (eds.), *Drama and Pedagogy in Medieval and Early Modern England*, Tübingen: Narr, 131–58.

Altman, J.B. (1978), *The Tudor Play of Mind: Rhetorical Inquiry and the Development of Elizabethan Drama*, Berkeley: University of California Press.

Binns, J.W. (1970), 'William Gager's Meleager and Ulysses Redux' in E.M. Blistein and L. Bradner (eds.), *The Drama of the Renaissance: Essays for Leicester Bradner*, Providence: Brown University Press, 27–41.

Binns, J.W. (1972), 'Alberico Gentili in Defense of Poetry and Acting' *Studies in the Renaissance*, 19: 224–72.

Binns, J.W. (1990), *Intellectual Culture in Elizabethan and Jacobean England: The Latin Writings of the Age*, Leeds: Francis Cairns.

Binns, J.W., H. Dethick, A. Gentili and C. Dalechamp (1999), *Latin Treatises on Poetry from Renaissance England*, Signal Mountain: Summertown.

Boas, F.S. (1914), *University Drama in the Tudor Age*, New York: B. Blom.

Braden, G. (1985), *Renaissance Tragedy and the Senecan Tradition: Anger's Privilege.* New Haven: Yale University Press.

Campbell, L.B. (1931), 'Theories of Revenge in Renaissance England' *Modern Philology*, 28: 281–96.

Coffin, C. (2008), 'Ulysse à la dérive : de déviations en faux-fuyants, un itinéraire élisabéthain' *Revue LISA*, 6(3): 108–22.

Cohen, W. (1992), 'Prerevolutionary Drama' in G. McMullan and J. Hope (eds.), *The Politics of Tragicomedy: Shakespeare and After*, London: Routledge, 122–50.

Craigwood, J. (2010), 'Sidney, Gentili, and the Poetics of Embassy' in R. Adams and R. Cox (eds.), *Diplomacy and Early Modern Culture*, Basingstoke: Palgrave Macmillan, 82–100.

Defaux, G. (1982), *Le Curieux, le glorieux et la sagesse du monde dans la première moitié du XVIe siècle: L'exemple de Panurge (Ulysse, Démosthène, Empédocle)*, Lexington KY: French Forum Publishers.

Dewar-Watson, S. (2007), 'Aristotle and Tragicomedy' in S. Mukherji and R. Lyne (eds.), *Early Modern Tragicomedy*, Cambridge: Cambridge University Press, 15–27.

Edwards, W.F. (1969), 'Jacopo Zabarella: A Renaissance Aristotelian's View of Rhetoric and Poetry and their Relation to Philosophy' in J. Koch (ed.) *Arts libéraux et philosophie au Moyen Äge* (*Actes du quatriéme congrés international de philosophie médiévale, Université de Montréal, Canada, 27 août–2 septembre 1967*), Montréal-Paris, 843–54.

Feingold, M. (1997), 'The Humanities' in Nicholas Tyacke (ed.), *The History of the University of Oxford*, vol. 4, Oxford: Oxford University Press, 211–358.

Hernández-Santano, S. (2016), (ed.), *William Webbe, A Discourse of English Poetry (1586)*, Cambridge: MHRA.

Fowler, A.D.S. ed., (1958), De re poetica *by Richard Wills; translated, and edited from the edition of 1753*, Oxford: Blackwell.

Gentili, Alberico (1585), *De legationibus, libri tres*, London.

Gentili, Alberico (1589), *De ivre belli commentationes tres*, London.

Gillespie, S. (2011), *English Translation and Classical Reception: Towards a New Literary History*, Malden MA: Wiley-Blackwell.

Halliwell, S., ed. and trans. (1995), *Aristotle: Poetics*, Cambridge MA: Harvard University Press.

Halliwell, S. (2002), *The Aesthetics of Mimesis: Ancient Texts and Modern Problems*, Princeton: Princeton University Press.

Hathaway, B. (1962), *The Age of Criticism: The Late Renaissance in Italy*, Ithaca: Cornell University Press.

Henke, R. (2007), 'Transporting Tragicomedy: Shakespeare and the Magical Pastoral of the commedia dell'Arte' in S. Mukherji and R. Lyne (eds.), *Early Modern Tragicomedy*, Cambridge: Cambridge University Press, 43–58.

Hyland, P. (2011), *Disguise on the Early Modern English Stage*, Farnham: Ashgate.

Hutson, L. (2007), *The Invention of Suspicion: Law and Mimesis in Shakespeare and Renaissance Drama*, Oxford: Oxford University Press.

Kerrigan, J. (1996), *Revenge Tragedy: Aeschylus to Armageddon*, Oxford: Oxford University Press.

Kingsbury, B. (1998), 'Confronting Difference: The Puzzling Durability of Gentili's Combination of Pragmatic Pluralism and Normative Judgement' *American Journal of International Law*, 92: 713–23.

Kristeller, P.O. (1985), 'The Active and Contemplative Life in Renaissance Humanism' in B. Vickers (ed.), *Arbeit, Musse, Meditation: Betrachtungen zur 'Vita activa' und 'Vita contemplativa'*, Zurich: Verlag der Fachvereine, 133–52.

Loomba, A. (2001), 'Women's Division of Experience' in Stevie Simkin (ed.), *Revenge Tragedy*, New York: Palgrave, 41–70.

Maguire, N.K., ed. (1987), *Renaissance Tragicomedy: Explorations in Genre and Politics*. New York: AMS Press.

Maslen, R.W., ed. (2002), *An Apology for Poetry, or, The Defence of Poesy*, Manchester: Manchester University Press.

McLuskie, K. (1992), '"A maidenhead, *Amintor*, at my yeraares": Chastity and Tragicomedy in the Fletcher plays' in G. McMullan and J. Hope (eds.), *The Politics of Tragicomedy: Shakespeare and After*, London: Routledge, 92–121.

McMullan, G. and J. Hope, eds. (1992), *The Politics of Tragicomedy: Shakespeare and After*. London: Routledge.

Miola, R.S. (1992), *Shakespeare and Classical Tragedy: The Influence of Seneca*, Oxford: Oxford University Press.

Mukherji S. and R. Lyne, eds. (2007), *Early Modern Tragicomedy*, Cambridge: Cambridge University Press.

Murray, A.T., trans. (1912), *The Odyssey*. Cambridge MA: Harvard University Press.

Norland, H.B. (2009), *Neoclassical tragedy in Elizabethan England*, Newark: University of Delaware Press.

O'Day, R. (1982), *Education and Society 1500–1800: The Social Foundations of Education in Early Modern Britain*. London: Longman.

Piirimäe, P. (2010), 'Alberico Gentili's Doctrine of Defensive War and its Impact on Seventeenth-Century Normative Views' in B. Kingsbury and B. Straussman (eds.),

The Roman Foundations of the Law of Nations: Alberico Gentili and the Justice of Empire, Oxford: Oxford University Press, 187–209.

Rigolot, F. (1999), 'The Rhetoric of Presence: Art, Literature, and Illusion' in Glyn P. Norton (ed.), *The Cambridge History of Literary Criticism*, vol. 3, Cambridge: Cambridge University Press, 161–7.

Ringler W. and W. Allen, eds. and trans., (1940), *John Rainolds Oratio in Laudem Artis Poeticae*, Princeton: Princeton University Press.

Schiesaro, A. (2003), *The Passions in Play: Thyestes and the Dynamics of Senecan Drama*, Cambridge: Cambridge University Press.

Schenk, L. (2008), 'Gown before Crown: Scholarly Abjection and Academic Entertainment under Queen Elizabeth I' in J. Walker and P.D. Streufert (eds.), *Early Modern Academic Drama: Studies in Performance and Early Modern Drama*, Farnham: Ashgate, 19–44.

Smith, G.G. (1950), *Elizabethan Critical Essays*, 2 vols., Oxford: Oxford University Press.

Stanford, W. B. and J.V. Luce (1974), *The Quest for Ulysses*, London: Phaidon.

Sutton, D.F., ed. (1994a), *William Gager: The Complete Works*, vol. 2, *The Shrovetide Plays*; (1994b) vol. 4; *Juvenalia, Pyramis, Collected Prose*, New York and London: Garland Publishing.

Vickers, B. (1988), 'Philosophy and Humanistic Disciplines: Rhetoric and Poetics', in C. Schmitt, Q. Skinner, E. Kessler and J. Kraye, (eds.), *The Cambridge History of Renaissance Philosophy*, Cambridge: Cambridge University Press, 713–45.

Warren, C.N. (2011), 'Gentili, the Poets, and the Laws of War' in B. Kingsbury and B. Straumann (eds.), *The Roman Foundations of the Law of Nations: Alberico Gentili and the Justice of Empire*, Oxford: Oxford University Press, 146–62.

Whigham, F. and Rebhorn, Wayne A. (2007), (eds.), *The Art of English Poesy. George Puttenham*. Ithaca: Cornell University Press.

Woodbridge, l. (2010), *English Revenge Drama: Money, Resistance, Equality*. Cambridge: Cambridge University Press.

Zwierlein, O. (1992), *Zur Kritik und Exegese des Plautus*, vol. 4: *Bacchides*, Stuttgart: Franz Steiner.

3 A Revolutionary Vergil: James Harrington, Poetry, and Political Performance

Burrow, C. (1997), 'Virgil in English Translation' in C. Martindale (ed.), *The Cambridge Companion to Virgil*, 21–37, Cambridge: Cambridge University Press.

Caldwell, T. (2008), *Virgil Made English: The Decline of Classical Authority*, New York: Palgrave.

Carminati, M.N., J. Stabler, A.M. Roberts, and M.H. Fischer (2006), 'Readers' responses to sub-genre and rhyme scheme in poetry' *Poetics*, 34: 204–18.

Clark, A., ed. (1898), *John Aubrey, Brief Lives,* vol. 1, Oxford: Clarendon.

Connolly, J. (2005), 'Border Wars: Literature, Politics, and the Public' *Transactions of the American Philological Association*, 135: 103–34.

Cotton, J. (1991), *James Harrington's Political Thought and its Context*, New York: Garland.

Davis J.C. (2013), '*de te fabula narratur*: The Narrative Constitutionalism of James Harrington's *Oceana*,' in S. Taylor and G. Tapsell (eds.), *The Nature of the English Revolution Revisited: Essays in Honour of John Morrill*, Woodbridge: Boydell Press, 151–74.

Fairclough, H.R., trans. and G.P. Goold, ed. (1999), *Eclogues. Georgics. Aeneid: Books 1–6*, Cambridge MA: Harvard University Press.

Gibson, B. (2011), 'Latin Manuscripts and Textual Traditions,' in J. Clackson (ed.), *A Companion to the Latin Language*, Malden: Wiley-Blackwell, 40–58.

Gillespie, S. (1992), 'A Checklist of Restoration English Translations and Adaptations of Classical Greek and Latin Poetry, 1660–1700' *Translation and Literature*, 1: 52–67.

Greenleaf, W.H. (1964), *Order, Empiricism and Politics: Two Traditions of English Political Thought, 1500–1700*, Oxford: Oxford University Press.

Hammersley, R. (2013), 'Rethinking the Political Thought of James Harrington: Royalism, Republicanism and Democracy' *History of European Ideas*, 39(3): 354–70.

Harrington, J. (1658), *An Essay Upon Two of Virgil's Eclogues, and Two Books of His Aeneis*. London.

Harrington, J. (1659), *Virgil's Aeneis: The Third, Fourth, Fifth, and Sixth Books*. London.

Kirby Smith, H.T. (1998), *The Origins of Free Verse*, Ann Arbor: University of Michigan Press.

Lombardo, S., trans. (2005), *Virgil, Aeneid*, Indianapolis: Hackett.

Nelson, E. (2004), *The Greek Tradition in Republican Thought*, Cambridge: Cambridge University Press.

Norbrook, D. (1999), *Writing the English Republic: Poetry, rhetoric and politics, 1627–1660*, Cambridge: Cambridge University Press.

Pocock, J.G.A. (1957), *The Ancient Constitution and the Feudal Law: A study of English historical thought in the seventeenth century*, Cambridge: Cambridge University Press.

Pocock, J.G.A. (1975), *The Machiavellian Moment: Florentine political thought and the Atlantic Republican Tradition*, Princeton: Princeton University Press.

Pocock, J.G.A. (1977), *The Political Works of James Harrington*, Cambridge: Cambridge University Press.

Power, H. (2010), 'The *Aeneid* in the Age of Milton,' in J. Farrell and M.C.J. Putnam (eds.), *A Companion to Vergil's Aeneid and its Tradition*, 186–202, Malden: Wiley-Blackwell.

Proudfoot, L. (1960), *Dryden's 'Aeneid' and Its Seventeenth Century Predecessors*, Manchester: Manchester University Press.

Schäffner, C., ed. (1999), *Translation and Norms*, Clevedon: Multilingual Matters.

Seider, A. (2013), *Memory in Vergil's Aeneid*, Cambridge: Cambridge University Press.

Simpson, J. (2016), 'The Aeneid Translations of Henry Howard, Earl of Surrey,' in Rita
Copeland (ed.), *The Oxford History of Classical Reception in English Literature*, vol. 1,
601–19, Oxford: Oxford University Press.

Thomas, R. (2001), *Virgil and the Augustan Reception*, Cambridge: Cambridge
University Press.

Waller, E. and S. Godolphin (1658), *The Passion of Dido for Aeneas. As it is Incomparably
exprest in the Fourth Book of Virgil*, London: Peter Parker.

4 The Devouring Maw

Bedford, R. (1998), 'Milton, Dryden and Marvell: An Exchange of Views on Rhyming'
Journal of the Australasian Universities Modern Language Association, 89: 1–14.

Benet, D.T. (2016), 'The Genius of Every Age: Milton and Dryden' *Milton Studies*,
57: 263–91.

Bloom, H. (1975), *A Map of Misreading*, Oxford and New York: Oxford University Press.

Braund, S. (2011), 'Translation as a Battlefield: Dryden, Pope and the frogs and mice'
International Journal of the Classical Tradition, 18(4): 547–68.

Burrow, C. (1999), 'Combative criticism: Jonson, Milton, and classical literary criticism
in England' in G. Norton (ed.), *The Cambridge History of Literary Criticism*, vol. 3,
Cambridge: Cambridge University Press, 487–99.

Churchill, G.B. (1906), 'The Relation of Dryden's "State of Innocence" to Milton's
"Paradise Lost" and Wycherley's "Plain Dealer": An Inquiry into Dates' *Modern
Philology*, 4(2): 381–8.

Coleridge, S.T. (1817), *Biographia Literaria; or Biographical Sketches of My Literary Life
and Opinions*, vol. 2, London: Rest Fenner.

Corns, T.N. (1991), 'Cultural and Genre Markers in Milton's *Paradise Lost*' *Revue belge
de philologie et d'histoire*, 69(3): 555–62.

Cronk, N. (1999), 'Aristotle, Horace, and Longinus: the conception of reader response' in
G. Norton (ed.), *The Cambridge History of Literary Criticism*, vol. 3, Cambridge:
Cambridge University Press, 199–204.

Darbishire, H. (1932), *The Early Lives of Milton*, London: Constable and Company.

Davis, P. (2012), 'Latin Epic: Virgil, Lucan, and Others' in D. Hopkins and C. Martindale
(eds.), *The Oxford History of Classical Reception in English Literature*, vol. 3, Oxford:
Oxford University Press, 133–63.

Dodds, L. (2009), '"To change in scenes and show it in a play": *Paradise Lost* and the
Stage Directions of Dryden's *The State of Innocence and Fall of Man*', *Restoration:
Studies in English Literary Culture, 1660–1700*, 33(2): 1–24.

Dryden, J. ([1667], 1691), *Of Dramatick Poesie, an Essay in The Works*, London: Tonson.

Dryden, J. ([1677], 1678), *The State of Innocence, and Fall of Man: An Opera*, London:
Herringman.

Dryden, J. (1685), *Sylvae: or the Second Part of Poetical Miscellanies*, London: Tonson.

Dryden, J. (1693), *The Satires of Juvenal and Persius*, London: Tonson.

Dryden, J. (1697), *The Works of Virgil: Containing his Pastorals, Georgics, and Aeneis*, London: Tonson.

Forsyth, N. (2014), 'Satan' in L. Schwartz (ed.), *The Cambridge Companion to Paradise Lost*, Cambridge: Cambridge University Press, 17–28.

Hale, J. (2001), 'The Classical Literary Tradition' in T.N. Corns (ed.), *A Companion to Milton*, Oxford: Blackwell, 22–36.

Ide, R. and Wittreich, J., eds. (1983), *Composite Orders: The Genres of Milton's Last Poems*, Pittsburgh: University of Pittsburgh Press.

Ide, R. (1983), 'On the Uses of Elizabethan Drama: The Revaluation of Epic in *Paradise Lost*' in R. Ide and J. Wittreich (eds.), *Composite Orders: The Genres of Milton's Last Poems*, Pittsburgh: University of Pittsburgh Press, 121–40.

Javitch, D. (1999a), 'The assimilation of Aristotle's *Poetics* in Sixteenth-century Italy' in G. Norton (ed.), *The Cambridge History of Literary Criticism*, vol. 3, Cambridge: Cambridge University Press, 53–65.

Javitch, D. (1999b), 'Italian Epic Theory' in G. Norton (ed.), *The Cambridge History of Literary Criticism*, vol. 3, Cambridge: Cambridge University Press, 205–15.

Kilgour, M. (2005), '"Thy Perfect Image Viewing": Poetic creation and Ovid's Narcissus in *Paradise Lost*' *Studies in Philology*, 102(3): 307–39.

Kilgour, M. (2012), *Milton and the Metamorphosis of Ovid*, Oxford: Oxford University Press.

Kilgour, M. (2014), 'Classical Models' in L. Schwartz (ed.), *The Cambridge Companion to Paradise Lost*, Cambridge: Cambridge University Press, 57–67.

Lewalski, B.K. (1983), 'The Genres of *Paradise Lost*: Literary Genre as a Means of Accommodation' in R. Ide and J. Wittreich (eds.), *Composite Orders: The Genres of Milton's Last Poems*, Pittsburgh: University of Pittsburgh Press, 75–103.

Lewalski, B.K. (1985), *Paradise Lost and the Rhetoric of Literary Forms*, Princeton: Princeton University Press.

Lewalski, B.K. (1989), 'The Genres of *Paradise Lost*' in D. Danielson (ed.), *The Cambridge Companion to Milton*, Cambridge: Cambridge University Press, 113–29.

Lewalski, B.K. (2001), 'Genre' in T.N. Corns (ed.), *A Companion to Milton*, Oxford: Blackwell, 3–21.

Lewalski, B.K. (2009), '*Paradise Lost* and the Contest over the Modern Heroic Poem' *Milton Quarterly*, 43(3): 153–65.

Lobis, S. (2014), 'Milton's Tended Garden and the Georgic Fall' *Milton Studies*, 55: 89–111.

Martindale, C. (1986), *John Milton and the Transformation of Ancient Epic*, London: Croom Helm.

Martindale, C. (2012), 'Milton's Classicism' in D. Hopkins and C. Martindale (eds.), *The Oxford History of Classical Reception in English Literature*, vol. 3, Oxford: Oxford University Press, 53–90.

Mason, T. (2012), 'Dryden's Classicism' in D. Hopkins and C. Martindale (eds.), *The Oxford History of Classical Reception in English Literature*, vol. 3, Oxford: Oxford University Press, 91–131.

Milton, J. (1642), *The Reason of Church-governement Urg'd against Prelaty*, London: Rothwell.

Milton, J. (1667), *Paradise Lost. A Poem Written in Ten Books*, London: Parker.

Milton, J. (1668), *Paradise Lost. A Poem Written in Ten Books*, London: Simmons.

Milton, J. (1671), *Paradise Regain'd. A Poem in* IV *Books. Samson Agonistes, A Dramatic Poem*, London: Starkey.

Milton, J. (1674), *Paradise Lost. A Poem in Twelve Books*, 3rd edn., Revised and Augmented London: Simmons.

Milton, J. (1688), *Paradise Lost. A Poem in Twelve Books*, 4th edn., London: Tonson.

Patterson, A. (1983), '*Paradise Regained*: A Last Chance at True Romance' in R. Ide and J. Wittreich (eds.), *Composite Orders: The Genres of Milton's Last Poems*, Pittsburgh: University of Pittsburgh Press, 187–208.

Quint, D. (1993), *Epic and Empire*, Princeton: Princeton University Press.

Rajan, B. (1983), '*Paradise Lost*: The Uncertain Epic' in R. Ide and J. Wittreich (eds.), *Composite Orders: The Genres of Milton's Last Poems*, 105–19, Pittsburgh: University of Pittsburgh Press, 105–19.

Scodel, J. (1999), 'Seventeenth-century English Literary criticism: classical values, English texts and contexts' in G. Norton (ed.), *The Cambridge History of Literary Criticism*, vol. 3, Cambridge: Cambridge University Press, 543–54.

Shawcross, J. (1983), 'The Genres of *Paradise Regain'd* and *Samson Agonistes*: The Wisdom of their Joint Publication' in R. Ide and J. Wittreich (eds.), *Composite Orders: The Genres of Milton's Last Poems*, Pittsburgh: Pittsburgh University Press, 225–48.

Sidney, P. (1595), *The Defence of Poesie*, London: Ponsonby.

Spenser, E. ([1596], 1993), *The Faerie Queene*, edited by H. Maclean and A. Prescott, New York: W.W. Norton & Company.

Stevenson, K.G. (2001), 'Reading Milton, 1674–1800' in T.N. Corns (ed.), *A Companion to Milton*, Oxford: Blackwell, 447–62.

St. Louis, L. (2006), 'Laying the Foundation for a New Work on the Pseudo-Virgilian Culex' *CLCWeb: Comparative Literature and Culture* 8(1). Available at: https://doi.org/10.7771/1481-4374.1294 (accessed 31 December 2017).

Weller, B. (1999), 'The Epic as Pastoral: Milton, Marvell, and the Plurality of Genre' *New Literary History*, 30(1): 143–56.

5 Georgic as Genre

Addison, J. ([1697] 1987), 'An Essay on the Georgics' in W. Frost and V.A. Dearing (eds.), *The Works of John Dryden*, vol. 5. *Poems: The Works of Virgil in English, 1697*, Berkeley: University of California Press, 145–53.

Allen, D.E. (2004), 'Martyn, John (1699–1768)' *Oxford Dictionary of National Biography*. Available online: http://www.oxforddnb.com/view/article/18235 (accessed 27 Feb 2017).

Barrell, J. (1983), *English Literature in History 1730–1780: An Equal, Wide Survey*, London: Hutchinson.

Barrell, J. (1999), 'Afterword: Moving stories, still lives' in G. MacLean, D. Landry and J.P. Ward (eds.), *The Country and the City Revisited*, Cambridge: Cambridge University Press, 160–79.

Barrell, J. and H. Guest (1987), 'On the Use of Contradiction: Economics and Morality in the Eighteenth-Century Long Poem' in F. Nussbaum and L. Brown (eds.), *The New Eighteenth Century: Theory, Politics, English Literature*, New York and London: Methuen, 121–43.

Benson, W. (1724), *Virgil's Husbandry, or an Essay on the Georgics: Being the Second Book Translated into English Verse. To which are added the Latin text, and Mr. Dryden's version. With notes critical, and rustick*, London: sold by W. and J. Innys.

Benson, W. (1725), *Virgil's Husbandry, or an Essay on the Georgics: Being the First Book. Translated into English Verse. To which are added, the Latin text, and Mr. Dryden's version. With notes critical and rustick*. London: privately printed (sold by W. and J. Innys and John Pemberton).

Bucknell, C. (2013), 'The Mid-Eighteenth-Century Georgic and Agricultural Improvement' *Journal for Eighteenth-Century Studies*, 36: 335–52.

Budd, A. (2011), *John Armstrong's The Art of Preserving Health: Eighteenth-Century Sensibility in Practice*, London: Ashgate.

Caldwell, T.M. (2008), *Virgil Made English: The Decline of Classical Authority*, New York: Palgrave Macmillan.

Chalker, J. (1969), *The English Georgic: A study in the development of a form*, London: Routledge and Kegan Paul.

Congleton, J.E. (1952), *Theories of Pastoral Poetry in England 1648–1798*, Gainesville: University of Florida Press.

Crawford, R. (2002), *Poetry, Enclosure, and the Vernacular Landscape, 1700–1830*, Cambridge: Cambridge University Press.

Davis, P. (1999), '"Dogmatical" Dryden: Translating the *Georgics* in the Age of Politeness' *Translation and Literature*, 8: 28–53.

De Bruyn, F. (1997), 'From Virgilian Georgic to Agricultural Science: An Instance in the Transvaluation of Literature in Eighteenth-Century Britain' in A.J. Rivero (ed.), *Augustan Subjects: Essays in Honor of Martin C. Battestin*, London: Associated University Presses, 47–67.

De Bruyn, F. (2004), 'Reading Virgil's *Georgics* as a Scientific Text: The Eighteenth-Century Debate Between Jethro Tull and Stephen Switzer' *English Literary History*, 71: 661–89.

De Bruyn, F. (2005), 'Eighteenth-Century Editions of Virgil's *Georgics*': From Classical Poem to Agricultural Treatise' *Lumen*, 24: 149–63.

Durling, D.L. (1935), *Georgic Tradition in English Poetry*, New York: Columbia University Press.

Fairer, D. (2003a), *English Poetry of the Eighteenth Century 1700–1789*, London: Longman.

Fairer, D. (2003b), 'A Caribbean Georgic: James Grainger's *The Sugar-Cane*' *Kunapipi*, 25: 21–8.

Fairer, D. (2016), 'Georgic' in J. Lynch (ed.), *The Oxford Handbook of British Poetry, 1660–1800*, Oxford: Oxford University Press, 457–72.

Feingold, R. (1978), *Nature and Society: Later Eighteenth-Century Uses of the Pastoral and Georgic*, Hassocks: Harvester Press.

Fowler, A. (1986), 'The Beginnings of English Georgic' in B.K. Lewalski (ed.), *Renaissance Genres: Essays on Theory, History, and Interpretation*, Cambridge MA and London: Harvard University Press, 105–25.

Fowler, A. (1992), 'Georgic and Pastoral: Laws of Genre in the Seventeenth Century' in M. Leslie and T. Raylor (eds.), *Culture and Cultivation in Early Modern England*, Leicester: Leicester University Press, 81–8.

Genovese, M. (2013), 'An Organic Commerce: Sociable Selfhood in Eighteenth-Century Georgic' *Eighteenth-Century Studies*, 46: 197–221.

Gilmore, J. (2000), *The Poetics of Empire: A Study of James Grainger's The Sugar-Cane (1764)*, London: Athlone.

Goldstein, L. (1977), *Ruins and Empire: The Evolution of a Theme in Augustan and Romantic Literature*, Pittsburgh: Pittsburgh University Press.

Goodman, K. (2004), *Georgic Modernity and British Romanticism: Poetry and the Mediation of History*, Cambridge: Cambridge University Press.

Goodridge, J. (1995), *Rural Life in Eighteenth-Century English Poetry*, Cambridge: Cambridge University Press.

Graver, B. (1996), 'Duncan Wu's *Wordsworth's Reading: 1770–1790*: A Supplementary List with Corrections' *Romanticism on the Net* 1, entries 28, 29.

Griffin, D. (1986), *Regaining Paradise: Milton and the Eighteenth Century*, Cambridge: Cambridge University Press.

Griffin, D. (1990), 'Redefining Georgic: Cowper's *Task*' *English Literary History*, 57: 865–79.

Griffin, D. (2002), *Patriotism and Poetry in Eighteenth-Century Britain*, Cambridge: Cambridge University Press, 180–204.

Holdsworth, E. (1749), *A Dissertation upon Eight Verses in Virgil's Georgics*, London: for William Russel.

Irlam, S. (2001), '"Wish You Were Here": Exporting England in James Grainger's *The Sugar-Cane*' *English Literary History*, 68: 377–96.

Kallendorf, C. (2015), *The Protean Virgil: Material Form and the Reception of the Classics*, Oxford: Oxford University Press.

Laird, A. (2002), 'Juan Luis De La Cerda, Virgil, and the Predicament of Commentary' in C.S. Kraus and R. Gibson (eds.), *The Classical Commentary*, Leiden: Brill, 171–203.

Lively, Penelope (2004), *The House at Norham Gardens*, London: Jane Nissen.

Low, A. (1985), *The Georgic Revolution*, Princeton: Princeton University Press.

Milbourne, L. (1698), *Notes on Dryden's Virgil in a letter to a friend: with an essay on the same poet*, London: for R. Clavill.

O'Brien, K. (1999), 'Imperial Georgic, 1660–1789' in G. MacLean, D. Landry and J.P. Ward (eds.), *The Country and the City Revisited*, Cambridge: Cambridge University Press, 160–79.

Pellicer, J.C. (2003), 'The Georgic at Mid-Eighteenth Century and the Case of Robert Dodsley's "Agriculture"' *Review of English Studies*, 54: 67–93.

Pellicer, J.C. (2006), 'The Georgic' in C. Gerrard (ed.), *A Companion to Eighteenth-Century Poetry*, Oxford: Wiley-Blackwell, 403–16,.

Pellicer, J.C. (2008), 'Corkscrew or Cathedral? The Politics of Alexander Pope's *Windsor-Forest* and the Dynamics of Literary Kind' *Huntington Library Quarterly*, 71: 453–88.

Pellicer, J.C. (2012), 'Pastoral and Georgic' in C. Martindale and D. Hopkins (eds.), *The Oxford History of Classical Reception in English Literature*, vol. 3, Oxford: Oxford University Press, 287–321.

Pellicer, J.C. (2015), 'Georgic' in G. Day and J. Lynch (eds.), *Encyclopedia of Eighteenth-Century Literature*, Chichester: Wiley, 2. 527–30.

Priestman, M. (2012), 'Didactic and Scientific Poetry' in C. Martindale and D. Hopkins (eds.), *The Oxford History of Classical Reception in English Literature*, vol. 3, Oxford: Oxford University Press, 401–25.

Proust, M. (1983), *Remembrance of Things Past*, trans. C.K. Scott Moncrieff and T. Kilmartin, Harmondsworth: Penguin.

Rogers, P. (2005), 'John Philips, Pope, and Political Georgic' *Modern Language Quarterly*, 66: 411–42.

Spurr, M.S. (2008), 'Agriculture and the *Georgics*' in K. Volk (ed.), *Oxford Readings in Classical Studies: Vergil's Georgics*, New York: Oxford University Press, 14–42.

Thackeray, M. (1992), 'Christopher Pitt, Joseph Warton, and Virgil' *Review of English Studies*, 43: 329–46.

Thomas, R.F. (2001), *Virgil and the Augustan Reception*, Cambridge: Cambridge University Press.

Wilkinson, L.P. (1997), *The Georgics of Virgil: A Critical Survey*, 2nd edn., Bristol: Bristol Classical Paperbacks.

Wu, D. (1990), 'Three Translations of Virgil Read by Wordsworth in 1788' *Notes and Queries*, 37: 409–11.

6 Rhyme and Reason

Alexander, C. (2015), *The Iliad: Homer*, London: Vintage Classics.

Bertolini, F. (1987), 'Ancora su Wolf e i prolegomena a Omero' *Athenaeum*, 65: 211–26.

Boos, F. (1984), 'Victorian response to *Earthly Paradise* tales' *Journal of the William Morris Society*, 5(4): 16–29.

Buckley, T.A. (1884), *The Iliad of Homer, translated by Alexander Pope*, Chicago and New York: Belford, Clarke & Co.

Canevaro, L.G. (2014), 'Genre and authority in Hesiod's *Works and Days*' in C. Werner, B.B. Sebastiani and A. Dourado-Lopes (eds.) *Gêneros poéticos na Grécia antiga: confluências e fronteiras*, São Paulo: Editora Humanitas, 23–48

Carminati, M.N., J. Stabler, A.M. Roberts and M.H. Fischer (2006), 'Readers' responses to sub-genre and rhyme scheme in poetry' *Poetics*, 34: 204–18.

Chambers, A.B., W. Frost and V.A. Dearing, eds. (1974), *The Works of John Dryden*, vol. 4: *Poems 1693-1696*, Berkeley and Los Angeles: University of California Press.

Connelly, P.J. (1988), 'The Ideology of Pope's *Iliad*' *Comparative Literature*, 40(4): 358–83.

Dalzell, A. (1996), *The Criticism of Didactic Poetry: Essays on Lucretius, Virgil, and Ovid*, Toronto: University of Toronto Press.

Di Donato, R. (1986), 'Storia della tradizione come storia della cultura. Filologia e storia nei Prolegomena di F. A. Wolf' *Annali della Scuola Normale Superiore di Pisa: Classe di Lettere e Filosofia*, III.16(1): 127–39.

Edwards, M.W. (1986), 'Homer and Oral Tradition: The Formula, Part I' *Oral Tradition*, 1(2): 171–230.

Edwards, M.W. (1988), 'Homer and Oral Tradition: The Formula, Part II' *Oral Tradition*, 3(1–2): 11–60.

Edwards, M.W. (1992), 'Homer and Oral Tradition: The Type-scene' *Oral Tradition*, 7(2): 284–330.

Fagles, R., trans. (1990), *The Iliad*, New York: Penguin Books.

Fagles, R., trans. (1996), *The Odyssey*, New York: Penguin Books.

Furniss, T. and M. Bath (1996), *Reading Poetry: An Introduction*, Harlow: Pearson Education Limited.

Fowler, A. (1979), 'Genre and the Literary Canon' *New Literary History*, 11: 97–119.

Fowler, A. (1982), *Kinds of Literature: An Introduction to the Theory of Genres and Modes*, Cambridge MA: Harvard University Press.

Fowler, A. (2003), 'The Formation of Genres in the Renaissance and After' *New Literary History*, 34(2): 185–200.

Fowler, R. (2004), 'The Homeric Question' in R. Fowler (ed.) *The Cambridge Companion to Homer*, Cambridge: Cambridge University Press, 220–32.

Frye, N., (1982), 'The Meeting of Past and Future in William Morris' *Studies in Romanticism*, 21(3): 303–18.

Grafton, A. (1981), 'Prolegomena to Friedrich August Wolf' *Journal of the Warburg and Courtauld Institutes*, 44: 101–29.

Grafton, A., ed. (1985), *Friedrich August Wolf: Prolegomena to Homer, 1795*, Princeton: Princeton University Press.

Hanauer, D. (1996), 'Integration of Phonetic and Graphic Features in Poetic Text Categorization Judgements' *Poetics*, 23: 363–80.

Higbie, C. (1990), *Measure and Music: Enjambment and Sentence Structure in the* Iliad, Oxford: Oxford University Press.

Hunter, J.P. (1996), 'Form as Meaning: Pope and the Ideology of the Couplet' *The Eighteenth Century*, 37(3): 257–70.

Kelvin, N., ed. (1984), *The Collected Letters of William Morris*, vol. 1, Princeton: Princeton University Press.

Kelvin, N., ed. (1987), *The Collected Letters of William Morris*, vol. 2.B, Princeton: Princeton University Press.

Kinsley, J., ed. (1958), *The Poems of John Dryden*, vol. 4, Oxford: Oxford University Press.

Lattimore, R., trans. ([1951] 2011), *The Iliad of Homer: With a New Introduction and Notes by Richard Martin*, Chicago: The University of Chicago Press.

Lefkowitz, M.R. (2012), *The Lives of the Greek Poets*, 2nd rev. edn., Baltimore: John Hopkins University Press.

Lord, A. (1960), *The Singer of Tales*, Cambridge MA: Harvard University Press.

Lynch, K.L. (1982), 'Homer's *Iliad* and Pope's Vile Forgery' *Comparative Literature*, 34(1): 1–15.

MacCarthy, F. (1994), *William Morris: A Life for our Time*, London: Faber and Faber.

Magnússon, E. (1905), *The Stories of the Kings of Norway (Heimskringla)* translated by William Morris and Eiríkr Magnússon, vol. 4, London: Quaritch 1905), xiii.

Mitchell, S. (2011), *The Iliad: Homer*, New York: Free Press.

Morris, M. (1912), *The Collected Works of William Morris*, vol. 13: *The Odyssey of Homer*, London: Longmans, Green and Company.

Murray, L. ed. (1989), *Oscar Wilde, The Major Works*, Oxford: Oxford University Press.

Parry, A., ed. (1987), *The Making of Homeric Verse: The Collected Papers of Milman Parry*, Oxford: Oxford University Press.

Salmon, N., ed. (1994), *William Morris: Political Writings: Contributions to* Justice *and* Commonweal *1883–1890*, Bristol: Thoemmes Continuum.

Schrott, R., trans. and P. Mauritsch, comm. (2008), *Homer*: Ilias, Munich: Hanser.

Shankman, S., ed. (1996), *The Iliad of Homer: Translated by Alexander Pope*, London: Penguin Books.

Sider, D. (2014), 'Didactic poetry: the Hellenistic invention of a pre-existing genre' in R. Hunter, A. Rengakos and E. Sistakou (eds.) *Hellenistic Studies at a Crossroads: Exploring Texts, Contexts and Metatexts*, Berlin and Boston: De Gruyter, 13–30.

Turner, F. (1997), 'The Homeric Question' in I. Morris and B. Powell (eds.) *A New Companion to Homer*, Leiden: Brill, 123–45.

Vaninskaya, A. (2010), *William Morris and the Idea of Community: Romance, History and Propaganda, 1880–1914*, Edinburgh: Edinburgh University Press.

West, A.S. ([1896] 2014), *Essay on Criticism, Alexander Pope*, Cambridge: Cambridge University Press.

West, M.L., ed. (1998), *Homerus* Ilias *Volumen I: Rhapsodiae I–XII*, Munich: K.G. Saur.

West, M.L., ed. (2000), *Homerus* Ilias *Volumen Alterum: Rhapsodiae XIII–XXIV*, Munich: K.G. Saur.

van Thiel, H., ed. (1991), *Homeri Odyssea*, Hildesheim: Georg Olms.

Whitla, W. (2004), 'William Morris' Translation of Homer's *Iliad* 1.1–214' *The Journal of Pre-Raphaelite Studies*, 13: 75–121.

Wohlleben, J. (1967), 'Goethe and the Homeric Question' *Germanic Review*, 42(4): 251–75.

7 From Epic to Monologue

Armstrong, I. (1972), *Victorian Scrutinies: Reviews of Poetry, 1830–1870*, London: Athlone Press.

Armstrong, I. (1993), *Victorian Poetry: Poetry, Poetics and Politics*, London: Routledge.

Arnold, M. (1960), *On the Classical Tradition*, ed. R.H. Super, Ann Arbor: University of Michigan Press.

Austin, A. (1870), *The Poetry of the Period*, London: Richard Bentley.

Baumbach, M. and S. Bär (2010), 'Quintus von Smyrna' in C. Walde (ed.), *Der Neue Pauly.* Suppl. vol. 7: *Die Rezeption der antiken Literatur: Kulturhistorisches Werklexikon*, Stuttgart: Metzler, 783–90.

Bridges, M. (2008), 'The Eros of Homeros: The Pleasures of Greek Epic in Victorian Literature and Archaeology' *Victorian Review*, 34: 165–83.

Byron, G. (2003), 'Rethinking the Dramatic Monologue: Victorian Women Poets and Social Critique' in A. Chapman (ed.), *Victorian Women Poets*, Cambridge: D.S. Brewer, 79–98.

Campbell, M. (1999), *Rhythm and Will in Victorian Poetry*, Cambridge: Cambridge University Press.

Christ, C.T. (1987), 'The Feminine Subject in Victorian Poetry' *English Literary History*, 54: 385–401.

Collins, J.C. (1891), *Illustrations of Tennyson*, London: Chatto & Windus.

Culler, A.D. (1975), 'Monodrama and the Dramatic Monologue' *Proceedings of the Modern Language Association*, 90: 366–85.

Decker, C. (2009), 'Tennyson's Limitations' in R. Douglas-Fairhurst and S. Perry (eds.), *Tennyson among the Poets: Bicentenary Essays*, Oxford: Oxford University Press, 57–75.

Downes, J.M. (1997), *Recursive Desire: Rereading Epic Tradition*, London: University of Alabama Press.

Elfenbein, A. (1995), *Byron and the Victorians*, Cambridge: Cambridge University Press.

Faas, E. (1988), *Retreat into the Mind: Victorian Poetry and the Rise of Psychiatry*, Princeton: Princeton University Press.

Fulkerson, L. (2005), *The Ovidian Heroine as Author: Reading, Writing, and Community in the 'Heroides'*, Cambridge: Cambridge University Press.

Gladstone, W.E. (1857), 'Homeric Characters in and Out of Homer' *Quarterly Review*, 102: 204–51.

Gladstone, W. E. (1858), *Studies on Homer and the Homeric Age*, Oxford: Oxford University Press.

Griffin, J. (2004), 'The Speeches' in R.L. Fowler (ed.), *The Cambridge Companion to Homer*, Cambridge: Cambridge University Press, 156–68.

Hainsworth, J.B. (1991), *The Idea of Epic*, Berkeley: University of California Press.

Harrison, S. (2002), 'Ovid and Genre: The Evolutions of an Elegist' in P. Hardie (ed.), *The Cambridge Companion to Ovid*, Cambridge: Cambridge University Press, 79–94.

Harrison, S. (2007), 'Some Victorian Versions of Greco-Roman Epic' in C. Stray (ed.), *Remaking the Classics: Literature, Genre and Media in Britain 1800–2000*, London: Duckworth, 21–36.

Hughes, L.K. (1979), 'From 'Tithon' to 'Tithonus': Tennyson as Mourner and Monologist' *Philological Quarterly*, 58: 82–9.

Hughes, L.K. (1987), *The Manyfacèd Glass: Tennyson's Dramatic Monologues*, Athens, OH: Ohio University Press.

Hughes, L.K. (2010), *The Cambridge Introduction to Victorian Poetry*, Cambridge: Cambridge University Press.

Jebb, R.C. (1873), *Translations into Greek and Latin Verse*, Cambridge: Bell and Daldy.

Jebb, R.C. (1887), *Homer: An Introduction to the Iliad and Odyssey*, 2nd edn., Glasgow: J. Maclehose and Sons.

Joseph, G. (1982), 'The Homeric Competitions of Tennyson and Gladstone' *Browning Institute Studies*, 10: 105–15.

Kennedy, D.F. (1984), 'The Epistolary Mode and the First of Ovid's *Heroides*' *Classical Quarterly*, 34: 413–22.

Lang, A. (1901), *Alfred Tennyson*, Edinburgh: Blackwood.

Langbaum, R. (1957), *The Poetry of Experience: The Dramatic Monologue in Modern Literary Tradition*, London: Chatto & Windus.

Lipking, L. (1988), *Abandoned Women and Poetic Tradition*, Chicago: University of Chicago Press.

Machann, C. (2010), *Masculinity in Four Victorian Epics: A Darwinist Reading*, Farnham: Ashgate.

Mack, S. (1988), *Ovid*, New Haven: Yale University Press.

Markley, A.A. (2004), *Stateliest Measures: Tennyson and the Literature of Greece and Rome*, Toronto: University of Toronto Press.

Markley, A.A. (2009), 'Tennyson and the Voices of Ovid's Heroines' in R. Douglas-Fairhurst and S. Perry (eds.), *Tennyson Among the Poets: Bicentenary Essays*, Oxford: Oxford University Press, 115–31.

Markley, A.A. (2015), 'Tennyson' in N. Vance and J. Wallace (eds.), *The Oxford History of Classical Reception in English Literature*, Oxford: Oxford University Press, 539–57.

Mermin, D. (1983), *The Audience in the Poem: Five Victorian Poets*, New Brunswick, NJ: Rutgers University Press.

Minchin, E. (2007), *Homeric Voices: Discourse, Memory, Gender*, Oxford: Oxford University Press.

O'Donnell, A.G. (1988), 'Tennyson's 'English Idyls': Studies in Poetic Decorum' *Studies in Philology*, 85: 125–44.

Olverson, T.D. (2010), *Women Writers and the Dark Side of Late Victorian Hellenism*, Basingstoke: Palgrave Macmillan.

Pastan, L. (1988), *The Imperfect Paradise*, New York: W.W. Norton.

Pattison, R. (1979), *Tennyson and Tradition*, Cambridge MA: Harvard University Press.

Pearsall, C.D.J. (2000), 'The Dramatic Monologue' in J. Bristow (ed.), *The Cambridge Companion to Victorian Poetry*, Cambridge: Cambridge University Press, 67–88.

Pearsall, C.D.J. (2008), *Tennyson's Rapture: Transformation in the Victorian Dramatic Monologue*, Oxford: Oxford University Press.

Peterson, L.H. (2009), 'Tennyson and the Ladies' *Victorian Poetry*, 47: 25–43.

Pucci, P. (1987), *Odysseus Polutropos: Intertextual Readings in the Odyssey and the Iliad*, Ithaca: Cornell University Press.

Quint, D. (1993), *Epic and Empire: Politics and Generic Form from Vergil to Milton*, Princeton: Princeton University Press.

Rader, R.W. (1984), 'Notes on Some Structural Varieties and Variations in Dramatic 'I' Poems and Their Theoretical Implications' *Victorian Poetry*, 22: 103–20.

Redpath, T. (1981), 'Tennyson and the Literature of Greece and Rome' in H. Tennyson (ed.), *Studies in Tennyson*, London: Macmillan, 105–30.

Rowlinson, M. (1992), 'The Ideological Moment of Tennyson's "Ulysses"' *Victorian Poetry*, 30: 265–76.

Scheinberg, C. (1997), 'Recasting 'Sympathy and Judgement': Amy Levy, Women Poets, and the Victorian Dramatic Monologue' *Victorian Poetry*, 35: 173–91.

Scholes, R., J. Phelan, and R.L. Kellogg. (2006), *The Nature of Narrative*, 2nd edn., Oxford: Oxford University Press.

Sinfield, A. (1977), *Dramatic Monologue*, London: Methuen.

Slinn, E.W. (2002), 'Dramatic Monologue' in R. Cronin, A. Chapman and A.H. Harrison (eds.), *A Companion to Victorian Poetry*, Oxford: Blackwell, 80–98.

Smyth, H.W. (1887), '*Homer: An Introduction to the Iliad and the Odyssey* by R. C. Jebb' *American Journal of Philology*, 8: 474–83.

Sullivan, J.P. (1993), 'Form Opposed: Elegy, Epigram, Satire' in A.J. Boyle (ed.), *Roman Epic*, London: Routledge, 143–61.

Talbot, J. (2015), '"The principle of the daguerreotype": Translation from the Classics' in N. Vance and J. Wallace (eds.), *The Oxford History of Classical Reception in English Literature*, Oxford: Oxford University Press, 57–78.

Taplin, O. (1992), *Homeric Soundings: The Shaping of the Iliad*, Oxford: Clarendon.

Tennyson, A. (1981), *The Letters of Alfred Lord Tennyson*, eds. C.Y. Lang and E.F. Shannon, Oxford: Clarendon Press.

Tennyson, A. (1987), *The Poems of Tennyson*, ed. C. Ricks, 2nd edn., Harlow: Longman.

Tennyson, H. (1897), *Alfred, Lord Tennyson: A Memoir*, London: Macmillan.

Tucker, H.F. (1984), 'From Monomania to Monologue: "St. Simeon Stylites" and the Rise of the Victorian Dramatic Monologue' *Victorian Poetry*, 22: 121–37.

Tucker, H.F. (1985), 'Dramatic Monologue and the Overhearing of Lyric' in C. Hošek and P. Parker (eds.), *Lyric Poetry: Beyond New Criticism*, 226–43, Ithaca: Cornell University Press.

Tucker, H.F. (2008), *Epic: Britain's Heroic Muse, 1790–1910*, Oxford: Oxford University Press.

Turner, F.M. (1981), *The Greek Heritage in Victorian Britain*, London: Yale University Press.

Verducci, F. (1985), *Ovid's Toyshop of the Heart: Epistulae Heroidum*, Princeton: Princeton University Press.

Webster, A. (2000), *Portraits and Other Poems*, ed. C. Sutphin, Peterborough ON: Broadview Press.

8 The Elizabethan Epyllion

Alexander, M. (2000), *A History of English Literature*, Basingstoke: Palgrave Macmillan.

Alexander, N., ed. (1967), *Elizabethan Narrative Verse*, London: Edward Arnold.

Allen, W., Jr. (1940), 'The Epyllion: A Chapter in the History of Literary Criticism' *Transactions of the American Philological Association*, 71: 1–26.

Allen, W., Jr. (1958), 'The Non-Existent Classical Epyllion' *Studies in Philology*, 55(3): 515–18.

Baldwin, T.W. (1955), 'Marlowe's Musaeus' *The Journal of English and Germanic Philology*, 54(4): 478–85.

Bär, S. (2015), 'Inventing and Deconstructing Epyllion: Some Thoughts on a Taxonomy of Greek Hexameter Poetry' *Thersites*, 2: 23–51.

Bate, J. (1993), *Shakespeare and Ovid*, Oxford: Clarendon Press.

Bradbrook, M.C. (1964), *Shakespeare and Elizabethan Poetry: A Study of His Earlier Work in Relation to the Poetry of the Time*, Harmondsworth and Ringwood: Penguin Books.

Braden, G. (1978), *The Classics and English Renaissance Poetry*, New Haven and London: Yale University Press.

Brown, G. (2004), *Redefining Elizabethan Literature*, Cambridge: Cambridge University Press.

Burrow, C. (2002), 'Re-embodying Ovid: Renaissance Afterlives' in P. Hardie (ed.), *The Cambridge Companion to Ovid*, Cambridge: Cambridge University Press, 301–19.

Bush, D. (1963), *Mythology and the Renaissance Tradition in English Poetry*, 2nd rev. edn., New York: W.W. Norton & Company.

Buté, N. (2004), 'La rhapsodie des genres dans l'épyllion élisabéthain' *Études anglaises*, 57(3): 259–70.

Cameron, A. (1995), *Callimachus and his Critics*, Princeton: Princeton University Press.

Cheney, P. (2007), 'Introduction: Shakespeare's poetry in the twenty-first century' in P. Cheney (ed.), *The Cambridge Companion to Shakespeare's Poetry*, Cambridge: Cambridge University Press, 1–13.

Chiari, S., ed. (2012), *Renaissance Tales of Desire: Hermaphroditus and Salmacis, Theseus and Ariadne, Ceyx and Alcione and Orpheus his Journey to Hell*, 2nd rev. edn., Newcastle-upon-Tyne: Cambridge Scholars Publishing.

Colie, R.L. (1973), *The Resources of Kind: Genre-Theory in the Renaissance*, Berkeley CA and New York: University of California Press.

Courtney, E. (1996), 'Epyllion' in S. Hornblower and A. Spawforth (eds.), *The Oxford Classical Dictionary*, 3rd rev. edn., Oxford: Oxford University Press, 550.

Crump, M.M. (1931), *The Epyllion from Theocritus to Ovid*, Oxford: Blackwell.

Demetriou, T. (2017), 'The Non-Ovidian Elizabethan Epyllion: Thomas Watson, Christopher Marlowe, Richard Barnfield' in J. Valls-Russell, A. Lafont and C. Coffin (eds.), *Interweaving Myths in Shakespeare and his Contemporaries*, Manchester: Manchester University Press, 41–64.

Donno, E.S., ed. (1963), *Elizabethan Minor Epics*, New York: Columbia University Press and London: Routledge and Kegan Paul.

Ellis, J. (2003), *Sexuality and Citizenship: Metamorphosis in Elizabethan Erotic Verse*, Toronto, Buffalo and London: University of Toronto Press.

Elze, K., ed. (1864), *Sir Walter Scott*, vol. 1, Dresden: Louis Ehlermann.

Enterline, L. (2015), 'Elizabethan Minor Epic' in P. Cheney and P. Hardie (eds.), *The Oxford History of Classical Reception in English Literature*, vol. 2, Oxford: Oxford University Press, 253–71.

Fantuzzi, M. (1998), 'Epyllion' *Der Neue Pauly*, 4: 31–3.

Greer, G. (1958), 'The Epyllion' Lecture notes, University of Melbourne. Available at: https://digitised-collections.unimelb.edu.au/handle/11343/91816 (accessed 31 July 2018).

Heumann, J. (1904), *De epyllio Alexandrino*, Königsee: Selmar de Ende.

Hollis, A.S. (2006), 'The Hellenistic Epyllion and its Descendants' in S.F. Johnson (ed.), *Greek Literature in Late Antiquity: Dynamism, Didacticism, Classicism*, Aldershot and Burlington: Routledge, 141–57.

Hulse, C. (1981), *Metamorphic Verse: The Elizabethan Minor Epic*, Princeton: Princeton University Press.

Ilgen, K.D., ed. (1796), *Hymni Homerici cum reliquis carminibus minoribus Homero tribui solitis et Batrachomyomachia*, Halle: Hemmerdeana.

Kahn, C. (2007), '*Venus and Adonis*' in P. Cheney (ed.), *The Cambridge Companion to Shakespeare's Poetry*, Cambridge: Cambridge University Press, 72–89.

Keach, W. (1977), *Elizabethan Erotic Narratives: Irony and Pathos in the Ovidian Poetry of Shakespeare, Marlowe, and Their Contemporaries*, New Brunswick: Rutgers University Press.

Kennedy, W.J. (2007), 'Shakespeare and the Development of English Poetry' in P. Cheney (ed.), *The Cambridge Companion to Shakespeare's Poetry*, Cambridge: Cambridge University Press, 14–32.

Körting, G. (1884), *Encyklopaedie und Methodologie der romanischen Philologie mit besonderer Berücksichtigung des Französischen und Italienischen*, vol. 1, Heilbronn: Gebr. Henninger.

Körting, G. (1910), *Grundriss der Geschichte der englischen Literatur von ihren Anfängen bis zur Gegenwart*, 5th rev. edn., Münster: Heinrich Schöningh.

Maslen, R.W. (2003), 'Lodge's *Glaucus and Scilla* and the Conditions of Catholic Authorship in Elizabethan England' *EnterText*, 3(1): 59–100.

Merriam, C.U. (2001), *The Development of the Epyllion Genre Through the Hellenistic and Roman Periods*, Lewiston, Queenston and Lampeter: The Edwin Mellen Press.

Miller, P.W. (1958), 'The Elizabethan Minor Epic' *Studies in Philology*, 55(1): 31–8.

Miller, P.W., ed. (1967), *Seven Minor Epics of the English Renaissance*, Gainesville: Scholars' Facsimiles and Reprints.

Most, G.W. (1982), 'Neues zur Geschichte des Terminus "Epyllion"' *Philologus*, 126(1–2): 153–6.

Reese, M.M., ed. (1968), *Elizabethan Verse Romances*, London: Routledge and Kegan Paul and New York: Humanities Press.

Rose, H.J. (1934), *A Handbook of Greek Literature: From Homer to the Age of Lucian*, 3rd rev. edn., London: Methuen.

Smith, H. (1952), *Elizabethan Poetry: A Study in Conventions, Meaning, and Expression*, Cambridge MA: Harvard University Press.

Tilg, S. (2012), 'On the Origins of the Modern Term "Epyllion": Some Revisions to a Chapter in the History of Classical Scholarship' in M. Baumbach and S. Bär (eds.), *Brill's Companion to Greek and Latin Epyllion and Its Reception*, Leiden and Boston: Brill, 29–54.

Trimble, G. (2012), 'Catullus 64: The Perfect Epyllion?' in M. Baumbach and S. Bär (eds.), *Brill's Companion to Greek and Latin Epyllion and Its Reception*, Leiden and Boston: Brill, 55–79.

Vessey, D.W.T.C. (1970), 'Thoughts on the Epyllion' *The Classical Journal*, 66(1): 38–43.

Weaver, W.P. (2012), *Untutored Lines: The Making of the English Epyllion*, Edinburgh: Edinburgh University Press.

Wilkinson, L.P. (1955), *Ovid Recalled*, Cambridge: Cambridge University Press.

9 'Homer Undone'

Asmis, E. (1992), 'Plato on Poetic Creativity' in R. Kraut (ed.), *The Cambridge Companion to Plato*, Cambridge: Cambridge University Press, 338–64.

Austin, N. (1994), *Helen of Troy and Her Shameless Phantom*, Ithaca: Cornell University Press.

Babcock, R.G. (1995), 'Verses, Translation, and Reflections from *The Anthology*: H.D., Ezra Pound, and the Greek Anthology' *Sagetrieb*, 14(1–2): 201–16.

Baccolini, R. (2003), '"And So Remembrance Brought Us to This Hour in Which I Strive to Save Identity": Figures of Memory in H.D.'s Late Poetry' in M. Camboni (ed.), *H.D.'s Poetry: 'The Meanings That Words Hide'*. New York: AMS Press, 143–72.

Bailey, P.D. (2006), '"Hear the Voice of the [Female] Bard": Aurora Leigh as a Female Romantic Epic' in B. Schweizer (ed.), *Approaches to the Anglo and American Female Epic, 1621–1982*, Aldershot: Ashgate, 117–37.

Barbour, S. (2012), 'The Origins of the Prose Captions in H.D.'s *Helen in Egypt*' *The Review of English Studies*, 63(260): 466–90.

Barrett Browning, E. (1877), *Letters of Elizabeth Barrett Browning Addressed to Richard Hengist Horne*, London: Richard Bentley and Son.

Barrett Browning, E. (1899), *The Letters of Elizabeth Barrett Browning*, ed. F.G. Kenyon, London: Macmillan.

Barrett Browning, E. ([1856] 1993), *Aurora Leigh*, ed. K. McSweeney, Oxford: Oxford University Press.

Beecroft, A.J. (2006), '"This Is Not a True Story": Stesichorus's *Palinode* and the Revenge of the Epichoric' *Transactions of the American Philological Association*, 136(1): 47–70.

Bergren, A. (1983), 'Language and the Female in Early Greek Thought' *Arethusa*, 16: 69–95.

Blondell, R. (2010), 'Refractions of Homer's Helen in Archaic Lyric' *American Journal of Philology*, 131(3): 349–91.

Bloom, H., ed. (1989), *H.D.*, New York, Philadelphia: Chelsea House.

Bloom, H. (1997), *The Anxiety of Influence: A Theory of Poetry*, 2nd edn., New York, Oxford: Oxford University Press.

Borges, J.L. (2000), 'The Telling of the Tale' in C.A. Mihailescu (ed.), *This Craft of Verse*, Cambridge MA: Harvard University Press, 43–56.

Bridges, M. (2008), 'The Eros of Homeros: The Pleasures of Greek Epic in Victorian Literature and Archaeology' *Victorian Review*, 34(2): 165–83.

Browning, R.W.B. (1913), *The Browning Collections: Catalogue of Oil Paintings, Drawings & Prints; Autograph Letters and Manuscripts; Books; Statuary, Furniture, Tapestries, and Works of Art*, London: J. Davy and Sons.

Byrd, D. (1999), 'Combating an Alien Tyranny: Elizabeth Barrett Browning's Evolution as a Feminist Poet' in S. Donaldson (ed.), *Critical Essays on Elizabeth Barrett Browning*. Boston: G. K. Hall, 202–17.

Cavanagh, S. (2006), 'Romancing the Epic: Lady Mary Wroth's *Urania* and Literary Traditions' in B. Schweizer (ed.), *Approaches to the Anglo and American Female Epic, 1621–1982*. Aldershot: Ashgate, 19–36.

Chakravarti, D. (2006), 'The Female Epic and the Journey Towards Self-Definition in Mary Tighe's *Psyche*' in B. Schweizer (ed.), *Approaches to the Anglo and American Female Epic, 1621–1982*. Aldershot: Ashgate, 99–116.

Chisholm, D. (1992), *H.D.'s Freudian Poetics: Psychoanalysis in Translation*, Ithaca NY: Cornell University Press.

Christodoulides, N.J. and P. Mackay, eds., 2011. *The Cambridge Companion to H.D.*, Cambridge: Cambridge University Press.

Cixous, H. (1976), 'The Laugh of the Medusa' *Signs*, 1(4): 875–93.

Collecott, D. (1999), *H.D. and Sapphic Modernism 1910–1950*, Cambridge: Cambridge University Press.

Comet, N. (2013), *Romantic Hellenism and Women Writers*, London: Springer.

Davies, D.W. (1954), *The World of the Elseviers, 1580–1712*, Dordrecht: Springer.

Dentith, S. (2006), *Epic and Empire in Nineteenth-Century Britain*, Cambridge: Cambridge University Press.

Dickey, E. (2007), *Ancient Greek Scholarship: A Guide to Finding, Reading, and Understanding Scholia, Commentaries, Lexica, and Grammatical Treatises, From Their Beginnings to the Byzantine Period*, Oxford: Oxford University Press.

Doolittle, H. (H.D.) (1961), *Helen in Egypt*, New York: New Directions.

Doolittle, H. (H.D.) (1983), *Collected Poems 1912–1944*, ed. L.L. Martz, New York: New Directions.

Dougher, S. (2001), 'An Epic for the Ladies: Contextualizing Samuel Butler's Theory of *Odyssey* Authorship' *Arethusa*, 34(2): 173–84.

Downes, J.M. (1997), *Recursive Desire: Rereading Epic Tradition*, Tuscaloosa: University of Alabama Press.

Downes, J.M. (2010), *The Female Homer: An Exploration of Women's Epic Poetry*, Newark DE: University of Delaware Press.

Drummond, C. (2006), 'A "Grand Possible": Elizabeth Barrett Browning's Translations of Aeschylus's *Prometheus Bound*' *International Journal of the Classical Tradition*, 12(4): 507–62.

DuPlessis, R.B. (1986), *H.D.: The Career of That Struggle*, Bloomington and Indianapolis: Indiana University Press.

Edmunds, S. (1994), *Out of Line: History, Psychoanalysis, & Montage in H.D.'s Long Poems*, Stanford CA: Stanford University Press.

Falk, A. (1991), 'Lady's Greek Without the Accents: Aurora Leigh and Authority' *Studies in Browning and His Circle*, 19: 84–92.

Fiske, S. (2008), *Heretical Hellenism: Women Writers, Ancient Greece, and the Victorian Popular Imagination*, Athens OH: Ohio University Press.

Flack, L.C. (2015), *Modernism and Homer*, Cambridge: Cambridge University Press.

Fowler, R. (2005), 'The Homeric Question' in R. Fowler (ed.), *The Cambridge Companion to Homer*, Cambridge: Cambridge University Press, 220–32.

Friedman, S. (1975), 'Who Buried H.D.? A Poet, Her Critics, and Her Place in "The Literary Tradition"' *College English*, 36(7): 801–14.

Friedman, S.S. (1981), *Psyche Reborn: The Emergence of H.D.*, Bloomington: Indiana University Press.

Friedman, S.S. (1986), 'Gender and Genre Anxiety: Elizabeth Barrett Browning and H. D. as Epic Poets' *Tulsa Studies in Women's Literature*, 5(2): 203–28.

Friedman, S.S. (1987), 'Against Discipleship: Collaboration and Intimacy in the Relationship of H.D. and Freud' *Literature and Psychology*, 33(3–4): 89–108.

Friedman, S.S. (1990a), 'Creating a Women's Mythology: H.D.'s *Helen in Egypt*' in S.S. Friedman and R.B. DuPlessis (eds.), *Signets: Reading H.D.*, Madison WI: University of Wisconsin Press, 373–405.

Friedman, S.S. (1990b), *Penelope's Web: Gender, Modernity, H.D.'s Fiction*, Cambridge: Cambridge University Press.

Friedman, S.S. (1995), 'Serendipity: Finding a Draft Manuscript of H.D.'s "Helen"' *Sagetrieb*, 14(1–2): 7–11.

Friedman, S.S. and R.B. DuPlessis, eds. (1990), *Signets: Reading H.D.*, Madison WI: University of Wisconsin Press.

Friedman, S.S., ed. (2005), *Analyzing Freud: Letters of H.D., Bryher and Their Circle*, New York: New Directions.

Gelpi, A. (1989), 'H.D.: Hilda in Egypt' in H. Bloom (ed.), *H.D.*, New York and Philadelphia: Chelsea House, 123–40.

Gilbert, S.M. (1984), 'From Patria to Matria: Elizabeth Barrett Browning's Risorgimento' *Proceedings of the Modern Language Association*, 99(2): 194–211.

Gilbert, S. and S. Gubar (1979), *The Madwoman in the Attic: The Woman Writer and the Nineteenth-Century Literary Imagination*, New Haven: Yale University Press.

Grafton, A. (1981), 'Prolegomena to Friedrich August Wolf' *Journal of the Warburg and Courtauld Institutes*, 44: 101–29.

Grafton, A., G.W. Most, and J. Zetzel, trans. (1985), *F.A. Wolf: Prolegomena to Homer, 1795*, Princeton: Princeton University Press.

Graziosi, B. (2002), *Inventing Homer*, Cambridge: Cambridge University Press.

Gregory, E. (1995), 'Euripides and H.D.'s Working Notebook for *Helen in Egypt*' *Sagetrieb*, 14(1–2): 83–109.

Gregory, E. (1997), *H. D. and Hellenism: Classic Lines*, Cambridge: Cambridge University Press.

Guest, B. (1984), *Herself Defined: The Poet H.D. and Her World*, Garden City and New York: Doubleday.

Gumpert, M. (2001), *Grafting Helen: The Abduction of the Classical Past*, Madison: University of Wisconsin Press.

Halliwell, S. (2002), *The Aesthetics of Mimesis: Ancient Texts and Modern Problems*, Princeton: Princeton University Press.

Hardwick, L. (2000), *Translating Words, Translating Cultures*, London: Duckworth.

Harrison, S. (2013), 'Some Victorian Versions of Greco-Roman Epic' in C. Stray (ed.), *Remaking the Classics: Literature, Genre and Media in Britain 1800–2000*, London: Bloomsbury, 21–36.

Hart, G. (1995), '"A Memory Forgotten": The Circle of Memory and Forgetting in H.D.'s *Helen in Egypt*' *Sagetrieb*, 14(1–2): 161–77.

Haubold, J. (2007), 'Homer After Parry: Tradition, Reception, and the Timeless Text' in B. Graziosi and E. Greenwood (eds.), *Homer in the Twentieth Century:*

Between World Literature and the Western Canon, Oxford: Oxford University Press, 27–46.

Hokanson, R. (1992), '"Is It All a Story?": Questioning Revision in H.D.'s *Helen in Egypt*' *American Literature*, 64(2): 331–46.

Hollenberg, D.K. (1991), *H.D.: The Poetics of Childbirth and Creativity*, Boston: Northeastern University Press.

Hollenberg, D.K., ed. (1997), *Between History and Poetry: The Letters of H.D. and Norman Holmes Pearson*, Iowa City: University of Iowa Press.

Houston, G.T. (2013), *Victorian Women Writers, Radical Grandmothers, and the Gendering of God*, Columbus OH: Ohio State University Press.

Hurst, I. (2006), *Victorian Women Writers and the Classics*, Oxford: Oxford University Press.

Hurst, I. (2015), 'Elizabeth Barrett Browning' in N. Vance and J. Wallace (eds.), *The Oxford History of Classical Reception in English Literature*, vol. 4, Oxford: Oxford University Press, 449–70.

Jarrott, C.A.L. (1970), 'Erasmus' Biblical Humanism' *Studies in the Renaissance*, 17: 119–52.

Jenkyns, R. (1989), *The Victorians and Ancient Greece*, Oxford: Wiley-Blackwell.

Johns-Putra, A. (2001), *Heroes and Housewives: Women's Epic Poetry and Domestic Ideology in the Romantic Age (1770–1835)*, Bern: Peter Lang.

Johns-Putra, A. (2006a), *The History of the Epic*, London: Springer.

Johns-Putra, A. (2006b), 'Gendering Telemachus: Anna Seward and the Epic Rewriting of Fénelon's *Télémaque*' in B. Schweizer (ed.), *Approaches to the Anglo and American Female Epic, 1621–1982*, Aldershot: Ashgate, 85–98.

Josefowicz, D.G. (2016), 'The Whig Interpretation of Homer: F.A. Wolf's *Prolegomena Ad Homerum* in England' in A. Blair and A. Goeing (eds.), *For the Sake of Learning: Essays in Honor of Anthony Grafton*, Leiden and Boston: Brill, 821–44.

Keith, A. (2000), *Engendering Rome: Women in Latin Epic*, Cambridge: Cambridge University Press.

Kinnahan, L.A. (1994), *Poetics of the Feminine: Authority and Literary Tradition in William Carlos Williams, Mina Loy, Denise Levertov, and Kathleen Fraser*, Cambridge: Cambridge University Press.

Kintner, E., ed. (1969), *The Letters of Robert Browning and Elizabeth Barrett, 1845–1846*, Cambridge MA: Harvard University Press.

Korg, J. (2003), *Winter Love: Ezra Pound and H.D.*, Madison WI: University of Wisconsin Press.

Laird, H. (1999), '*Aurora Leigh*: An Epical Ars Poetica' in S. Donaldson (ed.), *Critical Essays on Elizabeth Barrett Browning*, Boston: G.K. Hall, 275–90.

Lamberton, R. (2012), *Proclus the Successor on Poetics and the Homeric Poems: Essays 5 and 6 of his Commentary on the Republic of Plato*, Atlanta: Society of Biblical Literature.

Laurence, A., J. Bellamy, and G. Perry, eds. (2000), *Women, Scholarship and Criticism: Gender and Knowledge c. 1790–1900*, Manchester: Manchester University Press.

Lord, A. (2000), *The Singer of Tales*, eds. S. Mitchell and G. Nagy, 2nd edn., Cambridge MA: Harvard University Press.

Martin, R.P. (2005), 'Epic as Genre' in J.M. Foley (ed.), *A Companion to Ancient Epic*, Oxford: Blackwell, 9–19.

Mermin, D. (1989), *Elizabeth Barrett Browning: The Origins of a New Poetry*, Chicago: University of Chicago Press.

Morris, A. (2003), *How to Live/What to Do: H.D.'s Cultural Poetics*, Urbana and Chicago: University of Illinois Press.

Murnaghan, S. (2009), 'H.D., Daughter of Helen: Mythology as Actuality' in G.A. Staley (ed.), *American Women and Classical Myths*, Waco TX: Baylor University Press, 63–84.

Murray, P., ed. (1996), *Plato on Poetry*, Cambridge: Cambridge University Press.

Nagy, G. (1990), *Pindar's Homer: The Lyric Possession of an Epic Past*, Baltimore: Johns Hopkins University Press.

Nagy, G. (1996), *Homeric Questions*, Austin: University of Texas Press.

Pantelia, M.C. (1993), 'Spinning and Weaving: Ideas of Domestic Order in Homer' *American Journal of Philology*, 114(4): 493–501.

Parry, A., ed. (1971), *The Making of Homeric Verse*, Oxford: Oxford University Press.

Pattison, M. (1889), *Pattison's Essays*, ed. H. Nettleship. Oxford: Clarendon Press.

Pound, E. (1968), *The Spirit of Romance*, 2nd edn., New York: New Directions.

Prins, Y. (2017), *Ladies' Greek: Victorian Translations of Tragedy*, Princeton: Princeton University Press.

Schmidt, P. (1991), 'Introduction to Williams' "Letter to an Australian Editor" (1946): Williams' Manifesto for Multiculturalism' *William Carlos Williams Review*, 17(2): 4–7.

Schweizer, B., ed. (2006), *Approaches to the Anglo and American Female Epic, 1621–1982*, Aldershot: Ashgate.

Sheppard, A.D.R. (1980), *Studies on the 5th and 6th Essays of Proclus' Commentary on the Republic*, Göttingen: Vandenhoeck & Ruprecht.

Showalter, E. (1982), *A Literature of Their Own: British Women Novelists, From Brontë to Lessing*, Princeton: Princeton University Press.

Stone, M. (1987), 'Genre Subversion and Gender Inversion: *The Princess* and *Aurora Leigh*' *Victorian Poetry*, 25(2): 101–27.

Stone, M. (1995), *Elizabeth Barrett Browning*, Basingstoke: Macmillan.

Swedenberg, H.T. (1944), *The Theory of the Epic in England 1650–1800*, Los Angeles: University of California Press.

Tucker, H.F. (2008), *Epic: Britain's Heroic Muse 1790–1910*, Oxford: Oxford University Press.

Volkmann, R. (1874), *Geschichte und Kritik der Wolfschen Prolegomena zu Homer: Ein Beitrag zur Geschichte der Homerischen Frage*, Leipzig: Teubner.

Wallace, E.M. (1987), 'Hilda Doolittle at Friends' Central School in 1905' *H.D. Newsletter*, 1(1): 17–28.

Wallace, J. (2000), 'Elizabeth Barrett Browning: Knowing Greek' *Essays in Criticism*, 50(4): 329–53.

Willems, A. (1880), *Les Elzevier: Histoire et Annales Typographiques*, Brussels: Van Trigt.

Williams, W.C. (1991), 'Letter to an Australian Editor' *William Carlos Williams Review*, 17(2): 8–12.

Woolf, V. (1989), *A Room of One's Own*, 2nd edn., San Diego, New York and London: Harcourt.

Worman, N. (2001), 'This Voice Which Is Not One: Helen's Verbal Guises in Homeric Epic' in A. Lardinois and L. McClure (eds.), *Making Silence Speak: Women's Voices in Greek Literature and Society*, Princeton: Princeton University Press, 19–37.

Zajko, V. (2005), 'Homer and *Ulysses*' in R. Fowler (ed.), *The Cambridge Companion to Homer*, Cambridge: Cambridge University Press, 311–23.

10 Generic 'Transgressions' and the Personal Voice

Balmer, J. (2004), *Chasing Catullus: Poems, Translations and Transgressions*, Newcastle-upon-Tyne: Bloodaxe.

Balmer, J. (2010), 'Josephine Balmer, Poet and Translator, in interview with Lorna Hardwick (Oxford, 17 May 2010)' *Practitioners' Voices in Classical Reception*, 2 (2010). Available at: www.open.ac.uk/arts/research/pvcrs/2010/balmer (accessed 16 December 2017).

Balmer, J. (2012), 'Handbags and Gladrags: A Woman in Transgression, Reflecting' *Classical Receptions Journal*, 4(2): 261–71.

Balmer, J. (2013), *Piecing Together the Fragments: Translating Classical Verse, Creating Contemporary Poetry*, Oxford: Oxford University Press.

Balmer, J. (2017a), *Letting Go*, East Sussex: Agenda Editions.

Balmer, J. (2017b), 'Jo Balmer' *Practitioners' Voices in Classical Reception*, 8 (2017). Available at: www.open.ac.uk/arts/research/pvcrs/2017/balmer (accessed 16 December 2017).

Beye, C.R. (1997), 'A response' in J.P. Hallett and T. van Nortwick (eds.), *Compromising Traditions: The Personal Voice in Classical Scholarship*, London and New York: Routledge, 153–67.

Byatt, A.S. (2003), 'The Pink Ribbon' in A.S. Byatt (ed.), *Little Black Book of Stories*, London: Chatto and Windus, 224–76.

Carson, A. (2010) *Nox*. New York: New Directions.

Cox, F. (2011), *Sibylline Sisters: Virgil's Presence in Contemporary Women's Writing*. Oxford: Oxford University Press.

Foster, B., ed. and trans. (1929), *Livy: Books XXI–XXII with An English Translation*, Cambridge MA: Harvard University Press and London: William Heinemann.

Glück, L. (2012), *Poems 1962–2012*, New York: Farrar, Straus and Giroux.

Hadas, R. (2015) *Talking to the Dead*, New York: Spuyten Duyvil.

Hardie, P. (2013), *The Last Trojan Hero: A Cultural History of Virgil's Aeneid*, London: I.B. Tauris.

Holst-Warhaft, G. (1992), *Dangerous Voices: Women's Laments and Greek Literature*, London: Routledge.

Lewis, C.S. (1966), *A Grief Observed*, London: Faber and Faber.

Martindale, C. (1993), *Redeeming the Text: Latin Poetry and the Hermeneutics of Reception*, Cambridge: Cambridge University Press.

Martindale, C. (1997), 'Introduction: The Classic of All Europe' in C. Martindale (ed.), *Cambridge Companion to Virgil*, Cambridge: Cambridge University Press, 1–18.

Mendelsohn, D. (2017) *An Odyssey. A Father, A Son and An Epic.* Croydon: William Collins.

Ruden, S., trans. (2008), *Virgil: Aeneid*, New Haven and London: Yale University Press.

Theodorakopoulos, E. (2012) 'Women's Writing and the Classical Tradition' *Classical Receptions Journal*, 4(2): 149–163.

Vandiver, E. (2010), *Stand in the Trench, Achilles: Classical Receptions in British Poetry of the Great War*, Oxford: Oxford University Press.

van Nortwick, T. (1997), 'Who do I think I am?' in J.P. Hallett and T. van Nortwick (eds.), *Compromising Traditions: The Personal Voice in Classical Scholarship*, London and New York: Routledge, 16–24.

Weisman, K. (2010), 'Introduction' in K. Weisman (ed.), *Oxford Handbook of the Elegy*, Oxford: Oxford University Press, 1–13.

Zajko, V. (1997), 'False Things Which Seem Like the Truth' in J.P. Hallett and T. van Nortwick (eds.), *Compromising Traditions: The Personal Voice in Classical Scholarship*, London and New York: Routledge, 54–72.

General Index

Index of Passages Cited

Lightning Source UK Ltd.
Milton Keynes UK
UKHW020103010820
367532UK00003B/96